T0328207

Dynamic
Economic
Systems

JOHN M. BLATT

Dynamic Economic Systems

A Post-Keynesian Approach

Routledge
Taylor & Francis Group

LONDON AND NEW YORK

First published 2000 by M.E. Sharpe

Published 2015 by Routledge
2 Park Square, Milton Park, Abingdon, Oxon OX14 4RN
711 Third Avenue, New York, NY 10017

Routledge is an imprint of the Taylor & Francis Group, an informa business

Library of Congress Cataloging in Publication Data

Blatt, John Markus.
 Dynamic economic systems.
 1. Statics and dynamics (Social sciences)
 2. Economic development. 3. Business cycles.
 I. Title.
HB145.B55 1983 338.9'00724 82-24013
ISBN 0-87332-215-0

British Library Cataloguing in Publication Data

Blatt, John M.
 Dynamic economic systems.
 1. Statics and dynamics (Social Sciences)
 2. Economic development
 I. Title
338.9'01'51 HB145

ISBN 13: 978-0-8733-2306-2 (pbk)
ISBN 13: 978-0-8733-2215-7 (hbk)

Table of Contents

Preface

The aim of this book is explained and a brief description of its organization appears in the introductory chapter. The purpose of this preface is to express my thanks and appreciation to the people and the organizations who have been so helpful to me in writing this work.

My first thanks go to those who have been kind enough to read all, or nearly all, of the manuscript in various draft stages and who have contributed extremely valuable comments and criticisms: Professor Alfred Eichner of Rutgers University, Professor Peter Groenewegen of Sydney University, Professor Geoffrey Harcourt of Adelaide University, Professor Murray Kemp of the University of New South Wales, Dr. Ulrich Kohli of Sydney University, Dr. Helen Lapsley of the University of New South Wales, and Mr. Brian Martin of the Australian National University. It is impossible to exaggerate the importance of their contribution, or my debt to them singly and collectively.

I am also greatly indebted to many others who have given me valuable advice on particular areas, including Professor Malcolm Fisher, Dr. Flora Gill, Professor Jules Ginswick, Dr. Josef Halevy, Dr. Peter Jonson, and Dr. Robin Pope.

It should not be thought that all, or even most, of them are in agreement with the views put forward here. These views have developed and their literary expression has been improved through continued interaction with kind people willing to give of their time and expertise in order to aid a man come to the field but recently. This has been equally helpful, and equally appreciated by me, whether it has come from a person generally in agreement, or strongly in disagreement, with my own views. Naturally, I take full responsibility for the contents of this book, including all its short-

comings. These reflect on me only, not in any way on the many kind people to whom I owe so much gratitude.

The writing was greatly helped by a study leave of five months as a guest of the School of Economics at Sydney University. I thank the University of New South Wales for granting me this leave, and Sydney University for making my stay there such a thoroughly enjoyable, exciting, and stimulating experience.

Another area of indebtedness of any author is to the literature in his field. I am not, alas, an avid reader. As a result, I must now apologize to those scholars whose books and articles should have been, but have not been, cited. In all these cases, it may be taken for granted that the omission is due to my not having read the work in question, not to any deliberate decision on my part to omit citation of the work. Other omissions are associated with the very considerable delays before overseas books get into Australian university libraries. Partial amends are made, I hope, by citing review articles and books which contain fuller lists of scholarly references.

Mrs. Jill Pollock has been enormously helpful, particularly in connection with the list of references.

Last but not least, I owe profound gratitude to my wife, Ruth, for her love, good nature, and continued forbearance during an extended, and no doubt difficult, period with an author in the throes of writing.

John Blatt
Sydney

Dynamic
Economic
Systems

BOOK I

Preliminaries

Chapter 1 is an overall introduction to the book, explaining its purpose, its limitations, its structure, its organization, and its relationship to other work in theoretical economics.

Chapter 2 is a preparatory study of pure steady-state input-output systems, both for the case of bare subsistence and for the case of a social surplus. To get a steady state in the latter case, one must assume that the surplus is not invested for growth, but rather that all of it is consumed. The purpose of this chapter is twofold: (1) to show, following Sraffa (1960), that the neoclassical mechanism of supply and demand for determining prices can be bypassed in favor of a much simpler procedure, and (2) to show why Sraffa's procedure must be modified when we turn to dynamic economics, i.e., when steady-state conditions are no longer true for the system under study.

CHAPTER 1

Introduction

A. Purpose and limitations

The bicentenary of *The Wealth of Nations* has passed, and so has the centenary of the neoclassical revolution in economics. Yet the present state of *dynamic* economic theory leaves very much to be desired and appears to show little sign of significant improvement in the near future.

From the time of Adam Smith, economic theory has developed in terms of an almost universal concentration of thought and effort on the study of equilibrium states. These may be either states of static equilibrium, or states of proportional and balanced growth. Truly dynamic phenomena, of which the most striking example is the trade cycle, have been pushed to the sidelines of research.

In defense of this concentration on equilibrium and the neglect of true dynamics, there are two arguments:

1. Statics or (what comes to much the same thing) balanced proportional growth is much easier to handle theoretically than true dynamic phenomena. A good understanding of statics is a necessary prerequisite for the study of dynamics. We must learn to walk before we can attempt to run.

2. In any case, while no economic system is ever in strict equilibrium, the deviations from such a state are small and can be treated as comparatively minor perturbations. The equilibrium state is, so to speak, the reference state about which everything turns and toward which the system gravitates. Market prices fluctuate up and down, but there exist "natural prices" about which this fluctuation occurs, and these natural prices can be determined directly, by ignoring the fluctuations altogether and working as if strict equilibrium obtained throughout.

Such arguments did carry a great deal of conviction two hundred years ago, when the basic ideas of the science of economics were being formulated for the first time.

However, it is impossible to ignore the passage of two hundred years. A baby is expected to first crawl, then walk, before running. But what if a grown-up man is still crawling? At present, the state of our dynamic economics is more akin to a crawl than to a walk, to say nothing of a run. Indeed, some may think that capitalism as a social system may disappear before its dynamics are understood by economists.

It is possible, of course, that this deplorable lack of progress is due entirely to the technical difficulty of investigating dynamic systems and that economists, by following up the present lines of research, will eventually, in the long long long run, develop a useful dynamic theory of their subject.

However, another possibility must not be ignored. It is by no means true that *all* dynamic behavior can be understood best, or even understood at all, by starting from a study of the system in its equilibrium state. Consider the waves and tides of the sea. The equilibrium state is a tideless, waveless, perfectly flat ocean surface. This is no help at all in studying waves and tides. We lose the essence of the phenomenon we are trying to study when we concentrate on the equilibrium state. Exactly the same is true of meteorology, the study of the weather. Everything that matters and is of interest to us happens *because* the system is not in equilibrium.

In the first example, the equilibrium state is at least stable, in the sense that the system tends to approach equilibrium in the absence of disturbances. But there is no such stability in meteorology. The input of energy from the sun, the rotation of the earth, and various other effects keep the system from getting at all close to equilibrium. Nor, for that matter, would we wish it to approach equilibrium. The true equilibrium state, in the absence of heat input from the sun, is at a temperature where all life comes to a stop! The heat input from the sun is the basic power source for winds, clouds, etc., for everything that makes our weather. The heat input is very steady, but the resulting weather is not steady at all. *None* of this can be understood by concentrating on a study of equilibrium.

There exist known systems, therefore, in which the important and interesting features of the system are "essentially dynamic," in the sense that they are not just small perturbations around some equilibrium state, perturbations which can be understood by starting from a study of the equilibrium state and tacking on the dynamics as an afterthought.

If it should be true that a competitive market system is of that kind, then the lack of progress in dynamic economics is no longer surprising. No progress can then be made by continuing along the road that economists have been following for two hundred years. The study of economic equilibrium is then little more than a waste of time and effort.

This is the basic contention of *Dynamic Economic Systems*. Its main purpose is to present arguments for this contention and to start developing the tools which are needed to make progress in understanding truly dynamic economic systems.

A subsidiary purpose, related to the main one but not identical with it, is to present a critical survey of the more important existing dynamic economic theories—in particular, the theories of balanced proportional growth and the theories of the trade cycle. This survey serves three purposes:

1. It is useful in its own right, as a summary of present views, and it can be used as such by students of economics.

2. It establishes contact between the new approach and the literature.

3. It is necessary to clear the path to further advance, which is currently blocked by beliefs which are very commonly held, but which are not in accordance with the facts.

The third point needs some elaboration. The main enemy of scientific progress is *not* the things we do not know. Rather, it is the things which we think we know well, but which are actually not so! Progress can be retarded by a lack of facts. But when it comes to bringing progress to an absolute halt, there is nothing as effective as incorrect ideas and misleading concepts. "Everyone knows" that economic models must be stable about equilibrium, or else one gets nonsense.[1] So, models with unstable equilibria are never investigated! Yet, in this as in so much else, what "everyone knows" happens to be simply wrong. Such incorrect ideas must be overturned to clear the path to real progress in dynamic economics.

This is a book on basic economic theory, addressed to students of economics. It is *not* a book on "mathematical economics," and even less so a book on mathematical methods in economics. On the contrary, the mathematical level of this book has been kept deliberately to an irreducible, and extremely low, minimum. Chapters are literary, with mathematical appendices. The level of mathematics in the literary sections is the amount of elementary alge-

[1] E.g., Blaug (1968, p. 631) describes the result of Tooke (1838), that "the money market turns out always to be in unstable equilibrium," as an "absurdity." Tooke was, of course, completely right in this assertion.

bra reached rather early in high school; solving two linear equations in two unknowns is the most difficult mathematical operation used. In the mathematical appendices, the level is second year mathematics in universities; the meaning of a matrix, of eigenvalues, and of a matrix inverse are the main requirements. Whenever more advanced mathematics is required—and this is very rarely indeed—the relevant theorems are stated without proof, but with references to suitable textbooks. This very sparing use of mathematics should enable all economics students, and many laymen, to read and understand this book fully. Those who cannot follow the mathematical appendices must take the mathematics for granted, but if they are prepared to do that, they will lose nothing of the main message.

This does not mean that mathematics is unimportant or of little help, when used properly. This unfortunately all too common belief is incorrect. To make real progress in dynamic economics, researchers must know rather more, and somewhat different, mathematics from what is commonly taught to students of economics. But while mathematics is highly desirable, probably essential, to making further progress, the progress that has already been made can be phrased in terms understandable to people without mathematical background. This reliance on nonmathematical diction has not been easy for someone to whom mathematics is not some arcane foreign language, but rather his normal mode of thinking; only time can tell to what extent the effort has been successful.

Another limitation of this work is the restriction to classically competitive conditions in most cases. There is no discussion of monopoly, oligopoly, restrictions on entry, or related matters which are stressed, quite rightly, in the so-called post-Keynesian literature. This omission is *not* to be interpreted as disagreement with, or lack of sympathy for, the contentions of that school. Rather, the post-Keynesians have been entirely too kind and indulgent toward the neoclassical doctrine. The assumption of equilibrium has indeed been attacked (Robinson 1974, for example), but only in rather general terms. The more prominent part of the post-Keynesian critique has been that conventional economic theory bases itself on assumptions (e.g., perfect competition, perfect market clearing, certainty of the future) which are invalid in our time, though some of them (*not* perfect certainty of the future!) may have been appropriate a century ago. We agree with this criticism, but that is not the point we wish to make in this book.

Rather, *even under its own assumptions, conventional theory is incorrect.* A competitive economic system with market clearing and certainty of the future does *not* behave in the way that theory

claims it should behave. It is *not* true that, under these assumptions, the equilibrium state is stable and a natural center of attraction to which the system tends to return of its own accord. Obviously, in any such discussion, questions of oligopoly, imperfect market clearing, etc. are irrelevant. It is for that reason, and only for that reason, that such matters are ignored here.

In this view, the rise of oligopoly toward the end of the nineteenth century was not just an accident or an aberration of the system. Rather, it was a natural and necessary development, to be expected on basic economic grounds. John D. Rockefeller concealed his views on competition and paid lip service to prevailing ideas when it suited him. But he was a genius, who understood the system very well indeed and proved his understanding through phenomenal practical success. Alfred Marshall's *Principles of Economics* was written and refined at the same time that Rockefeller established the Standard Oil trust and piloted it to an absolute dominance of the oil industry. There can be little doubt who had the better understanding of the true dynamics of the system.[2]

It follows that the theory of this book should not be applied directly to conditions of monopoly or oligopoly, which are so prevalent in the twentieth century. However, the theory *is* directly relevant to something equally prevalent, namely the creation of economic myths and fairy tales, to the effect that all our present-day ills, such as unemployment and inflation, are due primarily to the mistaken intervention by the state in the working of what would otherwise be a perfect, self-adjusting system of competitive capitalism. This system was in power in the nineteenth century. It is well-known that it failed to ensure either common equity (read Charles Dickens on the conditions under which little children were worked to death!) or economic stability: There were "panics" every ten years or so. The theory of this book shows that the failure of stability was not an accident, but rather was, and is, an inherent and inescapable feature of a freely competitive system with perfect market clearing. The usual equilibrium analysis *assumes* stability from the start, whereas actually the equilibrium is highly unstable in the long run. The economic myths pushed by so many interested parties are not only in contradiction to known history, but also to sound theory.

B. Structure and contents

The structure of this work is as follows: There are five "books."

[2] This is an appropriate place to call attention to an excellent, and unjustly neglected, book, *The Emergence of Oligopoly: Sugar Refining as a Case Study* (Eichner 1969).

Each book contains a number of chapters, which are sequentially numbered from 1 to 16. For example, Book II contains chapters 3, 4, 5, 6, and 7. Each chapter contains sections which are labeled by letters, from section A onward. In many, though not in all, chapters, the final section is a "mathematical appendix."

Book I, called Preliminaries, contains chapters 1 and 2, which are the introduction and a study of the steady state, respectively. The purpose of studying the steady state is primarily to call attention to the advantages of using concepts akin to those of Sraffa (1960), rather than neoclassical supply and demand analysis, to begin the study of economic dynamics. We say concepts "akin" to those of Sraffa, since the Sraffa analysis itself is tied too closely to the steady state to be directly usable in dynamic economics. But the foundations laid by Sraffa, unlike those laid by Samuelson (1947), turn out to be extremely fruitful.

Book II is devoted to theories of balanced growth. There are several dimensions to this survey, since growth theories can be distinguished in several ways:

1. Different theories assume different technological bases for the economy.

2. Many theories assume "perfect thrift"; others allow for consumption.

3. The balanced state itself can be analyzed or, alternatively, it can be asked what happens when the system deviates from perfect balance. The latter case leads to investigations of dynamic stability or instability.

Book II is organized so as to start with the easiest case first and progress slowly but steadily toward the stability question. Chapter 3 explains what is meant by "Leontief technology" and studies balanced growth in an economy with this technology, one which practices "perfect thrift" (i.e., none but absolutely necessary consumption). The very severe restriction of Leontief technology is relaxed in chapter 4, devoted to von Neumann technology. Some economists may be unfamiliar with some of chapter 4's contents: in particular, the original results of von Neumann himself are *not* acceptable economically, since they are based upon a severe, indeed cripplingly so, economic assumption. This assumption has been removed in later work by Kemeny, Morgenstern, and Thompson. Their results, which differ significantly as regards "optimality" implications, are presented also.

Chapter 5 is in the nature of an interlude, since it deals, once more, with a steady-state system, namely the "open Leontief model." This introduces discretionary (as opposed to necessary) consumption into the system, but without the additional compli-

cations arising from growth. Apart from the description of the usual theory, this chapter contains some new results, associated with the possibility of "discretionary consumption goods," i.e., goods which would not be produced at all by a "perfect thrift" economy. An economy in which consumers demand such discretionary consumption goods is qualitatively different from a perfect thrift economy. In particular, one can prove the existence of some highly peculiar solutions of the equations. Furthermore, under certain not unreasonable conditions, these peculiar solutions turn out to be the only solutions of the system.

Chapter 6 returns to balanced growth, but this time with consumption permitted. The effect of consumption is to alter, drastically, the nature of the solutions. In the perfect thrift system, the rate of growth of the economy equals the rate of return to investors and is strictly limited: only a few discrete values (or perhaps only a single value) can exist for this common rate, on purely technological grounds. With consumption allowed, this is still true for the rate of return, but it is false for the rate of growth. The latter is free to take any value between instant collapse of the economy and the maximum which is achieved in a perfect thrift system. The actual value is related to the frugality, or lack of it, of the investors; it is *not* determined by the price system, nor does it alter the price system.

The final chapter of book II, chapter 7 on dynamic stability, is the heart and center of this work. This chapter contains the proof of the basic dynamic instability theorem for a perfect thrift Leontief system, it shows that input substitution possibilities do *not* destroy, or even seriously alter, this result, and the chapter ends with a discussion of the relevant stability literature.

It may be noted that book II is restricted to "disaggregated" growth theories and therefore contains no discussion of neoclassical one-sector or two-sector growth models. This work does *not* aim for encyclopedic coverage of the literature. The aim is not to "cover," but rather to "uncover," what is of main importance in that literature. Specific reasons for omission of neoclassical aggregated growth models are given in section 7D;[3] there one will also find the reasons for omitting all of turnpike theory and related subjects.

Book III is devoted to theories of the trade cycle (what is termed the business cycle in America). Chapter 8 is general, but very important for what follows. The chapter starts from dynamic instability, showing that this condition *need not* lead to ridiculous conclusions about the global behavior of the system. Next there ap-

[3] This is a short notation for chapter 7, section D.

pears the idea of a *limit cycle*,[4] a concept well known in engineering but much less well known to economists. It is suggested that the trade cycle is such a limit cycle. Finally, the chapter concludes with a digression on "natural price," relevant to the theory of value in economics.

Chapters 9 and 10 are devoted to the most important "schematic," as opposed to detailed econometric, models of the trade cycle. The accelerator-multiplier model of Samuelson and the inventory cycle model of Metzler are discussed in chapter 9. Chapter 10 takes up in turn the Hicks model, the Frisch model, and the Goodwin model.

Econometric models of cyclical behavior are discussed in chapter 11. This is not a critical discussion of econometrics as such (that comes later), but rather the chapter is devoted to explaining, and criticizing, the stability results commonly obtained from such models. In conventional wisdom, the econometric models show clearly that the underlying basic economy is stable about its equilibrium. Chapter 11 proves that this conclusion is untenable. The data, when analyzed properly, show that the conventionally accepted Frisch model (a stable system) is completely excluded.

Book IV is on the economics of uncertainty. Chapter 12 contains a detailed criticism of the theory of expected utility. Some rational people may indeed use expected utility concepts for ordering their preferences among uncertain prospects. But it is wrong that all rational people *must* order their preferences in that fashion. The chapter contains a number of arguments in favor of this view.

The matter is important in relation to investment evaluation under uncertainty, the subject matter of chapter 13. Everyone, at least after Keynes, agrees that investment is terribly important. Yet, the standard theory of investment evaluation is in a very sad shape. It has no place for the method which most businessmen use to decide on their investments in plant and machinery, the so-called "pay-back time" criterion. The theory presented in chapter 13 is new and, unlike the conventional theory, is compatible both with a pay-back time criterion and with the presence of true uncertainty of the future in the sense of Frank Knight (1921), rather than being restricted to the merely risky, but *not* uncertain, "lotteries" of the usual approach. Book IV is not in itself dynamic economics, but develops tools for such a study.

Book V returns to discuss three topics which were touched on earlier and deferred for later consideration in order to expedite the flow of the argument.

[4] Prior references to limit cycles can be found in Samuelson (1939a), Goodwin (1955, 1967, 1972), Schwartz (1961, 1965), and Torre (1977).

Chapter 14 goes into more detail on the nineteenth-century trade cycle, in particular relation to Ricardo's predictions regarding landlords and industrialists.

Chapter 15 contains the Tableau Economique of Francois Quesnay (1760). He was one of the most important of all economists, and his contribution tends to be neglected unfairly and unduly. This chapter is not a simple presentation of the Tableau in its original form. Rather, it is a completely new study, using input-output concepts (which are themselves based on the work of Quesnay) with quantities and prices kept separate, thus showing how both are determined within that system.

Finally, chapter 16, entitled "The Quicksand Foundations of Econometrics," contains a detailed critique of econometric theory and econometric methods. It is shown that this entire theory is a misapplication of the theory of mathematical statistics to an area of research in which the basic assumptions underlying mathematical statistics are not satisfied. Model builders are urged to avoid econometric methods, since those methods produce very much harm and very little, if any, good.

C. Relationship to other theories in economics

A detailed discussion of the relationship of this book to other theories in economics is, of course, entirely premature at this point. Rather, the purpose of this section is to indicate to the reader some of the relevant issues and to locate where these issues are discussed in the body of the work.

The approach taken here owes very much to that unfairly neglected genius of economics, Dr. Francois Quesnay. In his Tableau Economique, Quesnay sets out clearly that the economic system of his day, just as much as the economic system of the nineteenth century or of today, is *not* like a "fair" with independent buyers and sellers who come together only via the market. Rather, the economic system has a circular flow, similar to the flow of blood in the human body. The buyers are at the same time sellers, the sellers are at the same time buyers; there is thus a causal nexus between sales and purchases much more explicit and stringent than envisaged in, let us say, the "auction" of Walras.

The science of economics has paid a heavy price for ignoring the insight of its great founder. Indeed, the only economists who have made any significant progress in dynamic economics are those who have gone back, consciously or otherwise, to the Tableau Economique. Without the basic ideas of Quesnay, the problems of dynamic economics are insurmountable. Quesnay's Tableau Econo-

mique is presented explicitly in chapter 15, but his ideas are fundamental for just about everything in this book. The relationship to the classical economists, Adam Smith and David Ricardo in particular, is of a more mixed nature. On the one hand, "classical" assumptions are used throughout, for example, a minimum subsistence wage which is converted into a fixed standard bundle of wage goods. On the other hand, some of the main tenets of classical economics are denied explicitly. These include: the classical concept of exchange value (section 8E), the assertion that the "invisible hand" suffices to guide and determine the way the system develops (section 6D), and the dynamic stability of the classical equilibrium state (section 7B). The denial of Say's law is hardly novel after Keynes. But this denial has some interesting consequences for an evaluation of what went wrong with Ricardo's predictions about the relative position of landlords and industrialists in his long run (chapter 14).

The denial of the classical concept of "value" implies that the approach taken here is non-Marxist. Karl Marx maintained, correctly, that the labor theory of value is the essential basis for his whole system. Since we deny the validity of the concept of a stable exchange value, we do not enter into discussions of value theory[5] or of the "Cambridge controversy."[6] For the same reason, the views proposed in this book cannot claim descent from Marx. Naturally, this fact will not prevent some people from claiming that this book is nothing but thinly disguised Marxism—just as it will not prevent some other people from claiming that it is nothing but reactionary bourgeois propaganda.

Neoclassical economic theory is largely irrelevant for our study. It bases itself on a definition (Robbins 1935) which we do not consider useful for dynamic economics, and most of the work is tied irrevocably to states of economic equilibrium. Neoclassical theory has had more than a century to show what it can do in dynamic economics. Quite enough books already exist to cover what little there is that is realistic and useful. Thus neoclassical theory has been largely ignored in this volume. A few remarks can be found in the following places: utility theory—section 15E; optimality theory—sections 7D and 15E; production functions—section 7C; neoclassical growth models—section 7D; expected utility theory—chapter 12. This book is *not* intended as a critique of

[5] E.g., Blakley (1967), Burmeister (1968), Debreu (1959), Dobb (1973), Harris (1978), Hunt (1972), Morishima (1973), Pasinetti (1977), Sraffa (1960), Walsh (1980), von Weizsäcker (1973).
[6] Robinson (1954); see also Blaug (1975), Bliss (1975), Clark (1978), Collard (1973), Harcourt (1971, 1972, 1973, 1976a), Harris (1973).

neoclassical theory, for which there already exists a sizable literature.[7] What critique emerges is purely incidental to the main task, which is positive and constructive: to set up a basis for a future dynamic economic theory.

Turning to Keynesian economics, an exegesis of "what Keynes meant" is not our concern.[8] For the reasons explained in section A, we are also not concerned with monopoly, oligopoly, or the "managerial revolution."[9]

In this book, we use "classical" assumptions of a gold standard currency, and in most of our work we abstract from credit creation. This is not because we consider monetary questions unimportant—far from it—but rather because the essential points concerning dynamic stability or instability become clearer and less ambiguous if all markets are imagined to be operating only with spot cash. Credit creation merely adds a further source of instability (Hawtrey 1926). For these reasons, discussions of monetary theory, "monetarism," and the theory of inflation are not our concern.[10]

Econometrics has managed to rise to the status of an orthodoxy in its own right. For a discussion of the claims of econometrics, see section 11C and chapter 16.

* * *

A very determined attempt has been made to make the general style of this work clear and accessible to economists. But it may strike some readers as being considerably more terse and condensed than writing they are accustomed to. There is very little repetition. Those used to a more leisurely style may find that they

[7]E.g., Benassy (1973), Chamberlin (1933), Eichner (1975a, 1976), Galbraith (1958, 1971, 1973, 1973a), Hunt (1972), Kaldor (1972), Knapp (1973), Kornai (1971), Kregel (1972, 1973), Phelps Brown (1972), Robinson (1933), Shubik (1970), Veblen (1934), Worswick (1972).

[8]E.g., Clower (1965), Davidson (1965), Gramm (1973), Grossman (1972), Hahn (1976), Harrod (1970), Hotson (1967), Leijonhufvud (1968), Madden (1977), Mehta (1978), Weintraub (1971, 1973).

[9]Chamberlin (1933), Marris (1963, 1964, 1968, 1971), Means (1935, 1962), Robinson (1933); see also Blair (1974), King (1974), Larner (1966), Magdoff (1970), Mason (1959), Melman (1972), Monsen (1965), Mueller (1971), Solow (1968a), Tauber (1970), Townsend (1970).

[10]Monetary theory: Fisher (1930), Galbraith (1975), Keynes (1930); monetarism: Friedman (1956, 1963, 1968, 1970); inflation: Hansen (1951), Robinson (1938), as well as Barro (1976), Bronfenbrenner (1963), Carlson (1979), Clower (1967), Edwards (1952), Galbraith (1973a), Laidler (1977, 1977a), Means (1974), Moosa (1977), Nove (1974), Patinkin (1965), Weintraub (1974), Wiles (1973, 1974).

must read some sections several times, or perhaps reread earlier sections, for a full understanding. In extenuation, it may be said: (1) The style to which the author is accustomed is much more terse yet, and (2) a condensed style makes the book shorter and hence more economical.

We close this introduction with a philosophical point. Karl Marx said: "The philosophers hitherto have only interpreted the world in various ways; the thing, however, is to change it." There have been many changes in the world since this was written, about a century and a half ago. But only the foolhardy could claim that these changes have all, or even mostly, been for the better.

It is *not* the task of this book to change the world. Let us try to understand just a small part of it, namely the dynamics of competitive capitalism. It is by no means certain that the human race has a future at all. But if it does, that future can not be harmed, and may even be aided, by an honest attempt to understand our past.

CHAPTER 2

The steady state

A. Introduction

In this chapter, we shall investigate some highly oversimplified economic systems to see what we can learn from them. Our *aim is twofold*:

(a) We wish to show that the neoclassical mechanism of supply and demand can be bypassed in favor of a much simpler procedure, for the purpose of determining prices in the steady state (Sraffa 1960).

(b) We also point out that this procedure must be modified when steady-state conditions do not obtain, i.e., for dynamic economics.

All the models of this chapter are steady-state models, with production each period exactly the same as in all earlier periods and prices unchanged in time. In this section, we assume that there is no surplus at all; everything produced must be devoted either to maintenance of life for the work force, or to inputs for next year's production. The assumptions of this section are, in full:

1. All goods consumed within the system are produced within it, and vice versa (closed system).

2. In each period, the same commodities are produced, by the same methods.

3. There is no surplus; production in each period is exactly enough to continue the cycle, with identical production levels, in the next period.

4. Commodities are produced for sale at an annual market (we think of our "period" as one year), rather than for immediate consumption by the producer.

Since we wish to make certain logical, theoretical points, we

shall defer discussion of the historical meaning and validity, if any, of these assumptions to section D.

To show point (a), we take our example from the important book by Sraffa (1960). There are three commodities, namely, (1) corn (i.e., wheat) in quantities measured in quarters, (2) iron, measured in tons, and (3) pigs. The production system is set out in tabular form as follows:

Corn (quarters)		Iron (tons)		Pigs (number)	Output
240	+	12	+	18	⟶ 450 quarters corn
90	+	6	+	12	⟶ 21 tons iron
120	+	3	+	30	⟶ 60 pigs

Note that the plus signs in this table do not mean mathematical additions, but rather that the commodities listed to the left of each arrow are inputs, at the beginning of the year, necessary to produce, at the end of the year, the outputs listed to the right of the arrow.

To show that this system is balanced at bare subsistence, let us see what total input of corn is needed at the beginning of the year, in all three of our "industries." Since inputs of corn are listed in the leftmost column of our table, we add these numbers: 240 + 90 + 120, giving a total necessary input of 450 quarters of corn at the beginning of the year. This, however, is exactly equal to the total corn output of this economy (the rightmost number, after the arrow, in the first line). Thus all the corn produced in one year is needed to provide necessary inputs for next year's production; there is no surplus of corn. Similarly, adding the numbers in the second column of the table gives as the necessary total input of iron: 12 + 6 + 3 = 21 tons, which exactly equals the yearly output of iron; and adding the numbers in the third column yields as necessary input of pigs: 18 + 12 + 30 = 60 pigs, which again equals the yearly output of this commodity.

We conclude that this system is indeed exactly balanced. If, and only if, nothing whatever is wasted, and the output at the end of the year is redistributed between the industries as its equivalent was at the beginning of the year, then the same levels of production of all commodities can continue year after year.

Now suppose we wish to use neoclassical economic theory to determine the prices at which these three commodities exchange for each other in the yearly market. The neoclassical equilibrium condition states that the prices of the three commodities, which we shall call p_1, p_2, and p_3, respectively, must adjust themselves until the supply of each commodity, at these prices, equals the demand for the same commodity, also at these prices. To apply this theory, we need to know the supply schedules (supply functions)

$$S_1\ (p_1, p_2, p_3) \qquad S_2\ (p_1, p_2, p_3) \qquad S_3\ (p_1, p_2, p_3)$$

where $S_1\ (p_1, p_2, p_3)$ tells how much of commodity 1 (corn) will be supplied if the prices of the three commodities are p_1, p_2, p_3, respectively, and similarly for S_2 and S_3. We also need the demand schedules (demand functions)

$$D_1\ (p_1, p_2, p_3) \qquad D_2\ (p_1, p_2, p_3) \qquad D_3\ (p_1, p_2, p_3)$$

Althogether, we require knowledge of six functions of the three variables p_1, p_2, and p_3, *before* we can say anything at all about equilibrium prices in the neoclassical theory. This is an enormous information requirement, one which is rarely, if ever, fulfilled in practice.[1] Our table not only fails to give any information about prices; it does not even provide a "production function" relating *quantities* of inputs to *quantities* of outputs. All the table gives us is output quantities for *one* set of input quantities. This is one point, and one point only, on a production function. There is no information about other points on that function.

B. Price determination from quantities

The information requirement of neoclassical theory is enormous. But Sraffa points out that, under the stated conditions, *none* of this information is needed to determine the prices ruling in the annual market! It turns out, and we shall now show explicitly, that the table of quantities input at the start of the year, and output at the end of the year, is enough to *determine* all the price ratios ruling in the annual market. The entire procedure of equating supply to demand can be bypassed in favor of a much simpler procedure, which needs no more input information than what is contained in our table and which nevertheless arrives at the one unique set of price ratios which *must* be the final outcome of equating supply and demand.

To see how this comes about, let us consider the corn producers, as a body. Of the 450 quarters of corn which they have

[1] See Edwards (1952) for an example of how prices are really set.

produced, they need 240 quarters as input to their own industry for next year's production. Therefore, they come to the annual market with the difference, $450 - 240 = 210$ quarters of corn. This is what they have to sell; with the proceeds from that sale they must be able to purchase their other inputs, that is, 12 tons of iron and 18 pigs. The condition that their receipts must be at least as large as their outgoings is therefore:

$$210p_1 \geqslant 12p_2 + 18p_3$$

or equivalently

$$210p_1 - 12p_2 - 18p_3 \geqslant 0$$

(Here the sign \geqslant means "greater than or equal to.")

The iron producers need 6 tons of their 21 tons as input for next year. Sale of the remaining 15 tons must give them enough to purchase 90 quarters of corn and 12 pigs. Hence we get the condition:

$$15p_2 \geqslant 90p_1 + 12p_3$$

or equivalently

$$-90p_1 + 15p_2 - 12p_3 \geqslant 0$$

Finally, the same argument applied to the pig industry yields:

$$30p_3 \geqslant 120p_1 + 3p_2$$

or equivalently

$$-120p_1 - 3p_2 + 30p_3 \geqslant 0$$

We therefore have three conditions, each of which is an inequality, not an equation, connecting the three prices p_1, p_2, and p_3.

However these inequalities reduce to equations. For example, let us add together the first two inequalities. Since the sum of two things, each of which is nonnegative, must also be nonnegative, we get:

$$(210p_1 - 12p_2 - 18p_3) + (-90p_1 + 15p_2 - 12p_3) =$$
$$120p_1 + 3p_2 - 30p_3 \geqslant 0$$

Thus, this combination must be positive or zero. But condition three states that the negative of this very same combination must also be positive or zero, i.e., that same combination must be negative or zero. The only way a number can be both "positive or zero" *and* "negative or zero" is for the number to be exactly zero.

By applying exactly the same argument to the other inequal-

ities, we see that all three of them must be exact equations:

$$210p_1 - 12p_2 - 18p_3 = 0$$
$$-90p_1 + 15p_2 - 12p_3 = 0$$
$$-120p_1 - 3p_2 + 30p_3 = 0$$

Furthermore, not all these three equations are independent. Rather, the first two equations (on being added together) imply the third equation (or rather, its negative, which amounts to the same thing). Thus, only the first two of these three equations give significant information.

This is understandable, since the only thing that matters are price ratios, not absolute prices. Indeed, we are free to declare any one of the three to be our "numeraire" or measure of value. Let us declare one pig to be the unit of currency.[2] What matters to us are therefore the price ratios, which we shall denote by capital letters:

$$P_1 = p_1/p_3 \qquad P_2 = p_2/p_3$$

If we divide the first two equations by p_3 throughout, we get:

$$210P_1 - 12P_2 - 18 = 0$$
$$-90P_1 + 15P_2 - 12 = 0$$

These are two linear equations in the two unknowns P_1 and P_2. Multiply the first equation by 15, the second by 12, and add:

$$15(210P_1 - 12P_2 - 18) + 12(-90P_1 + 15P_2 - 12) =$$
$$2070P_1 + 0 - 414 = 0$$

from which we conclude:

$$P_1 = 414/2070 = 1/5$$

That is, five quarters of corn are needed to purchase one pig. To get the other price ratio, P_2, we substitute this value of P_1 into (say) the first equation, to get:

$$210P_1 - 12P_2 - 18 = 42 - 12P_2 - 18 = 24 - 12P_2 = 0$$

Hence

$$P_2 = 2$$

That is, half a ton of iron is enough to purchase one pig, or, one ton of iron buys two pigs.

At these price ratios, and *only* at these price ratios, can this economy continue to function. Whatever the "supply schedules"

[2] Exactly this unit was employed widely in New Guinea not so long ago.

and "demand schedules" may be as functions of the price ratios, the ultimate result of equating supply and demand *must* be what we have just deduced, if the system is to continue in the same steady state. The neoclassical theory is not "wrong" here; presumably, if all the huge amount of information about all these schedules is available and is used, the outcome will indeed confirm what we have deduced. The charge against neoclassical theory is not that it is wrong, but that it is superfluous for what concerns us here.

Why can we obtain our results with so very much less initial information than is required within the neoclassical framework?

The answer is simple, but very basic. The "market" under consideration here is *not* a neoclassical market of the sort envisaged by Walras. In the neoclassical market there are buyers, one group, and sellers, another quite distinct group. The sellers come with goods; the buyers come with purchasing power (we shall call it "money" for short, even though the numeraire commodity of Walras is hardly money in the full sense). The total purchasing power of the buyers is given in advance, independently of the prices which are eventually established within the market. The buyers and sellers interact with each other *only* via the market.

None of this applies to our "annual fair." In this fair, every seller is also a buyer; every buyer is also a seller. The total purchasing power available to each buying group depends on the price at which it is able to sell its product. Also, *supply determines demand.* For example, the supply of pigs is 60 pigs total, or 30 pigs net after subtracting what the pig raisers need for next year. In order to maintain the same level of production of pigs next year, the pig raisers *must* demand exactly 120 quarters of corn and exactly 3 tons of iron. *There is no room for supply and demand to operate in this market.* Supply is given by what was produced last year, and demand is determined completely by the requirement that exactly the same amounts of every commodity be produced in the year to come. Neither supply nor demand can be affected by prices, since both supply and demand are already determined before we even consider prices. The necessary prices, necessary to maintain the system in its steady state, then emerge as an afterthought, from a set of balance conditions to make the market "clear" in terms of purchasing power.

In our table of inputs and outputs, there is no reference to labor or wages. The inputs are commodities (corn, iron, pigs), and so are the outputs. This does not mean that commodities are being produced without labor. Rather, the inputs to each production process already include the commodity equivalents of the wages of

labor. For example, the corn input to the production of iron (90 quarters of corn) is used not to process iron in the foundry, but rather it is baked into the bread which the foundry workers require to survive. In the bare subsistence economy under discussion in this section, the wage is of course also a bare subsistence wage. There is no question of "distributive shares," since there is no surplus product available for distribution.

Note that we do not deny that markets exist in which supply and demand analysis is useful.[3] All we assert, with Sraffa, is that this is not true of the present kind of market, which however is a very important kind. Markets for intermediate, as opposed to final, goods are mostly of this type. Such markets account for the greater proportion of all business done by firms in a modern economy, with the exception of retail enterprises.

C. Steady state with surplus

Let us now assume that there exists some surplus, over and above the inputs needed to resume production at the same levels next year. As soon as there is a surplus, at least three questions arise which are entirely meaningless in a pure subsistence economy. The three questions are:

1. Who gets the surplus?
2. How is the surplus used?
3. If (the usual case) the surplus allows of some choice in what is to be produced and how, then who makes these choices and on what basis?

Neoclassical economics has standard answers to these questions: Everything is decided by the play of a free market, with the consumer as the ultimate king. But this answer is by no means universally true. There have been economies without such a free market; and even with a tolerably free market, we shall find that there are considerable difficulties.

Here, we restrict ourselves to a brief discussion of the treatment in Sraffa (1960). Sraffa assumes a competitive system, hence the same rate of return to all productive activities in the system. But, in line with his main purpose (prelude to a critique of economic theory) he takes a particularly simple special case, namely a pure steady state with no change in time. Each year, the same quantities are produced of each commodity, and the same prices

[3] Important supply and demand markets are: (a) commodity markets in which the sellers are price-takers, (b) markets where inelasticities of supply are due to natural factors, or to inherent scarcity, e.g., old paintings; these are the "peculiar cases" of Ricardo (1821).

prevail. What surplus there is, is consumed, not invested for growth. While one might cavil at this assumption as being a realistic description of what happens under capitalism, this was not the purpose of Sraffa's work. He wanted a theoretical critique of neoclassical economics, including the general equilibrium theory of Walras (1874) and the partial equilibrium approach of Marshall (1890). A steady-state assumption is entirely in order for this purpose.

The simplest system of this type is obtained if workers get a basic subsistence wage, no more, and the surplus is distributed among the entrepreneurs, in proportion to the initial money outlay of each entrepreneur at the beginning of the year (i.e., a uniform rate of return in all industries, called r). Let the physical surplus be entirely in corn production, with an output of 480 quarters, rather than 450 quarters, of corn. The new input-output table reads:

Corn (quarters)		Iron (tons)		Pigs (number)		Output
240	+	12	+	18	⟶	480 quarters corn
90	+	6	+	12	⟶	21 tons iron
120	+	3	+	30	⟶	60 pigs

Sraffa's conditions on price ratios and the rate of return r can now be derived as follows: The corn producers have to pay, at the start of the year, $240p_1 + 12p_2 + 18p_3$ for their inputs. At the end of the year, they receive $480p_1$ for their output. Their rate of return r is therefore given by:

$$(240p_1 + 12p_2 + 18p_3)(1 + r) = 480p_1$$

The same argument gives for iron producers:

$$(90p_1 + 6p_2 + 12p_3)(1 + r) = 21p_2$$

and for pig producers:

$$(120p_1 + 3p_2 + 30p_3)(1 + r) = 60p_3$$

The condition that there be a uniform rate of return in all industries shows up in the fact that the same rate of return r is used in all three equations.

Since the equations are linear and homogeneous in the three

prices p_1, p_2, and p_3, we can divide by any one price (say by p_3) and retain only price ratios $P_1 = p_1/p_3$ and $P_2 = p_2/p_3$, just as before. We then have a system of three equations for the three quantities P_1, P_2, and r. It can be verified by direct substitution that the following is a solution:

$$P_1 = p_1/p_3 = 0.18556 \quad P_2 = p_2/p_3 = 1.99476 \quad r = 0.030025$$

Thus the rate of return r is slightly better than 3 percent per period, and the price ratios are close to, but not identical with, the ones found for the bare subsistence case (i.e., $P_1 = 0.2$ and $P_2 = 2.0$). It is not our purpose here to go into detail how this solution is obtained, or to show that it is unique (it actually is).

The rate of return r obtained from this calculation, on the assumption of bare subsistence wages, is the maximum rate of return for such a system. If the workers manage to obtain wages higher than bare subsistence, they get a share of the surplus product (the excess of corn, i.e., $480 - 450 = 30$ quarters), and the rate of return to the entrepreneurs goes down correspondingly. This relationship between wages and the rate of return is one of the points of main interest to Sraffa, and it is brought out very well by his extended system of equations, which includes wages explicitly; we do not reproduce this extended system here.

Rather, we call attention to the fact that Sraffa's system, in spite of its undoubted importance (Roncaglia 1978), is *not* suitable as a basis for the study of dynamic economics. The steady-state assumption is built much too firmly into the foundation of that system. (I am indebted to Professor Peter Groenewegen for this important point.) In a dynamic system, there is always the possibility that prices may vary from one year to the next; thus the equations describing such a system must, among other requirements, suffice to determine the movement of prices. Let p_1, p_2, p_3 be the unit prices at which inputs are purchased and p_1', p_2', p_3' be the unit prices at which the outputs are sold at the end of the year. The return to corn producers is then given by:

$$(240p_1 + 12p_2 + 18p_3)(1 + r) = 480p_1'$$

with similar equations for iron and pig production. We therefore have a system with five unknown price ratios and one unknown rate of return r; but with only three equations connecting these six unknowns. If and only if there is a steady state, we can set $p_1' = p_1$, $p_2' = p_2$, and $p_3' = p_3$, which results in a determinate system.

This is in no sense a criticism of Sraffa. For the task he set himself, his system works perfectly. But it is inadequate for a quite different task, namely, the study of dynamic economics. For this,

one needs more information, in particular full production functions for all commodities, not merely one point on each production function.

However, the Sraffa example is most important in warning against asking for superfluous information. The information requirement of neoclassical theory is so enormous that it is hardly ever fulfilled even for the steady state. There is no real hope of progress in dynamic economics on such a basis. It is therefore not at all accidental that so little progress in dynamic economics has in fact been made on the neoclassical basis. Sraffa's work shows that one can do with much less information and still obtain meaningful results about prices and rates of return. In dynamic economics, we need more information than Sraffa allows himself, but still very much less information than neoclassical theory insists on.

D. Some qualitative remarks

In this section, we intend to relate the purely mathematical models of the earlier sections to possible historical or quasi-historical societies, so as to investigate the reasonableness, or otherwise, of our initial assumptions. This section is not needed for the logical argument and may be skipped by readers who dislike conjectural history.

Let us, then, go back to the four assumptions listed near the start of section A and discuss them in the light of historical knowledge of societies past and present.

Steady-state, subsistence economies are, unfortunately enough, very common in human history. While the surplus is seldom exactly zero, it is small and can support only a small ruling class at a level of consumption higher than the rest. The limiting case of no surplus at all is not far from the truth, in many cases. Let us think, for definiteness, of a medieval village in Europe. Then our first three assumptions are quite reasonable approximations:

1. The economic system of the village is not exactly closed, but nearly so. There is little trade even within the village, to say nothing of external trade. Indeed, the decline of trade was one of the most telling signs of the decay of the Roman empire during the onset of the Middle Ages (Pirenne 1925).

2. A steady state is a very good approximation for such a village. The same crops are planted each year, in the same way; apart from the vagaries of good and bad harvests, a steady state obtains. Population, and with it production, may change very slowly, over generations, but can be considered essentially constant for periods of a few years.

3. The actual surplus is exceedingly small, and there is some doubt whether it should be called a surplus at all. The lord of the manor can obtain armor and a horse and maintain a fortified castle, out of the surplus over bare subsistence. But all these are necessary for defense of the village against all-too-frequent predators, be they Vikings, Hungarians, or Saracens. Thus, on a wider view, there is no true surplus whatever.

So far, then, our assumptions look pretty fair. But we strike trouble with the fourth assumption, that most goods are produced as commodities for sale in an annual market. There exist market economies, of course; and there exist, and existed, subsistence economies. But it is difficult to think of an example of an economy that was at subsistence level and that also exhibited relatively complex exchange relationships. Within the typical village, most goods are produced for direct consumption by the villagers themselves, or by the lord of the manor. A few goods may be exchanged with neighboring villages on a barter basis. But almost never are goods brought to a commodity market in the modern sense, exchanged for money, and this money used to buy other goods. Markets existed. But, except for local markets in implements, the traded goods were largely luxuries, and few. History seems to show that subsistence economies do *not* organize the production and distribution of their goods through a market mechanism.

It would be nice if economic theory could give us a clue to why this might be so. Of course, neoclassical theory cannot do so, since it starts from the assumption of a market mechanism and is meaningless without it.

But the input-output approach does lead to a suggestion. Let us look once more at the determination of prices, in section B. There was exactly one solution for the price ratios, a set of inevitable, fully determined exchange values; only then do all producers receive enough money from their sales to purchase their needed inputs for next year.

Let us now ask by what mechanism these "inevitable" price ratios are maintained. So, let us suppose that "wrong" prices prevail in the market one year. What is the result? Well, the market can no longer clear; some goods will be left over. As a result, production next year will be lower. If the "wrong" prices continue, this happens year after year, until everyone starves to death. Thus, the market does *not* provide a self-adjusting mechanism; indeed, people may be unaware of why things are going wrong. It may be far from obvious to the people in the village that the root cause of

the trouble right now was a set of wrong prices the year before. The mechanism for maintenance of the "right" prices is therefore more than a bit disconcerting: the economy does not correct itself; it simply runs down to starvation point. Those economies which survive have the right prices in their markets. This is reminiscent of Darwin's theory of evolution: A wrong mutation is never "corrected"; it just dies out.

We suggest that this consideration may explain why subsistence economies do not operate their main productive effort by means of a free market in commodities needed for further production. After all, there is no need for a market mechanism to make production decisions. The only right decision is to produce, each year, exactly what was produced the year before, by exactly the same methods. That decision can be reached through a highly conservative ruling body, perhaps a council of village elders, or a hereditary lord who has a natural interest in preserving the status quo, or a firmly established church which can give divine sanction to its conservative rulings; or a combination of all three.

But a commodity market is superfluous, and is even dangerous. In such a society, a certain amount of corn is sown, a certain number of pigs are raised, etc., not because there is a market demand for this much corn and that many pigs, but rather because this is the way it was done by us last year, this is what our fathers did, and their fathers before them from time immemorial; this is what the lord demands, and what the church assures us is the will of God.

Before modern capitalism swung into operation, before the Industrial Revolution proper got underway, there was a long preparatory period of overcoming, and destroying, these traditional ways of doing things and of establishing production for a wider market. These changes were by no means popular; not only was there resistance, but this resistance often took violent form (see, for example, Heilbroner 1972 or Polanyi 1957).

There is no doubt that the traditionalists who resisted this process were "forces of reaction." But even forces of reaction may have a valid point. Until the productive system is capable of generating a sizable social surplus and doing so fairly reliably, it is highly dangerous for a subsistence economy to depart from its tried and true traditional ways. The attempt to progress to a market economy may succeed, so that the economy "takes off" onto a "growth path." But the attempt may fail, in which case the economy sinks into stagnation first, and perhaps into starvation after. This second possibility is by no means farfetched, as even re-

cent twentieth-century history attests.

E. Mathematical appendix

We consider a system of n commodities, labeled $i = 1,2, \ldots ,n$. The output of commodity i each year is called y_i, measured in whatever units are appropriate for this commodity. To produce this output, one needs inputs of this and other commodities. The input of commodity j at the beginning of the year, needed to produce amount y_i of commodity i at the end of the year, is called x_{ij}. Note that we do *not* say anything about outputs obtainable from a different choice of inputs; that is, x_{ij} is the actual input of j, needed to produce the actual output y_i of i. (The choice of the order of subscripts is awkward; sometimes the quantity which we have called x_{ij} is denoted by subscripts in reverse order, say q_{ji}; Leontief theory uses one convention, von Neumann theory the opposite. We shall use a uniform convention throughout this book; the left index refers to the output commodity, the right index to the input commodity.)

The "bare subsistence" condition reads:

$$\sum_{i=1}^{n} x_{ij} = y_j \quad \text{for} \quad j = 1,2, \ldots ,n \tag{2.1}$$

The balance condition for money amounts received and disbursed by the producers of commodity i reads:

$$\sum_{j=1}^{n} x_{ij}p_j = y_i p_i \tag{2.2}$$

Here we have already assumed equality, rather than inequality; the original condition has a "less than or equal" sign in place of the equality sign; but it is easy to show, and we have shown it in section B for a special case, that (2.1) together with all these inequalities implies the equations (2.2).

Thus (2.2), for $i = 1,2, \ldots ,n$, is a linear homogeneous system of n equations in the n unknown prices p_1, p_2, \ldots , p_n. This system has a nonzero solution if and only if the determinant of the following matrix vanishes:

$$M_{ij} = x_{ij} - y_i \delta_{ij} \tag{2.3}$$

where δ_{ij} is the Kronecker delta (equal to 1 if $i = j$; equal to zero otherwise). We now prove that the det(M) does indeed vanish. In evaluating this determinant, we may add or subtract rows from

each other, at will. Let us add rows 2, 3, . . . ,n, in turn, to row 1. As a result, the first row of the transformed determinant has the elements:

$$M'_{1j} = \sum_{i=1}^{n} M_{ij} = \sum_{i=1}^{n} x_{ij} - y_j = 0 \qquad (2.4)$$

where the final equality is a result of condition (2.1). Thus the entire first row of the transformed determinant consists of zeros, and hence $\det(M) = 0$. This proves that the linear equations (2.2) are consistent with a nonzero solution for the prices.

BOOK II

Theories of
Balanced Exponential Growth

Once we go away from entirely static systems, the simplest dynamic system is one undergoing *balanced growth*; that is, all quantities increase uniformly with time, by the same growth factor each period, and all prices stay constant. Not surprisingly, just such systems have been studied extensively.

Chapter 3 is introductory, a straightforward extension of the work of chapter 2 to a balanced growth system. To make such an extension, we must assume something about the entire production possibility set, not merely state actual production levels in any one period. Chapter 3 assumes an input-output production set of Leontief type, i.e., fixed factor proportions, no joint production. Regarding consumption, we assume "perfect thrift," i.e., none but absolutely necessary consumption. Much of chapter 3 is well-known material and can be read quickly by advanced students. The mathematical appendix contains a summary of the relevant theorems.

Chapter 4 extends this to the von Neumann technology, which permits joint production, alternative processes for producing the same output, and (discrete) input substitution. This also is largely well-known material, though the last two results of the KMT theory (results K5 and K6) have disastrous implications for the "optimality" implications of the theory: If there is any real choice at all, then the solution with maximum growth is *not* the one with the lowest rate of return; and the solution with the lowest rate of return does *not* give maximum growth. This fact, which is a direct consequence of the theory, is sometimes glossed over.

We strike really new material in chapter 5, where we first introduce discretionary consumption; i.e., there is now a choice between consumption and investment for further growth. In chapter 5, we assume that this choice is made so as to lead to an exact

steady state. The result is a theoretical counterpart to the well-known open Leontief model familiar to applied economists. The "theoretical" aspect is that we distinguish clearly between quantities and values (i.e., prices are deduced, not taken from market observation) and we assume the competitive condition that rates of return are the same in all industries. The surprising result is that such a system may fail to have any sensible solution whatever.

Chapter 6 introduces growth along with consumption. Here again there are new results. With Leontief technology, it turns out that the competitive conditions for a state of steady balanced growth are *not* sufficient to pick out a particular rate of growth, though they do pick out a particular rate of return. The growth rate can vary from instant collapse of the economy to a maximum equal to the rate of return, depending upon the degree of "frugality" of the capitalists. Furthermore, under certain circumstances, no sensible state of balanced growth exists at all.

Finally, in chapter 7, we show that a Leontief system without consumption is perfectly unstable; any deviation from the correct proportions between commodity outputs, for any reason whatever, results in ever increasing departures from balance, with eventual disaster (some commodities must have negative amounts of output). We also show that input substitution, when treated correctly and restrained to reasonable elasticities of substitution, does *not* alter this result. Section 7D relates these new results to the literature on long-term stability.

Balanced growth with Leontief technology

A. Leontief technology

We are now ready to embark on the study of dynamic economic systems, in which production levels, and possibly prices, change with time from one production period ("year") to the next. We have seen in section 2C that a simple statement of actual quantities produced, and actual inputs necessary to produce that output, is no longer adequate to derive conclusions. We need to know alternatives, i.e., what outputs are obtainable from any (reasonable) choice of inputs.

Obviously, we need some restrictive assumptions to limit the range of possibilities to something we can handle. In this chapter we shall make a number of assumptions concerning the production possibility set, more restrictive than is either reasonable or necessary, so as to obtain simple and easily understood results with a minimum of mathematics. The more realistic, but also much more complicated "von Neumann technology," is left for chapter 4. For now, we restrict ourselves to "Leontief technology"—the name is taken from the input-output system of Leontief (1951, 1953), which is related but not identical— a technology which we shall now define.

The first restrictive assumption is *constant returns to scale*. If all input quantities are, say, tripled, then the output also triples. Naturally, this assumption is not exact; but neither is it at all far from reality. In classical capitalistic economies, with many small independent producers in each industry, expansion of output in an industry is achieved mainly by new producers entering this industry, using the same techniques and building factories of roughly the same size as before. Constant returns to scale is then an excellent approximation. In fully developed capitalism, of the twentieth-

century variety, many industries are dominated by one, or a few, large corporations. But each corporation runs a number of similar factories; if output is to be contracted, some of these factories are kept idle while the other factories continue to run at optimum capacity. Thus, again, constant returns to scale is not at all a bad assumption (Johnston 1960). Constant returns to scale will be assumed not only in this chapter, but through much of this book.

However, even with constant returns to scale there can be quite a few complications, including:

1. *Input substitution*: By changing the production process used, one may produce the same amount of some commodity with different inputs, either altogether different input commodities or the same input commodities in different proportions and amounts.

2. *Joint production*: A production process may lead to output of two or more commodities, in definite proportions; for example, the production of corn necessarily leads also to the production of straw, with a fixed ratio of outputs of these two commodities. Even if straw turns out to be a free good, it must still be produced if we wish to produce corn.

3. *Fixed capital*: A machine, say a tractor, used in a production process is not "used up" in one time period. At the end of the year, it is still there, one year older, for use the year after.

In this chapter, we shall assume away all these complications, for the sake of getting simple results, easy to derive and see. The technological assumptions for what is called "Leontief technology" are:

1. Every commodity is produced in one precise way, with fixed proportions between all the inputs.

2. Each production process has precisely one output commodity, a different output for each process. There are exactly as many production processes as there are commodities, one process for each commodity.

3. All inputs are used up completely in producing the year's output; that is, there may be circulating capital (e.g., seed corn and a "wages fund" for corn production) but no fixed capital (tractors).

Precisely because of the extreme severity of these assumptions, there is little point in discussing their applicability to actual economies. Rather, the assumptions should be considered mathematical simplifications designed to get at the essence of growth theory without unnecessary complications. If a realistic theory is wanted, then the much more elaborate "von Neumann technology" of chapter 4 must be used.

As an example of an input-output table under Leontief technology, consider the table on the following page:

Corn (quarters)		Iron (tons)	Output
0.9	+	0.05	——————————→ 1 quarter corn
0.6	+	0.2	——————————→ 1 ton iron

Although this looks rather similar to the tables in chapter 2, it contains much more information, because of the assumption of production to scale for both production processes, corn production and iron production. For example, to produce 100 quarters of corn, we need as inputs 90 quarters of corn and 5 tons of iron, obtained by multiplying the first row of the table by 100 throughout. Similarly, to produce 20 tons of iron, we need as inputs 12 quarters of corn and 4 tons of iron, obtained by multiplying the second row of the table by 20 throughout. Thus, unlike the tables of chapter 2, the present table gives the entire "production possibility set," not merely some particular actual inputs and outputs.

Note: Labor is "hidden" in the input-output table; for example, the 0.6 quarters of corn required for production of each ton of iron is not fed to the iron furnace, but rather it is baked into bread which the iron workers eat. As a result, a change in the real wages of labor shows itself by way of a change in the coefficients of the input-output table. For example, if the workers manage to obtain an increase in their real wage, then more input corn will be required to produce corn as output, as well as to produce iron as output.[1] The corn-corn coefficient in the table, 0.90, may rise to 0.92, say, and the iron-corn coefficient, 0.60, may rise to 0.62. What is called a "subsistence" wage can be rather flexible, therefore.

A similar point relates to the labor force and unemployment. In the classical system, say of Ricardo and Malthus around 1820, it was taken for granted that laborers have many children, of whom many die before they reach working age (in that time, that meant an age of ten years!). If real wages improve, more children stay alive and subsequently depress wages back down to subsistence level. Contrariwise, if there are any unemployed, they die of starvation. The "iron law of wages" thus enforces full employment at subsistence level wages. One need not accept this theory as being at all realistic (least of all under present-day conditions) to observe that it has the effect of greatly simplifying the theoretical devel-

[1] The changes in the corn-corn and iron-corn coefficients depend upon indirect requirements, as well as upon the obvious direct requirements. They are related to what is called the "Leontief inverse" of the input-output matrix.

opment. Since our main interest is in a quite different direction, we employ the iron law as a first, rough and ready, approach.

Note also that the "Leontief technology" introduced here is not identical with the input-output system of Leontief (1951, 1953). We shall discuss the differences later on, in section 5D; suffice it to say here that these differences are so fundamental that they are more important than the similarities.

B. Balanced exponential growth: quantities

Suppose we wish to produce y_1 quarters of corn and y_2 tons of iron next year, that is, at time $t + 1$, time t being now. To start production of y_1 quarters of corn we require as inputs, now, $0.9y_1$ quarters of corn and $0.05y_1$ tons of iron. To start production of y_2 tons of iron we require as inputs, now, $0.6y_2$ quarters of corn and $0.2y_2$ tons of iron. Thus our total input requirements are:

Input of corn at time $t = 0.9y_1 (t + 1) +$

$0.6y_2 (t + 1)$ quarters corn

Input of iron at time $t = 0.05y_1 (t + 1) +$

$0.2y_2 (t + 1)$ tons iron

At this stage we impose the conditions for *balanced exponential growth*:

1. All commodity outputs alter by the same "growth factor" a each year, i.e.,

$$y_1 (t + 1) = ay_1 (t) \qquad y_2 (t + 1) = ay_2 (t)$$

and so on if there are more than two commodities.

2. The annual market clears completely.

We shall look for solutions which satisfy these two conditions, year after year; such solutions are called "balanced growth solutions." Other solutions exist, infinitely many of them, and we shall return to them in later chapters. But the balanced growth solutions are particularly simple and form the basis for what is called "growth theory" in economics. Balanced growth solutions are the nearest analog, in dynamic economics, of a purely static equilibrium in which nothing changes at all.[2] In balanced growth, change does occur, but it is kept to an absolute minimum: Only absolute production levels alter from one year to the next; but since all production levels increase by the same factor a, relative

[2] For example, Montgomery (1971) maintains that the system of Walras (!) can be interpreted as a growth theory.

production levels do not change at all. For example, the ratio of y_1 to y_2 remains the same from one year to the next. For this same reason, we shall be able to postulate, in the next section, that all prices stay constant for a growth solution.

A caution is necessary: One speaks of "growth" theories and "growth" solutions, but this can be misleading. All we really assume about the factor a is that it cannot be negative. If a is larger than one, then there is real growth, i.e., production levels at time $t + 1$ exceed those at time t. But if $a = 1$, we have a stationary state with constant production levels. If a is less than one, production levels *decline* year after year, so we have a contracting economy, not a growing one. It is clear that "balanced exponential change" is a better term than "balanced exponential growth" for what we have defined here; but the word "growth" is so common in the literature that it is too late to change it now.

The third condition which we shall impose for now is *perfect thrift*:

3. All outputs are used as inputs to next year's production; nothing at all is used for discretionary (as opposed to absolutely necessary) consumption.

This condition is not necessary to get growth solutions; later on, we shall investigate growth in the presence of discretionary consumption. But it is obvious intuitively that maximum growth is obtained by a single-minded concentration of all resources of the economy on growth and growth alone. Thus, the perfect thrift condition ensures that we get that growth solution which has maximum growth, i.e., the largest possible value of the growth factor a (we note that the "growth rate" g is related to the "growth factor" a through: $a = g + 1$).

Conditions 2 and 3 imply that the input of corn at time t equals the entire corn production from the year before, and similarly for iron. Thus we obtain:

$$y_1(t) = 0.9y_1(t + 1) + 0.6y_2(t + 1)$$

$$y_2(t) = 0.05y_1(t + 1) + 0.2y_2(t + 1)$$

We note that this follows from "market clearing" and "perfect thrift" alone and does not require assumption 1. However, let us now impose this condition as well. Then $y_1(t + 1)$ on the right-hand side can be replaced by $ay_1(t)$, and similarly for y_2. At this stage all production quantities y_1 and y_2 in the equations refer to the *same* time period t, and we can therefore omit the time variable altogether:

$$y_1 = a(0.9y_1 + 0.6y_2)$$

$$y_2 = a(0.05y_1 + 0.2y_2)$$

If and only if these two equations hold can we get balanced exponential growth with growth factor a.

We shall now prove that these two equations determine, in a unique fashion, everything that matters about this economy. We intend to demonstrate that there is one unique value of the growth factor a consistent with these equations, as well as one unique value of the ratio of outputs y_1/y_2. Later on, in section C, we shall show that price ratios are also determined uniquely.

We now proceed to the proof of these assertions. We start by writing the two equations above in equivalent forms:

$$(1 - 0.9a)y_1 = 0.6ay_2 \quad \text{and hence} \quad y_1/y_2 = 0.6a/(1 - 0.9a)$$

$$0.05ay_1 = (1 - 0.2a)y_2 \quad \text{and hence} \quad y_1/y_2 = (1 - 0.2a)/(0.05a)$$

Since both expressions for the output ratio y_1/y_2 must lead to the same answer, we must have:

$$0.6a/(1 - 0.9a) = (1 - 0.2a)/(0.05a)$$

We multiply both sides of this equation by the product $0.05a(1 - 0.9a)$ to get:

$$0.03a^2 = (1 - 0.2a)(1 - 0.9a) = 1 - 1.1a + 0.18a^2$$

and thus, finally, the following quadratic equation for a:

$$0.15a^2 - 1.1a + 1 = 0$$

The standard formula for solving a quadratic equation leads to the following two solutions:

$$a_a = (1.1 + \sqrt{1.21 - 0.6})/0.3 = 6.27008$$

$$a_b = (1.1 - \sqrt{1.21 - 0.6})/0.3 = 1.06325$$

This appears to contradict our initial assertion that there is a unique solution to the system: we have two distinct solutions to the quadratic equation.

However, we assert that the first of these two solutions is impossible economically. To see this, let us evaluate the output ratio y_1/y_2 from the first of the two formulas given before (we could use the second formula equally well, with the same result), and let us do so for both values of a found above:

For $a_a = 6.27008$: $y_1/y_2 = 0.6a/(1 - 0.9a) = -0.81025$

For $a_b = 1.06325$: $y_1/y_2 = 0.6a/(1 - 0.9a) = 14.81025$

It is the negative value $y_1/y_2 = -0.81025$ for the first solution

which makes this solution impossible economically: We cannot produce negative amounts of anything; we can produce positive amounts or zero, but not less than zero. With y_1/y_2 negative, one of y_1 and y_2 must be negative (the other being positive). This is impossible, and therefore we are left with *one, unique solution*, $a = 1.06325$, which means a growth rate $g = a - 1 = 0.06325$, or a bit over 6 percent growth per period. To achieve this steady growth, 14.81025 quarters of corn *must* be produced for every ton of iron. These results follow of *necessity* from the assumed input-output table.

In the mathematical appendix to this chapter, we state certain mathematical theorems which give the extension of this result to the case of an arbitrary number n of commodities in the system, rather than just two commodities. An input-output table is called "irreducible" if every commodity is needed, directly or indirect- ly, as an input to produce every commodity in the system. For ex- ample, our table is irreducible, because corn is needed to produce corn and to produce iron, and iron is needed to produce corn and to produce iron. In both cases the need is direct, but in general it may be indirect, i.e., one commodity may be needed as an input to production of a second commodity, and this second commod- ity is needed as an input for a third commodity. In such a case, the first commodity is needed, but needed indirectly, to produce the third commodity.

The extreme opposite of "irreducible" is called "fully reduc- ible." Think of two countries which do not trade with each other at all. Certain commodities are produced in country A and used as inputs in this country. Entirely different commodities (or at least with different labels) are produced in country B and used as inputs in that country. But no commodities from A are used in B, and vice versa. The input-output table then splits into two quite separ- ate tables, one for country A, the other for country B. It is then obvious that there can be two different growth factors, one for country A, the other for country B; and hence there is no longer a unique solution. However, this type of nonuniqueness is without real economic significance, since all the meaningful information can be obtained by considering each country separately, one at a time.

However, it is not true that "fully reducible" and "irreducible" are the only two possibilities for an input-output table. Rather, there exists an intermediate case which is called "reducible" (but not "fully reducible"). Economically this occurs when there are "discretionary consumption goods," that is, goods which can be produced if there is a demand for them, but need not be produced

at all under "perfect thrift." Consider, in addition to our "corn" and "iron," a third commodity called "white elephants." To produce white elephants, one requires corn (as food), iron (for fencing), and some white elephants. However, no white elephants are needed in corn or iron production. This economy is not "fully reducible," because it cannot be split into two viable subeconomies which are unrelated to each other: A subeconomy containing only corn and iron is viable; but the other subeconomy, containing only white elephants, is not viable because it requires inputs of corn and iron. Equally so, however, our three-commodity economy is not "irreducible": Elephants are not needed, directly or indirectly, for the production of either corn or iron.

This possibility is of considerable importance when we discuss growth with consumption. However, we can ignore it now since we have assumed a "perfect thrift" condition. It is a consequence of our definition of perfect thrift that no white elephants are produced in a perfect thrift economy. Thus, under the conditions assumed in this chapter, we may validly postulate that our input-output matrix is irreducible.

In the mathematical appendix, we quote theorems to the effect that an *irreducible input-output matrix results in a unique solution of the balanced growth equations*, unique both in the value of the growth factor a and in the proportions $y_1 : y_2 : y_3 : \ldots : y_n$ between the quantities of the various commodities which must be produced each year to maintain this balanced growth. We point out, however, that this result depends on the very strong assumptions (Leontief technology and perfect thrift) in this chapter.

C. Balanced exponential growth: prices

Some words are needed here about our "prices." They are:

1. "Market-clearing prices"—that is, we assume that the annual market is organized so perfectly, say by an auctioneer, that it clears perfectly. The price ratios required to bring about this result are our "market-clearing prices." Our prices are neither claimed, nor intended, to be in any sense stable in time or some kind of center of gravity about which actual market prices move. On the contrary, our market-clearing prices are directly applicable to dynamic situations in which price ratios which clear the annual market of year t fail to clear the market of year $t + 1$. Deviations between our prices and actual market prices arise solely from market imperfections.

We mention this because economists have distinguished between quite a few types of "prices," *none* of which corresponds at all

closely to our concept. Among these types of prices, a few prominent ones are:

2. "Market prices."

3. The classical notion of "natural price" (Smith 1776, Ricardo 1821, particularly chapter 4 of the latter).

4. The Marxian notion of "prices of production" (Marx 1894), and the closely related price concept of Sraffa (1960).

5. The early neoclassical notions of "general equilibrium prices" (Walras 1874, 1877) and "partial equilibrium prices" (Marshall 1890).

6. The late neoclassical notions of "general equilibrium prices" (Debreu 1959, 1962, Arrow 1971).

We repeat that *none* of these equals our concept of market-clearing prices, though some are not too far away.

In particular, in this chapter and for some time to come, we deliberately assume away price changes from one year to the next; that is, we *impose* conditions of "balanced growth" which are consistent with the assumption of constant price ratios. Under such special assumptions, our market-clearing prices become very similar to the "prices of production" of Marx and Sraffa.

But such special assumptions, i.e., constant price ratios, are inconsistent with a fully dynamical approach. Prices, or price ratios, cannot be so constrained in advance. This will become apparent in chapter 7, and it would take us too far to explain it fully here. All we need for now is the fact that, in the general dynamical system, our market-clearing prices are neither constant, nor closely related to the conventional "prices of production."

Next, we intend to prove that the solution we have just found for the growth factor and for quantities produced also implies a unique value for the price ratio p_1/p_2 of the price of one quarter of corn to the price of one ton of iron, as well as a unique value for the rate of return to the owner in either industry.

In addition to conditions 1, 2, and 3 imposed in section B, we now impose further conditions:

4. All prices are constant year after year.

5. All industries offer the same rate of return r to their owners. Condition 4 is not necessary if the unit in which prices are measured is itself a given (unit) quantity of some specific commodity (the numeraire). For then, with quantity ratios constant by assumption 1, price ratios are automatically constant, and the "price" of some other commodity is a price ratio (to the price of the unit quantity of the numeraire) by definition. But if the currency is paper, then assumption 4 is required to exclude the possibility of a uniform inflation or deflation of the value of that currency.

Condition 5 arises as follows: If the production of iron should give a higher rate of return r_2 than the rate of return in the corn industry r_1, then there is an incentive to corn producers to switch to production of iron so as to partake of the higher returns there. If there are no barriers to entry into the iron industry, then conditions next year will be different from those of the present year, not merely in total amounts, but in the proportions produced. This is inconsistent with balanced growth and must therefore be excluded. Barriers to entry are outside the scope of this book (section 1A).

Let us now figure out the rate of return in the two industries. Under our assumptions, this rate of return does not depend upon the scale of production and can therefore be calculated on the basis of production of a unit quantity of the output commodity. To produce one quarter of corn, the entrepreneur must purchase, at the beginning of the year, 0.9 quarters of corn and 0.05 tons of iron. His expenditure is therefore equal to $0.9p_1 + 0.05p_2$. At the end of the year, he has one quarter of output corn to sell, at unit price p_1. By assumption 2, all the output is actually sold; hence the entrepreneur receives an amount p_1 for his one quarter of corn. His rate of return r_1 is therefore given by:

$$1 + r_1 = p_1/(0.9p_1 + 0.05p_2)$$

The entrepreneur in the iron industry purchases inputs of 0.6 quarters of corn and 0.2 tons of iron, at a total expenditure of $0.6p_1 + 0.2p_2$, and he receives the amount p_2 at the end of the year for his one ton of iron; his rate of return is therefore given by:

$$1 + r_2 = p_2/(0.6p_1 + 0.2p_2)$$

At this stage, we impose condition 5, equality of the two rates of return, that is, $r_1 = r_2$. Since the left-hand sides of our two equations are now equal, the right-hand sides must also be equal:

$$p_1/(0.9p_1 + 0.05p_2) = p_2/(0.6p_1 + 0.2p_2)$$

Since only the price ratio $P_1 = p_1/p_2$ is determined by this condition, we divide numerators and denominators on both sides by p_2, to get:

$$P_1/(0.9P_1 + 0.05) = 1/(0.6P_1 + 0.2)$$

Hence:

$$P_1(0.6P_1 + 0.2) = 0.9P_1 + 0.05$$

whence:

$$0.6P_1^2 - 0.7P_1 - 0.05 = 0$$

This is a quadratic equation for the price ratio $P_1 = p_1/p_2$. The two solutions of this quadratic equation are:

$$P_1 = (0.7 \pm \sqrt{0.49 + 0.12})/1.2 = \begin{cases} 1.23419 \text{ (plus sign)} \\ -0.067521 \text{ (minus sign)} \end{cases}$$

The solution with negative value $P_1 = -0.067521$ can be discarded as impossible economically: If the ratio p_1/p_2 is to be negative, then one of the two separate prices must be negative, the other positive; but there cannot be negative prices. Thus we are left, as claimed, with a uniquely determined price ratio $P_1 = p_1/p_2 = 1.23419$. One quarter of corn exchanges for 1.23419 tons of iron in the market.

Equally, the common rate of return is now known, and is unique: Using either one of the two earlier expressions for $1 + r$, we get (say from the second one)

$$1 + r = p_2/(0.6p_1 + 0.2p_2) = 1/(0.6P_1 + 0.2) = 1.06325$$

which means a return of slightly better than 6 percent on money invested. This particular rate of return, and this particular price ratio, is determined uniquely by the input-output table and the conditions 1 to 5 which we have imposed. No other balanced exponential growth solution is possible.

It is apparent that the "return factor"

$$\beta = 1 + r$$

(we always use the symbol β for the return factor defined this way) has turned out to be identically equal to the "growth factor" a. Consequently there is also *equality between the rate of growth $g = a - 1$ and the rate of return $r = \beta - 1$*. This is a fundamental result of the theory of economic growth, and we see in the next few chapters both how widely it extends (for example, it is not necessary to have Leontief technology) and what its limitations are. In the mathematical appendix, we quote theorems to the effect that, with the assumptions of this chapter, the rate of growth and the rate of return are equal and determined uniquely, no matter how many commodities there are in the system, provided only that the input-output matrix is irreducible. Under this same condition, all price ratios are determined uniquely.

D. The effect of a wage rise, and other qualitative points

We mentioned before that the wages of labor are hidden in our

input-output table; for example, the input of corn for production
of one ton of iron represents bread eaten by the workers in the
iron foundry.

Now suppose the workers form a union and succeed in getting a
real wage rise, i.e., more corn for themselves for the same total
output. Within the model, this shows up as an increase in the corn
inputs within the input-output table. Let us say, by way of exam-
ple, that the coefficient 0.9 for corn production increases to 0.92,
and the coefficient 0.6 for iron production increases to 0.62 (they
do *not* increase in the same ratio, because some of the corn needed
for corn prodution is seed corn and food for draft animals, not
wages for agricultural laborers). The new input-output table there-
fore reads:

Corn (quarters)		Iron (tons)		Output
0.92	+	0.05	⟶	1 quarter corn
0.62	+	0.20	⟶	1 ton iron

Working through the argument in the same way that we did in sec-
tion B, we find that the new quadratic equation for the growth
factor a reads:

$$0.62 \times 0.05a^2 = (1 - 0.2a)(1 - 0.92a) = 1 - 1.12a + 0.184a^2$$

with the unique positive solution (positive in the ratio y_1/y_2):

$$a = (1.12 - \sqrt{1.2544 - 0.612})/0.306 = 1.04085$$

This is less than the growth factor found in section B; the growth
rate has declined from 6.3 percent per period to 4.1 percent per
period.

One way of looking at this result is to say that the "selfish"
workers, by demanding higher real wages, have interfered with the
growth of the economy. But one must recognize that this is hardly
the way the situation would appear to a worker. From his point of
view, his wages are depressed in order to produce a fast rate of
economic growth, without his getting any personal benefit what-
ever from the growth. Higher growth means a higher rate of re-
turn for the capitalist entrepreneurs, or perhaps the owners if
these are different people; this follows from the fact that the rate

of return equals the rate of growth in this theory. But there is no higher return, or any return, to the working man; as long as the input-output table remains the same, a higher level of output means that there are more workers to produce that output, but each worker gets the same real wage. The rational worker is out to change the input-output table so as to benefit himself through increased consumption (of corn), not to maximize growth and the rate of return to capitalists, at zero benefit to himself.

However, there are at least two things which must be added to this discussion, to make it slightly more realistic:

1. A high rate of growth of production (and, under our assumptions, of working population as well) makes a nation more powerful militarily, more capable of aggression against others and of defense against aggression by other nations. This aspect of growth can be, and historically has been quite often, used as an argument to make the goal of maximum growth acceptable to the working class. Indeed, if a powerful nation can take control of foreign territories and make them colonies, the workers within the home country may be better off objectively as a result. Conversely, a nation that fails to grow economically as fast as its neighbors may leave itself open to being attacked and conquered.

2. The complete neglect of technological progress in the discussion so far is an extremely serious flaw in the argument (Eichner 1980, p. 304 ff). *If* technology does not change (no change in the input-output table), *then* a rise in real wages slows down growth. But the "if" is most unrealistic, since the level of wages itself has a major influence on the advance of technology (Ford 1974). In practice, modern economies do *not* grow by starving their workers, but rather by high investment in new technology. This type of investment is inhibited, not furthered, if wages are low, since then there is little incentive to install labor-saving machinery, or to pay good money for inventing and developing machinery which will never be installed. Throughout the nineteenth century, the United States was a high-wage country; the United Kingdom had much lower wages. There is strong historical evidence (Saul 1970) that the much more rapid growth of technology in the United States than in the United Kingdom can be explained on purely economic grounds: it pays to install new technology in a high-wage country, more than in a low-wage country. We are not suggesting that high wages were the *only* factor favoring growth of the U.S. economy, or that other issues can be ignored (for example, how the Americans got the initial capital to install all this machinery). But it is clear historically that high real wages favor, rather than inhibit, economic growth.

This is one of the unfortunately all too common examples of how seriously misleading an oversimplified economic model may be.

Another limitation of growth theory is this: If there is real growth, i.e., a growth factor larger than unity, then this state of affairs cannot go on forever. Eventually, we come up against some limit which makes further growth impossible. In the classical system, this limit is natural resources, called "land." Once all available land is under cultivation, no more growth of output (say, of corn) is possible unless there is technological improvement in the use of the land—something the simple growth theory cannot handle.

To those people who maintain that human ingenuity will always be able to overcome such limitations, there is a simple answer: shortage of living space on the earth. If the population doubles every so many years then it is a simple exercise in arithmetic to calculate the date at which each human being will have less than one square centimeter of space on which to stand on this earth. Going out to colonize space (as if there were any reason to believe that other planets exist capable of supporting *human* life!) does not avoid this dilemma: The volume of space colonized increases with time like t^3, the population increases exponentially with time, and eventually an exponential always overtakes a power of t.

Thus, growth theories can apply, at best, to a limited and restricted set of conditions, to times when land is plentiful and so are all other needed natural resources. This does not say that growth theories are useless: but, like all simplified models, they must be used with considerable caution.

Another word of caution: Technological assumptions, such as Leontief technology, can be considered, within economics, more or less as "laws of nature," givens as far as the economic argument is concerned. But the same is *not* true for strictly economic assumptions such as the "competitive" assumption 5, equal rates of return in all industries. This is associated with absence of monopoly and with absence of barriers preventing shifts from one industry to another to equalize the rates of return. The determination of prices in section C depended upon such assumptions. If any of these assumptions is violated in fact—for example, if there exist state monopolies (British East India Company) or private monopolies (John D. Rockefeller's Standard Oil Company)—then the conclusions of the theory must also be modified. A theory appropriate to competition must not be used in the presence of monopoly, or of barriers to entry. Unfortunately, this very obvious caution is ignored completely in much published work in economics.

E. Mathematical appendix

There are n commodities, labeled by an index i which takes values 1, 2, . . . ,n. The output of commodity i at the end of year number t is denoted by $y_i(t)$. The unit price of commodity i is called p_i and is assumed to stay constant. All p_i and all y_i must be nonnegative.

The input-output matrix A has matrix elements a_{ij}, representing the input amount of commodity j required at the beginning of the period, to produce one unit of commodity i at the end of the period. All production is to scale, and there is one and only one way to produce each commodity i.

The exponential growth condition 1 of section B is:

$$y_i(t+1) = ay_i(t) \quad \text{for all} \quad i = 1,2,\ldots,n \quad \text{and all } t \qquad (3.1)$$

Conditions 2 (market clearing in quantity terms) and 3 (perfect thrift) lead to

$$\sum_{i=1}^{n} y_i(t+1)a_{ij} = y_j(t) \quad \text{for all} \quad j = 1,2,\ldots,n \quad \text{and all } t \qquad (3.2)$$

Let us introduce the symbol s for the reciprocal of the growth factor a:

$$s = 1/a \qquad (3.3)$$

When we combine (3.1) and (3.2), and use the notation (3.3), we get:

$$\sum_{i=1}^{n} y_i a_{ij} = sy_j \quad \text{for all} \quad j = 1,2,\ldots,n \qquad (3.4)$$

In mathematical terms, the production quantities y_i form the components of a left eigenvector of the input-output matrix A, with an eigenvalue s which is the reciprocal of the growth factor.

The producers of commodity i must purchase, per unit amount of i to be produced, quantities a_{ij} of the various commodities j, each at unit price p_j. At the end of the production period, they sell one unit of i, at price p_i. The rate of return r, assumed to be common (assumption 5), and the return factor $\beta = 1 + r$ are then given by:

$$p_i = (1 + r) \sum_{j=1}^{n} a_{ij}p_j = \beta \sum_{j=1}^{n} a_{ij}p_j \qquad (3.5)$$

Thus the unit prices p_i form the components of a right eigenvector of the input-output matrix, with eigenvalue equal to $1/\beta = 1/(1+r)$.

By a general theorem on eigenvalues, the eigenvalues are solutions of the secular equation:

$$\det(a_{ij} - s\delta_{ij}) = \det(A - sI) = 0 \tag{3.6}$$

where I is the n-by-n unit matrix and δ_{ij} is the Kronecker delta, which is unity when $i = j$ and is zero otherwise. Since this determinant is unchanged by the process of replacing the matrix A by its transpose, we conclude that the eigenvalues s of problem (3.4) are pairwise identical with the eigenvalues $1/\beta = 1/(1+r)$ of problem (3.5). We therefore expect to find, among the possible solutions, ones with $\alpha = \beta$. However, we can say very much more than that rather weak statement.

The reason for this is the nonnegativity requirement that all quantities y_i and all prices p_i must be positive or zero. Before proceeding, we must define "fully reducible," "reducible," and "irreducible" input-output matrices, as well as "nonnegative" and "strictly positive" matrices.

DEFINITION
A matrix A is called *nonnegative* if all its elements $a_{ij} \geqslant 0$.

DEFINITION
A matrix A is called *strictly positive* if all its elements $a_{ij} > 0$.

Note: These concepts have to do with properties of individual matrix elements and must not be confused with "positive definite" and "positive indefinite" matrices. For example, the two-by-two matrix $\begin{pmatrix} 1 & 2 \\ 2 & 1 \end{pmatrix}$ is "strictly positive" but is *not* positive definite. The matrix $\begin{pmatrix} 2 & -1 \\ -1 & 2 \end{pmatrix}$ is positive definite but is neither strictly positive nor nonnegative.

Let I be the set of indices $I = \{1,2,3,\ldots,n\}$ and let this be divided into two mutually exclusive sets J and K, which between them exhaust I. A subset J of the set I is called a "proper subset" if J has at least one element and J has fewer elements than I. In the following definitions, all matrices are *square*.

DEFINITION
A matrix A is called *fully reducible* if there exists a division of the index set I into proper subsets J and K, such that for all indices $j \in J$ and $k \in K$, it is true that $a_{jk} = a_{kj} = 0$.

DEFINITION

A matrix A is called *reducible* if there exists a division of the index set I into proper subsets J and K, such that for all indices $j \in J$ and $k \in K$, it is true that $a_{jk} = 0$.

DEFINITION

A matrix A is called *irreducible* if it is not reducible.

Examples: The following matrix is fully reducible: $A = \begin{pmatrix} 2 & 0 & 7 \\ 0 & 5 & 0 \\ 6 & 0 & 9 \end{pmatrix}$. The index

set $I = \{1,2,3\}$ and the subsets are $J = \{1,3\}$ $K = \{2\}$. In terms of the input-output interpretation, commodities 1 and 3 (set J) are produced and used as inputs in one country and commodity 2 (set K) is produced and used as (sole) input in another country, the two countries not trading with each other.

The following matrix is reducible, but not fully reducible:

$A' = \begin{pmatrix} 2 & 0 & 7 \\ 4 & 5 & 1 \\ 6 & 0 & 9 \end{pmatrix}$. The sets I, J, K are the same as before. Commodities

1 and 3 are necessary goods, without which the economy dies; good 2 is a discretionary good, which is not required for the production of 1 and 3, but which requires 1 and 3 as inputs for its own production.

The following matrix is irreducible: $A'' = \begin{pmatrix} 2 & 0 & 7 \\ 4 & 5 & 1 \\ 6 & 9 & 0 \end{pmatrix}$. All three goods

are now necessary inputs: 1 is an input to 2, 2 is an input to 3, and 3 is an input to 1. Thus 2 is also an indirect input to 1.

We shall now state several theorems, all of them without proof. Since the main theorems are quite difficult to prove, well beyond the level of this book, it makes little sense to prove only the trivial theorems (such as the first four). For all proofs, we refer to the books by Karlin (1959) or by Kemp and Kimura (Kemp 1978).

THEOREM 3.1.

If A is fully reducible, then so is every power A^m of A.

THEOREM 3.2.

If A is reducible, then so is every power A^m of A.

Note: This is not true for irreducibility. The matrix $A = \begin{pmatrix} 0 & 1 \\ 1 & 0 \end{pmatrix}$ is irreducible, but its square is the unit matrix, and hence is fully reducible.

THEOREM 3.3.

Given an irreducible nonnegative matrix A and two indices i and j, there always exists a positive power m such that $(A^m)_{ij} > 0$. (Note that the value of m may depend on the choice of i and j.)

THEOREM 3.4.

An irreducible nonnegative n-by-n matrix A must contain at least n distinct strictly positive elements off the diagonal, distributed in such a way that there exists a positive off-diagonal element in every row of the matrix (this is necessary but not, by itself, sufficient).

Note: The zero matrix and the unit matrix are fully reducible.

DEFINITION

A vector x is called *nonnegative*, denoted by $x \geqslant 0$, if $x_i \geqslant 0$ for all i

DEFINITION

A vector x is called *positive*, denoted by $x > 0$, if $x \geqslant 0$ and there exists at least one positive vector element x_i.

DEFINITION

A vector x is called *strictly positive*, denoted by $x \gg 0$, if *all* vector elements x_i are positive.

THEOREM 3.5.

Let A be a nonnegative irreducible n-by-n matrix, and let the vector x satisfy the two conditions: $x > 0$ and $x \geqslant xA$. Then $x \gg 0$.

Note: The proof depends on theorem 3.3. Intuitively, theorem 3.5 asserts that, if every commodity is needed as an input, directly or indirectly, to production of every other commodity (irreducibility) and if at least one commodity is actually produced $(x > 0)$, then all commodities must be produced $(x \gg 0)$.

Associated with every nonnegative matrix $A \geqslant 0$ there is a *dominant eigenvalue* which we shall call $s^*(A)$. It is defined as follows:

DEFINITION

Let $A \geqslant 0$. A nonnegative number $s \geqslant 0$ is called "admissible" if there exists a vector $x > 0$ such that $xA - sx \geqslant 0$. Then $s^*(A)$ is the lowest upper bound of all admissible numbers s.

Note: If A is a diagonal matrix with diagonal elements $a_{ii} \geqslant 0$, then $s^*(A)$ equals the largest of these diagonal elements and is therefore also equal to the largest eigenvalue of A. The zero matrix has $s^* = 0$; the unit matrix has

$s^* = 1$. Our main interest, however, is in matrices with nonzero off-diagonal elements. Note that the definition of s^* says nothing, of itself, about s^* being an eigenvalue of A. However, the following theorem states this as one of the consequences (nontrivial) of the definition.

THEOREM 3.6.

Let A be an irreducible nonnegative n-by-n matrix. Then:

(a) $s^*(A)$ is an eigenvalue of A, with a unique left eigenvector \mathbf{y}^* and a unique right eigenvector \mathbf{p}^*.

(b) $\mathbf{y}^* \gg 0$ and $\mathbf{p}^* \gg 0$.

(c) Let s' be any other eigenvalue of A. Then the absolute value $|s'|$ is less than or equal to s^*. Furthermore, if A has at least one nonzero element on the diagonal (at least one $a_{ii} > 0$), then $|s'| < s^*$ with strict inequality.

(d) If s' is a real eigenvalue of A, different from s^*, and if it has a real left eigenvector \mathbf{y}' (that is, $\mathbf{y}'A = s'A$), then the vector \mathbf{y}' has at least one strictly negative component. The corresponding statement holds for a real right eigenvector \mathbf{p}' with $A\mathbf{p}' = s'\mathbf{p}'$.

Note: The assumption of irreducibility is essential for this theorem. Without it, $s^*(A)$ is still an eigenvalue of A and assertion (c) still holds. But (b) must be weakened to $\mathbf{y}^* > 0$ and $\mathbf{p}^* > 0$; and (d) may be false altogether.

DEFINITION

For two vectors x, y, the statement $\mathbf{x} \geqslant \mathbf{y}$ means $\mathbf{x} - \mathbf{y} \geqslant 0$; ditto for $\mathbf{x} > \mathbf{y}$ and $\mathbf{x} \gg \mathbf{y}$. For two matrices A, B, the statement $A \geqslant B$ means $A - B \geqslant 0$, and $A \gg B$ means $A - B \gg 0$.

THEOREM 3.7.

Let $A \geqslant B$ and $B \geqslant 0$. Then $s^*(A) \geqslant s^*(B) \geqslant 0$.

THEOREM 3.8.

Let $A \geqslant 0$ and let q be any real number larger than the dominant eigenvalue of A: $q > s^*(A)$. Let I be the unit matrix. Then the operator $(qI - A)^{-1}$ exists and is nonnegative.

THEOREM 3.9.

Let A be nonnegative; let q be a real number such that the operator $(qI - A)^{-1}$ exists and is nonnegative. Then $q > s^*(A)$.

DEFINITION

A nonnegative matrix A is called *productive* if there exists a nonnegative vector of outputs $\mathbf{y} \geqslant 0$ such that the necessary inputs are, all of them, strictly smaller than these outputs, i.e., such that $\mathbf{y} \gg \mathbf{y}A$.

Note: An economy with a productive input-output matrix A is capable of

producing a surplus in every commodity i each year, at least for this set of outputs.

THEOREM 3.10.
Let \mathbf{A} be productive. Then $s^*(\mathbf{A}) < 1$ and the operator $(\mathbf{I} - \mathbf{A})^{-1}$ exists and is nonnegative.

THEOREM 3.11.
(Converse to theorem 3.10) If $\mathbf{A} \geqslant 0$ and $s^*(\mathbf{A}) \geqslant 1$, then \mathbf{A} is not productive; i.e., it is then impossible to find a vector $\mathbf{y} \geqslant 0$ such that $\mathbf{y} \gg \mathbf{yA}$.

THEOREM 3.12.
The transpose matrix \mathbf{A}^t of \mathbf{A} is productive if and only if \mathbf{A} is productive.

THEOREM 3.13.
(Corollary of 3.11 and 3.12) If $\mathbf{A} \geqslant 0$ and $s^*(\mathbf{A}) \geqslant 1$, then it is impossible to find a set of prices $\mathbf{p} \geqslant 0$ such that $\mathbf{p} \gg \mathbf{Ap}$.

This concludes the statement, without proof, of the mathematical theorems underlying growth theory with Leontief technology. We shall have frequent occasion, in later chapters, to make use of one or more of these theorems. Let us now trace out the consequences of these theorems for the solutions of equations (3.1) through (3.5). We assume that our "perfect thrift" economy produces only strictly necessary goods, so that the input-output matrix \mathbf{A} is irreducible as well as being nonnegative.

Theorem 3.6 then implies that there exists only one eigenvalue s in (3.4) such that all quantities y_i are nonnegative—see part (d) of the theorem. Furthermore, the right eigenvector \mathbf{p}^* for this same eigenvalue is also unique, so there is just one system of relative prices and of relative quantities which solves equations (3.4) and (3.5). For this system, $\alpha = \beta$, since both equal $1/s^*$, so the growth factor equals the return factor, the growth rate equals the rate of return. By part (b) of theorem 3.6, all price ratios and all quantity ratios are strictly positive; there are no nonproduced goods in the system (since all goods are, by assumption, necessary), and there are no free goods.

So far, we have said nothing about whether there is actual growth, i.e., whether the growth factor α is bigger than unity. But theorem 3.10 tells us: If the economy is productive, i.e., capable (with some choice of production levels) of generating a surplus of every commodity in the system, then $s^* < 1$ and hence $\alpha = 1/s^*$ exceeds unity, meaning growth.

Theorem 3.7 provides the generalization of our example of the effect of a real wage increase (see section D). Let B be the original input-output matrix, A the matrix after the wage increase. Then $A \geqslant B \geqslant 0$, and hence $s^*(A) \geqslant s^*(B)$. Hence $a(A) \leqslant a(B)$, so that growth has become less rapid. However, we emphasize that this result depends on the unrealistic assumption that the wage rate has no effect at all on technological change (indeed, that there is no technological change whatever).

CHAPTER 4

Balanced growth with von Neumann technology

A. von Neumann technology

We shall now discard some, but not all, of the restrictive assumptions made in chapter 3. The generalized theory represents a major step forward. It was first formulated by John von Neumann in 1932 and first published (in German) in the late thirties (von Neumann 1937); it was reprinted in English translation after World War II (von Neumann 1945). This publication history explains why the theory took so long to acquire its amply deserved general recognition. A second reason is the style of von Neumann's paper; it is typical of papers in mathematics, extremely condensed, and the reader needs to have considerable mathematical knowledge before he can even start to comprehend it. Mathematically simpler proofs have been found later (Gale 1956, Karlin 1959), but these also are well beyond the mathematical level of this book. We therefore confine ourselves to quoting the important results and explaining their economic meaning, and we omit all proofs. (For a "diagrammatic" explanation of the von Neumann theory, see Koopmans 1964; for a very interesting "inside" view of the history of this theory, see Morgenstern 1977).

The original results of von Neumann are subject to serious doubt, because he imposed an extremely severe restriction (condition N on p. 61) on top of his otherwise very reasonable technological assumptions. This restriction has turned out to be not at all reasonable or economically acceptable. Fortunately, Kemeny, Morgenstern, and Thompson (Kemeny 1956; see also Morgenstern 1976) have developed an alternative theory with the same basic technology but without this unreasonable restriction. It is their results, not the original von Neumann results, which should be accepted whenever the two differ.

In this section, we explain the technological assumptions which, in sum, make up "von Neumann technology" (sometimes called "general linear technology") as opposed to Leontief technology: and we propose to show how the limitations inherent in Leontief technology (no input substitution, no joint production, no fixed capital) are overcome by this more general technology. One other limitation of Leontief technology, production to scale, is retained in von Neumann technology; but production to scale was discussed in section 3A and found there to be an eminently reasonable approximation.

Von Neumann technology starts from a large number M of *production processes*, also called *activities*, labeled by an index m which can take the values $m = 1, 2, \ldots, M$. Each activity works on some set of *inputs* so as to produce, at the end of the period, a set of *outputs*. The inputs and outputs of each activity are commodities, just as in the Leontief technology. Labor as such is still "hidden" within the input commodities. But it is no longer true that there is only one way (one activity) available for producing each commodity. On the contrary, any one commodity may be the output, or more precisely, may be one of the many outputs, of a number of different activities. Thus we now have a choice as to which of these available activities should actually be employed to produce the commodity. The other processes, or at least most of them, will then not be used at all. However, there is no need to omit these other processes from the list of possible processes. Rather, we associate with each activity m an *activity level* $z_m \geqslant 0$. If z_m is positive, the process is used, with that intensity. If $z_m = 0$, then process number m is not used at all.

The "linear" character of the technology shows itself as follows: For every process m which is actually used (for which $z_m > 0$) the required inputs and the resulting outputs are directly proportional to the activity level z_m. Twice the activity level means twice as much input quantity of every required input commodity, and twice as much output quantity of every output commodity from the process. Thus, each separate process, and hence also the economy as a whole, is subject to constant returns to scale.

We can therefore specify the essential properties of each process m by stating what are the precise inputs needed, and the precise outputs produced, if the activity level z_m of this process is exactly equal to unity, $z_m = 1$. At any other activity level, all inputs and outputs change in direct proportion.

We define the *input coefficients* of process m by saying that, at unit activity level $z_m = 1$, the required inputs to the process are:

a_{m1} of commodity 1, a_{m2} of commodity 2, ... ,

a_{mi} of commodity i, ...

These input coefficients are nonnegative: $a_{mi} \geqslant 0$ (all m, all i). If a particular commodity, let us say commodity number 2, is not actually required as an input to activity number m, then the corresponding input coefficient is zero: $a_{m2} = 0$.

We define the *output coefficients* of process m by saying that, at unit activity level $z_m = 1$, the commodity outputs resulting from operation of the process at that level are:

b_{m1} of commodity 1, b_{m2} of commodity 2, ... ,

b_{mi} of commodity i, ...

These output coefficients are nonnegative: $b_{mi} \geqslant 0$ (all m, all i). If a particular commodity, say commodity number 2, is not actually one of the outputs of activity number m, then the corresponding output coefficient is zero: $b_{m2} = 0$.

In practice, most processes m in a real economy require only a few commodities as inputs, and produce only a few, perhaps even only one, commodities as outputs. Hence all but a few of the input coefficients a_{mi} for any one process m, and all but a few (perhaps only one) of the output coefficients b_{mi} of that process, are just zero. But this does not hurt; zero coefficients are perfectly permissible.[1]

It should be obvious now how two of the limitations of Leontief technology (no input substitution, no joint production) have been overcome: Since any one commodity i may be one of the outputs of several different processes m, m', m'', ... , (i.e., b_{mi}, $b_{m'i}$, and $b_{m''i}$ may all be positive), we have a choice which process to use; in general these processes will differ in the nature and proportions of the input commodities needed to get the same output of commodity i. Suppose that corn can be produced by different processes, one a primitive method using mostly corn input (agricultural labor, draft animals) and little iron, the other using less corn input but more iron input (machines). By choosing the second process rather than the first, we go to a more "capital-intensive" method. Unlike the standard neoclassical theory, this method of input substitution is not continuous; i.e., we can use one process (with a certain capital-to-labor ratio) *or* the second process, with its own ratio; but nothing in between. However, this absence

[1] There is a great deal of freedom here, and in particular one may wish to insist that all "activities" be linearly independent; we skip details.

of continuous transformation between inputs is not at all a serious objection to the theory, because:

1. If there are not just two processes, but many different processes, available for production of a commodity, then the discrete substitutions in effect come very close to a single continuous production possibility curve. The curve is replaced by a series of straight line segments. This point is explained very well by Dorfman, Samuelson, and Solow (Dorfman 1958).

2. The discrete substitution between different processes is a much better description of what actually happens than the neoclassical continuous substitution curve. It is the latter which is unrealistic, not the activity analysis.

Next, let us show how we have overcome the other two limitations of Leontief technology, that is, no joint production and no fixed capital. Joint production is obviously included in the general linear technology; all we require is that more than one of the output coefficients b_{mi} of process m be nonzero. Fixed capital, the other problem area, is handled by a simple, but ingenious, trick. Suppose it takes corn and a tractor to produce next year's corn. The tractor, a fixed capital item, is used, but not used up, during the year. It is still available for use the year after. Now suppose corn is commodity number 1, but let there *not* be one commodity called "tractor." Rather, commodity 2 is a new tractor; commodity 3 is a one-year-old tractor; commodity 4 is a two-year-old tractor; and so on. Let us also allow for commodity number 99, which is scrap metal. Let us suppose a tractor falls to bits naturally after three years' use.

If we start from corn and a new tractor as inputs, the outputs (plural!) are output corn and a one-year old tractor. If we start from corn and a one-year-old tractor as inputs, the outputs are .corn and a two-year-old tractor; and from corn plus a two-year-old tractor as inputs, the outputs are corn and scrap metal. We therefore have three *different* activities for producing corn. A moment's thought shows that this distinction between tractors of different vintages, calling them different commodities, is quite realistic. Used tractors can be placed on the market and sold at a price which depends on their vintage. No practical businessman would consider a new machine and a ten-year-old machine, say, as being one and the same commodity.

Nor do the three activities which we have mentioned exhaust all possibilities. By assumption, a tractor falls to pieces and becomes scrap metal after three years' use. But, it may happen that a two-year-old tractor, though usable technically, in so inefficient, so expensive to keep in repair, as to make it economically undesirable

to use it. It is then better to scrap it, i.e., sell it as scrap metal, commodity 99. Thus another possible production process uses corn and a one-year-old tractor as inputs, but produces corn and scrap metal (not a two-year-old tractor) as outputs. Similarly, though less likely, we may wish to scrap even one-year-old tractors for economic reasons. There are therefore five, not three, distinct production activities available for choice (Table 4.1).

Table 4.1

Activity	Input coefficients a_{mi}					Output coefficients b_{mi}				
m	$i=1$	$i=2$	$i=3$	$i=4$	$\ldots i=99$	$i=1$	$i=2$	$i=3$	$i=4$	$\ldots \ i=99$
1	a_{11}	a_{12}	0	0	\ldots 0	b_{11}	0	b_{13}	0	\ldots 0
2	a_{21}	0	a_{23}	0	\ldots 0	b_{21}	0	0	b_{24}	\ldots 0
3	a_{31}	0	0	a_{34}	\ldots 0	b_{31}	0	0	0	\ldots $b_{3,99}$
4	a_{41}	a_{42}	0	0	\ldots 0	b_{41}	0	0	0	\ldots $b_{4,99}$
5	a_{51}	0	a_{53}	0	\ldots 0	b_{51}	0	0	0	\ldots $b_{5,99}$
\ldots										

In this way we have not only accommodated the existence of fixed capital, but also the possibility of choice between retaining a machine another year, or scrapping it. Note that the ability of the general linear technology to handle joint production is essential. A theory incapable of describing joint production, such as the Leontief technology, by that very fact is unable to accommodate fixed capital.[2]

What about production processes which take more than one period to complete? Suppose it takes three years to construct a battleship. We then allow for three different commodities: (a) a one-third completed battleship, produced as a result of the first year's work; (b) a two-thirds completed battleship; and (c) a finished battleship. We require commodity (a) as an input for production of commodity (b), and we require commodity (b) as an input for production of commodity (c). Simple, isn't it? (But, perhaps, a bit artificial: one-third completed battleships are rarely, if ever, traded in a commodity market.)

What about technological progress? This can be included by assuming that the list of activities $m = 1, 2, \ldots, M$ is not final, but new activities may be invented and hence become available for use, as time goes on. This makes the total number of processes a func-

[2] This point has been stressed forcefully by Sraffa (1960).

tion of time: $M = M(t)$.[3] There is no need to remove obsolete processes from the list, since such processes may be run at zero activity level. Although this way of handling technological progress exists in principle, we are not aware of any actual theoretical work making use of this idea. Von Neumann himself developed his theory on the basis of an unchanged technology (all input coefficients, output coefficients, and the number of processes M are constant in time), and his successors have done the same. The inclusion of technological progress appears to us to be a highly interesting avenue for further exploration.

Of course, one pays a price for so much increased generality. To describe any actual economy by von Neumann technology, one needs to allow for a huge number N of distinct commodities (remember the tractors of different vintages!) and an even more enormous number M of distinct activities. This is hardly possible in practice, and thus the theory is very theoretical indeed and is to that extent open to the charge of being impossible to validate empirically. Nonetheless, some very interesting conclusions emerge, and von Neumann theory is generally considered an important step forward in economics.

Finally, let us show just how Leontief technology emerges as a special case, a very special case, of von Neumann technology. To get Leontief technology, assume the following: (a) there are exactly as many activities as there are commodities; i.e., $M = N$; (b) Each activity has one and only one commodity as an output, a different commodity for each activity; by a suitable renumbering, we can ensure that activity number m produces, as its sole output, commodity number $i = m$; (c) We are free to define what we mean by "unit activity level" for each activity; let us use this freedom to declare that unit activity level of process number m results in output of one unit of commodity number $i = m$ (and of nothing else). Under these assumptions the output coefficients b_{mi} of activity m are zero except when $i = m$, and then $b_{ii} = 1$. Since unit activity level results in output of one unit of commodity i, the total output y_i of commodity i is a measure of the activity level z_i of that (one and only) activity $m = i$ by which this commodity can be produced: $z_i = y_i$. The input coefficients $a_{mj} = a_{ij}$ defining the inputs of commodities j necessary to produce a unit amount of commodity i (with unit activity level z_m of process $m = i$) are then exactly the same input-output coefficients which we used in chapter 3.

Note that one simplification possible in Leontief theory is not possible with von Neumann technology: The distinction between

[3] Not necessarily *only* of time; economic factors may influence the rate of invention.

activity levels z_m and commodity outputs y_i cannot be ignored in the general case. Any commodity i may be produced by several activities; an activity may produce several commodities. There is no longer a one-to-one correspondence between output commodities and activities, and hence it is impossible to decide, from knowledge of the commodity output levels, what the various activity levels are. Different combinations of activity levels may result in identical commodity output levels.

B. Conditions for balanced exponential growth

In chapter 3, we defined balanced exponential growth by five conditions, three of them in section 3B, the other two (involving prices and rates of return) in section 3C. Let us now write down the appropriate conditions for von Neumann technology rather than Leontief technology. We write these conditions in a sequence convenient for later on, rather than following the precise sequence of chapter 3.

First of all, the growth condition 1 of section 3B now applies to activity levels z_m, in the first instance. It then follows from linearity that the output levels y_i also grow by the same factor a each year. Our new condition is:

1. All activity levels z_m change with time through the same growth factor a:

$$z_m(t + 1) = az_m(t) \quad \text{all } m = 1,2,\ldots,M \quad \text{and all } t.$$

Next, there is a quantity condition necessary to make continued operation of the economy possible:

2. All inputs needed to run activities in period $t + 1$ must be available at time t, from outputs of the same commodities during the preceding period.

In chapter 3, we imposed the condition (2) that the annual market clears completely. We assert that this condition must be *dropped* for von Neumann technology, since it is impossible to fulfill it. Consider the following example: In the country of Lower Slobbovia, pigs' feet are considered a delicacy. But the Slobbovians have found out that it is impossible to make silk purses out of sows' ears, and as a result the ears of a pig are not at all in demand. However, every Slobbovian pig has four feet and two ears. If enough pigs are raised to satisfy the demand for pigs' feet, then there is an excess supply of pigs' ears on the market, and there is no way of avoiding this.

However, we can say something else: If some commodity, such as pigs' ears, is in consistent oversupply, year after year, then this

commodity must become a free good, fetching zero price in the market. This *"free good"* condition therefore replaces the previous market clearing condition:

3. If the output of commodity i in year t is in excess of the needed productive input of this commodity for production in period $t + 1$, then the price $p_i = 0$.

Next, we turn to conditions involving prices and rates of return. In chapter 3, we demanded that every productive process must give the same rate of return under competitive conditions. This, also, must be revised for general linear technology. What we can still say is that those activities which are actually run with positive activity level z_m must give equal returns. No activity can exist which gives a *higher* rate of return than the standard rate r. But it is entirely possible that there are other activities which, if run, give a *lower* rate of return at prevailing prices, that is, economically inefficient activities. Naturally, these activities will not be run at all (activity level equal to zero) under free competition. But rates of return depend on price levels; one and the same activity, from a technological point of view, may be economically inefficient (and hence not run) at one set of prices, and become economically efficient (earning the standard rate of return r across the economy) at some other set of prices. Our new conditions are therefore:

4. There is a standard rate of return r, and hence a standard return factor $\beta = 1 + r$, across the whole economy. The return offered by any activity m must be no higher than this standard rate, but it may be lower.

5. If an activity m offers a rate of return below the standard rate, then its activity level $z_m = 0$.

Our next two conditions are straightforward:

6. All activity levels z_m are positive or zero (not negative), and at least one activity level is positive.

7. All prices p_i are positive or zero (not negative), and at least one price is positive. Furthermore, we assume that all prices are constant in time.

This finishes the list of formal conditions for balanced exponential growth. However, we emphasize that there is a "hidden" condition here, which we now make explicit, namely, the condition of *perfect thrift*:

8. All outputs from production in year t are available as productive inputs for activities in year $t + 1$. That is, there is no discretionary consumption at all. All surplus production is invested.

Where does this condition come in? It comes into our "balance condition" 2: If there exists some discretionary (as opposed to strictly necessary) consumption, then outputs from year t must be

enough to cover not only all the inputs needed for productive activities in year $t + 1$, but also all ultimate consumption in year $t + 1$. Equally, perfect thrift enters into condition 3: If commodity i is in excess of the needed productive input of this commodity for period $t + 1$, but the entire excess is used up in ultimate consumption, then there is no net excess, and the price need not drop to zero.

We remarked, in chapter 3, that the growth condition 1 with actual growth (growth factor in excess of unity) cannot be maintained forever, because of various natural limitations to indefinite growth. But now note also that condition 1 is most unlikely to happen if there is technological progress, i.e., if new activities m become available as time goes on. Condition 1 requires, inter alia, that a process m not used at time $t = 0$ is never used thereafter.

C. The growth theory of von Neumann

At this stage, we have a clearly defined mathematical problem: Given a set of activities $m = 1,2, \ldots ,M$ with known input coefficients a_{mi} and known output coefficients b_{mi}, all nonnegative, is it possible to find real positive numbers for the growth factor a and the return factor β, nonnegative initial activity levels $z_m(0)$ at time $t = 0$, and prices p_i, such that conditions 1 to 7 are all satisfied; and if it is possible, what can we say about the solution?

When the problem is stated in this form, the answer is simple and straightforward, but disappointing: No!

The reason is that we have not imposed any conditions at all to ensure that our input and output coefficients are "reasonable." As a result, we have allowed the possibility of complete nonsense:

a. All a_{mi} nonnegative allows *all* the a_{mi} to be zero. This means everything can be produced from nothing.

b. Conversely, all b_{mi} nonnegative allows *all* the b_{mi} to be zero. In that case, the entire economy is incapable of producing anything at all, and everyone starves to death.

We conclude that, both from an economic point of view and from a mathematical point of view, it is essential to impose further conditions on the a_{mi} and b_{mi} coefficients. In his paper, John von Neumann assumed (von Neumann 1945, equ. 9):

N.
Every production process m involves every commodity i, either as a necessary input or as a produced output, or both. (Mathematically, for each m and each i, either a_{mi} is positive or b_{mi} is positive, or both are positive.)

We intend to discuss this condition at considerable length later on. For now, let us quote von Neumann's own justification for imposing this condition: "Since the a_{mi} and b_{mi} may be arbitrarily small this restriction is not very far-reaching." That is, he asserts that it cannot make much difference whether we require some exceedingly tiny quantity of some commodity i as an input to activity m, or no input at all of i. If you don't like to fiddle with the inputs, then what about outputs? Surely, he says, it cannot matter much whether an activity produces no output at all of commodity i, or some 0.0000000000001 quantity of that commodity.

We shall return to this argument subsequently; for now, let us state the mathematical conclusions which von Neumann reached, starting from assumptions 1 to 7 together with assumption N. These conclusions are:

N1.
An exponential growth solution does exist (i.e., at least one; there may be several distinct solutions).

N2.
All solutions, though perhaps differing in relative activity levels, must have exactly the same growth factor a and the same return factor β. Furthermore, for all of them $a = \beta$.

N3.
The unique growth factor a of these solutions is also the maximum possible growth factor on technological grounds alone: If we ignore all conditions involving prices and rates of return (conditions 3, 4, 5, and 7) and restrict ourselves to conditions 1, 2, and 6 only, then there are many possible growth factors a satisfying these conditions; but the largest growth factor of all these precisely equals the (unique) $a = \beta$ when *all* conditions must be satisfied. Thus, competition results in maximum growth.

N4.
The unique return factor β (which equals a) is also the minimum possible return factor in conditions of competition. That is, if we ignore all conditions involving activity levels (conditions 1, 2, 3, 5, and 6) and restrict ourselves to conditions 4 and 7 only, then there are many possible return factors β satisfying these conditions; but the smallest return factor of all these precisely equals the (unique) $\beta = a$ when *all* conditions must be satisfied. Thus, the balanced growth solution results in a minimum rate of return, which exactly equals the maximum growth rate.

These conclusions are surprisingly definite and sharp. With all the choices of activities available in the general linear technology,

it is astounding that one should arrive at the statement that there is only one, uniquely determined, growth factor. There is no caviling at the mathematical truth of von Neumann's theorems; not only was he a professional mathematician of the highest caliber, but other mathematicians have checked through his work and have provided alternative proofs of the same theorems (Gale 1956, Karlin 1959, Kemeny 1956). We must accept that von Neumann's assumptions lead logically to his theorems.

But do we have to accept the assumptions, in particular assumption N? We shall now give arguments to show that assumption N is "very far-reaching" indeed, so much so that *assumption N cannot be accepted by economists.*[4]

1. Assumption N excludes choices of the first importance. For example, we may produce energy from coal or from oil. The processes involved in the coal option (coal mining, construction and use of coal-fired engines, etc.) need not involve the commodity oil either as an input or as an output; and vice versa. But assumption N insists that every commodity, including oil, be involved in *every* activity. Thus assumption N is inconsistent with any real choice between coal and oil.

2. Assumption N destroys von Neumann's method of allowing for fixed capital. The process ($m = 1$ in the table in section A) which uses corn and new tractors to produce as outputs corn and one-year-old tractors does *not* involve the commodity "two-year-old tractors" either as an input or as an output. Furthermore, the existence of two alternative processes, $m = 2$ and $m = 5$ in the table, one of which outputs scrap iron rather than two-year-old tractors, means that two-year-old tractors need never be produced at all. This is inconsistent with assumption N.

There is a world of difference between "arbitrarily small" positive amounts of a commodity, and exactly zero. A strict zero allows *choices* (do not produce any oil at all; scrap tractors after two years' use) which are forbidden when there are nonzero coefficients, no matter how small those coefficients might be.

The very definite results of von Neumann are due to his inhibiting and economically unacceptable assumption N. There is no reason to think that the same results hold for more realistic assumptions about economic life.

D. The growth theory of Kemeny, Morgenstern, and Thompson (perfect thrift)

The work of Kemeny, Morgenstern, and Thompson (Kemeny

[4] Assumption N is rejected generally nowadays; but argument 2, in particular, is new.

1956) has replaced assumption N by a more reasonable set and shows what can, and what cannot, be said with more realistic assumptions. There are two aspects of the KMT (as we shall refer to it henceforth) paper:

1. The von Neumann assumption N is replaced by a set of assumptions which are much less restrictive.

2. KMT also attempt to include ultimate, discretionary consumption into growth theory, i.e., to remove condition 8, the condition of "perfect thrift."

In this chapter we discuss the KMT theory without consumption, i.e., we retain condition 8; growth theory with consumption, including the KMT treatment of that theory, is discussed in chapter 6.

The new conditions, which replace condition N of von Neumann, are:

KMT1: Every productive activity m requires at least one positive input; i.e., there is at least one commodity i such that $a_{mi} > 0$, for each m.

KMT2: Every commodity i in the system can be produced by at least one activity; i.e., for each i, there exists at least one activity m such that $b_{mi} > 0$.

KMT3: At least one commodity i produced in nonzero amount by the economy must carry a nonzero price (this condition excludes "noneconomic" solutions in which *all* goods produced within the economy are free goods).

It is clear that these three assumptions, unlike assumption N, are reasonable from an economic point of view. Indeed, they look rather like being too mild and "harmless" to obtain any results at all.

Fortunately, this is not the case. KMT show that the following, very interesting, results follow from these conditions together with conditions 1 to 8 of section B:

K1. Exponential growth solutions do exist (i.e., at least one; there may be several distinct solutions).

K2. Each solution has a growth factor a and a return factor β which must be equal to each other: $a = \beta$. However, different solutions may correspond to different growth (and return) factors. For example, we may get one growth factor when using the coal option, another when using the oil option.

K3. Denote the possible values of $a = \beta$ by an index, i.e., a_1

,

a_2, \ldots, a_k. Then k must not exceed the number of commodities in the system (N) nor must it exceed the number of processes in the system (M); i.e., $k \leqslant N$ and $k \leqslant M$. (Typically, in a highly connected economic system there will be only a few distinct solutions; the von Neumann assumption N represents an extreme degree of interconnection; in that case, $k = 1$.)

K4. For each permitted solution, there exists a subeconomy (containing certain commodities but not some others, and using certain activities m but not some others) which can exist by itself and which, taken on its own, has just this one solution as the only possible rate of growth.

K5. If we ignore all conditions involving prices and rates of return (conditions 3, 4, 5, and 7) and restrict ourselves to conditions 1, 2, and 6 only, then there are many possible growth factors a satisfying these conditions. But the largest growth factor of all these equals the largest of the permissible values of $a = \beta$ in K2.

K6. If we ignore all conditions involving activity levels (conditions 1, 2, 3, 5, and 6) and restrict ourselves to conditions 4 and 7 only, then there are many possible return factors β satisfying these conditions. But the smallest return factor among all these equals the smallest of the permissible values of $a = \beta$ in K2.

Comparing these results with the results N1 to N4 obtained by von Neumann, we see clearly that N1 and K1 agree; K2, K3, and K4 together generalize N2; K5 generalizes N3; and K6 generalizes N4.

Though less definite and compelling, the KMT results are much more reasonable from an economic point of view. The existence of different possible rates of growth (and of return) must be expected once the technology of an economy permits a real choice. Result K3 is still quite strong, since one might have expected a continuous range of possibilities for the growth factor, whereas actually there are only a finite number (less than either N or M) of possibilities. On the other hand, *K5 and K6 destroy the "optimality" implications of the von Neumann theory:* Solutions which grow more slowly than the technological maximum growth rate are now possible; so are solutions with a rate of return higher than the economically possible minimum rate of return. Indeed, if k in K3 exceeds unity, then *no* solution provides *both* maximum possible growth and minimum possible rate of return!

One very strong result is retained, however, in the KMT theory, namely, the *equality of the rate of growth and the rate of return.* The rates themselves are not determined uniquely any more, but

in each solution we have $a = \beta$. From this point of view, the rate of return to capitalists may be considered as their "reward" for producing economic growth (though *not* their reward for "waiting" or "abstaining"—everyone else abstains, too, under the perfect thrift assumption). It is important, however, that the result $a = \beta$ depends on the "perfect thrift" assumption. It is no longer true once there is consumption (see chapter 6).

E. Some qualitative points

We conclude our survey of growth theory in the absence of ultimate consumption by listing a number of points about the von Neumann and KMT theories, following largely the excellent paper by D. G. Champernowne (1945).

1. The von Neumann model is a "slave economy" in which workers obtain bare subsistence and capitalists reinvest everything they get. To quote Sir John Hicks (1965): "It is a war mentality, a Stalinist mentality, and one may be forgiven for finding it distasteful."

2. Limitations of natural resources, land, etc., make an indefinitely expanding state impossible. Stationary or contracting states may exist, but on the theories discussed so far, such states do not yield a positive rate of return (since rate of return = rate of growth).

3. The treatment of consumption requires an extension of the model. This may well change the results significantly. We shall see that this prediction by Champernowne has turned out to be fully correct.

4. More realistic economic assumptions, such as non-constant returns to scale, existence of monopolies and/or oligopolies, existence of nonproducible goods, etc., all tend to make the mathematical problem much more difficult, and possibly insoluble.

5. The assumption of constant prices destroys all "monetary" considerations in this theory. Does inflation inhibit growth or stimulate growth? In the von Neumann theory, we have no way of even asking the question.

6. Suppose a growth equilibrium with $a = \beta$ exists. How long does an economic system take to come close to this equilibrium? Does it tend to approach equilibrium at all? If there are several different solutions, as in the more realistic KMT theory, which of these, if any, is approached? Which of them, if any, is stable with respect to small disturbances, for example, the disturbance introduced by a new invention?

7. How does "labor" fit into this whole picture? Can the the-

ory be extended to allow for wages higher than a bare subsistence minimum?

8. The "Stalinist mentality" noted by Sir John Hicks is most definitely noticeable in the literature on these growth theories. In particular, there is much discussion of "turnpike theorems," which are related to "optimal programs of capital accumulation." We defer discussion of this part of the literature to later chapters, since in any balancing between growth and consumption, one must first have a theory which allows for consumption. But we note for now that "optimal programs" of anything demand that there be an agreed-upon idea of what is best, and an agency, such as a five-year planning authority, with the power to make economy-wide plans and enforce them. This is more typical of totalitarian than of democratic states.

9. Many of the preceding points have had a critical flavor. It would be highly unfair to conclude on such a note. The von Neumann work is a great achievement of mathematical model building in dynamic economics. It is the best available theory of capital and of the rate of return. The intimate relationship between the rate of growth and the rate of return, which emerges from this theory, is a highly interesting and important result.

F. Mathematical appendix

We start from activities $m = 1, 2, \ldots, M$, activity levels $z_m \geqslant 0$, commodities $i = 1, 2, \ldots, N$, and prices $p_i \geqslant 0$. For each process m, we have input coefficients $a_{mi} \geqslant 0$ and output coefficients $b_{mi} \geqslant 0$. We now write down the mathematical forms of all the conditions in section B, in sequence:

1. $z_m(t + 1) = az_m(t)$ for $m = 1, 2, \ldots, M$ (4.1)

From now on, $z_m(t)$ will be called simply z_m; if the activity level at any time other than time t is wanted, we shall use condition 1 to write it in terms of z_m. All $z_m \geqslant 0$ and at least one $z_m > 0$ for acceptable solutions. Condition 2, together with "perfect thrift" (condition 8) can be written as follows (we give the equation first, and the explanation below it):

2. $\displaystyle\sum_{m=1}^{M} z_m b_{mi} \geqslant a \sum_{m=1}^{M} z_m a_{mi}$ all $i = 1, 2, \ldots, N$ (4.2)

Explanation: The sum on the left-hand side is y_i, the total output of commodity number i at the end of year number t. Without the factor a, the sum on the right-hand side is x_i, the total required input at these activity

levels, of commodity number i. The factor a makes the activity levels correct for time $t + 1$. If all commodity outputs from year t are available to be used as productive inputs for year $t + 1$ (this is the "perfect thrift" condition, condition 8), then the above condition must be satisfied, thereby ensuring that enough of commodity i is available in the market at time t, to start productive activities in period $t + 1$.

For the reasons explained in the chapter, we must permit the possibility of excess production of some commodities; however, such commodities become free goods, condition 3:

3. If, for some i, there is strict inequality in (4.2),
$$\text{then } p_i = 0. \tag{4.3}$$

Next, we turn to the condition that no activity m can earn more than the standard rate of return r; we write this condition in terms of the return factor $\beta = 1 + r$; and we figure the return factor for unit activity level $z_m = 1$, which is permissible because of our basic assumption of constant returns to scale in all production processes. The money output from an activity is obtained by multiplying each output level b_{mi} (for $z_m = 1$) by the unit price p_i of commodity i, and summing over i. The money input cost of this same activity, at unit activity level, is obtained by multiplying each input level a_{mi} by the unit price p_i of commodity i, and summing over all i. Condition 4 therefore becomes:

$$4. \qquad \sum_{i=1}^{N} b_{mi} p_i \leqslant \beta \sum_{i=1}^{N} a_{mi} p_i \quad \text{all } m = 1, 2, \ldots, M \tag{4.4}$$

Condition 5 states that activities earning less than the standard rate of return are not run, i.e., are run at zero activity level:

5. If, for some m, there is strict inequality in (4.4),
$$\text{then } z_m = 0. \tag{4.5}$$

Finally, conditions 6 and 7 ensure that not everything is zero:

6. For all m, $z_m \geqslant 0$; and for at least one m, $z_m > 0$. (4.6)

7. For all i, $p_i \geqslant 0$; and for at least one i, $p_i > 0$. (4.7)

These are the mathematical forms of the conditions for balanced growth with general linear technology and perfect thrift. We now turn to the additional conditions imposed in the von Neumann and the KMT theories.

The von Neumann condition N takes the following mathematical form:

N.
$$a_{mi} + b_{mi} > 0 \quad \text{all } m = 1, 2, \ldots, M$$
$$\text{and all } i = 1, 2, \ldots, N \tag{4.8}$$

This condition leads to the results stated in section C, but is unacceptable economically, as discussed in section C.

The economically acceptable assumptions of the KMT theory are, in mathematical form:

KMT1: For each m, there exists a value of i
 such that $a_{mi} > 0$ (4.9)

KMT2: For each i, there exists a value of m
 such that $b_{mi} > 0$ (4.10)

KMT3: Value of entire output = $\displaystyle\sum_{i=1}^{N} \sum_{m=1}^{M} z_m b_{mi} p_i > 0$ (4.11)

The intuitive meaning of KMT1 and KMT2 was given in section D; the mathematical form of KMT3, given here, means that the entire economic value of the gross output of the economy must not be zero. This can happen if and only if at least one commodity i which is output in nonzero quantity also has a nonzero price; and that is the form of KMT3 stated in section D, which is therefore equivalent to (4.11).

The mathematical proof of the KMT results listed in section D is well beyond the mathematical level of this book. We refer to Gale (1956) for a rather neat proof which uses mainly algebraic methods. We must warn, however, that Gale's proof makes use of the theory of convex spaces, in particular the Hahn-Banach separation theorem, which may be unfamiliar to economists.

The von Neumann condition N leads to one unique solution for $a = \beta$; the KMT conditions permit several solutions, in general. The question arises just what is necessary and sufficient to ensure exactly one solution for $a = \beta$. This question has been answered fully, by Jaksch (1977). The Jaksch condition is less restrictive than the von Neumann condition N; but it is harder to state (we shall not state it here) and is very unlikely to be obeyed in any realistic economic system.

Von Neumann theory has led to many papers of a purely mathematical nature, in which the theory is generalized from a mathematical (but usually not from an economic) point of view. The reader interested in such developments may be referred to the collection of Loś (1976), the paper by Van Moeseke (1980), and references contained therein.

The open Leontief model

In this chapter, we take the first step in removing the unreasonable restriction to "perfect thrift" which we have imposed heretofore. We now wish to allow for *discretionary consumption* levels c_i of commodity i within the theoretical model.

In principle, this could be done in a single step, starting from growth theory with von Neumann technology (i.e., from the most general case). We prefer, however, to proceed at a somewhat slower pace, so as to take one difficulty at a time. The resulting theory is a theoretical version of a very well-known and useful method in applied economics, called Leontief input-output analysis. (The relationship between our theoretical version and the practical technique is discussed in section D.) The basic simplifications adopted in this chapter are two:

1. We use Leontief technology (section 3A) rather than von Neumann technology.

2. We assume a steady state (i.e., no growth); all production and consumption levels are constant in time; all of the surplus, and no more than that, is used for consumption rather than for net investment. Formally, in terms of the growth factor a of chapters 3 and 4, we insist that a be equal to unity.

These are strong assumptions, and they greatly limit this theory's range of applicability. But the resulting, much simpler, theory can serve as an easy introduction to the more complicated growth theory in the presence of consumption. Furthermore, already in this simple case of a steady state, some new and surprising results emerge.

Section A presents standard material and can therefore be read quickly by advanced students. However, such students should not skip the discussion of our differences with the neoclassical ap-

proach, at the beginning of section A. By contrast, sections B and C are new and not to be found in the literature. We define a "discretionary consumption good" as a commodity which need not be produced at all under perfect thrift conditions. We then show that the presence of such goods alters the mathematical nature of the input-output matrix, making it "reducible." This in turn gives rise to a new type of solution, the "peculiar solutions," in which all necessary goods are free goods. Furthermore, there are cases in which the *only* solutions to the system are of this "peculiar" type.

A. Consumption under steady-state conditions

As our first example we take an economy with just two commodities, corn and iron, and with the same production technology as in chapter 3 (see the table on p. 34).

The new thing is that now we allow for a consumption demand for c_1 quarters of corn and c_2 tons of iron, demands over and above the requirements for productive inputs for the next production period.

This is the point at which we part ways with the neoclassical approach. In neoclassical theory, consumption demands c_i [or $c_i(t)$ in growth theory] are *not* taken as *given* quantities. Rather, the c_i terms are *derived* quantities, determined by maximization of a social utility function $U(c_1, c_2, \ldots, c_N)$, subject to the constraints arising from what can be produced with given input resources. The resulting mathematical problem is then quite complicated. However, one can think of this problem as divided into two separate portions or steps:

1. For a *given* set of consumption demands, we need to determine the required input quantities, required total production levels, and the market-clearing prices. This is the problem discussed in the present chapter.

2. *After* step 1 has been completed, for all possible sets of consumption levels, one can then proceed to assign a social utility $U(c_1, c_2, \ldots, c_N)$ to each of the possible consumption patterns, and one may then search for that pattern which maximizes utility. We do *not* discuss step 2 in this chapter, for the following reasons:

a. If utility "determines" consumption demands, what determines utility? The difficulty is not removed merely by pushing it one step further back, especially not if this step involves replacing a simple assumption (given consumption demands) by a very much more complicated assumption (given utility function).

b. The concept of a "social utility function" has severe difficulties, some of which are discussed later on, in section 15E. At a

minimum, no one has ever succeeded in giving an operationally meaningful definition of U.

c. In growth theory (chapter 6) additional difficulties arise, from consumption in the future. If future consumption is ignored, one gets silly results (consume everything right now, with no thought for the future). Thus, future consumption must be included in U. Yet, the future is uncertain and unknown. Neoclassical growth theory usually assumes perfect certainty of the future! This has little relationship to reality.

d. Usually, neoclassical growth theories introduce "capital" as an explicit input. This procedure runs up against the Cambridge controversy (Robinson 1954, Harcourt 1972), of which the outcome has been that it is impossible to give a consistent definition of a "quantity of capital" independent of prices and the rate of return.

For all these reasons, and some additional ones to which we come later, the neoclassical procedure rests on an entirely inadequate foundation. For descriptions of these theories, see for example Morishima (1964, 1969) and Wan (1971). We do not present such theories here, but restrict ourselves to step 1 above. Note that if step 1 fails to yield a sensible solution, then so does the neoclassical approach, of necessity, since then step 2 cannot even be started.

To return to our example, to produce y_1 quarters of corn next period, we require as inputs $0.9y_1$ quarters of corn and $0.05y_1$ tons of iron. Note that (by assumption) all inputs and all outputs are constant in time. In a steady state, we need not append a time variable t to y_1, or to any other quantity.

Similarly, to produce y_2 tons of iron next period, we need as inputs $0.6y_2$ quarters of corn and $0.2y_2$ tons of iron.

The previous period's output of corn, itself equal to y_1 in the steady state, must be enough to meet the sum of these productive input needs, $0.9y_1 + 0.6y_2$, *as well as* the consumption demand for corn c_1. A similar statement holds for the previous period's output of iron, again equal to y_2 in a steady state. The balance conditions therefore read:

$$y_1 \geqslant 0.9y_1 + 0.6y_2 + c_1$$
$$y_2 \geqslant 0.05y_1 + 0.2y_2 + c_2$$

We have allowed for possible overproduction of one or both of these commodities; i.e., we have *not* assumed strict equality of supply (left-hand side) and demand (right-hand side) from the start, merely the condition that the supply must be large enough to cover all demands. However, under steady-state conditions any

commodity which is in persistent oversupply, year after year, becomes a free good; i.e., its price drops to zero. Thus the full "quantity" conditions are:

$$y_1 \geqslant 0.9y_1 + 0.6y_2 + c_1 \quad \text{If strictly greater, then } p_1 = 0$$
$$y_2 \geqslant 0.05y_1 + 0.2y_2 + c_2 \quad \text{If strictly greater, then } p_2 = 0$$

The second set of conditions involves prices and rates of return. There exists, under free competition, a standard rate of return r, and hence also a standard value of the return factor $\beta = 1 + r$, for all productive activities which are actually pursued by entrepreneurs.[1] No productive activity can give promise of a higher return factor. Any activity which yields less than this return factor is ignored by entrepreneurs; i.e., the corresponding activity level drops to zero. For the postulated input-output table, these conditions become:

$$p_1 \leqslant \beta(0.9p_1 + 0.05p_2) \quad \text{If strictly less, then } y_1 = 0$$
$$p_2 \leqslant \beta(0.6p_1 + 0.2p_2) \quad \text{If strictly less, then } y_2 = 0$$

It is important to note that these conditions, unlike the quantity conditions given earlier, are *unaffected* by the existence of demands for ultimate consumption; i.e., the consumption demands c_1 and c_2 do not appear at all in the price conditions. The point is that a producer, when figuring his rate of return on sales, does not care at all to whom he makes the sale, to another producer or to an ultimate consumer. A ton of iron sold is just that, no matter to whom it is sold. The same price is charged, under free competition, to all buyers, no matter what they want to use the iron for.

In the absence of ultimate consumption, i.e., when $c_1 = c_2 = 0$, there is considerable symmetry between the quantity conditions and the price conditions. But this symmetry disappears in the presence of ultimate consumption.

We have now written down the entire set of conditions for the open Leontief model, for our simple example. The discretionary consumption demands c_1 and c_2 are taken to be given amounts, determined from outside the system by factors, such as consumer preferences, whose description does *not* form part of the mathematical system. Such variables determined from "outside" are

[1] We assume that entrepreneurs purchase all inputs in advance of production and receive a return, at rate of return r, for providing this working capital. As a result, the "value added" by industry i equals this common rate of return r, multiplied by the total of all input costs. For this reason, our theoretical input-output table has no "value added" row. For the reasons outlined on page 34 the theoretical table also has no "labor input" column. In both these respects, it differs from the "practical" input-output tables discussed in section D.

called *exogenous* variables. We claim that, once c_1 and c_2 are given, everything else significant about the system is determined completely and uniquely. This includes: the production levels y_1 and y_2, the return factor β, and the price ratio $P_1 = p_1/p_2$.

We now proceed to give a proof of this assertion. By assumption, at least one consumption demand must be nonzero. Let us assume this to be true of c_1 (a similar argument goes through if $c_1 = 0$ but $c_2 > 0$). With $c_1 > 0$, the quantity inequality for y_1 implies $y_1 \geqslant c_1 > 0$; hence $y_1 > 0$. The quantity inequality for y_2 then implies: $y_2 \geqslant 0.05y_1 > 0$; hence $y_2 > 0$. Thus *both* corn and iron must be produced in nonzero amounts in order to meet a nonzero consumption demand for corn. Considering that iron is needed to produce corn, this is not surprising.

Next, let us look at the price inequalities. *If* there is strict inequality for p_1, *then* $y_1 = 0$. But we know, from the preceding argument, that y_1 is *not* zero. Hence there cannot be strict inequality for p_1; the only remaining possibility is equality. The same argument goes through for p_2, and we are left with the *equations*:

$$p_1 = \beta(0.9p_1 + 0.05p_2)$$
$$p_2 = \beta(0.6p_1 + 0.2p_2)$$

If we divide the first of these by the second, the return factor β drops out, and we obtain:

$$p_1/p_2 = (0.9p_1 + 0.05p_2)/(0.6p_1 + 0.2p_2)$$

In terms of the price ratio $P_1 = p_1/p_2$, this assumes the form:

$$P_1 = (0.9P_1 + 0.05)/(0.6P_1 + 0.2)$$

Hence

$$0.6P_1^2 + 0.2P_1 = 0.9P_1 + 0.05$$

whence

$$0.6P_1^2 - 0.7P_1 - 0.05 = 0$$

This equation is *identical* with the one we obtained in section 3C for the Leontief model with growth but no consumption. We conclude that *prices and rates of return are unaffected by the presence of consumption demands*, in this simple case at least. The results, which we copy from section 3C, are:

$$P_1 = p_1/p_2 = 1.23419 \qquad \beta = 1 + r = 1.06325$$

No other price ratio, and no other return factor, can satisfy the conditions of the model.

Furthermore, at this stage, we can say more about the produc-

tion quantities y_1 and y_2 than merely that they are nonzero. With a price ratio which is positive, both prices p_1 and p_2 must be separately positive; i.e., neither price can be zero. Now look at the quantity condition for y_1. *If* there should be strict inequality in that condition, *then $p_1 = 0$*. But we know now that p_1 is *not* zero. Hence there must be strict equality for y_1, and, by a similar argument, also for y_2. We therefore get a set of two *equations* for the two unknowns y_1, y_2, in terms of the (assumed known) consumption demands c_1 and c_2:

$$y_1 = 0.9y_1 + 0.6y_2 + c_1 \qquad y_2 = 0.05y_1 + 0.2y_2 + c_2$$

Putting all unknowns on the left-hand side yields:

$$0.1y_1 - 0.6y_2 = c_1 \qquad -0.05y_1 + 0.8y_2 = c_2$$

Multiply the second of these equations by 2, and add that to the first equation. The result is: $0 + y_2 = c_1 + 2c_2$, thus determining y_2. Substitute this result into either of the two original equations, and solve for y_1. The outcome is:

$$y_1 = 16c_1 + 12c_2 \qquad y_2 = c_1 + 2c_2$$

At this stage we have proved our original assertion that everything of significance about this system, i.e., all of y_1, y_2, β, and $P_1 = p_1/p_2$, can be determined completely and uniquely, once the consumption levels c_1 and c_2 have been specified. In spite of the apparent freedom provided by the presence of inequalities, rather than equations, in the basic conditions for quantities and prices in this model, it is nevertheless true that there exists only one, unique solution, and in that solution all the inequalities become equations.

It is of supreme importance to note something else as well: The very fact that we have been able to obtain a solution with growth factor $a = 1$ and return factor $\beta = 1.06325$ proves that *the equality $a = \beta$ of von Neumann and KMT growth theory is no longer correct in the presence of consumption*. We shall investigate, in chapter 6, what can be said about the relationship between a and β once there is consumption. But the special case $a = 1$ which we have just investigated is enough to act as a counterexample to any assertion that a and β must always be equal to each other. (The fact that we are using Leontief technology does not alter the logic of the argument, since Leontief technology has been shown, in section 4A, to be a special case of von Neuman technology.)

The main results of this section are:

1. With Leontief technology and given consumption demands, all price ratios are the same as for the "perfect thrift" system of

chapter 3. Thus, consumption levels have no effect on relative prices.

2. Quantities produced, and input quantities needed for this production, are affected by the need to meet consumption demands.

B. Discretionary consumption goods and peculiar solutions

There is an important respect in which our simple example of section A is *too* simple and thereby hides certain complexities of the real situation.

In that example, the commodities (corn and iron) for which we assumed the existence of an ultimate consumption demand are both themselves *necessary* commodities, if the economy is to survive at all. It is of course quite true that an ultimate consumption demand, over and above minimum subsistence, can exist for such commodities. But it is quite false to say that *all* discretionary consumption demands are of this type.

On the contrary, discretionary consumption demands may exist for some commodity, such as the "velvets" of Ricardo (1821, p. 196) or the "multitude of dogs and horses" of Smith (1776, p. 329), which need not be produced at all merely to keep the economy going and would not in fact be produced in an economy aiming for maximum growth to the exclusion of every other consideration.

We shall define a *discretionary consumption good*, abbreviated as DCG hereafter, as a commodity which is not needed, on technical grounds, to keep the economy operating. All DCG's are "nonbasics" in the sense of Sraffa (1960), but some nonbasics are not DCG's. The simple example of section A lacked a DCG.

Let us now introduce into our system a third commodity, which will be a DCG. This third commodity is *not* an input to production of either corn or iron, but corn and/or iron is needed to produce the DCG. Let us assume, for the sake of definiteness, that in order to produce one unit (whatever this may be) of the DCG we need the following inputs: 0.1 quarters of corn, 0.02 tons of iron, and an amount a_{33} of the DCG itself. If the DCG is "velvets," then $a_{33} = 0$; that is, one does not require an input of velvets in order to produce velvets. But a_{33} becomes nonzero when the DCG is a "multitude of dogs and horses." We shall write our conditions in terms of the general a_{33} and substitute particular values of a_{33} at a later stage; this saves tedious repetition of what are nearly the same equations, when a_{33} is given a different value.

The input-output table of coefficients now takes the form:

Corn		Iron		DCG		Output
0.9	+	0.05	+	0	⟶	1 quarter corn
0.6	+	0.2	+	0	⟶	1 ton iron
0.1	+	0.02	+	a_{33}	⟶	1 unit of DCG

Let us recall the discussion in section 3B of "irreducible," "fully reducible," and "reducible" input-output tables. The table given here is *not* "fully reducible," since the commodities cannot be divided into two sets which are independent of each other. But the table is also *not* "irreducible": This would mean that *every* commodity in the table is a necessary input, directly or indirectly, for the production of every other commodity as well as for its own production. This statement is true for corn and for iron, but false for the DCG. The DCG may be needed for production of itself (if a_{33} is nonzero) but is not needed either directly or indirectly for the production of corn or of iron. Thus, *discretionary consumption goods show themselves mathematically through producing a reducible input-output table, reducible but not fully reducible.*[2]

Like all input-output coefficients, a_{33} must not be negative. But there is another restriction on the possible values of a_{33}: This coefficient cannot be larger than unity, or even equal to unity.[3] Otherwise, the economy cannot be maintained in a steady state, since it takes more than one unit (or exactly one unit) of the DCG to produce one unit of the DCG. With "more than," production quantities y_3 of the DCG have to go down year after year. With "exactly one," we shall see that we also get into difficulties. Thus, the permissible values of a_{33} are restricted by: $0 \leqslant a_{33} < 1$.

At this stage, we can write down the quantity conditions and the price conditions of the open Leontief model for this input-

[2] It is most unfortunate that some economists have allowed themselves to be influenced, and misled, by considerations of mathematical convenience. Irreducibility is convenient but is economically unacceptable.

[3] The same restriction also applies to a_{11} and a_{22}.

output table. The arguments are exactly as in section A and need not be repeated. The results are:

Quantity conditions

$$y_1 \geqslant 0.9y_1 + 0.6y_2 + 0.1y_3 + c_1$$
If strictly greater, then $p_1 = 0$

$$y_2 \geqslant 0.05y_1 + 0.2y_2 + 0.02y_3 + c_2$$
If strictly greater, then $p_2 = 0$

$$y_3 \geqslant 0 + 0 + a_{33}y_3 + c_3$$
If strictly greater, then $p_3 = 0$

Price conditions

$$p_1 \leqslant \beta(0.9p_1 + 0.05p_2 + 0) \qquad \text{If strictly less, then } y_1 = 0$$
$$p_2 \leqslant \beta(0.6p_1 + 0.2p_2 + 0) \qquad \text{If strictly less, then } y_2 = 0$$
$$p_3 \leqslant \beta(0.1p_1 + 0.02p_2 + a_{33}p_3) \qquad \text{If strictly less, then } y_3 = 0$$

We assume that there is a demand for the DCG (i.e., that $c_3 > 0$) and that the coefficient a_{33} is within the permissible range, $0 \leqslant a_{33} < 1$; and we wish to find the possible solutions (if any) to this system. We shall go as far as we can while keeping the coefficient a_{33} general and insert numbers for a_{33} only at the end.

With $c_3 > 0$, the quantity condition on y_3 implies $y_3 \geqslant c_3 > 0$; hence $y_3 > 0$. Then the quantity condition for y_1 implies $y_1 \geqslant 0.1y_3 > 0$; hence $y_1 > 0$. The quantity condition for y_2 implies $y_2 \geqslant 0.02y_3 > 0$; hence $y_2 > 0$. Thus, finally, all three production levels y_i must be positive, not zero.

But then, by the same argument as before, all three price conditions must be satisfied with *strict equality*, i.e., as equations. For later convenience, we introduce the reciprocal of the return factor $\beta = 1 + r$ through:

$$s = 1/\beta = 1/(1 + r)$$

The price *equations* then assume the form:

$$0.9p_1 + 0.05p_2 + 0 = sp_1$$
$$0.6p_1 + 0.2p_2 + 0 = sp_2$$
$$0.1p_1 + 0.02p_2 + a_{33}p_3 = sp_3$$

In mathematical terminology, s is an eigenvalue of the input-output matrix, and the three prices (p_1, p_2, p_3) form a right eigenvector of the matrix.

We can obtain a solution to this system by a very simple process: Ignore the third equation altogether! The first two equations, taken by themselves, are exactly what we wrote down for prices in

section A, except for the use of $s = 1/\beta$ instead of β. Thus the same solution applies, namely $p_1/p_2 = 1.23419$, $\beta = 1.06325$, and hence $s = 1/\beta = 0.94051$. Having these numbers at our disposal, we can now also solve the third of the price equations. We write this third equation in the form (dividing by p_2 throughout):

$$0.1p_1/p_2 + 0.02 = (s - a_{33})p_3/p_2$$

At this stage, we shall specialize to a particular value of the coefficient a_{33} in the input-output matrix, namely to the one appropriate for "velvets," $a_{33} = 0$. With the given values of s and p_1/p_2, we then obtain:

$$p_3/p_2 = (0.1p_1/p_2 + 0.02)/(s - a_{33}) = 0.15249 \quad \text{for } a_{33} = 0$$

Since both price ratios p_1/p_2 and p_3/p_2 are positive numbers, all three prices must be separately positive. The quantity conditions must then be satisfied with strict equality, for all three quantities y_i. This means that there are three equations in the three unknown quantities, and these three equations lead to one, unique solution for all quantities. We shall not write down the answers explicitly here.

The solution which we have now obtained is perfectly sensible from an economic point of view. The necessary goods, corn and iron, sell at exactly the same prices as before, and the return factor β is exactly the same as before. All these are determined by the conditions for the necessary commodities only. The price of the DCG (of velvets) is then determined by the input cost together with the standard rate of return. For all three goods, the quantity conditions must be satisfied with equality; i.e., no good is produced in excess of total demand, and the resulting production levels y_i are determined uniquely by that condition. So far, we seem to have discovered nothing whatever that is new.

However, we have obtained *one* solution to the price equations. Is it the only solution, or are there other solutions? We assert that one other solution does exist and has some awfully peculiar properties from the point of view of an economist. This other solution is as follows:

$$p_1 = 0 \qquad p_2 = 0 \qquad p_3 = 1 \qquad s = a_{33}$$

Simple inspection shows that the three price equations are indeed satisfied by this choice of prices. The quantity conditions also check: Since p_3 is positive (not zero), the quantity condition for y_3 must be satisfied with equality; hence:

$$y_3 = c_3/(1 - a_{33})$$

Since $p_1 = p_2 = 0$, the quantity conditions for y_1 and y_2 remain (possibly) inequalities; they lead to:

$$y_1 \geqslant 16c_1 + 12c_2 + 1.84y_3$$

$$y_2 \geqslant c_1 + 2c_2 + 0.14y_3$$

As long as $a_{33} < 1$, then y_3 comes out positive and so do y_1 and y_2. All conditions are satisfied. Mathematically speaking, we therefore have a solution of the system.

However, from an economic point of view, this solution is highly peculiar, so much so that many (but not all) economists reject this kind of solution altogether. The two necessary commodities, corn and iron, are free goods. The rate of return to their producers is not well defined, since the producers buy all their inputs at zero cost and sell their outputs at zero price! Even worse, if the third good (the DCG) is "velvets," i.e., if $a_{33} = 0$, then $s = 0$ and the return factor $\beta = 1/s$ becomes infinite! The inputs to velvet production come at zero cost, whereas the output is sold for a nonzero unit price. The resulting rate of return must be infinite.

We shall refer to these solutions as "peculiar solutions." This name is to indicate that they are solutions, mathematically speaking, but are peculiar from an economic point of view. Such solutions occur when there is a demand for DCGs. The input-output matrix is then reducible (without being fully reducible), and this mathematical property has as a consequence the existence of peculiar solutions.

C. Peculiar solutions, or none

In common sense, peculiar solutions should be rejected. The producers of necessary goods, corn and iron, buy their inputs at zero price and sell their output at zero price. Why should they wish to continue playing such a silly game? Yet, should they tire of the game and stop playing it, then the entire economy comes to a standstill.

Economists who are impressed by "existence proofs" for the existence of equilibrium solutions, however, are often prepared to accept peculiar solutions. Morishima (1964, 1969) falls into this category. He proves the existence of solutions, without requiring that the solutions which have been proved to exist are economically acceptable: some, or even all, of his solutions may turn out to be peculiar solutions. We shall exhibit a specific example shortly.

Are there standard economic conditions which exclude such peculiar solutions?[4]

The von Neumann condition N of section 4C does exclude them, but that condition is itself economically unacceptable.

The KMT conditions of section 4D are all right economically, but do *not* exclude these peculiar solutions: it is easy to show that the peculiar solution of section B satisfies all three KMT conditions.

It is possible, of course, to think up a new condition which does exclude all peculiar solutions. But such a condition runs up against two difficulties:

1. Neoclassical economists are far from unanimous in rejecting peculiar solutions and hence in accepting any such new condition. Their argument is that, in neoclassical theory, *all* entrepreneurs make zero net profit (the return goes to the owner, not to the entrepreneur); hence all entrepreneurs, not merely the ones engaged in production of particular types of goods, continue playing a fruitless (to them) game. Having accepted neoclassical theory, these economists see no grounds for rejecting peculiar (to us) solutions.

2. If we exclude all peculiar solutions from consideration, by some new condition, we may be left with no solution at all! Believers in the efficacy of the free market to solve all problems tend to be very disconcerted by such an outcome.

Let us now document our assertion that *all* solutions may turn out to be "peculiar" ones. The general case is discussed in the mathematical appendix. Here, we construct one particular example (which is, logically, all we need to make our point).

We consider a DCG which needs some of itself as an input to its own production; i.e., we assume $a_{33} > 0$. Let us think of the DCG as an animal with a long time between successive generations, and hence a slow biological growth rate. We shall refer to these animals as "white elephants." In the input-output table, this means that the coefficient a_{33} is only slightly lower than its maximum upper

[4] Our present system is very close to that of Sraffa (1960), who distinguishes between "basic" and "nonbasic" commodities. Our discretionary consumption goods are "nonbasic," though his category is wider than ours. Sraffa addresses himself to the possibility of peculiar solutions in his Appendix B (pp. 90-91) and rejects such solutions outright; we agree they should be rejected. But they deserve a more detailed discussion, since the difficulties for neoclassical economics arising from the existence of peculiar solutions are of the same sort as those arising from Sraffa's reswitching result. Neoclassical theory gets into dilemmas in attempting to accommodate either of these mathematical results.

limit, unity. For example, if we take $a_{33} = 0.98$, then the growth factor cannot exceed $1/0.98 = 1.0204$, i.e., about 2% growth per annum. This upper limit to the growth rate of the population of white elephants is biological in origin, nothing to do with economics. Yet, we shall now show that it has important economic consequences.

In the formulas of section B, the coefficient a_{33} has been left free. Let us now substitute the value $a_{33} = 0.98$ appropriate for white elephants, in place of the earlier value $a_{33} = 0$ appropriate for "velvets."

For the "sensible" solution we obtained: $p_1/p_2 = 1.23419$ and $s = 0.94051$. We substitute these numbers into the expression found for the price ratio p_3/p_2 :

$$p_3/p_2 = (0.1p_1/p_2 + 0.02)/(s - a_{33}) =$$

$$(0.1 \times 1.23419 + 0.02)/(0.94051 - 0.98) = -3.63$$

This ratio is negative; hence either the price of iron p_2 or the price of white elephants p_3 must be negative. This is impossible.[5]

Hence the "sensible" solution is no longer a solution at all!

The "peculiar" solution, however, remains valid mathematically. This solution has $s = a_{33} = 0.98$, hence a rate of return (to elephant raisers) $r = 1/0.98 - 1 = 0.02041$, slightly better than 2%. The rates of return to corn and iron producers come out as 0/0, hence undefined. The quantity conditions lead to perfectly acceptable results. Thus, there are no *mathematical* grounds for rejecting this peculiar solution.

From an economic point of view, however, standard economic theory is up against a *dilemma*: Either this theory accepts peculiar solutions, or it rejects them; but it gets into trouble either way:

1. If peculiar solutions are rejected on commonsense grounds, then it is no longer true that an input-output system always has acceptable solutions.

2. If peculiar solutions are accepted to avoid conclusion 1, then there is no reason to reject them in other cases where "sensible" solutions exist; indeed there is then no reason to prefer the sensible solutions to the peculiar ones.

We emphasize that this dilemma has nothing to do with the *size*

[5] As can be seen from the calculation, the trouble arises whenever a_{33} exceeds s, i.e., exceeds the reciprocal of the growth factor $\alpha = \beta$ for the same system under conditions of perfect thrift. That is, the "sensible" solution fails when the demand for the DCG, because of the slow growth rate of this DCG, forces the economy to grow more slowly than it could in the absence of this demand.

of the demand c_3 for the discretionary consumption good. Our arguments retain their force no matter how small c_3 may be, as long as c_3 is not precisely equal to zero. An economy with Leontief technology under steady-state conditions, when asked to produce "white elephants," can do so *only* by means of a price system in which all necessary goods are free, while only white elephants carry a price tag.

We consider that this paradox is real and provides one reason (we shall give other reasons later on) for questioning the emphasis, in conventional economic theory, on equilibrium (steady-state) analysis. *What we have just exhibited, in full detail, is a simple model system in which no sensible equilibrium solution exists.*

This finding does *not* contradict various "existence proofs" in the literature: An equilibrium solution does exist, namely the "peculiar" solution. But this solution is not sensible economically in real life.

Let us emphasize the purely theoretical nature of this result. One often hears claims to the effect that a balanced growth solution always exists, and is unique. What we have established is that such claims cannot be sustained. The balanced growth solutions may fail to be unique (i.e., there may be several different ones), and *all* the available balanced growth solutions may have to be rejected on commonsense economic grounds.

The importance of such a theoretical result has nothing to do with whether a demand for "white elephants" is actually a practical problem in present-day economies. It may or may not be: For instance, it is possible that similar things happen in some "developing" countries. But, whether such situations can be found often, or seldom, or not at all, in real life, the theoretical result remains a valid counterexample to an invalid theoretical claim.

Let us now, in conclusion, reiterate what can, and cannot, be said about steady-state solutions to (Leontief) input-output systems with consumption:

1. One should distinguish between discretionary demands for necessary goods (i.e., demands over and above the minimum necessary to keep the economy alive) on the one hand, and demands for discretionary consumption goods (goods which need not be, and would not be, produced at all in a perfect thrift economy) on the other hand.

2. If all goods in demand are necessary goods, such a system results in an irreducible input-output matrix, with a unique steady-state solution which is sensible from an economic point of view. All prices are unaffected by the level of demand.

3. If some of the goods in demand are discretionary consump-

tion goods, the input-output matrix turns out to be reducible, but not fully reducible. This shows itself through the appearance of peculiar solutions, in which all necessary goods become free goods.

4. Cases exist in which all mathematical solutions are of this peculiar type. This presents a dilemma for conventional economic theory.

5. If one takes the commonsense view that peculiar solutions should be rejected, then it is not true that every input-output system possesses an acceptable steady-state (or, for that matter, as we shall see, an acceptable balanced growth) solution.

D. The Leontief input-output model

In this section, we discuss the relationship of the theory developed so far in this chapter with the input-output model of Wassily Leontief (1951, 1953) and with the practical input-output tables which are based on the Leontief model. The relationship is not at all as close as might appear at first sight.

The importance of the Leontief contribution is that it has a direct empirical counterpart in the input-output tables which have been derived for actual economies. This makes Leontief's model unlike most other models in theoretical economics. The practical orientation of Leontief's model is very much appreciated by applied economists who use this model as a way to systematize the collection of economic data, and who then use the resulting input-output tables to understand, and perhaps control, actual economies. This practical orientation, however, has consequences for the way Leontief's theory is formulated, consequences which make Leontief's own model quite different from the very theoretical (hence not directly applicable) formulation of this book. A number of things which can, and should, be done in pure theory are entirely unsuitable in applied work. Both approaches are important, and neither should be neglected; in pointing out the differences here, we have no intention of considering either approach as being "superior"; they serve different functions.

1. In applied economics, it is absolutely essential to aggregate. The purely theoretical input-output matrix of section 3A is impossibly large for practical work, since there each distinguishable commodity (for example, each model of passenger car produced by each manufacturer) gives rise to a separate row of the matrix. By contrast, Leontief's industries produce not single commodities, but rather aggregates of related commodities; for example, there may be a "motor vehicle industry" which produces all types of passenger cars, trucks, and motorcycles, perhaps even tanks for

the army. This aggregation is, we repeat, *essential* in applied work.

2. As a logical consequence, industry inputs and outputs *must* themselves be aggregated. This cannot be done in physical terms. We must not add a Rolls Royce car, a delivery van, and a motorcycle, so as to get "three motor vehicles." Rather, we must add their values, using either current market prices, or else prices corrected back to some base date by means of a price index. In either case, though, the prices are taken from market observation; they do not emerge as a result of the theory. The theory can be made to produce predictions about price *changes* as a result of, say, shifts in demand, but these changes are from a base which is not itself determined within the theory. In particular, rates of return to producers are not consequences of the theory, but are taken from market observation. The fact that the price and quantity dimensions are not separately factored out in Leontief's model is unfortunate, but *unavoidable* in a model aiming for practical application.

3. Leontief allows for nonproduced inputs, e.g., land and labor, whereas we have taken all explicit inputs to be producible commodities such as corn and iron. Our procedure is permissible under "classical" conditions of the "iron law of wages" but fails when there are, for example, powerful unions able to extract real wages in excess of minimum subsistence levels. For the reasons explained in chapter 1, this is not important for what we want to do; but it is exceedingly important in applied economics.

4. In our "Leontief technology," there is no fixed capital, no "stocks" of either machines or even of finished salable products ("inventories"). When fixed capital must be included, we use von Neumann technology as the way to include it. In the practical input-output model of Leontief, the complications arising from the joint production aspects of von Neumann technology cannot be tolerated. Therefore, the Leontief system makes explicit allowances for "stocks" (which may be of machines, of input raw materials for production, and of finished or semifinished products). These "stocks" are subject to "depreciation," at some conventional depreciation rate. The practical model therefore has two matrices, A and S, compared to our theoretical matrix of input-output coefficients. The matrix A, with elements a_{ij}, states how much (in value terms!) industry i must purchase from industry j so as to be able to produce one dollar's worth of output of their own products i. This refers to purchase of raw materials, intermediate products, etc., not to the purchase of fixed capital. The second matrix S, with matrix elements s_{ij}, states how much (again in value terms!) stock of the type produced by industry j must be kept on hand to

produce one dollar's worth of output of commodities from industry i. This stock is not purchased in the current period, or at least not all of it—a bit may have to be purchased to keep pace with physical depreciation; that is all. This is a rough and ready method for handling fixed capital within the confines of a practical model and is entirely acceptable for that purpose. It is not at all acceptable for pure economic theory, for the reasons given in chapter 4.[6]

5. The open Leontief model is static; i.e., it is assumed from the start that production and consumption next year will be at the same levels as this year. It is a common, but incorrect, belief of many that the introduction of "stocks," point 4 above, is *necessary* to make Leontief theory "dynamic." This belief arises from a mistake in the formulation of the theory. Inputs of various commodities j (not stocks) to production of commodity i are taken to occur at the same time t as the output of i makes its appearance; this is incorrect, since production takes a nonzero time interval. In chapter 3, we assumed that inputs at the *beginning* of period t produce outputs at the *end* of that period; i.e., we took production to require one unit of time. Whether one uses this assumption, or some more complicated (and more realistic) assumption about time intervals between inputs and outputs in the various industries, whether one uses a formulation in which time is divided into discrete "periods" or uses a "continuous time" formulation—in all cases, a correct formulation of input-output theory, allowing for time delays in production, makes the theory properly "dynamic" even in the absence of "stock" variables. The usual "dynamic Leontief model," in which the dynamics is associated purely with stocks, has not been accepted as widely as the static model—we believe, for excellent reasons.

6. The theoretical model *assumes* the same rate of return to all producers. Thus, the "value added" by an industry can be deduced directly from the industry's input costs (including labor); just multiply the total input cost by the rate of return r to get value added. For this reason, the theoretical model does not require, and does not possess, a separate row of the matrix for "value added." The practical model needs such a value added row (as well as a labor demand column, which is also not needed in the theoretical model), and it needs it very badly indeed. For the plain truth is that rates of return in different industries are not at all equal to each other! Our theoretical model is intended to elucidate economic theory under competitive conditions; but assuming equal rates of

[6]We are aware that this is a contentious issue; what we state here is our considered opinion, which agrees with that of Sraffa (1960) but is not accepted universally.

return is simply not permissible in a practical model for applied economists.

This completes our list of differences between the practical input-output model of Leontief and the purely theoretical model of this book. As emphasized already, these differences arise from differences in basic purpose and must not be taken as criticisms of either model. When one wants to do different things, different types of models are required.

We do not go beyond this brief set of comments regarding the practical model. For more information, readers may consult Leontief (1951, 1953), Carter (1972), Chenery (1959), Dorfman (1958), and Eichner (1980), the last of which is post-Keynesian in outlook; as well as Ara (1959), Batten (1979), and Day (1972). For the history of the model, see Clark (1974); for the handling of technology, Gigantes (1972); for depreciation, Atkinson (1978); for neoclassical theory, Morishima (1958, 1959); and for further studies, references contained in all these.

E. Mathematical appendix

As in chapter 3, we have n commodities, with production level y_i and price p_i for commodity i. It requires a_{ij} units of j as input for production of one unit of commodity i. The new concept is a consumption demand $c_i \geq 0$, with at least one c_i strictly positive. Let r be the rate of return and $\beta = 1 + r$ the return factor. We define:

$$s = 1/(1 + r) = 1/\beta \qquad (5.1)$$

The conditions for the open Leontief model are:

$$y_j \geq \sum_{i=1}^{n} y_i a_{ij} + c_j \qquad \text{for } j = 1, 2, \ldots, n \qquad (5.2)$$

If there is strict inequality for some j in (5.2), then $p_j = 0$ (5.3)

$$sp_i \leq \sum_{j=1}^{n} a_{ij} p_j \qquad \text{for } j = 1, 2, \ldots, n \qquad (5.4)$$

If there is strict inequality for some i in (5.4), then $y_i = 0$ (5.5)

THEOREM 5.1

If the input-output matrix A is productive and irreducible, then there exists one unique solution to the Leontief conditions, with all prices and all production levels strictly positive.

Proof: We use the notation of section 3E for nonnegative, positive, and strictly positive vectors: $v \geqslant 0$, $v > 0$, $v \gg 0$. By assumption, $c > 0$. By (5.2), $y \geqslant yA + c \geqslant c > 0$; hence $y > 0$. By theorem 3.5, then, $y \gg 0$. By (5.5) and $y \gg 0$, we conclude that there must be equality in (5.4); hence s is an eigenvalue, and p a nonnegative right eigenvector, of A. By theorem 3.6, there is only one eigenvalue which can do this, namely $s = s^*(A)$, and the right eigenvector $p \gg 0$. By (5.3) and $p \gg 0$, there must be equality in (5.2); hence $y = c(I - A)^{-1}$. By theorem 3.10, the inverse operator in question exists and is nonnegative; we have already proved that y is strictly positive. Q.E.D.

Now introduce DCGs. We shall assume that there are k essential goods, labeled $i = 1, 2, \ldots, k$, and $m = n - k$ DCGs, labeled $i = k + 1, k + 2, \ldots, k + m = n$. The input-output matrix takes the form:

$$A = \begin{pmatrix} E & 0 \\ - & - \\ F & G \end{pmatrix} \tag{5.6}$$

where A is n-by-n, E is k-by-k, F is m-by-k, and G is m-by-m. The k-by-m zero matrix on the top right makes A reducible. We avoid full reducibility by the requirement.:

$$\text{No row of F consists entirely of zeros} \tag{5.7}$$

which means, economically, that every DCG needs at least one necessary good as an input. The "necessary" nature of goods 1 to k means the mathematical condition:

$$\text{E is irreducible and productive} \tag{5.8}$$

In section B, we pointed out that a_{33} cannot exceed unity if we want to have a steady-state solution. The generalization of this condition is:

$$\begin{array}{l}\text{The dominant eigenvalue of G, called } g^* \\ \text{henceforth, is below unity}\end{array} \tag{5.9}$$

Finally, we impose the condition that *all* DCGs are actually in demand:

$$\text{For } i = k + 1, k + 2, \ldots, k + m = n, \quad c_i > 0 \tag{5.10}$$

THEOREM 5.2

Let $z = (z_1, z_2, \ldots, z_m)$ be a positive right eigenvector of G belonging to the eigenvalue g of G. Then the open Leontief system has a class of solutions with $s = g$ and with zero prices for all essential goods; the prices of the DCGs are given by: $p_{k+i} = z_i$ for

$i = 1, 2, \ldots, m$. There are infinitely many solutions of this class.

Note: These are the "peculiar" solutions. Since G need not be irreducible, but on the contrary may consist of all zeros, we cannot assert that the eigenvalue g in question is unique; there may be several such, in which case each such eigenvalue leads to an infinite number of peculiar solutions.

Proof: For all $i \geqslant k + 1$, (5.10) and (5.2) imply: $y_i \geqslant c_i > 0$. Next, write down (5.2) for $j = 1, 2, \ldots, k$ in turn and retain only the last m terms of the sum on the right:

$$y_j \geqslant \sum_{i=k+1}^{n} y_i a_{ij} \qquad \text{for } j = 1, 2, \ldots, k \tag{5.11}$$

The matrix elements on the right-hand side are the ones of submatrix F in (5.6). Now sum (5.11) over these j-values and make use of property (5.7) to obtain the result that the sum $y_1 + y_2 + \ldots + y_k > 0$. Hence this k-component subvector has at least one nonzero component. By exactly the same argument as for the proof of theorem 5.1, but using the assumed irreducibility of the submatrix E, we conclude that *all* these k components are strictly positive. Hence, finally, all n components of y are positive; that is, $y \gg 0$. From $y \gg 0$ and (5.5), we conclude equality in (5.4). The secular equation for the eigenvalue s reads:

$$\det(A - sI_n) = \det(E - sI_k) \det(G - sI_m) = 0 \tag{5.12}$$

where I_n is the n-by-n unit matrix, etc. The decomposition of the determinant into two factors is a consequence of condition (5.6). We conclude that every eigenvalue g of G with a nonnegative right eigenvector is also an eigenvalue of the full matrix A. The m components of the right eigenvector of G are related to the prices of the DCGs as claimed in the theorem. It is easy to see that the other prices are all zero. The quantity conditions (5.2) then lead to:

$$y \geqslant c(I_n - A)^{-1} \tag{5.13}$$

with strict equality for those indices $i \geqslant k + 1$ for which $p_i = z_{i-k} > 0$. There may be inequality for all the other DCGs and for all the essential goods. By our assumptions (5.6) to (5.9) and theorem 3.10, the inverse operator exists and is nonnegative. The presence of inequalities means that there are infinitely many solutions (differing in one or more output levels) for each permissible g. Q.E.D.

THEOREM 5.3

Let e^* be the dominant eigenvalue of E, g^* of G. Let the vector $p^* = (p_1^*, p_2^*, \ldots, p_k^*)$ with k components be the right eigenvector of E for eigenvalue e^*. Then: (a) If $e^* \leqslant g^*$, the peculiar solutions of theorem 5.2 are the *only* solutions, and (b) if $e^* > g^*$, then there exists exactly one further, unique "sensible" solution with

$s = e^*$, $p_i = p_i^*$ for $i = 1, 2, \ldots, k$, all other prices determined in terms of these, and quantities determined by (5.13) with strict equality for all components.

Proof: The argument leading to $y \gg 0$ and equation (5.12) still holds. The choice $s =$ eigenvalue of G was explored in theorem 5.2; all that remains is that $s =$ eigenvalue of E. By (5.8) and theorem 3.6, only the dominant eigenvalue e^* of E gives positive prices for the first k goods; hence $s = e^*$ if at all. For ease of notation, define the m-component vector t by

$$t_i = p_{k+i} \qquad \text{for } i = 1, 2, \ldots, m \tag{5.14}$$

Using equality in (5.4), the breakup (5.6), and $s = e^*$, we get:

$$e^*t = Fp^* + Gt \tag{5.15}$$

We define the matrix (m-by-m)

$$H = (1/e^*)G \tag{5.16}$$

and we note that (5.7) and $p^* \gg 0$ imply $Fp^* \gg 0$. Hence:

$$t = Ht + (1/e^*)Fp^* \gg Ht \tag{5.17}$$

By theorem 3.13, there is no solution t to this if the dominant eigenvalue of H, call it h^*, is equal to or larger than unity. But $h^* = g^*/e^*$ by (5.16). This proves statement (a) of the theorem. Conversely, if $e^* > g^*$, then $h^* < 1$, and by theorem 3.10 the inverse operator $(I_m - H)^{-1}$ exists and is nonnegative. Thus equations (5.17) can be solved for t and lead to $t \gg 0$, all prices strictly positive. Then (5.2) and (5.3) imply equality in (5.13). This proves part (b) of the theorem. Q.E.D.

Growth theory with consumption

In chapter 6, we remove the simplifying assumptions of chapter 5 (no growth, Leontief technology). We intend to investigate states of balanced growth in the presence of discretionary consumption and (at least as far as possible) with general von Neumann technology. It will turn out that the presence of consumption makes quite a difference, so that the results are not at all the same as those of chapter 4.

As in chapter 5, we shall investigate a system with *given* consumption demands $c_i(t)$ for commodity number i in period number t; the "balanced growth" feature shows itself through the fact that all these consumption demands grow by the same factor a each year, this being also the growth factor for production levels $y_i(t)$ of the economy:

$$c_i(t + 1) = ac_i(t) \quad \text{and} \quad y_i(t + 1) = ay_i(t)$$

Thus, the given quantities are: (1) the consumption demands $c_i(0)$ in the initial period $t = 0$; and (2) the growth factor a.

We do *not* relate consumption levels to "social utility" in the way that neoclassical theory does (for example, see Morishima 1964, 1969). The reasons for this have been stated already (section 5A) and we need not repeat them here.

Section A is introductory and can be read quickly by the advanced student. Section B deals with the rather intricate question of alternative specifications of the conditions for a balanced growth solution. This section can be skipped in a first reading; it contains, however, material of interest to people working in this area, that is, some new material. Section C deals with the attempt by KMT (see section 4D) to include consumption; we show that the assumptions of KMT in this area are not valid for what one normally calls "consumption" but rather refer to a peculiar and special case only.

Section D provides a discussion of the results of growth theory with consumption. This discussion is nonmathematical (for the mathematics, see section E) and is not given elsewhere within the literature.

A. The simplest case

To introduce the subject, let us start with the corn-iron economy and the input-output table of section 3A, i.e., the same economy we studied in section 5A. The new material consists in our now allowing consumption demands $c_i(t)$, as well as production levels $y_i(t)$, to depend upon time t, growing from one period to the next by the common growth factor a, so that everything grows together, in balance, and all ratios c_i/c_j and y_i/y_j are independent of time.

If we want to produce, in period $t + 1$, an amount of corn equal to $y_1(t + 1)$ and an amount of iron equal to $y_2(t + 1)$, and we wish to consume, in period $t + 1$, $c_1(t + 1)$ quarters of corn, then the amount of corn which must be available at the beginning of this period, i.e., at time t, equals:

$$0.9y_1(t + 1) + 0.6y_2(t + 1) + c_1(t + 1)$$
$$= a[0.9y_1(t) + 0.6y_2(t) + c_1(t)]$$

This input quantity of corn must be available from the output of the preceding period, i.e., from $y_1(t)$. Thus $y_1(t)$, or just y_1 for short, must be greater than or equal to this required input; furthermore, if y_1 exceeds requirements in every period, then corn becomes a free good with price equal to zero. We therefore obtain the following *quantity conditions*:

$$y_1 \geqslant a(0.9y_1 + 0.6y_2 + c_1) \qquad \text{If strictly greater, then } p_1 = 0$$
$$y_2 \geqslant a(0.05y_1 + 0.2y_2 + c_2) \qquad \text{If strictly greater, then } p_2 = 0$$

The second condition, for iron, was obtained by an exactly similar argument. We can omit the time variable t, since it is the same on both sides of each condition. In the special case of no growth, $a = 1$, these more general conditions reduce exactly to the quantity conditions of section 5A.

The conditions for prices and the rate of return are *unchanged* from chapter 5, since we assume all prices to be time-independent so that producers compute their rates of return exactly as before. We repeat these *price conditions*:

$$p_1 \leqslant \beta(0.9p_1 + 0.05p_2) \qquad \text{If strictly less, then } y_1 = 0$$
$$p_2 \leqslant \beta(0.6p_1 + 0.2p_2) \qquad \text{If strictly less, then } y_2 = 0$$

We recall that β is related to the rate of return r through $\beta = 1 + r$.

These are the conditions which must be satisfied by a balanced growth solution in this simple case. However, it is still necessary to decide which quantities are exogenous here, and which endogenous. We shall discuss this in considerable detail in subsequent sections. For now, we make a choice which has two advantages: (1) it is convenient, and (2) it is the natural generalization of the choice made for the open Leontief model of chapter 5. Our choice is:

Exogenous: Growth factor a, initial consumption levels $c_i(0)$

Endogenous: Return factor β, production levels $y_i(0)$, prices p_i

For the special case of no growth, $a = 1$, this is precisely the specification of the open Leontief model; that is, consumption levels are specified, and everything else is then deduced from the conditions. For any other value of the growth factor a, this is the nearest we can come. Note that values of consumption levels and production levels at time $t = 0$, together with the value of the growth factor, are enough to determine consumption levels and production levels at all times t.

We now assert that the specification listed above is indeed complete; i.e., everything significant about the endogenous variables is determined completely once the exogenous variables are known. Furthermore, we shall find that a can be chosen quite freely within a wide range of values, although not all values of a are allowed.

The proof of these statements, which we now commence, is very similar to the corresponding proof in section 5A. At least one consumption demand is nonzero. Let us suppose it is c_1; furthermore, we assume $a > 0$, a natural enough condition. The quantity inequality for y_1 then implies: $y_1 \geqslant ac_1 > 0$; hence $y_1 > 0$; and for y_2 we get: $y_2 \geqslant a(0.05y_1) > 0$; hence $y_2 > 0$. Both commodities must be produced in positive amounts. Looking at the price conditions, we now see that both of them must be satisfied with strict equality. This, however, is exactly what we found in section 5A, and it leads to exactly the *same* unique result for the return factor and the price ratio p_1/p_2, namely:

$$p_1/p_2 = 1.23419 \qquad \beta = 1.06325$$

The price system and the rate of return are exactly the same for a growing economy as for a steady-state, open Leontief model, economy. The presence of growth has no influence at all on the price system, or on the rate of return.

Next, let us look at quantities. With a positive price ratio p_1/p_2, both p_1 and p_2 must be separately positive, i.e., not zero. The quantity conditions then imply that both inequalities become equations. We rewrite these equations so as to put all production

Table 6.1

Growth factor a (exogenous)	Equations	Solutions
1.00	$0.1y_1 - 0.6y_2 = c_1$ $-0.05y_1 + 0.8y_2 = c_2$	$y_1 = 16c_1 + 12c_2$ $y_2 = c_1 + 2c_2$
1.03	$0.073y_1 - 0.618y_2 = 1.03c_1$ $-0.0515y_1 + 0.794y_2 = 1.03c_2$	$y_1 = 31.292c_1 + 24.356c_2$ $y_2 = 2.030c_1 + 2.877c_2$
1.06	$0.046y_1 - 0.636y_2 = 1.06c_1$ $-0.053y_1 + 0.788y_2 = 1.06c_2$	$y_1 = 328.850c_1 + 265.417c_2$ $y_2 = 22.118c_1 + 19.197c_2$
1.10	$0.010y_1 - 0.660y_2 = 1.10c_1$ $-0.055y_1 + 0.780y_2 = 1.10c_2$	$y_1 = -30.105c_1 - 25.474c_2$ $y_2 = -2.123c_1 - 0.386c_2$

levels on one side of each equation, all consumption levels on the other side. This gives:

$$(1 - 0.9a)y_1 - 0.6ay_2 = ac_1$$
$$-0.05ay_1 + (1 - 0.2a)y_2 = ac_2$$

With the specification discussed before, y_1 and y_2 are the two unknowns, and we have two linear equations in these two unknowns. In Table 6.1, we list, for certain particular values of the exogenous variable a, the form taken by these equations, as well as the solutions for y_1 and y_2 in terms of c_1 and c_2.

Discussion

The first case, $a = 1$, is the open Leontief theory with steady state, no growth. The equations, and the results, are exactly as in section 5A.

The next case, $a = 1.03$, postulates a 3% growth per period. The equations look very similar; the solutions are clearly feasible. Note, though, that the ratio of total production to final consumption has become much larger. For example, assume that corn, commodity 1, is the only desired consumption good, and look at the ratio c_1/y_1 for that case. With $a = 1$, we had $c_1/y_1 = 1/16$, whereas with $a = 1.03$ the same ratio is $c_1/y_1 = 1/31.292$. With no growth, we could divert 1 quarter of corn in every 16 to ultimate consumption; if we aim for 3% per annum growth, the diversion amount drops to 1 quarter in every 31 quarters, a very significant sacrifice indeed.

The third case, $a = 1.06$, a growth rate of 6% per period, shows

the same tendency in much stronger fashion. For $c_2 = 0$, the ratio $c_1/y_1 = 1/328.85$ means that less than 1 part in 300 of the entire output of corn is available for ultimate consumption. The sacrifice has become extreme.

In the fourth case, $a = 1.10$, the solution which we get from the mathematical equations is unacceptable economically, since the production quantities y_1 and y_2 have turned out to be negative, i.e., impossible. The economic system described by the input-output table used here, and listed in section 3A, is simply incapable of such rapid growth. This is hardly surprising: In section 3B, we studied this same system under the assumption of perfect thrift, no consumption at all; there we found a growth factor $a = 1.06325$. Obviously, consumption demands can only slow down growth, not speed it up. Thus, when we specify a growth factor in excess of 1.06325—for instance, $a = 1.10$—we must not be surprised if we fail to get a viable solution to the equations.

It is shown in the mathematical appendix that this situation is quite general. We state the results, only, at this point:

1. The return factor β is in the nature of an eigenvalue; i.e., there are only a limited number (quite often only one) of possible values for β. For each such value, there is an associated system of price ratios. At most one of these sets is "sensible."

2. Both the system of prices and the return factor do not change at all when different growth factors a are specified, as long as a lies within the permissible range; see point 3. Prices and the return factor also do not depend on the precise consumption demands specified, as long as these are positive, not zero.

3. The permissible range of a is as follows: a must be positive— i.e., $a > 0$—and a must be less than the *smallest* permissible value of β among the eigenvalues mentioned under point 1.

4. For given consumption demands c_i at time $t = 0$, the necessary production levels y_i are increasing functions of a, which transcend all bounds as a approaches its upper limit as given in point 3.

In the very simple example of this section, there is only one permissible value of the return factor, namely $\beta = 1.06325$, and associated price system. This return factor and these prices rule for all feasible cases in our table ($a = 1.00$, 1.03, and 1.06), indeed for all values of the growth factor a within the permissible range $0 < a < 1.06325$. The fourth point is illustrated very clearly within our table.

These and some other results are discussed much more fully in a later section of this chapter.

B. Formulation of growth theory with consumption

This and the next section are devoted to more detailed questions and can be skipped in a first reading. In this section, we show how the problem of growth theory with consumption can be formulated in a number of different ways, or "specifications." The choice of which variables are taken as given (exogenous) and which are deduced (endogenous) is rather open. But two of the specifications discussed below (called B and C) are invalid, even though they appear in the literature. Specifications A and D are equivalent economically, but mathematically A is much easier to handle than D.

All specifications have certain things in common. We start with these. The conditions which must be satisfied for a von Neumann economy under perfect thrift are stated in section 4B. Let us now indicate how these must be modified when there is consumption.

1'. Condition 1 of section 4B, the condition for balanced growth, is unaltered; but we must *add* that all consumption levels $c_i(t)$ grow at the same rate:

$$c_i(t + 1) = ac_i(t) \qquad \text{all } i = 1, 2, \ldots, N \qquad \text{and all } t$$

2'. Condition 2 of section 4B, the quantity balance condition, is altered only to the extent that commodity outputs from period t must suffice to cover not only all productive inputs needed in period $t + 1$, but also all consumption levels $c_i(t + 1)$ in that period.

3'. A similar change is required in the "free goods" condition 3 of section 4B. Good number i is in excess supply and hence must be a free good only if its output is larger than the sum total of needed productive inputs of that good *and* the consumption demand for that good, in the next period.

8. Condition 8 of section 4B, the "perfect thrift" condition, is now *discarded*.

All other conditions of section 4B (conditions 4, 5, 6, and 7) are *unchanged*. These are the conditions involving prices and rates of return. These are unchanged by the presence of demands for ultimate consumption. A producer figuring his rate of return does not care in the least to whom he sells his output, to another producer or to an ultimate consumer—the same price is charged to both types of buyers.

The mathematical form of all these conditions is given in the mathematical appendix.

We now turn to questions of specification; in particular, which variables are to be taken as exogenous (given from outside the system) and which as endogenous (determined within the system). There are several possible specifications, which we discuss in turn.

Specification A

Exogenous: Growth factor a, initial
 consumption levels $c_i(0)$

Endogenous: Return factor β, prices p_i,
 initial activity levels $z_m(0)$

This is our preferred specification, which we have already used in section A for the special case of Leontief technology.

Specification B

Exogenous: Ratios c_i/y_i (consumption/total
 output) for $i = 1, 2, \ldots, N$

Endogenous: Growth factor a, return factor
 β, prices p_i, activity levels $z_m(0)$.

This specification is often used in the literature; it results in a mathematical problem (a double eigenvalue problem) which is very difficult to solve, and it is even difficult to decide whether solutions exist for the given ratios. Worse than that, however, this specification is *unacceptable* whenever there are demands for discretionary consumption goods (see section 5B). Suppose good i is "velvets." Then the entire output of this commodity is used for consumption; none of the output is needed as productive input for later years. Thus $c_i = y_i$ and the ratio $c_i/y_i = 1$, no matter what the actual demand c_i is. As a result, this specification does not provide us with sufficient information to determine a solution. The specification may be used if the only goods in demand are necessary goods; but this is a severe restriction.

Specification C

Define "total activity" Z by

$$Z \equiv \sum_m z_m$$

Exogenous: Ratios c_i/Z for $i = 1, 2, \ldots, N$

Endogenous: Growth factor a, return factor β,
 prices p_i, activity levels $z_m(0)$

This specification is used by KMT (Kemeny 1956). The total activity Z cannot be zero; hence, we may divide by it. Since Z grows with the same growth factor as all the c_i, the ratios c_i/Z are time-independent. Furthermore, this specification provides sufficient information to obtain a solution, even when there are discretionary consumption goods in demand.

Nonetheless, this specification is *unacceptable*: The "total activity" Z is a sum of activity levels z_m, each of which is *not* well defined, for the following reason: Suppose, for some activity m, we double all the input coefficients a_{mi} and all the output coefficients b_{mi}, and we halve the activity level z_m. The net result is no change at all! All quantities input to the system, and all quantities output, are unaltered, and so are all prices. Yet, this modification does change the value of Z, since one of the z_m in the sum has been halved. The difficulty is particularly clear when we consider the special case of Leontief technology, where (by agreement) unit activity level $z_m = 1$ is taken to mean production of a unit amount of the one and only commodity produced by activity m. In this case, the activity levels are just quantities of commodities. To find Z, we are then obliged to add quarters of corn to tons of iron, hardly a sensible procedure. Thus Z does not make sense economically.

Specification D

Suppose that there exists an essential ingredient—for example, calories of food value—present in some of the commodities, which must be produced to maintain a viable economy; without food value, everyone starves to death. Let unit amount of commodity i contain q_i calories, with at least one q_i strictly positive. Total food value is:

$$Q(t) = \sum_{i=1}^{N} \sum_{m=1}^{M} z_m(t) b_{mi} q_i > 0$$

By assumption, this quantity Q cannot be zero but must be strictly positive. In a balanced growth situation, Q grows at the same rate as everything else. We are now ready to state the specification:

Exogenous: Ratios c_i/Q_i; call these ratios d_i

Endogenous: a, β, prices p_i, activity levels z_m

This is a possible, acceptable specification; the items added in the definition of Q are commensurable, all being numbers of calories of food value; Q must be positive, so we are allowed to divide by it; and the ratios d_i are independent of the time variable t.

Nonetheless, specification D, or an equivalent specification in the literature (Loś 1976), is much less natural than our preferred specification A. With specification D, both a and β are eigenvalues, i.e., restricted to discrete sets of values. Not only is such a double eigenvalue problem considerably more difficult to solve than the

single eigenvalue problem for specification A, but simple facts in specification A are completely obscured in specification D. In particular, we have seen in section A, and shall confirm in section D, that a and β behave very differently from each other: The growth factor a can be specified freely within wide limits and can take on values within a continuous range, whereas the return factor β is an eigenvalue, restricted to a few, perhaps only one, discrete values, and these come out as results once the input and output coefficients are known. That is, not only is it impossible to "specify" values of β, but the values which one actually gets are largely independent of consumption demands.

C. Consumption within the KMT theory

This section can be skipped at a first reading. The theory of Kemeny, Morgenstern, and Thompson (Kemeny 1956; see also Morgenstern 1976) has two aspects: (1) conditions on the technological input and output coefficients, to replace the unacceptable von Neumann condition N; this was discussed in section 4D; (2) an attempt to include consumption, leading to results which differ significantly from what we find here. It is necessary to understand where this difference comes from. This is the task of the present section.

KMT start their section on consumption with the "requirement that at each time period the economy should supply to an outside consumer . . . goods already being produced by the economy."

Now, first of all, this phrasing excludes the possibility of the "outside consumer" wanting discretionary consumption goods, such as white elephants, which are not "already being produced" by the perfect thrift economy in the absence of the outside consumer. This is an extremely serious restriction, as we have seen.

But also, when one studies their equations (see the mathematical appendix), it becomes apparent that the "outside" consumer is "outside" the economy in a most remarkable sense: He does not pay for what he receives! Rather, our government imposes a tax, proportional to the activity level z_m of each activity. The coefficient of proportionality is adjusted so that the total yield of the tax is sufficient to enable the government to purchase all these commodities wanted by the "outside consumer" and remit them to the "outside consumer" *free of charge*. Such a situation can happen: The "outside consumer" may be a foreign country which has vanquished our nation in a war and now has the power to impose war reparations payments, in kind, from our nation.[1]

[1] Another possibility is transfer payments to old-age pensioners, etc.

Although such consumption is a possibility, this is not what is meant by the word "consumption" in common parlance. The usual meaning of this term is discretionary consumption by agents *within* the economy, out of income gained within that economy. Within the context of "production of commodities by means of commodities," this means discretionary consumption is paid for out of dividends. Labor as such is not considered a separate "input"; rather, labor is paid a conventional subsistence wage, which is then spent on a predetermined and unchanging market basket of commodities. These commodities, not labor as such, form part of the input to every activity in the economy. Within such a theory, consumption by workers is not a meaningful economic variable, and neither is employment. The number of employed adjusts itself automatically to the current level of economic activity; all employed workers consume their wage in the same way; there is never any shortage of labor; and the unemployed, if there are any, live on air. Thus discretionary consumption has nothing to do with wages. Rather, it is out of income from investments. But, whether wages or investment income, the income is gained within the economic system, and the consumption demands are paid for by the consumer himself.

The KMT theory takes a different point of view and therefore arrives at quite different results. In particular, that theory leads to $a = \beta$, even in the presence of their peculiar type of "consumption."

In our view, the KMT paper is a most valuable contribution to growth theory under perfect thrift; but their treatment of consumption applies only to a very peculiar special case and is seriously misleading for the ordinary meaning of "consumption."

D. Results and discussion

With full von Neumann technology, the mathematical problems associated with growth theory in the presence of discretionary consumption become truly formidable. This is still a wide open field for further research. Even with our preferred specification of the problem, which is significantly easier to handle than the alternative specifications in the literature, and with KMT conditions on the input and output coefficients, it is *not* known whether sensible solutions always exist; nor is it known under what additional conditions, if any, we can be sure of sensible solutions.[2]

[2] The existence theorem of Los' (1976) requires a condition which is a generalization of the von Neumann condition N of section 4C and hence is unacceptable. The KMT paper gives an existence theorem, but that theorem depends upon the authors' special method of introducing an "outside consumer,"

If all commodities i in the economy can be consumed, *then* one can say something of considerable interest, even in the most general case. Now, in fact, our "if" is an implausible assumption: Who wants to consume lathes, blast furnaces, and similar commodities? We quote Morishima (1969, p. 101):

> It seems absurd and very unrealistic at first sight. But no one can refute that in Paradise the Capitalist will use a blast furnace to heat his dog's house, while the Worker's children will do their homework with the aid of electronic computers (!).

Whatever the merits of this argument, it at least establishes that the assumption that *all* commodities can serve as consumption goods is considered acceptable in the literature of the field. Let us therefore investigate a consequence of this assumption, returning to a discussion of it afterward.

In the mathematical appendix, we provide a proof of the following *theorem*:

THEOREM
Assume that a growth solution exists for initial consumption levels $c_i(0)$ (at time $t = 0$) and a particular growth factor a_1. Let the return factor of this solution be β, let the prices be p_i, and let the activity levels at time $t = 0$ be $z_m(0)$. *Then* for any growth factor in the range $0 < a < a_1$, there exists an "associated" solution of the growth problem, with the *same* return factor β, the *same* prices p_i, and the *same* initial activity levels $z_m(0)$; the associated solution has different consumption levels $c_i'(0)$, in general, but no consumption level is lowered; i.e., for all $i = 1, 2, \ldots, N$ it is true that $c_i'(0) \geqslant c_i(0)$.

This theorem, note, does *not* assert that a solution always exists. Rather, *if* one solution exists, *then* there also exists a whole infinity of "associated solutions," with exactly identical prices and rate of return, but with lower growth rates. That is, it is always possible to go to a lower balanced growth rate. We are *not* concerned with the problem of "traverse" here; that is, we are comparing balanced growth solutions with each other——if you wish, "comparative balanced growth" rather than true dynamics. But the "traverse" is made much easier by the fact that, to go from the

which we have discussed in section C. The existence proof of Morishima (1964, 1969) pays no attention to whether the solution which has been proved to exist is sensible economically; i.e., Morishima *accepts* the "peculiar" solutions of sections 5B and 5C in which *all* necessary commodities are free goods. We are not prepared to do so.

high growth factor (a_1) solution to the low growth factor (a) solution, we need not change activity levels at all, nor prices, nor rates of return, but merely consumption levels; and changes in consumption levels, if any, are always in an upward direction, so (at least in the initial period) no one suffers.

This theorem is a mathematical generalization of assertion 2 at the end of section A, that prices and the rate of return do not change at all when we specify an altered growth factor. There, in section A, we were using Leontief technology (hence, no true "investment goods" at all, only circulating capital), and we then did not even need to alter consumption levels $c_i(0)$ to get the result. With von Neumann technology, we must be prepared to alter initial consumption levels. But if we are willing to do that (upward only, never downward), then *the growth factor can be specified freely, without any necessary change in the price system or the rate of return.*

In a way, this theorem is a mathematical version of one of the most famous maxims in economics: "Every prodigal appears to be a public enemy, and every frugal man a public benefactor" (Smith 1776).

Let us now return to this question of consumption of lathes and blast furnaces: If commodity $i = 5$, say, is a blast furnace, then it is likely that $c_i(0) = c_5(0) = 0$ in the original solution; i.e., no blast furnaces are consumed. In the "associated solution" for a lower growth factor a, the readjusted consumption level $c_5'(0)$ then has a nonzero, positive value. Some of our capitalists must thus be prepared to pay money to consume this blast furnace, perhaps to heat their doghouses.

From an economic point of view, it is not too surprising that the presence of true investment goods makes difficulties.[3] The growth rate cannot be varied without varying the rate of investment (assuming investment requires capital inputs), and changing the rate of investment means changing the composition of final demand. Thus the set of relative prices can hardly be expected to remain unaltered.

It is unfortunate that we cannot give a theorem for full von Neumann technology, stating just how relative prices change, etc. Still, on intuitive grounds, there seems to be little doubt that in many cases (though perhaps not always) it is possible to go from a solution for one growth rate to a solution for a lower growth rate, in

[3] These difficulties, arising from investment goods which no one wishes to consume, should not be confused with the difficulties arising from discretionary consumption goods (sections 5B, 5C). These latter difficulties are, of course, also present.

some reasonable fashion, and to do so for a *continuous range* of growth rates.

In order to obtain more specific results, at the present state of research in this area, it is necessary to restrict ourselves further, to Leontief rather than von Neumann technology. The main results for that special case have been stated already, results 1 to 4 at the end of section A. Let us now discuss these results a bit further:

1. The return factor β is the inverse of an eigenvalue of the input-output matrix. It is therefore determined *from technology*. In input-output theory, such neoclassical notions as individual or social "time-preference" and/or "utility" have *no* influence on the rate of return.

2. Although there can be several eigenvalues of the input-output matrix which are acceptable from a mathematical point of view, i.e., satisfy all stated conditions including that of nonnegative prices, only one of these, at most, is "sensible" under Leontief technology. The others are "peculiar" in the sense discussed in chapter 5; i.e., the prices of all the necessary commodities are zero. The difficulties arising from the existence of such peculiar solutions, and the possible nonexistence of sensible solutions, have been discussed already in section 5C.

3. For Leontief technology, the permissible range of growth factors a in our preferred specification, A, is known; i.e., $0 < a < \beta_{min}$ where β_{min} is the *smallest* permissible return factor, i.e., the inverse of the *largest* eigenvalue of the input-output matrix. The choice of any value of a within that range has no influence at all on prices and/or the rate of return. Opting for decreased growth, i.e., lower a, does result in a more favorable ratio of present consumption to present output levels, so we are free, within very wide limits, to trade off growth versus present consumption. But the trade-off does not affect prices or the rate of return.

In the discussion of growth theory under perfect thrift, section 4E, we mentioned the existence of a large "optimality" literature in the field of growth theory. We are now in a better position to discuss this, since we have allowed for final consumption of some of the output. However, we choose to defer this discussion to the next chapter, where we go into time-paths different from simple balanced proportional growth.

We have already remarked that the permissible trade-off between present consumption and future growth reminds us of Adam Smith's views on prodigality and thrift.

To believers in Adam Smith's "invisible hand," however, it may be disturbing to find that *there is no automatic market mechanism to penalize men for their prodigality*. A society which opts for

higher present consumption, at the expense of future growth, runs with the *same* prices p_j and the *same* rate of return $r = \beta - 1$ as a more frugal society. With Leontief technology, there is no "market signal" at all in terms of prices and the rate of return; these are exactly the same. (With von Neumann technology, the situation is less clear-cut, but, on intuitive grounds, one would expect that slackening of growth is associated at most with a smaller demand for investment goods, hence possibly lower prices for these types of goods.) There is some warning, of course, but this is mainly in terms of quantities, not prices. The warning signal is nonspecific, just a general slowing down, or perhaps even reversal, of growth. The warning does *not* appear in market terms as something to urge producers or consumers, or both, to mend their ways.

Indeed, every producer of Adam Smith's "jewels, baubles, and ingenious trinkets of all kinds" wishes to increase, not decrease, the demand for his products. This frivolous demand may be pushing the economy into a decline, but try telling that to him! If he can advertise to persuade consumers that his products are necessary for self-esteem, success in love, or entry to heaven, he will most certainly advertise. It is hard to argue that he is wrong in so doing. The overall growth of the economy is not supposed to be his private concern.

As Adam Smith said quite rightly: "It is not from the benevolence of the butcher, the brewer, or the baker, that we expect our dinner, but from their regard to their own interest." But we must add the proviso that we *cannot* expect, from the same source, any particular result for the growth rate!

A competitive capitalistic system is not tied to any particular rate of growth, positive, negative, or zero. To the extent encompassed in the best available theories of economic growth, the market mechanism is able to accommodate itself to a wide range of choices of the growth rate; in the case of Leontief technology, the market can do so with no change at all in prices and the rate of return. Note that this assumes a perfectly competitive market, i.e., "ideal" conditions for economic theory.

To be fair to Adam Smith, though, we must point out that the "best available theory" of growth is still woefully deficient, since we have assumed that the available production technology does not change. The list of activities m with their input coefficients a_{mi} and output coefficients b_{mi} is taken to stay the same, no matter what happens in the choice between consumption now and growth in the future. To the extent that this is true, the theoretical results are valid. But if the invention and development of an improved

production process leads to higher returns, even if only for a limited time, then one should expect Adam Smith's motive of "regard to their own interest" to act in the direction of higher growth, overall. However, invention and development are long, risky processes; it would be nice to have a more immediate, direct market incentive to frugality rather than prodigality; what the theory shows is that no such direct incentive exists.

E. Mathematical appendix

We start with the conditions, under von Neumann technology, for balanced proportional growth. We refer to equations in section 4F and state alterations necessary.

Equations (4.1) are *augmented* by the new condition:

1′. $c_i(t + 1) = ac_i(t)$ for $i = 1,2, \ldots ,N$ and all t (6.1)

Condition 2, equation (4.2), is *altered* to read:

2. $\displaystyle \sum_{m=1}^{M} z_m b_{mi} \geqslant a \left(\sum_{m=1}^{M} z_m a_{mi} + c_i \right)$ for $i = 1,2, \ldots ,N$ (6.2)

3. If, for some i, there is strict inequality in (6.2), then $p_i = 0$ (6.3)

Thereafter, conditions 4 to 7 embodied in equations (4.4) to (4.7) inclusive, are unchanged. So are the (unacceptable) von Neumann condition N (4.8) and the more reasonable KMT conditions (4.9) to (4.11); we accept the latter. Note that sometimes we use the notation

$$s = 1/\beta = 1/(1 + r)$$

for the inverse of the return factor; this helps with "peculiar" solutions, where s may be zero. The change to equation (4.4) is obvious.

As our specification, we take specification A of section B; that is, the growth factor a and the consumption levels c_i at time $t = 0$ are taken as exogenous; everything else is endogenous.

Next, we present the mathematics of the KMT treatment of consumption by an "outside consumer." Suppose our government imposes a tax on each activity, proportional to the activity level. The tax on activity m is:

$$T_m = hz_m \tag{6.4}$$

The constant h is chosen so that the total yield from this tax is enough to cover the cost, at market prices p_i, of the entire "consumption" demand. Hence:

$$\sum_{m=1}^{M} hz_m = \sum_{i=1}^{N} c_i p_i \qquad (6.5)$$

We *define* coefficients d_i by

$$d_i = c_i / (\sum_{m=1}^{M} z_m) \qquad (6.6)$$

These coefficients are independent of time, since consumption and activity levels all grow at the same rate; but definition (6.6) is very much subject to the objection mentioned in section B, that the sum in the denominator involves adding incommensurable things. That objection, in only slightly different form, also applies to the tax specification (6.4): the activity levels z_m are not really well specified.

In equation (6.5), the factor h on the left-hand side can be taken outside the sum, as a common factor. Using the definition (6.6), we then get:

$$h = \sum_{i=1}^{N} d_i p_i \qquad (6.7)$$

Since the tax T_m is, by assumption, proportional to the activity level, each producer figures this tax as a cost, which is equal to h per unit activity level. This extra cost then appears as an additional element on the right-hand side of condition (4.4). The KMT form of this condition therefore becomes, after insertion of (6.7):

$$4''. \quad \sum_{i=1}^{N} b_{mi} p_i \leqslant \beta \sum_{i=1}^{N} (a_{mi} + d_i) p_i \quad \text{for all } m = 1, 2, \ldots, M \qquad (6.8)$$

This is the price condition used by KMT in their theory. With this condition, they obtain the result $a = \beta$; no such result is possible with consumption in the more normal sense.

Next, we give the mathematics of specification D of section B. If commodity i contains q_i "calories of food value" per unit amount of that commodity, then the total number of calories produced by running activity m at unit activity level $z_m = 1$ is:

$$r_m = \sum_{i=1}^{N} b_{mi} q_i \qquad (6.9)$$

and the total number of calories produced by the whole economy is:

$$Q(t) = \sum_{m=1}^{M} z_m(t)r_m \qquad (6.10)$$

We now specify "consumption coefficients" d_i by:

$$c_i(t) = d_i Q(t) \qquad (6.11)$$

The d_i are given, nonnegative coefficients, with at least one of them strictly positive. With this specification of consumption, condition (6.2) can be rewritten as:

$$\sum_{m=1}^{M} z_m b_{mi} \geqslant a \sum_{m=1}^{M} z_m e_{mi} \quad \text{where } e_{mi} = a_{mi} + r_m d_i \quad (6.12)$$

This is now a homogeneous condition in the activity levels, and as a result the growth factor a is now restricted to discrete values, perhaps only one discrete value. The system just specified is a special case of the one studied by Los (1976). His matrix A_1 equals our E, his A_2 our A; his B_1 and B_2 are equal to each other, and equal our B. His conditions 7 and 8 reduce to the standard KMT conditions KMT1 and KMT2; his condition 9 becomes equivalent to $(z, Ap) > 0$ in place of KMT3, $(z, Bp) > 0$. Specification D is logically permissible but leads to a theory very much more complicated than specification A.

THEOREM 6.1
Suppose there exists a solution for specified growth factor a and specified initial consumption levels c_i. Let the return factor in this solution have the value β, the prices have values p_i, and the initial activity levels have values z_m Let a' be any number in the range $0 < a' < a$. Then a solution exists with identical return factor, identical prices, and identical activity levels, with a' as the new growth factor, and consumption levels, at time $t = 0$, given by $c_i' \geqslant c_i$.

Proof: Rewrite the quantity condition (6.2) in the equivalent form:

$$v_i(a) \geqslant c_i \quad \text{where} \quad v_i(a) = \sum_{m=1}^{M} z_m[(1/a)b_{mi} - a_{mi}] \qquad (6.13)$$

The functions $v_i(a)$ defined in (6.13) are clearly nonincreasing functions of a.

The adjustment in consumption levels for the altered growth factor a' is then done as follows:

$$\text{If} \quad v_i(a) = c_i \quad \text{put} \quad c_1' = v_i(a')$$

$$\text{If} \quad v_i(a) > c_i \quad \text{put} \quad c_1' = c_i$$

With these adjustments to consumption levels, it is verified easily that all conditions are satisfied with unchanged values for β, all p_i, and all z_m.

<div align="right">Q.E.D.</div>

Note: The particular adjustment given in this proof is not unique. Free goods, namely those which give inequality in (6.13), need not be kept at identical consumption levels; rather, their consumption levels could be increased also if desired.

Next, we turn to theorems, generalizations of those of chapter 5, valid with *Leontief technology*. When we introduce this technology, i.e., when we set $M = N$ and $b_{mi} = 1$ for $m = i$, $b_{mi} = 0$ for $m \neq i$, the conditions simplify to:

$$y_j \geqslant a\left(\sum_{i=1}^{N} y_i a_{ij} + c_j\right) \quad \text{for } j = 1,2,\ldots,N \tag{6.14}$$

If there is strict inequality for some j in (6.14), then $p_j = 0$ (6.15)

$$sp_i \leqslant \sum_{j=1}^{N} a_{ij}p_j \quad \text{for } i = 1,2,\ldots,N \tag{6.16}$$

If there is strict inequality for some i in (6.16), then $y_i = 0$ (6.17)

THEOREM 6.2.
Let the matrix \mathbf{A} be irreducible and nonnegative, and let a^* be its dominant eigenvalue. Let a be a number in the range $0 < a < 1/a^*$, and let the vector $\mathbf{c} > 0$ be given. Then there is a unique solution to these conditions, with strictly positive prices $\mathbf{p} \gg 0$ and strictly positive production levels $\mathbf{y} \gg 0$. The return factor is $\beta = 1/a^*$.

Proof: Since $a > 0$ and $\mathbf{c} > 0$, (6.14) implies $\mathbf{y} \geqslant a\mathbf{c} > 0$. By (6.14), $\mathbf{y} \geqslant \mathbf{y}(a\mathbf{A})$. Then \mathbf{A} irreducible and positive implies $a\mathbf{A}$ irreducible and positive. Hence theorem 3.5 yields $\mathbf{y} \gg 0$. Equation (6.17) and $\mathbf{y} \gg 0$ imply equality in (6.16), so that s is an eigenvalue of \mathbf{A}, and \mathbf{p} is a right eigenvector. By theorem 3.6, the dominant eigenvalue a^* is the only one giving nonnegative \mathbf{p}, and then $\mathbf{p} \gg 0$. This, along with (6.15), implies equality in (6.14). The solution for the output levels is then:

$$y = c[(1/a)I - A]^{-1} \tag{6.18}$$

Theorems 3.8 and 3.9 ensure that the inverse operator in (6.18) exists and is nonnegative if and only if $1/a > a^*$; i.e., $0 < a < 1/a^*$. The return factor β is related to the eigenvalue s by $\beta = 1/s$; hence $\beta = 1/a^*$.

Q.E.D.

Next, we introduce discretionary consumption goods in the same way as in section 5E; that is, we accept (5.6), (5.7), and (5.10). In (5.8), we omit the requirement that E be productive, since the "growth" theory of this chapter permits the "growth" to be negative, i.e., a decay; that is, a growth factor $a < 1$ is mathematically acceptable within this theory, so there is no need to insist that the input-output system be productive, at least no formal need. For exactly the same reason, condition (5.9) can be dropped altogether. Our *assumptions* are therefore: (5.6), (5.7), (5.10), and irreducibility of E.

THEOREM 6.3

Let $z = (z_1, z_2, \ldots, z_m)$ be a positive right eigenvector of G belonging to the eigenvalue g of G. Let a be within the range $0 < a < 1/a^*$. Then there exists a class of growth solutions with $s = g$ and with zero prices for all essential goods: $p_i = 0$ for $i = 1, 2, \ldots, k$; the prices of the DCGs are given by: $p_{k+i} = z_i$ for $i = 1, 2, \ldots, m$. There are infinitely many solutions in this class.

Note: This is the direct generalization of theorem 5.2; the solutions in question are the "peculiar" solutions which cause so much discomfort.

Proof: The proof starts almost exactly as does the proof of theorem 5.2, with only trivial changes associated with having to insert factors a at various points. This leads to equation (5.12) and the conclusions regarding $s = g$ and the price system, as before. Thereafter, (5.13) is replaced by:

$$y \geqslant c[(1/a)I_n - A]^{-1} \tag{6.19}$$

where I_n is the n-by-n unit matrix, $n = k + m$, and strict equality must hold for those indices i for which $p_i > 0$. All those indices must exceed k for the solution discussed here. For free goods, $p_i = 0$, inequality is possible in (6.19). Since this includes at least all the necessary goods $i = 1, 2, \ldots, k$, we have infinitely many solutions for the quantities. The condition on a follows from theorems 3.8 and 3.9.

Q.E.D.

Note: The values of $1/\beta$ must be eigenvalues of G, and any eigenvalue of G leading to a nonnegative right eigenvector is acceptable. But the condition on permissible growth factors a refers to the *dominant* eigenvalue a^* of A, which corresponds to the *smallest* permissible return factor β; call this $\beta_{min} = 1/a^*$. The restriction on allowable growth factors is then

$$0 < a < \beta_{min} \qquad (6.20)$$

This is true for *all* solutions, not only for solutions with this smallest return factor. Thus, while $a < \beta$ for all permissible solutions, the true restriction on a is often rather stronger than this.

THEOREM 6.4

Let e^* be the dominant eigenvalue of **E**, g^* of **G**. Let the k-component vector $p^* \geqslant 0$ be the right eigenvector of **E** belonging to e^*. Then: (a) If $e^* \leqslant g^*$, then the peculiar solutions of theorem 6.3 are the *only* solutions, and (b) if $e^* > g^*$ and a is chosen within the range $0 < a < 1/e^* = 1/a^*$, then there exists exactly one further unique, "sensible" solution with $s = e^*$, $p_i = p_i^*$ for $i = 1, 2, \ldots, k$, and quantities determined uniquely and positively by (6.18). The prices of the DCGs are determined in terms of the prices of essential goods; all prices are strictly positive.

Proof: This proof is identical with the proof of theorem 5.3, along with the obvious fact that $e^* > g^*$ implies $a^* = \max(e^*, g^*) = e^*$.

Q.E.D.

CHAPTER 7

Dynamic stability

A. Introduction

In chapters 3 through 6 we have investigated balanced growth paths, where all commodity outputs are in exactly the correct proportions to make the system continue along the same path. If there are consumption demands over and above bare subsistence (i.e., we do not have perfect thrift) then consumption demands also grow at the same rate. Such balanced growth solutions always exist in a perfect thrift system (chapters 3 and 4) but may turn out to be "peculiar" when there are consumption demands for discretionary consumption goods (chapter 5). In the present chapter, we address ourselves to another type of difficulty with growth solutions, a type which, it turns out, happens even in a "perfect thrift" system.

These new difficulties arise if the proportions between quantities are not quite right at the initial time, or if the system is thrown slightly off the balanced growth path by some unforeseen event, such as an unusually good harvest of corn one year. If such small deviations have a tendency to smooth out in subsequent years, so that the system returns to a state of balanced growth, then we say that the growth path is *locally stable*. On the other hand, if small initial deviations tend to amplify in subsequent years, so that we get ever bigger deviations, then the growth path is said to be *unstable*. This stability or instability, as the case may be, is *dynamic* rather than static, since our comparison, normal behavior, is not a state of static equilibrium, but rather a dynamic, growing state. The "local" in "locally stable" means that we are concerned, for the moment, only with states fairly close to the state of balanced growth, that is, with rather small deviations.

In discussing stability questions, it is absolutely necessary to

consider situations away from perfect balance, situations with a time-dependence more complicated than simple proportional growth. The effect of this is to make the theory inherently more difficult. We quote Frank Hahn (1970): "No unifying principle, such as maximization, seems available; no elegant separation theorems reduce the mass of ugly differential or difference equations to the splendid order of a chapter in Debreu. To discuss and analyze how the economy works it may be necessary to go and look."

Happily, we are able to suggest a way out for the theorist which avoids the terrible prospect opened up by Hahn's final sentence. A unifying principle *is* available and can be used to make quite definite statements about the system. Like most such theoretical principles, it is not a precise, but only an approximate, description of the real world. But it is no worse in this respect than, for example, the very prevalent assumption of general equilibrium.

The suggested principle consists of two separate assumptions:

1. Perfect clearing of all markets.
2. Perfect thrift.

We have encountered these two assumptions many times already, in connection with the theory of balanced growth. But it is now important to emphasize that these two assumptions suffice to *determine the future path of an input-output system, even if this path is not one of balanced growth at all.* Intuitively, it should be clear how this comes about: First, if there is perfect thrift, the entire output from last year is used as production inputs (including, of course, necessary consumption, but excluding discretionary consumption) for the year after. Second, if all markets clear, and if the technological relationships between inputs and outputs have been specified, then there is really only one way to proceed. We see this, in much more detail, in later sections. With (fixed coefficient) Leontief technology, one gets a determinate system in terms of quantities only; if the technology permits input substitution, one still gets a determinate system, provided only that each producer attempts to minimize his input costs for given outputs, but the system involves price ratios as well as quantities. We describe both types in this chapter, but we shall start with the simpler, Leontief technology.

There is a considerable literature on the subject of local stability of the balanced growth path. Generally, stability is considered to be a highly desirable property of an economic model, and great efforts are made to ensure that economic models are stable. A number of possible sources of instability have been postulated in the literature. But it is believed, fairly generally, that all of these are in the nature of "imperfections" of some sort and would not

occur in a state of perfect competition, perfect clearing of markets, etc. Let us now list a few possible sources of instability:

(a) Consumer-caused instabilities, for example, sudden changes in taste or in the propensity to consume.

(b) Uncertainty of the future, including sudden changes of expectations about what the future may bring.

(c) Market imperfections, such as elements of monopoly or oligopoly, "sticky wages," imperfect information about choices leading to incomplete market clearing.

(d) The need for accumulation of fixed capital, and the associated large investment in machinery needed to accommodate *rapid* changes in demand for output, even if the absolute amount of the change is fairly small (the key word is "acceleration principle"; we discuss this effect in chapter 9).

(e) "Credit is inherently unstable. . . . Activity causes credit expansion, credit expansion increases demand, demand evokes greater activity" (Hawtrey 1926, p. 344).

In this chapter, we shall *not* investigate such matters at all. Rather, we set out now to construct a model which is so simplified that *none* of the above causes of instability is present. The model has a well-defined growth path and is of the type studied in chapter 3. In relation to the possible causes of instability listed above, we have the following:

(a) Our assumption of "perfect thrift" excludes discretionary consumption altogether. Workers get a subsistence wage which they spend on an unvarying basket of goods; capitalists reinvest all their returns so as to attain maximum growth. Changes in taste do not come in, because tastes do not come in. Composition of final demand is unchanged, because this demand is zero.

(b) We assume perfect certainty of the future. Given the inputs at the start of a year, the outputs are completely predictable.

(c) We assume perfect markets throughout. No monopolies exist; all markets clear perfectly at completely flexible prices. The wage of labor is fixed completely in terms of the "wage bundle" of necessary consumption goods, for all of which prices are adjusted by an auctioneer so that the market clears exactly.

(d) We assume away fixed capital, by using a Leontief technology rather than a von Neumann technology.

(e) No credit is given, or received, in our annual market. All trading is for spot cash, and no trading at all is done until after the auctioneer has determined a set of prices which will just clear the market. Market clearing is true both for quantities and for values.

Naturally, we do not suggest that there ever was, or ever will be such a perfect market. But we shall find it worthwhile to investi-

gate such a perfect model, to see what its dynamic properties are. Most economists suppose that such an extreme model results in a dynamically stable balanced growth path. We know, from chapters 3 and 4, that the balanced growth path is unique (recall that perfect thrift implies, among other things, no production of discretionary consumption goods and, in a Leontief technology, irreducibility of the input-output matrix). The question before us now is: Is this unique balanced growth path stable?

B. Dynamic instability—Leontief technology

We start from the input-output table of the two-commodity system of section 3A. To produce one quarter of corn, one needs as inputs 0.9 quarters of corn and 0.05 tons of iron. To produce one ton of iron, one needs as inputs 0.6 quarters of corn and 0.2 tons of iron.

Suppose we plan to produce, in period $t + 1$, $y_1(t + 1)$ quarters of corn and $y_2(t + 1)$ tons of iron. To do this we need the following inputs at the start of the period:

Input of corn $= 0.90y_1(t + 1) + 0.6y_2(t + 1)$ quarters

Input of iron $= 0.05y_1(t + 1) + 0.2y_2(t + 1)$ tons

At this stage, we invoke our basic assumptions of perfect thrift and perfect market clearing: With perfect thrift, the entire output of the preceding year is available for productive inputs this year, and, with perfect market clearing, all of it will actually be used in that fashion, none of it being wasted or left over.[1] Thus, the required inputs which we have just worked out must *equal* the actual outputs of these commodities from the preceding year. Whatever prices are finally fixed by the auctioneer, they must work out in such a way that we reach the following condition for quantities:

$$y_1(t) = 0.90y_1(t + 1) + 0.6y_2(t + 1)$$

$$y_2(t) = 0.05y_1(t + 1) + 0.2y_2(t + 1)$$

These equations, in quantities alone, can be looked at in two ways: (1) if the production plans for year $t + 1$ are known, then the equations determine the (minimum) amounts of the two commodities which must be available to meet these plans; or (2) if the quantities available now, $y_1(t)$ and $y_2(t)$, are given, then these equations *determine* the one, unique set of production plans for

[1] One might think this is impossible because of the fixed coefficients; however, it *is* possible as long as the two productive activities require *different ratios* of corn input to iron input ($0.9/0.6 \neq 0.05/0.2$).

year $t + 1$ which will work out so as to clear the market at time t.

It is this second way of looking at these equations which interests us now. To show that the production plans are indeed completely determined, let us solve these equations explicitly for the unknown production plans in period $t + 1$. We multiply the first equation by 0.2 and the second by 0.6 and then subtract the resulting equations, to get:

$$0.2y_1(t) - 0.6y_2(t) = (0.2 \times 0.9 - 0.6 \times 0.05)y_1(t + 1) + 0$$
$$= 0.15y_1(t + 1)$$

This yields the value of $y_1(t + 1)$ in terms of quantities available now. We then substitute this value into either one of the two original equations and solve for $y_2(t + 1)$. The final result is:

$$y_1(t + 1) = (4/3)y_1(t) - 4y_2(t)$$
$$y_2(t + 1) = -(1/3)y_1(t) + 6y_2(t)$$

These production plans, and *only* these production plans, for period $t + 1$ clear the market at time t. The outcome is completely determined by our basic assumptions of market clearing and perfect thrift.

Let us check, first of all, that the balanced growth solution of section 3B satisfies these equations. In balanced growth, we found that 14.81025 quarters of corn must be produced for every ton of iron; and then output grows with a growth factor 1.06325, equally in both commodities. Suppose we start, then, with 148,102.5 quarters of corn and 10,000 tons of iron as initial quantities, at time $t = 0$. We substitute these into our equations above, to get:

$$y_1(1) = (4/3)(148,102.5) - 4 \times 10,000 =$$
$$157,470.0 \text{ quarters of corn}$$

$$y_2(1) = -(1/3)(148,102.5) + 6 \times 10,000 =$$
$$10,632.5 \text{ tons of iron}$$

This is correct: (a) The ratio y_1/y_2 is unchanged; i.e., 157,470.0/10,632.5 = 14.81025, the same ratio as before; and (b) both outputs have grown by the same growth factor: 157,470.0/148,102.5 = 10,632.5/10,000 = 1.06325. If we now continue to compute market-clearing production plans for period 2, given the quantities available at the end of year 1 (by assumption, exactly equal to the planned values), then the same balanced growth continues; and so on, period after period.

Let us now suppose that our initial quantities are slightly out of balance; we had unusually good weather the year before, and as a

Table 7.1

Table of Production Levels with Perfect Markets

Year t	Corn $y_1(t)$	Iron $y_2(t)$	Ratio y_1/y_2	Comments
0	148,250.6	10,000.0	14.82506	0.1 percent imbalance
1	157,667.5	10,583.1	14.8980	0.6 percent imbalance
2	167,890.8	10,943.0	15.3423	3.6 percent imbalance
3	180,082.5	9,694.0	18.5762	Iron output decreasing
4	201,333.0	−1,862.0	Negative	Disaster!

result the value of $y_1(0)$ is slightly larger than 148,102.5 quarters, let us say larger by 0.1 percent: $y_1(0) = 1.001 \times 148,102.5 = 148,250.6$ quarters; nothing has changed for iron, so $y_2(0) = 10,000$ tons. Furthermore, we assume that, ever after, the weather behaves precisely as predicted, so all production plans, from this moment on, work out precisely, actual outputs being equal to planned outputs for times $t = 1, 2, 3, \ldots$ until eternity.

The same calculation as before now gives:

$$y_1(1) = (4/3)(148,250.6) - 4 \times 10,000 =$$
$$157,667.5 \text{ quarters of corn}$$

$$y_2(1) = -(1/3)(148,250.6) + 6 \times 10,000 =$$
$$10,583.1 \text{ tons of iron}$$

As expected, these planned, and by assumption eventually achieved, production levels for year 1 do not differ by much from the perfectly balanced levels for year 1. But the ratio of $y_1 : y_2$ is extremely worrying: At time $t = 0$, this ratio was 14.82506, a mere 0.1 percent above the perfectly balanced value; at time $t = 1$, we have $y_1 : y_2 = 14.8980$, farther away from the balanced value, the new discrepancy being 0.6 percent instead of 0.1 percent. This does not augur well for stability!

In Table 7.1, we give for each year the production levels y_1 and y_2, as well as their ratio $y_1 : y_2$, and we append some comments.

This is instability with a vengeance! We started from an imbalance of 0.1 percent in year 0. With absolutely perfect markets, the degree of imbalance worsens year by year, and we strike absolute disaster (a negative output of iron needed for year 4) in the market at the end of year 3. Not only is the system unstable, the insta-

bility is so violent it shows up in the first few years.[2]

What about prices? We start with slightly too much corn, compared to perfect balance. A simple first guess is that this should lead to a drop in the price of corn, compared to that of iron; that is, we expect a drop in the price ratio $P = p_1/p_2$. This drop in price should then induce corn producers to plan for lower production levels, thereby tending to restore balance.

Well, let us work out this price ratio $P = p_1/p_2$. To do so, look at the corn producers. They start with 148,250.6 quarters of corn, but of course they must withhold some of that corn from the market, because they need corn as part of their own input for production in year 1. Their planned production level is 157,667.5 quarters, and the required corn input for this is $0.9 \times 157,667.5 = 141,900.8$ quarters. Thus, the corn they bring to the market for sale is $148,250.6 - 141,900.8 = 6,349.9$ quarters. Similarly, the iron producers start with 10,000 tons, but they must withhold for their own needs 0.2 times the planned production level of iron; i.e., they withhold $0.2 \times 10,583.1 = 2,116.6$ tons and bring to market $10,000 - 2,116.6 = 7,883.4$ tons. In the market, then, 6,349.9 quarters of corn exchange for 7,883.4 tons of iron; this can come about, with perfect market clearing, if and only if the price ratio is:

$$P = p_1/p_2 = 7,883.4/6,349.9 = 1.2415$$

This value differs from the balanced price ratio found in section 3C, which was $P^* = 1.23419$. The price mechanism is at work, all right.

But is it working in such a direction as to aid stability? Not at all! The price ratio P is *higher* than the balanced one, P^*; that is, corn has *risen* in price compared to iron. In a situation where we have started with too much corn, compared to balanced growth ratios, a higher price for corn is completely wrong for producing stability. Adam Smith's invisible hand is at work, all right, but it is pushing in the wrong direction!

But how can a larger quantity of corn lead to a higher price for corn? Is the whole thing perhaps just an error of calculation?

There is an error all right, but it is not in the calculation; it is an error in the classical reasoning. Not enough attention is paid, in that reasoning, to the distinction between total production of a commodity and the supply of that same commodity to the market. We worked out, above, the supply of corn to the market when the total quantity of corn is 0.1 percent above balance; this

[2] In practice, such imbalances are often exhibited first as changes in inventory (stock) levels. For "inventory cycles," see chapter 9.

supply turned out to be 6,349.9 quarters. What would it have been in perfect balance? If we start from 148,102.5 quarters initially and plan to produce next year 157,470.0 quarters (these are the balanced values we worked out as a check, initially), then the amount of corn supplied to the market is:

$$148{,}102.5 - 0.9 \times 157{,}470.0 = 6{,}379.5 \text{ quarters}$$

This is *more* than the 6,349.9 quarters of corn reaching the market in the unbalanced case.

The origin of the paradox is now clear: A larger-than-balanced total output of corn leads to a smaller-than-balanced supply of corn to the market. With such a "perverse" behavior for quantities, market-clearing prices *must* be equally "perverse."

We are now in a position to discuss the possibility that some corn producers may decide to use part of the money they gain from selling corn to enter iron production the year after. Our calculation has ignored this possibility; i.e., we have assumed that no such shifting of roles occurs. In a situation of excess corn (compared to balance), balance can be restored if corn producers shift to iron production. However, they have absolutely no incentive to do so! With the price ratio behaving "perversely," it is the *corn* producers, not the iron producers, who are making excess profits. If any switching takes place at all, it is by iron producers switching to production of corn. Far from helping to restore balance, this effect therefore just makes the imbalance even worse.

But perhaps this "perverse" or paradoxical behavior is exceptional, true for the particular case which we have constructed, but not generally true. Not so! In the mathematical appendix, we prove that *the balanced growth path is always locally unstable if the input-output matrix is irreducible and has an inverse*. (Perfect thrift implies irreducibility—see section 3B; if an irreducible matrix has no inverse, changing a few coefficients by infinitesimal amounts is enough to make it have an inverse; hence the conditions are not seriously restrictive.) Instability holds no matter how many commodities are in the system (except of course when there is only one commodity!), and no matter how the initial endowments differ from perfect balance. Any deviation at all, no matter how small and no matter in which commodities, leads to growing imbalance and eventual disaster. Our special example *is* the general case!

One may, of course, question some of our assumptions, such as "perfect thrift" or fixed coefficients Leontief technology. We shall allow input substitution in section C; as regards perfect thrift, note that we have *not* excluded all consumption: Consumption of necessities is included in the theory, within the input coefficients (input

corn is needed for iron production to provide food for iron workers). Furthermore, exactly this same assumption of perfect thrift is made in the von Neumann growth theory, which is accepted conventionally. Since Leontief technology is a special case of von Neumann technology (see section 4A) we have now provided a proof that there exist instances in which the von Neumann system is dynamically unstable.

There is a common belief that the balanced growth path is a "natural center of attraction" for a competitive economic system, a path which is approached by such a system as a result of its inherent dynamics. *This belief is false.*

C. Input substitution

From a neoclassical point of view, one is likely to question the rather rigid "fixed coefficients" nature of Leontief technology on which the work of section B is based. It may be argued, and has indeed been argued, that our instability is due to this extreme rigidity. A more flexible set of technological assumptions, permitting substitution between input factors in response to changes in relative prices, might then result in a stable growth path. In this section, we address ourselves to this argument, and we show that a reasonable degree of input substitution does *not* alter our conclusions. Since the ultimate result is the same as in section B and the detailed arguments tend to get complicated (as usual in neoclassical theories), this section may be omitted without loss of continuity in the main argument.

Let x_1 be an input quantity of corn, x_2 of iron, to some productive activity of which y is the output quantity (let us say, for now, of corn). A "production function" is a functional relationship $y = f(x_1, x_2)$, which defines how much output we obtain for given input quantities. Since our inputs are commodities (corn and iron) which are used up in the production process, the difficulties associated with defining a "quantity of capital" do not concern us here (Harcourt 1972). We shall assume that production gives constant returns to scale, so that f is a linearly homogeneous function. Twice the input leads to twice the output. Hence everything significant about the function $f(x_1, x_2)$ can be read off from a graph of the "unit isoquant," that is, the graph of the relationship:

$$f(x_1, x_2) = 1 \qquad \text{Unit Isoquant}$$

All other isoquants can be obtained from this one by simple scaling.

It is possible to represent Leontief technology in this form, but the unit isoquant is then a rather peculiar "curve," consisting of a

vertical straight line segment and a horizontal straight line segment, which meet at a corner point corresponding to the assumed input coefficients a_{ij}; for example, for corn production in our usual example, the two straight line segments meet at $x_1 = 0.9$ and $x_2 = 0.05$. The meaning is this: If we have exactly 0.9 quarters of corn and 0.05 tons of iron, we can use them to produce one quarter of corn. If we have "too much" iron, say 0.08 tons of iron, and we wish to produce corn, then the only way we can do so is to use 0.9 quarters of corn with 0.05 tons of iron, as before, and to *throw away* the extra 0.03 tons of iron. This is what we mean by the rigidity of fixed coefficient technology. There is no doubt that this is a rather extreme limiting case.

Let us now proceed to show how we can set up the problem with arbitrary production functions for corn production and iron production. As before (section A), we assume perfect thrift and perfect market clearing. To this we now add further assumptions:

3. Each producer attempts to minimize his input costs per unit of output, at whatever prices rule in the market; all producers are price-takers.

4. All production functions satisfy the so-called Inada (1963) conditions, standard in neoclassical analysis. Our chosen functions do.

5. Producers neither ask for, nor receive, credit (we recall that credit is itself a possible source of instability and has been excluded *only* for that reason). Thus next year's productive inputs are purchased out of sales revenue of existing output (from last year's production).

6. Each producer may attempt to maximize his expected profit from next year's production; this may move him to switch from producing corn last year to producing iron next year, or vice versa. But the information available to him for this maximization consists only of prices (past prices, current prices cried out by the auctioneer, guessed future prices), *not* of economy-wide total quantities of commodities. Only the auctioneer knows those. Thus, optimization subject to quantity constraints is *impossible* for our small firms.

7. While some producers may switch from producing iron to corn, the fraction that does so is zero if expected return rates in the corn industry are lower. The fraction is an increasing function of the disparity in rates of return if corn production promises better returns. (This picture contrasts with the less realistic assumption, often found in the literature, that all producers switch instantaneously as soon as there is even the smallest disparity in rates of return.) Thus, in the immediate neighborhood of the bal-

anced growth path, the effects of switching are always small. We ignore switching in this section, but we show in the mathematical appendix that this neglect is justified for an investigation of *local* stability of the system.

The analysis which follows uses many neoclassical concepts but is not neoclassical in spirit. We start by outlining the intuitive picture.

At the start of the annual market day, numerous small producers of corn show up, each with his small quantity of corn; and so do the small iron producers, with their iron. The auctioneer now appears and "calls out" prices for corn and for iron. Each producer calculates, on the basis of these prices (and perhaps also past prices and guessed future prices), what he will get from selling his output, and what input quantities of corn and of iron he can purchase, in optimum proportions for least cost of production next year, with the proceeds. The producer then makes his bid to the auctioneer. The auctioneer notes down all these bids. If the bids result in some corn or some iron's being left unsold, the auctioneer concludes that the prices he has called out fail to clear the market. He then "cries out" a different set of prices. This process continues until a set of market-clearing prices is found by the auctioneer.[3] At this point, and only then, does the auctioneer permit transactions to take place. The exchanges now commence, and at the end of the market day all the corn and all the iron have been cleared, and every small producer has spent, on purchases of his inputs of corn and iron for next year's production, exactly that amount which he has received from selling his product from last year.

Let us now write down the various conditions which must be satisfied by such a market. We start with the "efficiency" conditions for producing at least cost, for given current prices. The "factors" producing the results are input quantities of corn and of iron, *not* "labor" or "capital." Let us denote by $g(x_1, x_2)$ the *ratio* of the marginal product of factor 1 to the marginal product of factor 2. The least-cost proportion between inputs is reached when this ratio is equal to the ratio between the prices p_1 and p_2 of these two factors, denoted by P henceforward: $P = p_1/p_2$. The prices in question are prices in the *current* market (prices cried out by the auctioneer); no guessing at future prices is involved in the condition:

$$g(x_1, x_2) = P$$

[3] We shall *not* be concerned with the method used by the auctioneer to find these market-clearing prices. Rather, we assume that, if market-clearing prices exist at all, the auctioneer will find them.

So far, we have considered "a" production process. However, two commodities are being produced (by different firms), corn and iron. We must therefore improve our notation, to make clear which production process is being considered. We have two distinct production functions, f_1 for corn production, f_2 for iron production. Similarly, there are two marginal product ratios, g_1 for corn and g_2 for iron. Finally, we must distinguish between corn input to corn production, called x_{11}, and corn input for production of iron, called x_{21}.[4] The first subscript indicates what is being produced; the second subscript defines the nature of the input commodity. There are then two "efficiency" conditions:

$$g_1 (x_{11}, x_{12}) = P \qquad \text{Efficiency condition, corn production}$$
$$g_2 (x_{21}, x_{22}) = P \qquad \text{Efficiency condition, iron production}$$

Note that our notation does *not* mean that x_{11} and x_{21} are in any sense different *types* of corn, or that corn cannot be switched from input to one process to the other. Not at all: Both x_{11} and x_{21} denote amounts of corn; the first subscript merely serves to distinguish the process for which the corn acts as input.

Although these conditions have been written in terms of total input quantities x_{ij}, this is deceptive. The production functions f_i are (by assumption) linearly homogeneous functions (constant returns to scale); hence the ratios g_i are homogeneous functions of degree zero. Thus, it makes no difference at all whether we use total inputs x_{ij} over the whole economy, or inputs relevant to one small producer. The thing which is determined is the *ratio* x_{i1}/x_{i2} for production process i to run at least cost, and this ratio is the same for every producer, and hence also for the whole economy.

Next, we invoke the assumptions of perfect thrift and perfect market clearing. By exactly the same reasoning as in section B, this means that the total input of corn for production in period $t + 1$ must be exactly equal to the entire output of corn from the preceding period, which latter we shall denote by $y_1 (t)$, and the same for iron. Hence:

$$x_{11} + x_{21} = y_1 (t) \qquad \text{Market clearing, quantities of corn}$$
$$x_{12} + x_{22} = y_2 (t) \qquad \text{Market clearing, quantities of iron}$$

Note that these conditions are in the nature of commands to the auctioneer, to tell him not to be satisfied until his cried-out prices are such that the market clears. They are *not* conditions on individual small producers and are *not* constraints under which the in-

[4] These symbols should be read as "ex-one-one" and "ex-two-one," respectively, not as "ex-eleven" or "ex—twenty-one." The two numerals are separate subscripts; the general form is x_{ij}.

dividual small producer maximizes anything whatever.

Finally, we come to the most difficult condition, namely, that the market must also clear in value terms. The general case, with producers switching from production of corn to production of iron, or vice versa, is discussed in the mathematical appendix. Here, we restrict ourselves to the case where no such switching occurs. (It is shown in the appendix that this special case is sufficient for discussion of local stability in the immediate neighborhood of the balanced growth path.)

With no switching allowed, the market exchange is simply between a quantity x_{21} of corn (sold by corn producers to the iron industry) and a quantity x_{12} of iron (sold by iron producers to the corn industry). This market exchange clears in value terms if and only if $x_{21}p_1 = x_{12}p_2$. We divide both sides by p_2 to get:

$$x_{12} = Px_{21} \qquad \text{Market clearing, values, no switching}$$

We note that all conditions written down so far involve either no prices at all, or the price ratio $P = p_1/p_2$ between *current* prices called out by the auctioneer. No guessing of future prices is needed for any of these conditions.[5]

Let us now count unknowns and equations. We see that $y_1(t)$ and $y_2(t)$, the outputs from last year, are *given* quantities; they are our "initial endowments." The unknowns are the price ratio P and the four input quantities x_{11}, x_{12}, x_{21}, and x_{22}. These are five unknowns, and we have just written down five equations connecting them.

Therefore there cannot be a continuous range of solutions, only a discrete number of distinct, separate solutions. A more mathematical investigation shows that this number must be odd; i.e., there may be one solution only, or three distinct solutions, or five distinct solutions, etc. In particular, the system will always have at least one solution, though there is no guarantee that this solution will be economically reasonable (for example, the price ratio P may turn out to be entirely wild).

It follows that there is only the most limited opportunity for the auctioneer to maximize anything whatever. If there is only one solution, the auctioneer has no choice at all. If there are three, or five, etc., distinct solutions, the auctioneer can select the "best" one among those, and only those, solutions. In our computer program, we have defined the "best" price ratio P to be the one closest

[5] This is no longer true when switching is permitted. Calculation of expected rates of return for corn and iron production, on which switching decisions are based, does involve guesses at future prices, as discussed in the mathematical appendix.

to the price ratio for balanced growth (closest in a ratio sense). This biases the calculation in favor of returning to the balanced growth path, i.e., in favor of stability. If the auctioneer is instructed to aim for this "best" P among all solutions, then the auctioneer has no more choice: His job henceforth is not to optimize anything, but merely to clear the market. Under our present assumptions (no switching) the market-clearing and efficiency conditions involve neither past prices, nor future prices; the prices which are involved here are *only* those cried out by the auctioneer.

Now let us suppose that the auctioneer has done his assigned job, for this year's market. We now know the price ratio P and the input quantities x_{ij} at time t. Given the input quantities at the start of the time period $t + 1$, we can immediately deduce the output quantities at the end of that year, from the two production functions:

$$y_1(t + 1) = f_1(x_{11}, x_{12}) \qquad \text{Output of corn in year } t + 1$$
$$y_2(t + 1) = f_2(x_{21}, x_{22}) \qquad \text{Output of iron in year } t + 1$$

These are our "initial endowments" for the market at time $t + 1$. We can now repeat the same calculation, leading to outputs for the market at time $t + 2$; and so on and on and on.

If we start, at time $t = 0$, from initial endowments $y_1(0)$ and $y_2(0)$ very close to, but not precisely equal to, the proportions needed for balanced growth, then we can follow the resulting time development, period by period. If the ratio $y_1(t)/y_2(t)$ tends to come back to the ratio for balanced growth, we say the system is locally stable. If this ratio tends to deviate further and further from balance, reaching values not at all close to balanced proportions, then we say the system is locally unstable.

Let us now turn to assumptions about the production functions. In real life, there are two quite different types of "input substitution," and it turns out to be important to keep these two types distinct in the analysis:

1. We may vary input proportions slightly while still staying within one basic technique of production. This can be done usually, but only to a very limited extent. For this type of input substitution, the "elasticity of substitution" σ is necessarily quite low. (Chenery 1949, Johansen 1959).

2. We may switch to an entirely different technique of production which uses more of the cheaper input, less of the more expensive input.

Let us start with the first type of input substitution. It turns out (see the mathematical appendix) that the so-called "C.E.S.

production function"[6] (C.E.S. standing for "constant elasticity of substitution") is very well suited for our purpose. This function has three adjustable parameters, one of which is the elasticity of substitution σ. The other two parameters can be adjusted so as to mimic the same *balanced* growth path as is obtained from some given Leontief input-output matrix A with matrix elements a_{ij}. For given matrix elements a_{ij}, we therefore have two additional parameters at our disposal, namely, the elasticities of input substitution for corn production, σ_1, and for iron production, σ_2.

It can be proved, albeit by mathematics too lengthy to appear in this book, that the balanced growth path is dynamically stable *if and only if*

$$\frac{a_{11}\sigma_1 + a_{22}\sigma_2}{a_{11} + a_{22}} > \frac{1}{2} \qquad \text{Dynamic stability condition}$$

This result, which has been checked by computer simulations, bears out the qualitative analysis of section B. There we found that the instability of the Leontief system arises from the need of corn producers to withhold some of their corn output from the market, for their own use as input for next year's production, and the same for iron producers. The coefficient a_{11} of the input-output matrix (equal to 0.9 in our usual example) defines how much corn must be retained by the corn producers; the coefficient a_{22} defines how much iron must be retained by the iron producers. Our stability condition involves, on the left side, a weighted average of the two elasticities of substitution, with the higher weight to that commodity which needs more of itself for its own production.

At first sight, this result may appear encouraging for stability. The system is stable if the elasticities of substitution are, on such a weighted average, bigger than one-half.

However, such high elasticities of substitution are quite unreasonable for the first type of input substitution, where we are staying within one basic technique of production of the commodity in question. Reasonable values of elasticities are well below one-half (Chenery 1949; see p. 527).

Let us now, therefore, turn to the second type of input substitution, where we have a choice between two or more entirely different techniques for producing one commodity. Suppose, for the sake of illustration, that we can choose between two methods of iron production. At the "balanced" price ratio $P = 1.234187$, method A is efficient with inputs of 0.54 quarters of corn and 0.28 tons of iron (for unit output of iron); method B is efficient

[6] Arrow (1961), Brown (1962, 1963).

with inputs of 0.70 quarters of corn and 0.08 tons of iron. Further-more, at this same price ratio, the two methods are competitive; i.e., the straight line segment connecting the points (0.54, 0.28) and (0.70, 0.08) has a slope equal to the price ratio (except for sign). The situation is sketched in Figure 7.1. Technique A allows input substitution, as given by a C.E.S. function (say) with a modest elasticity of substitution; ditto for technique B. But we may also produce our iron with a mixture of techniques, say 60 percent produced by technique A, 40 percent by technique B. Such mixtures lead to points on the dashed straight line in the figure. If the slope of this dashed line equals the price ratio, all points on the line are equally "efficient," and thus the effective elasticity of substitution is infinite at this price ratio.

If there are more techniques for producing iron, say techniques A, B, C, D, . . . , then Figure 7.1 must be amended corresponding-ly. We get a whole series of rounded corners, connected pairwise by straight line segments.

In neoclassical analysis, it is conventional to replace such a pic-ture by one, smooth and smoothly differentiable, composite pro-duction function. The production function is, in some sense, a rea-sonable approximation to the more precise picture. It then serves as input for further calculations.

We now present *two arguments against this approach*:[7]

1. The replacement of the actual function, with its rounded corners and connecting straight line segments, by a smooth ap-proximating function is unsuitable. The smooth function may, perhaps, represent a fair approximation to function *values*, but not at all to *derivatives* of the function. Since neoclassical analysis de-pends upon taking derivatives, it is insufficient to merely approx-imate function values. For Figure 7.1, the elasticity of substitution is not at all smooth. It equals the elasticity σ_A for pure technique A when the price ratio is such that technique A is superior; it equals the elasticity σ_B for pure technique B when the price ratio favors that technique. In between, at exactly one precisely given price ratio (equal to the slope of the dashed line), the elasticity of substitution is infinite! Hence, the derivatives of the "true" function are completely different from anything "smooth."

2. Furthermore, the "true" function is, at best, valid only in the long run. But for stability analysis, we require a short-run calcula-tion, from one year's market to the next. In the short run, iron is produced by two separate techniques, A and B, and each set of iron producers looks only to its own inputs and outputs and

[7] Note that these two arguments invalidate a great deal of published material in economics.

money returns. The composite function, with the dashed straight line segment, may be the end result in the long run, *if* the system is stable enough so that this end result can be reached. But assuming the composite function at the start of our analysis amounts to nothing more than to assume what needs to be proved!

For these two reasons, a valid analysis of the second type of input substitution must not start from the composite production function, but rather must start from the separate techniques (A and B in our example) for producing the commodity, keeping track of the input and output quantities of iron and corn for both these types of iron-producing activities.

This can be done easily enough, merely by extending our previous scheme of analysis. Assuming just one method of producing corn (as before) and exactly two separate methods, A and B, for producing iron, we then have three activities in the economy: (1) production of corn, (2) production of iron by technique A, and (3) production of iron by technique B. Our "initial endowments" are now $y_1(0)$, $y_2(0)$, and $y_3(0)$, where $y_3(0)$ is the output, from the preceding year, of those iron producers who employed technique B; i.e., $y_3(0)$ is the quantity of output from activity 3, the year before. Total amount of iron available at time $t = 0$ is $y_2(0) + y_3(0)$.

We then have three, not two, efficiency conditions (one for each activity). There are two market-clearing conditions for quantities, namely, one for total quantity of corn, the other for total quantity of iron:

$$x_{11} + x_{21} + x_{31} = y_1(0) \qquad x_{12} + x_{22} + x_{32} = y_2(0) + y_3(0)$$

There are, at first sight, three market-clearing conditions for values, one for each activity:

$$x_{11}p_1 + x_{12}p_2 = p_1 y_1(0) \qquad \text{Value balance, activity 1}$$
$$x_{21}p_1 + x_{22}p_2 = p_2 y_2(0) \qquad \text{Value balance, activity 2}$$
$$x_{31}p_1 + x_{32}p_2 = p_2 y_3(0) \qquad \text{Value balance, activity 3}$$

But closer investigation shows that the last of these conditions is not independent. Thus we get $3 + 2 + 2 = 7$ independent equations, for the unknowns x_{11}, x_{12}, x_{21}, x_{22}, x_{31}, x_{32}, and the price ratio $P = p_1/p_2$. These are seven unknowns altogether. Thus, the system is determined to the same extent as before, and the path can be followed into the future, once $y_1(0)$, $y_2(0)$, and $y_3(0)$ have been specified.

We have followed this path with computer simulations, and the result is that the system is highly unstable. For example, we can arrange things so that the balanced growth path uses 60 percent of

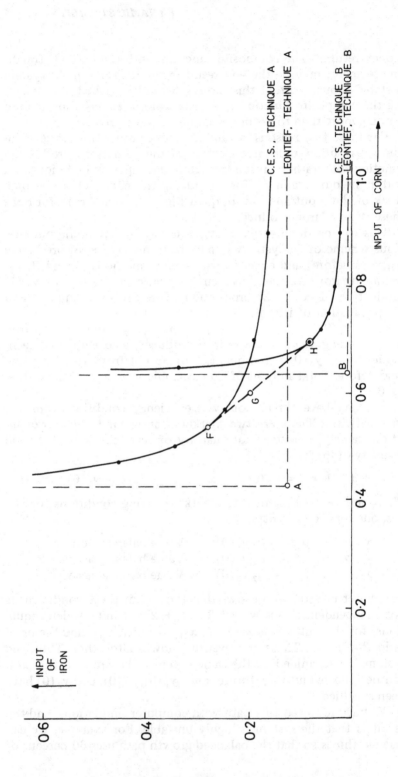

Figure 7.1

Two techniques, A and B, exist for iron production. Both techniques use corn and iron as inputs. The curve labeled "C.E.S., technique A" is the isoquant for unit output of iron, with elasticity of input substitution equal to 0.4. The corresponding fixed coefficient Leontief (zero elasticity) isoquant is the pair of straight lines meeting at point A in the figure. The other curve is the isoquant for technique B, with assumed elasticity of 0.5; the Leontief isoquant has its corner at point B.

If the ratio of available input iron to input corn exceeds that for point F, technique A is optimal. If this ratio falls below that for point H, technique B is optimal. At ratios in between, the optimal procedure is to mix the two techniques, producing some of the iron by technique A, the rest by technique B. The inputs for unit output then lie on the straight line segment FGH. For example, point G is a mixture of 60 percent technique A and 40 percent technique B. The constants have been adjusted so that point G is the iron production point for the balanced growth path of the system.

In the computer simulation, the elasticity of substitution for corn production was taken as 0.3, and the initial endowments were taken so that the ratio corn/iron agrees precisely with the one needed for balanced growth; the ratio $y_2 A / y_2 B$ of iron produced by the two techniques the year before was 59.99/40.01 (instead of 60/40 for balanced growth). The price ratios in the current market at time t turned out to be, in sequence: 1.2343, 1.2337, 1.2355, 1.2303, 1.2456, 1.2013, 1.3352, 0.9763, 2.3768, 0.14469, 157.3758, the last at time $t = 10$. The next market, at $t = 11$, could not be cleared by any price ratio between 0.00016 and 1.8×10^{25}; the computer gave up at that point.

technique A and 40 percent of technique B for iron, and the over-
all quantities and price ratio are just as for the Leontief system.
Setting initial endowments close to (within 0.02 percent) of the
balanced values leads to increasing deviations from the balanced
path. After 12 periods, the "solution" is entirely unreasonable.
(Some details are given in the caption to Figure 7.1).

We conclude that *input substitution does not alter the essential
result of section B, that is instability of the balanced growth path.*

D. Discussion

From a historical point of view, the basic mistake of the conven-
tional reasoning lies in ignoring the lesson taught by one of the
earliest, and in our opinion the greatest, of all economists: Dr.
Francois Quesnay. In his Tableau Economique (Quesnay 1760,
Meek 1963, Kuczynski 1972) Quesnay set out clearly that the eco-
nomic system is *not* like a "fair" with independent buyers and sel-
lers, but rather has a circular flow, like the flow of blood in the
human body. The buyers are at the same time sellers, the sellers
are at the same time buyers, and thus there is a causal nexus be-
tween sales and purchases much more explicit and stringent than
envisaged in the "auction" of Walras (1874, 1877).

The science of economics has paid a heavy price for ignoring the
insight of its great founder. Indeed, the only economists who have
made any significant progress in dynamic economics are those who
have gone back, consciously or otherwise, to the Tableau Econ-
omique. All the others (unfortunately, an overwhelming majority)
have confined themselves to the study of equilibrium states (either
static or growth equilibria) or at best to completely ad hoc and un-
supported postulates for nonequilibrium behavior. We believe that
this is not an accident, but lies in the nature of the case. Without
the Tableau Economique, the problems of dynamic economics are
insurmountable.

In view of the instability which we have demonstrated, there is a
strong presumption that all equilibrium states are locally unstable:
They are unstable if all markets clear perfectly and if all the causes
of instability pointed out in the economic literature are postulated
away. Added realism of the models used is highly unlikely, there-
fore, to make the situation better for stability.

Locally unstable states, however, carry almost no scientific in-
terest. Their properties are not worth investigating in any detail,
since such states cannot maintain themselves for any significant
length of time. Any little initial disturbance is amplified rapidly as
time goes on, so the system rapidly moves away from the balanced

state. We conclude that *the study of growth equilibrium is uninteresting.*

We conclude this chapter with some historical notes and remarks on the literature on economic stability.

There is nothing whatever new about the suggestion that a competitive economy is unstable. In 1960, D. W. Jorgenson published a "dual instability theorem" (Jorgenson 1960). In 1958, Sargan demonstrated the instability of the Leontief system, for a system defined in continuous time and considerably more general than the one used here (Sargan 1958; see also Leontief 1961, Sargan 1961, and Wurtele 1959). Long before these authors, Roy Harrod suggested instability in 1939 (Harrod 1939; see also Harrod 1948, 1973), with the graphic simile of the economy's being "balanced on a knife-edge." And, long long before all of these, Ralph Hawtrey had talked about the inherent instability of credit (Hawtrey 1926, p. 344). And so did Bagehot (1873), more than a century ago!!

Thus, what is required is not an explanation of why no one thought of instability——plenty of economists did——but why these views were ignored so completely by the vast majority of the profession. All too often people refuse to see things which make them uncomfortable. There can be no doubt about the discomfort caused by the presence of local instability:

1. An unstable system is much harder to handle than one in, or near, a state of stable equilibrium.

2. Equilibrium analysis is entirely inadequate for locally unstable systems.

3. Those economists who take the view that free competition produces an "optimal" result are disturbed at the thought that such an "optimal" system is unstable.

Whatever the reason for the discomfort, the result is indisputable. We quote from Professor Hahn's perceptive introduction to his collection *Readings in the Theory of Growth* (Hahn 1971):

> Of course, one can conceive of steady-state theory which seeks to show that no steady state exists. This was precisely Harrod's intention, and he is one of the few growth theorists (Mrs. Robinson is another) to remain faithful to Keynes. . . . Almost everything written since has been a headlong retreat from this point of view. . . . The final outcome has always been essentially non-Keynesian: permanent, steady, full-employment growth is possible.

There are honorable exceptions to this severe judgment, but there is no doubt that Hahn is right about the predominant tendency in the literature. Faced with a highly unpleasant prospect, people

have tried very hard indeed to close their eyes. Most of them have succeeded.

We do not wish to go into the abstract mathematical work on growth theory in general, nor into the use of growth theories in the context of a planned economy. It is necessary to say something, however, about the innumerable attempts to prove stability where there is no stability.

Within the context of general equilibrium theory, there are two quite separate notions of "stability," namely, "short-run stability" and "long-run stability." The first of these refers to the behavior of a market, or rather of a series of markets all occurring at the same time, for various commodities and factor services. This short-run theory is summarized by Arrow and Hahn (Arrow 1971).[8] Their discussion deals with rules for an auctioneer to go about determining market-clearing prices. "Stability" means that these rules define a process of "tatonnement" which converges to such a set of prices. All this has no relation to what we call stability. We *assume* that market-clearing prices, if they exist at all, will be reached somehow (our assumption 1, perfect clearing of all markets).

The second stability concept, "long-run stability," is the one of interest to us here. To investigate long-run stability, one assumes that short-run stability holds (i.e., that market-clearing prices are established in every annual market). One follows what happens in each of these markets in turn, starting from an initial state (in the first market) which is different from the exact state of balanced growth. "Long-run stability" means that the system tends to come ever closer to the state of balanced growth; long-run instability means that it tends to deviate ever farther from balance.

Neoclassical growth theory is covered in many places, of which we mention Wan (1971), Hahn (1964), Morishima (1958, 1959, 1964, 1969), Dorfman (1958), Hicks (1965), Hamberg (1971). Since all we wish to do is to make a few remarks about the relationship of that theory to the growth theory discussed here, there is no need to reproduce this material in full.[9]

The neoclassical growth theories may be classified in two ways: (1) by degree of aggregation, into one-sector, two-sector, and many-sector models; and (2) by aim, into positive (descriptive)

[8] See also Arrow 1954, 1959, 1973; Negishi 1962; Smale 1976.

[9] The full literature is vast. See, for example, Amano (1964), Arrow (1960), Champernowne (1958), Kahn (1959), Levhari (1968), Meade (1961), Mirrlees (1973), Solow (1956, 1959, 1960, 1966), Stein (1966), Swan (1956), Tobin (1955, 1965), and many others.

theories and normative (welfare) theories.

In one-sector models, there is only one thing produced, called simply "output" (for example, see Gale 1973 and Hamberg 1971). This approach avoids our instability by the device of just assuming it away from the start: No imbalance between outputs of different commodities can occur if there exists only one output commodity!

The two-sector models (e.g., see Johnson 1971) are closer to, but far from identical with, the model used by us. Some of the differences are: (1) The inputs in neoclassical two-sector models are *not* commodities (like our corn and iron), but rather are the "factors of production" called "labor" and "capital," respectively. This has two consequences: (a) Assumptions are required about the "savings propensity" of owners of these two factors, as well as about the extent to which savings show up as investment in new capital goods; for example, workers may save a fraction s_w, and capitalists a larger fraction s_r of their respective incomes, and all savings may be invested. [Our model avoids all such difficulties by starting from perfect thrift and from no fixed capital.] (b) The "factor of production" called "capital" runs afoul of the difficulties pointed out in the Cambridge controversy (Robinson 1954, Harcourt 1972): It cannot be defined properly! (2) While the outputs from a neoclassical two-sector model are indeed commodities, called consumption goods and capital goods, respectively, these two commodities are rather different from our corn and iron. Consumption goods correspond to corn, all right; but capital goods do not behave like our "iron." Rather, capital goods are treated as "stocks" which are *not* used up during the subsequent processes of production, except perhaps for a given, predetermined fractional depreciation each year. A proper treatment of "capital goods" must therefore, following Sraffa (1960), involve joint production: The consumption goods industry produces, each year, *two* commodity outputs, namely, consumption goods and (one year older) capital goods. This is *not* done in neoclassical growth theory.

As a result of these differences, the stability conditions also differ. The existing neoclassical long-run stability conditions are sufficient but not necessary. There are two main conditions:

1. Uzawa (1961, 1963) condition: The consumption goods industry must be *more* capital intensive (i.e., must have a higher capital-to-labor ratio) than the capital goods industry. This condition (see also Inada 1963) is related to the special nature of the commodity "capital goods" and is therefore not comparable to our stability condition of section C. The condition itself seems to be rather implausible in relation to real life (see, however, Kohli 1979).

2. Drandakis (1963) conditions: (a) A unique short-run equi-

librium (unique market-clearing prices) exists if the elasticities of substitution are positive and satisfy $\sigma_1 + \sigma_2 \geqslant 1$. (b) Any one of the following is a sufficient condition for long-run stability: (b1) The elasticity of substitution of the capital goods industry exceeds unity; (b2) ditto for the consumption goods industry, and s_r sufficiently near unity; or (b3) as (b2), but s_w sufficiently near zero.

Clearly the Drandakis condition (a) is closely related to our (necessary *and* sufficient) condition. We can write his (a) in the form: $(\sigma_1 + \sigma_2)/2 \geqslant 1/2$. This differs from our condition in section C only through the fact that the quantity on the left is a simple, rather than a weighted, average of the two separate elasticities. Thus, in spite of some very real differences between the theories, some of the stability conditions bear considerable resemblance. However, as pointed out in section C, factor substitution *within* one basic technique of production does not have such high elasticities (Chenery 1949), and factor substitution through switching of techniques must be handled quite differently from the usual neoclassical approach.

Let us now turn to neoclassical multi-sector growth models. These are closest to our approach. McKenzie (1960) claims long-run stability but gets this result by assuming conditions for excess demand functions; in view of the counter-intuitive results found in section B for perfect thrift, ad hoc assumptions of this sort amount to little more than assuming what needs to be proved.

A most interesting set of two papers is: Jorgenson (1960), in which he proves "dual instability" of the Leontief system (see also Gelber 1977); and, just one year later, Jorgenson (1961), in which he proves stability! He gets the latter result by adding, to the simple Leontief system, assumptions concerning the reactions of producers to levels of unsold stocks and to observed trends in prices, as well as by adding a central bank which sets an entirely exogenous rate of interest. Jorgenson then claims: "By suitable restrictions on the initial values of the disequilibrium variables, the non-negativity of all economic variables is preserved."

This paper, however, has been subjected to an absolutely devastating critique by McManus (1963), which, in our opinion, is not answered at all by Jorgenson's rejoinder (Jorgenson 1963). We shall restrict ourselves to two main points:

1. On page 112 of Jorgenson (1961), "... n_i is a negative constant," whereas on page 115 "... n_i is a positive number." The economically plausible sign is negative, and when this is used in the argument on page 115, stability goes out the window. Not only do the new roots indicate instability absolutely, but they may dominate over the roots corresponding to balanced growth,

so that "speculative activity may result in larger and larger excess-stocks and profits relative to outputs and prices" (McManus 1963).

2. Jorgenson's "suitable restrictions on the initial values of the disequilibrium variables" are so thoroughly "suitable" that any system whatever can thereby be proved to be stable: If there exists a "normal mode" of the system leading to instability, Jorgenson simply *assumes* that the initial amplitude of this particular mode (and of all such modes) is zero; in a linear system, such a "suitable restriction" indeed ensures that this mode has zero amplitude ever thereafter! Jorgenson's rejoinder that this involves ". . . an incorrect interpretation of the initial conditions" is feeble indeed. In our view, McManus's interpretation is only too correct.

We conclude that, far from the claim made in Jorgenson (1961), his system is, usually, utterly unstable.[10] We note, incidentally, that application of input-output analysis to actual data from Japan (Tsukui 1968) strongly suggests instability, as we should expect. For further views on instability, see Hahn (1973) and Kurz (1968).

The main reaction of neoclassical economics to the difficulty of demonstrated dynamic instability, however, has been considerably more subtle than to deny it by using invalid arguments. Rather, there has been a complete shift in the grounds of the argument, by introducing "a wholly different way of viewing the system which prevents it [the difficulty] from ever arising" (Solow 1959). The shift has been from "positive economics" to "welfare economics." It will prove highly instructive to follow this shift in some detail.

The basic reference is the famous book by Dorfman, Samuelson, and Solow (Dorfman 1958). They discuss balanced growth in a Leontief system much as we have done, though they allow for stocks of working and/or fixed capital. They then prove (pp. 297-300) that this balanced growth is unstable! They call it "indeterminacy" rather than "instability," but their indeterminacy arises

[10] In our view, this whole story cries out for investigation by a historian of science. Mistakes and excessive claims, as such, are of little interest; they occur much too often. But this case is special because of the way this paper has been handled by other economists. If the proclaimed result had been instability, rather than stability, we are convinced that the manuscript should never have passed the first referee. The criticisms made later by McManus would have been made at that stage, so that the paper would not have been published. But, we think largely because of the proclaimed result, the paper was not only published, but it was actually reprinted ten years later in an authoritative collection of twenty, only, papers on growth theory, of which von Neumann's paper is the first. In the reprint, there is no mention at all of the critique by McManus, so that the reader gets the impression that Jorgenson's paper has passed the test of time and critical perusal by other economists, and is correct as it stands! This paper was studied, to my definite knowledge, by university students of economics in 1980, and these students were urged to accept the much desired conclusion of stability.

only because of the instability, which forces the system away from the balanced path to a far-out situation in which it becomes indeterminate. They themselves state: "Leontief systems are as often as not such that the slightest disturbance away from the razor's edge of balanced growth will necessarily result in a growth of capitals that will ultimately either (1) violate the requirement [of positivity] or (2) require us to replace by inequalities one or more of the [market-clearing] equalities." Nothing could be clearer, or more correct.

But what happens afterward? Do they accept this instability as a fact of life and work toward a realistic description of such an economic system? Not at all. The "resolution" of the difficulty offered in their next chapter is through the concept of "efficient programs of capital accumulation." The basic idea is simplicity itself: *If* an economy is organized so as to maximize some kind of "social utility," *then* certain growth paths, including the fully balanced growth path, turn out to be "optimal" and will therefore be adopted by the central planning agency. Furthermore, suppose that the initial endowments of the economy at time $t = 0$ are not in the proportions required for balanced growth; and suppose that the goal of the planners, at time $t = T$, the end of the planning period, is also out of proportion for balanced growth. In spite of this, it turns out that the "optimal plan" is one in which the economy is kept very close to the state of balanced growth in the intervening time interval, departing significantly from that state only at times t close to $t = 0$ and close to $t = T$. Thus, the balanced growth path is seen to be a "turnpike" along which the planners can make optimal progress toward their planning objective.[11]

In our view, the turnpike theorems are of great and enduring interest—for a planned socialist economy! They have nothing whatever to do with an economy of free competitive capitalism. The latter has no central planning agency producing some long-term optimal plan, nor does it permit a mechanism to enforce adherence to such a plan, should it be made. *The turnpike is irrelevant for capitalism.*

The effect of all this has been to shift the ground of argument from a realistic description of the economic system in which we

[11] Whatever else it may have done, there is no doubt that this work started a real growth industry: More and more economists began to travel along the turnpike, in ever more top-heavy mathematical vehicles. The end is not yet in sight. Some of this work arose from an earlier paper by Malinvaud (1953), but travel along the turnpike got into high gear only after the Dorfman (1958) book. See, for example, Cass (1976), Furuja (1962), Gale (1967, 1975), Hahn (1971), Los (1976a), Mirrlees (1967), Morishima (1969), Razin (1972), Shell (1967), Tsukui (1979), and innumerable others.

live, to a normative discussion of the best way to run a centrally planned system. This question may be, and in fact is, of profound interest to socialist planners; but under capitalism, it is a red herring pure and simple! The "wholly different way of viewing the system" has resulted in diverting, rather than advancing, the science of economics.

It would be unfair, to the point of churlishness, to ignore the fact that a number of economists have battled valiantly for more common sense and realism in economic theory. There are even some neoclassical economists in this group of dissidents. We quote from Frank Hahn's presidential address to the Econometric Society (Hahn 1970):

"There is something scandalous in the spectacle of so many people refining the analyses of economic states which they give no reason to suppose will ever, or have ever, come about."

The majority of the dissidents, however, are to be found among the so-called post-Keynesians. In the older generation, the names of Roy Harrod, Nicholas Kaldor, Michael Kalecki, Luigi Pasinetti, Joan Robinson, and Piero Sraffa spring to mind. Fortunately for the progress of economic science, the younger generation of post-Keynesians is too numerous to list here with any hope of completeness.

E. Mathematical appendix

We start with the mathematics for section B. As before, a_{ij} denotes the input of commodity j needed to produce a unit quantity of output of commodity i. We take year number t to start at time $t - 1$ and to end at time t (for example, year 1 starts at $t = 0$ and ends at $t = 1$). The condition that the market at time t clears in terms of quantities is equation (3.4), which we repeat here for easier reference:

$$\sum_{i=1}^{n} y_i(t + 1)a_{ij} = y_j(t) \qquad \text{for } j = 1, 2, \ldots, n \qquad (7.1)$$

The condition that values should balance is:

$$\sum_{j=1}^{n} y_i(t + 1)a_{ij}p_j(t) = y_i(t)p_i(t) \qquad \text{for } i = 1, 2, \ldots, n \qquad (7.2)$$

For given quantities $y_i(t)$ and $y_i(t + 1)$, this is a set of n homogeneous linear equations in the n unknown prices $p_i(t)$, so that only price ratios are determined, not absolute prices. Equations (7.2)

are consistent; i.e., they allow a nonzero solution for the prices, provided that the quantities satisfy (7.1). To prove this, rewrite (7.2) in the equivalent form:

$$\sum_{j=1}^{n} M_{ij} p_j = 0 \quad \text{where} \quad M_{ij} = y_i(t+1)a_{ij} - y_i(t)\delta_{ij} \qquad (7.3)$$

We can now use (7.1) and this definition of M_{ij} to obtain the identity:

$$\sum_{i=1}^{n} M_{ij} = 0 \qquad (7.4)$$

Equations (7.3), and hence also their equivalent (7.2), are consistent if and only if the determinant of M vanishes. In evaluating det(M) we are allowed to add any row to any other row, without altering the value of the determinant. Let us add, in turn, row 2 to row 1, row 3 to row 1, . . . , row n to row 1. Then (7.4) shows that the first row of the new determinant consists entirely of zeros. Thus det$(M) = 0$, and thus the price equations are consistent with nonzero prices.

The proof of instability, to which we now proceed, requires certain necessary economic assumptions, namely:

1. The input-output matrix is irreducible (we know that this is reasonable under the basic assumption of perfect thrift).

2. At least one diagonal element a_{ii} of the input-output matrix is nonzero; that is, there exists at least one commodity which is needed as an input for its own production (an example is corn, which requires seed corn).

3. The balance equations (7.1) can always be solved uniquely for the quantities at time $t + 1$, when the quantities at time t are given. Mathematically, the input-output matrix must possess an inverse.

To simplify the proof, we introduce an additional assumption:[12]

4. The input-output matrix is diagonalizable.

THEOREM 7.1

If the input-output matrix of a Leontief system has properties 1 to 4, then its balanced growth path is unstable.

Note: Since the proof itself is slightly lengthy, we preface it by indicating the basic idea behind it. The development of the output vector y(t) forward in time, to y$(t + 1)$, is governed not by the input-output matrix A, but rather by its inverse matrix A^{-1}. The eigenvalues of A^{-1} are the reciprocals of the

[12] This assumption is *not* necessary. Without it, one can still transform A to the "Jordan normal form" and carry out the proof that way. Alternatively, Dr. Noussair of the University of New South Wales has developed a proof which makes no use of that normal form.

eigenvalues of A. The eigenvalue of A which leads to balanced growth, a^*, is the dominant eigenvalue of A, hence the largest of all the eigenvalues of A. The corresponding eigenvalue of A^{-1}, namely $a = 1/a^*$, is thus the *smallest* (in absolute value) of all the eigenvalues of A^{-1}. As time goes on, the solution associated with that eigenvector (the balanced solution) is the one that grows at the *lowest* rate and is therefore swamped eventually by one or more of the other solutions, if these are present at all to start with, no matter in how small an amount. Thus balanced growth can be maintained if and only if the initial conditions for it are exactly right, without any deviation whatsoever.

Second note: The idea underlying this proof depends on the Frobenius-Perron theorem (theorem 3.6), which is nontrivial mathematics. There is therefore no way of getting this important result by "literary" reasoning. The special case $n = 2$, corn and iron, can be made intuitively plausible, and we hope that we have succeeded in doing so in the chapter. But, mathematics is required for the general case. We hope this fact will encourage at least some students of economics to spend more time on their mathematics. Mathematics has acquired a bad name in economics because it has been misused so often; but it can be used to good purpose.

Proof: Denote the eigenvalues of A by z_1, z_2, \ldots, z_n and order them so that

$$z_1 > |z_2| \geqslant |z_3| \geqslant |z_4| \; V \ldots \geqslant |z_n| \qquad (7.5)$$

The first eigenvalue z_1 is real and, by theorem 3.6 and assumptions 1 and 2, strictly greater than all the others. Subsequent eigenvalues may come in complex conjugate pairs, and thus there may be equalities within (7.5). By assumption 4, there exists a complete set of n left eigenvectors, one for each eigenvalue z_i. We assemble these into a matrix S_{ij} with the property:

$$\sum_{i=1}^{n} S_{ki} a_{ij} = z_k S_{kj} \qquad \text{for } k = 1, 2, \ldots, n \quad \text{and } j = 1, 2, \ldots, n \qquad (7.6)$$

By assumption 4, the vectors within that matrix span the entire space; hence any vector can be expressed as a linear combination of them. We do this for the initial quantities:

$$y_j(0) = \sum_{i=1}^{n} c_i S_{ij} \qquad \text{for } j = 1, 2, \ldots, n \qquad (7.7)$$

We now assert that the following expression is correct for the quantities $y_j(t)$ at any later time t:

$$y_j(t) = \sum_{k=1}^{n} c_k (z_k)^{-t} S_{kj} \qquad \text{for } j = 1, 2, \ldots, n \qquad (7.8)$$

To *prove* this assertion, note first that it gives the right answer, (7.7), when we put $t = 0$. Next, assume (7.8) is right for time t, and look at time $t + 1$. We replace t by $t + 1$ in (7.8) and substitute the result into the expression

on the left-hand side of (7.1) to get:

$$\sum_{i=1}^{n} y_i(t+1)a_{ij} = \sum_{i=1}^{n} \sum_{k=1}^{n} c_k(z_k)^{-t-1} S_{ki} a_{ij} =$$

$$\sum_{k=1}^{n} c_k(z_k)^{-t-1} z_k S_{kj} = y_j(t)$$

where we have used (7.8) in the first step, (7.6) in the second step, and (7.8) again in the final step. This completes our proof by induction that (7.8) is valid for all t.

Now let us denote by K the *largest* index i such that $c_i \neq 0$ in (7.7). If the initial quantities are precisely correct for a state of balanced growth, then $K = 1$; but this special situation is of no interest for stability analysis. Hence, we may assume that $K \geqslant 2$.

We assert that, in (7.8) the term with $k = K$ (and, if z_K is complex, the equally important term $k = K - 1$, where z_{K-1} is the complex conjugate of z_K) *dominates* the sum on the right-hand side for sufficiently large times t. To see that this is true, recall our ordering of the eigenvalues (7.5). Since *negative* powers of z_k occur in (7.8), the z_k of *smallest* absolute value leads to the term of *largest* absolute value in (7.8), in the limit of large t. At this stage, the proof is nearly finished. We distinguish the two cases: z_K real and z_K complex.

Case a: z_K is real. By theorem 3.6, part (d), the associated eigenvector, which we have called $(S_{K1}, S_{K2}, \ldots, S_{Kn})$ here, has at least one strictly negative component. For large enough t, this eigenvector dominates the solution; hence the corresponding component of $y(t)$ is negative if c_K is positive; if c_K is negative, all positive S_{Kj} result in negative output quantities of the corresponding commodities.

Case b: z_K is complex, and z_{K-1} is its complex conjugate. Then c_K and c_{K-1} are complex conjugates; so are S_{Kj} and $S_{K-1,j}$ for each j. Write $z_K = Z \exp(i\zeta_K)$, $c_K = C \exp(i\gamma)$ and $S_{Kj} = T_j \exp(i\sigma_j)$, where Z, ζ_K, C, γ, T_j, and σ_j are real. Substitution in (7.8) gives for the dominant term: $y_j(t) \cong 2CZ^{-t}T_j \cos(\zeta_K t - \gamma - \sigma_j)$, which must turn negative for some j and t.

Hence, in either case, at least one commodity in the system must be produced in a negative quantity, for some (large enough) time t. The system is therefore unstable.

<div align="right">Q.E.D.</div>

Note (to mathematicians): We apologize for the crudity and lack of neatness

of this proof; better proofs exist, but require more mathematical background than assumed here.

Let us now turn to the mathematics for section C, production with possible input substitution. We present, first, the equations for n commodities and specialize to $n = 2$ afterward.

Let x_{ij} be the quantity of commodity j used as input to production of commodity i. Let f_i be the production function for this commodity. Then the output of i, achieved at the end of the year with these inputs, is:

$$y_i(t + 1) = f_i(x_{i1}, x_{i2}, \ldots, x_{in}) \quad \text{for } i = 1,2,\ldots,n \qquad (7.9)$$

We *define* the marginal product ratio (between inputs j and n) for production of i by means of:

$$g_{ij}(x_{i1}, x_{i2}, \ldots, x_{in}) = (\partial f_i/\partial x_{ij})/(\partial f_i/\partial x_{in})$$
$$i = 1,2,\ldots,n,$$
$$j = 1,2,\ldots,n-1 \qquad (7.10)$$

We assume that f_i is linearly homogeneous in its arguments (constant returns to scale); then g_{ij} is homogeneous of degree zero, i.e., is a function only of the ratios x_{ij}/x_{in}. Suppose the auctioneer "cries out" unit prices p_1, p_2, \ldots, p_n for the n commodities. We define price ratios for n as the "numeraire":

$$P_j = p_j/p_n \quad \text{for } j = 1,2,\ldots,n \qquad (7.11)$$

The condition for any one producer of i to produce at least cost is then given by:

$$g_{ij}(x_{i1}, x_{i2}, \ldots, x_{in}) = P_j$$
$$\text{for } i = 1,2,\ldots,n,$$
$$j = 1,2,\ldots,n-1 \ (7.12)$$

This determines input *ratios* x_{ij}/x_{in} for least-cost production. The index j goes only to $n - 1$, since $j = n$ gives the identity $1 = 1$.

The auctioneer is instructed to clear the market. The condition that the entire "endowment" $y_j(t)$ of commodity j be cleared is:

$$\sum_{i=1}^{n} x_{ij} = y_j(t) \quad \text{for } j = 1,2,\ldots,n \qquad (7.13)$$

So far, there are $n(n-1)$ conditions (7.12) and n conditions (7.13), a total of n^2 conditions. For given endowments $y_j(t)$ and given (by the auctioneer) current price ratios $P_1, P_2, \ldots, P_{n-1}$, this is enough to determine the n^2 input quantities x_{ij}. We shall

call the price system *feasible* if a solution can be found in which all the x_{ij} are nonnegative. Feasibility depends, of course, on the initial endowments.

The conventional approach is to stop here and attempt to maximize something or other (social utility, for example) over the economy as a whole. This is faulty, however, since the market must clear not only in quantity terms, but also in value terms.

With no credit asked for, or received, any one firm must finance its inputs for next year's production from sales (in the same market!) of its production from the preceding year. Let us look at firms planning to produce commodity i next year. Their total expenditure on input commodity j is then $x_{ij}p_j$, and the total outlay for productive inputs to production of i next year is the sum of this, over all $j = 1, 2, \ldots, n$.

If all these firms produced the same commodity (i) last year, and no firm which produced i last year decides to switch to producing something else next year, *then* values balance if the total market receipts from sales of i equal total expenditure on productive inputs for production of i next year. This gives:

$$\sum_{j=1}^{n} x_{ij}p_j = y_i(t)p_i \qquad \text{for } i = 1, 2, \ldots, n-1, \text{ no switching}$$

The index i goes only up to $n - 1$, because if the books of producers of $1, 2, \ldots, n - 1$ all balance, then the books of producers of n *must* balance automatically. When we divide this whole equation by p_n (use commodity n as the numeraire), we get:

$$\sum_{j=1}^{n} x_{ij}P_j = y_i(t)P_i \qquad \text{for } i = 1, 2, \ldots, n-1, \text{ no switching} \quad (7.14)$$

These are an additional $n - 1$ conditions on the system, thereby being enough to determine the $n - 1$ unknown price ratios P_1, P_2, \ldots, P_{n-1}. Except for choosing between a finite number (usually small) of distinct feasible solutions, the auctioneer has no choice to maximize anything. Equations (7.12), (7.13), and (7.14), specialized to $n = 2$, are the ones underlying the work of section C.

Let us now, however, go beyond this, by allowing for firms deciding to switch from production of j last year to production of i next year. Let p_i' be the (guessed, or expected, or anticipated) unit prices in next year's market. Then the return factor (= rate of return plus one) for production of i is given by:

$$\beta_i = y_i(t + 1)p_i' \bigg/ \sum_{j=1}^{n} x_{ij}p_j \qquad (7.15)$$

where next year's output $y_i(t + 1)$ is given by (7.9). The *incentive* to switch from production of k, say, to production of i is contained in the ratio:

$$R_{ik} \equiv \beta_i/\beta_k \qquad (7.16)$$

If R_{ik} is less than unity (i.e., the rate of return in industry i is expected to be less than in industry k) no producers of k will switch to i. But when R_{ik} exceeds unity, some switching must be expected, the more so the more R_{ik} exceeds unity. We note that a uniform inflation of prices expected next year (multiply all p_i' by a common factor) cancels out in (7.16); hence, only ratios between expected prices are relevant, not absolute prices.

Let us *define* ψ_{ik} to be the fraction (in value terms) of last year's producers of commodity k who decide to produce commodity i in the year to come. In particular then, ψ_{kk} is the fraction who decide *not* to switch at all. Under the usual competitive assumptions, the ψ_{ik} are functions of the incentives perceived by producers of k last year, i.e.,

$$\psi_{ik} = \psi_{ik}(R_{1k}, R_{2k}, \ldots, R_{nk}) \qquad (7.17)$$

Very little is known about these functions, but something can be said:

(i) $\psi_{ik} = 0$ if $R_{ik} \leqslant 1$ (no switching to a lower rate of return activity).

(ii) ψ_{ik} is an increasing function of R_{ik} if the other R_{jk} are kept constant.

(iii) These firms must do *something* next year; hence the sum $\psi_{1k} + \psi_{2k} + \ldots + \psi_{nk} = 1$.

(iv) By definition, every $\psi_{ik} \geqslant 0$. (Firms switching *from i to k* are involved in a positive value of ψ_{ki}; there is not a negative value of ψ_{ik}.)

(v) Unless firms behave very erratically, the functions (7.17) must be smooth functions of all their arguments; we shall assume that these functions are at least twice differentiable.

Let us now write down the revised version of (7.14), valid in the presence of switching. The left-hand side of (7.14) is still valid, as the total outlay of those producers who plan to produce commodity i in the year to come. On the right-hand side, we must correct

for two effects: (1) some producers of other commodities last year decide to switch to i, thereby bringing in their sales proceeds; and (2) some producers of i last year decide to switch elsewhere, thereby taking their sales proceeds elsewhere as well. The result (after using commodity n as numeraire) is:

$$\sum_{j=1}^{n} x_{ij}P_j = y_i(t)P_i + \sum_{\substack{k=1 \\ (k \neq i)}}^{n} \psi_{ik}y_k(t)P_k - (1 - \psi_{ii})y_i(t)P_i$$

$$\tag{7.18}$$

$$= \sum_{k=1}^{n} \psi_{ik}y_k(t)P_k$$

Note that this reduces to (7.14) if we make the "no switching" assumption $\psi_{ik} = 0$ for $i \neq k$, and $\psi_{ii} = 1$.

It is obvious that equations (7.18) are much more complicated than (7.14), in particular because we now require expected price ratios next year and functions ψ_{ik} describing producers' reactions to incentives to switch.

However, none of this turns out to be needed for a discussion of *local* stability, in the immediate neighborhood of the balanced growth path! Under our "smoothness" assumption (v) above, the first partial derivatives of ψ_{ik} with respect to R_{ik} must vanish at $R_{ik} = 1$ (since they vanish for all values below unity). Thus ψ_{ik} behaves for *small* $R_{ik} - 1$, like $(R_{ik} - 1)^m$ with m greater than one. The balanced growth path has $R_{ik} = 1$, all i and k (equal rate of return in all industries). Thus for *small* deviations from balance, the fraction ψ_{ik} switching from k to i ($k \neq i$) is of higher order in the size of the deviation. Since the terms for no switching [right-hand side of (7.14)] are *linear* in this size, the other terms can be ignored as long as the deviations are really small. We conclude that *switching can be neglected so long as we are close to the balanced growth path; switching does not influence local stability, though of course it can influence the behavior of the system far away from balance.*

For local stability, we are therefore back at equations (7.12) through (7.14). For just two commodities, $n = 2$, (7.13) yields:

$$x_{11} + x_{21} = y_1(t) \quad \text{and} \quad x_{12} + x_{22} = y_2(t) \tag{7.19a}$$

Then (7.14) can be simplified:

$$x_{11}P_1 + x_{12} \times 1 = y_1(t)P_1 \quad \text{but} \quad x_{11} = y_1(t) - x_{21};$$
$$\text{hence} \quad x_{21}P_1 = x_{12} \tag{7.19b}$$

These are three of the five equations we wrote down in section C;

the other two are just the efficiency conditions (7.12), for $i = j = 1$ and for $i = 2, j = 1$, respectively.

Next, we show how the parameters in a production function should be adjusted so that the balanced growth path, using these production functions, agrees precisely with the balanced growth path for a Leontief (fixed coefficients) system with some given input-output matrix (a_{ij}).[13] The Leontief system determines price ratios $P_j^* = p_j^*/p_n^*$, quantity input ratios $x_{ij}/x_{in} = a_{ij}/a_{in}$, quantity output ratios $Y_j^* = y_j^*/y_n^*$, and a growth factor a. To get the same results from the production functions, we must impose the conditions:

$$f_i(a_{i1}, a_{i2}, \ldots, a_{in}) = 1 \qquad i = 1, 2, \ldots, n \qquad (7.20a)$$
$$g_{ij}(a_{i1}, a_{i2}, \ldots, a_{in}) = P_j^* \qquad i = 1, 2, \ldots, n \qquad (7.20b)$$

The first of these asserts that the inputs $x_{ij} = ay_i^* a_{ij}$ produce outputs $y_i(t + 1) = ay_i^*$ next year (the ay_i^* cancels because the f_i are linearly homogeneous). The second condition asserts that these particular inputs are least-cost inputs at the balanced price ratios.

We take as our production functions the forms:

$$f_i(x_{i1}, x_{i2}, \ldots, x_{in}) = \left[\sum_{j=1}^{n} \gamma_{ij}(x_{ij})^{-\rho_i} \right]^{-(1/\rho_i)} \qquad (7.21)$$

where the γ_{ij} and the ρ_i are constants. For $n = 2$, this is the so-called C.E.S. (constant elasticity of substitution) production function. For all n, g_{ij} is then:

$$g_{ij}(x_{i1}, x_{i2}, \ldots, x_{in}) = (\gamma_{ij}/\gamma_{in})(x_{in}/x_{ij})^{\rho_i + 1} \qquad (7.22)$$

For the case $n = 2$, the elasticity of substitution is

$$\sigma_i = (\rho_i + 1)^{-1} \qquad (7.23)$$

Conditions (7.20) are satisfied, it can be shown, when the constants γ_{ij} equal:

$$\gamma_{ij} = a(a_{ij})^{\rho_i + 1}(p_j^*/p_i^*) \qquad (7.24)$$

Thus, once a Leontief input-output matrix (a_{ij}) and a set of elasticities σ_i are given, the production functions of form (7.21) which lead to the same balanced growth path are determined uniquely, and the marginal productivity ratios g_{ij} turn out to be particularly simple functions.

From here on, one can proceed fairly straightforwardly to a derivation of the stability condition of section C for the case $n = 2$.

[13] We skip the mathematics of how one determines a balanced growth path, given a set of linearly homogeneous production functions $f_i(x_{i1}, x_{i2}, \ldots, x_{in})$.

The derivation is, however, too lengthy and somewhat too heavy mathematics for inclusion here.

Finally, let us indicate how equations (7.9) through (7.14) must be altered to allow for several alternative ways of producing any one commodity (but, no joint production). This then includes the case of two commodities and three activities (two ways of producing iron, one way of producing corn).

Commodities are labeled by $j = 1, 2, \ldots, n$, as before. Activities, however, are labeled by an index i which covers a wider range of values $i = 1, 2, \ldots, I$, with $I > n$. In order to indicate which activity produces which (unique) commodity, we partition the set of activities $\{1, 2, \ldots, I\}$ into subsets S_1, S_2, \ldots, S_n, such that activities $i \epsilon S_j$ produce commodity j, only. Every index i is in one and only one of the subsets S_j. For the example at the end of section C, the index set $\{1, 2, 3\}$ is partitioned into subsets $S_1 = \{1\}$ and $S_2 = \{2, 3\}$, showing that activity 1 produces commodity 1 (corn); activities 2 and 3 both produce commodity 2 (iron). The symbol x_{ij} now stands for the input quantity of commodity j for pursuing activity i, and $y_i(t)$ is the output quantity, at the end of period t, from activity i; this output quantity is of course measured in the units appropriate for that unique commodity which is produced by activity i.

Equation (7.9) is altered only to the extent that $i = 1, 2, \ldots, I$ now.

Equation (7.10) is altered in the same fashion, $i = 1, 2, \ldots, I$. Now (7.11) is unchanged; (7.12) has i running from 1 to I; otherwise it is identical. The market-clearing condition for quantities, (7.13) is altered, however, and now reads:

$$\sum_{i=1}^{I} x_{ij} = \sum_{i \epsilon S_j} y_i(t) \qquad \text{for } j = 1, 2, \ldots, n \qquad (7.25)$$

where the quantity on the right-hand side is the total output of j from all those activities i which produced j in period t. In the absence of switching, condition (7.14) is unchanged, except that $i = 1, 2, \ldots, I - 1$. The books of the final activity, I, must balance if the books of all other activities have balanced. The argument for ignoring switching in the immediate neighborhood of the balanced growth path is unchanged.

The number of independent equations (7.12), (7.25), and (7.14) is now $I(n - 1) + n + (I - 1) = In + n - 1$. The number of unknowns is $I \times n$ unknown x_{ij}, and $n - 1$ unknown P_j—thus, again, equally many equations and unknowns. (The really difficult complications arise not from choice of alternative activities for producing any one commodity but rather from joint production.)

BOOK III

Theories of the Trade Cycle

Having deduced that steady balanced growth is dynamically unstable, we must ask what happens when growth is not characterized by steady-state expansion.

Chapter 8 explains that instability in the *neighborhood* of the state of balanced growth *need not* imply that the system must "run away to infinity" or "collapse to zero." This very common misconception is true if the dynamical system is linear, but is false for nonlinear systems. These latter systems may exhibit a phenomenon called a "limit cycle," with very striking analogies to the well-known trade cycle in economics. We therefore devote book III to a survey and critique of economic theories of the trade cycle.

Chapter 9 explains the acceleration principle, the accelerator-multiplier model of Samuelson, and the inventory cycle model of Lloyd Metzler. This is standard material.

Chapter 10 is devoted to the models associated with the names of John Hicks, Ragnar Frisch, and Richard Goodwin. The first two types are well known, but the Goodwin model has not, in our view, received the attention it deserves. Our discussion of the Goodwin model is new and contains new results.

Chapter 11 turns to econometric models of the trade cycle and results obtained from such models. The essential question is whether such models "prove" stability of the economy. If they do, models of the Hicks or Goodwin type are excluded, and Frisch-type models are the only acceptable ones. This is the standard doctrine; but it is wrong. In section 11C, we show that the usual econometric analysis is incapable of distinguishing between local stability and instability of a model; in particular, an unstable model with a limit cycle, when subjected to this analysis, emerges as being apparently stable. In section 11D, we exhibit an alternative method of analysis, designed deliberately to test for a symmetry property (sym-

metry between the ascending and descending phase of a typical trade cycle) which is true of Frisch-type models but not necessarily true of nonlinear limit cycle models. The symmetry property in question is clearly excluded by the data, and with it so are all Frisch-type models of the trade cycle.

The implications of these new results for economic theory are far-reaching. If the equilibrium state (or the "moving equilibrium" state which we call "balanced growth") is inherently unstable, then theoretical study of this state is of very little relevance to what really happens to a competitive economy. The planning commission of a communist state may attempt to keep the system close to balanced growth (though generally with rather limited success), but there is no such body under competitive capitalism. The competitive system must not be treated as if it should be in, or near, the balanced growth state (or, even less realistically, a state of static equilibrium). The system, instead, has a natural tendency to depart from this state and undergo oscillations of the limit cycle (trade cycle) type. This conclusion, arrived at theoretically, is confirmed by some two centuries of empirical observation. It is about time we recognize the obvious facts about the system in which we live.

Limit cycles

A. Linear systems and their limitations

Instability of a balanced growth path, such as we found in chapter 7, is often interpreted as equivalent to ultimate failure of the underlying theory. The conventional reasoning goes as follows:

If any small disturbance away from equilibrium tends to be amplified, then eventually the system must get into a completely impossible state (for example, we may be required to produce negative amounts of one or more commodities). Since we know from experience that the actual economic system does not ever reach such an impasse, any theory which leads to such a result must be discarded as false.

In this chapter, we propose to show that *this reasoning is invalid, and its conclusion is incorrect*.

Before doing so, however, let us first of all trace how this piece of fallacious reasoning has come to be accepted so widely by economists. In our opinion, this is due to the fact that the above reasoning does work *if* the underlying system is a *linear* system, and economists have been exposed to linear systems much more than to nonlinear systems.

For our purposes, a linear system can be defined as follows: It is a system which has a state of equilibrium, which state may be stable or unstable, and for which the *deviations* from this equilibrium state satisfy the following two conditions:

1. If a certain time-path of deviations from equilibrium is a solution to the dynamic equations of the system, then this time-path can be scaled up or down by an arbitrary constant factor; the resulting motion will then still be a solution of the equations of motion.

2. If two different time-paths of deviations from equilibrium are

separately solutions of the equations of motion, then the time-path obtained by adding these two sets of deviations together is also a solution of the equations of motion.

The models which we have been discussing in book II are linear models in the above sense. The "state of equilibrium" is the balanced growth path, i.e., a growth equilibrium rather than a static equilibrium. Deviations from this balanced growth path can be scaled up arbitrarily, without thereby losing their validity as solutions of the equations of motion of the system, mathematically speaking.

Now let us see how this property of linearity enters into the discussion of stability questions. If the system is linear, then *large* deviations from equilibrium behave exactly the same way as small deviations, only scaled up by a (large) constant factor. Thus, if we know how a linear system behaves in relation to small deviations, we can say precisely how this system will behave when the deviations are large.

In particular, suppose that, in a linear system, an initial small deviation has a tendency to grow bigger. This is the property which we have called "local instability" of the equilibrium path and which we have demonstrated in chapter 7. Then it follows, from the linearity of the system, that the same tendency for deviations to grow bigger is also true of medium-sized and of large deviations. Thus, as time goes on, the initial small deviation grows larger, and larger, and still larger, until eventually it becomes infinitely large (in mathematical terms it is unbounded). The entire system "runs off to infinity," and there is nothing which we can do about it.

This picture underlies the conventional argument quoted earlier. For linear systems, there is no doubt that the argument is correct. *If a system is truly linear, then instability of the equilibrium is a fatal flaw of the theory.*

Note that no such trouble arises if the equilibrium path is dynamically stable, i.e., if all possible initial deviations from equilibrium have a tendency to grow smaller as time goes on.

However, all this reasoning depends upon the linear nature of the system. We must therefore look into the question whether actual economic systems are ever linear in the strict, mathematical sense of our definition. We claim that this is *never* the case. *Strictly speaking, all economic systems are nonlinear.*

In economics, there may be *small* deviations from equilibrium (or from any reference state) in either direction, upward or downward. But something is sure to go wrong when we attempt to scale up such small fluctuations to the point where they become really

large fluctuations. A large upward fluctuation is bound to run afoul of some inherent limitation, for example, not enough land, not enough raw materials, not enough labor. Well before that, the fluctuation may produce market distortions which affect other activities in the economy, in a way not encompassed within any set of *linear* system equations. Thus, sufficiently large upward fluctuations are highly likely to strike a "ceiling" of some sort. Still, this may conceivably happen only for such very large upward fluctuations as are of no practical interest. But large *downward* fluctuations are another matter. They *must* strike a "floor," since it is impossible to produce negative quantities of goods, charge negative prices for them, produce them with negative inputs, on negative amounts of land, etc., etc.

The economic requirement that all quantities and all prices must be nonnegative means, as an automatic, logical consequence, that no economic theory can be both economically valid under all conditions and, in a mathematical sense, strictly linear. It may be one or the other, but not both.

Why, then, is so much mathematical modeling in economics done with linear systems? The answer reflects little credit on applied mathematicians: Linear systems are infinitely easier to handle, mathematically, than nonlinear systems. For the sake of mathematical convenience, and very largely just for that one reason, do we so often do major violence to a realistic description of the world in which we live.

Still, this is not the *only* reason. Circumstances do exist in which a linear model, though not strictly valid, is at least approximately valid; indeed, the approximation may be quite good. What, then, are these circumstances? They arise when the equilibrium is *stable*. Suppose this is true. If the initial deviation of the state from equilibrium is not too large, then the future deviations from equilibrium will be even smaller, until we approach full equilibrium in the end. If the linear approximation to the true system is of adequate accuracy for our purposes at the initial time $t = 0$, then it will be of even better accuracy (since we shall then be closer to the equilibrium state) at all future times t. *If the system is locally stable, and initial deviations from equilibrium are not too large, a linear approximation to the system equations can be an entirely adequate treatment.*

At this stage, the desperate quest for local stability becomes understandable, though still not excusable. *If* the system is locally stable, *then* we are justified in using a linear set of system equations as an approximate treatment.

But what if the approximate, linear set of system equations leads

to local instability of the equilibrium? Then any initial small deviation from equilibrium becomes larger and larger as time goes on, until eventually, and inevitably, it gets to be so large that we move out of the range of validity of the linear approximation.

We have now come full circle, to return to the "argument" given at the very beginning of this section. This argument is *invalid* because it makes the *silent assumption* that the system behaves, in states far away from equilibrium, in exactly the same way as it behaves in the immediate neighborhood of the equilibrium state. This assumption, though true for strictly linear systems, is false for almost every actual system known to man. Since the argument is based on a (hidden) false assumption, it is an invalid argument. The conclusion does not follow from the premises.

The true and correct conclusion is quite different. It is this: *If a system shows local instability around the equilibrium path, then this system cannot be described adequately by any linear approximation to the system equations.*

To anyone familiar with the real difficulties involved in the mathematics of nonlinear systems, this is quite bad enough. But it is not the ultimate disaster postulated in the usual, invalid, argument. A linear theory which leads to local instability may be quite acceptable in the immediate neighborhood of equilibrium and need not be rejected once and for all because of the instability. Rather, if the linear approximation is unstable, the theory must be amended and improved, so as to allow for the unavoidable nonlinear effects far away from equilibrium.

B. Limit cycles

If the system is nonlinear, it is no longer possible to deduce, from what the system does close to equilibrium, what it will do far away from equilibrium. The range of possibilities is now very much larger than a simple choice between "stable," and "unstable."

In particular, it is entirely possible for a nonlinear system to be "locally unstable" and yet "bounded." "Local instability" means that *small* deviations from the equilibrium path tend to grow bigger. "Boundedness"[1] means that no large deviation ever becomes infinitely large; i.e., the motion of the system never runs out of bounds, altogether.

The conventional (invalid) argument asserts that, from observation, no economic system is unbounded. True enough. But for a

[1] The usual mathematical term is "global stability," but this is used in a different sense in the literature of economics; hence we use the term "boundedness."

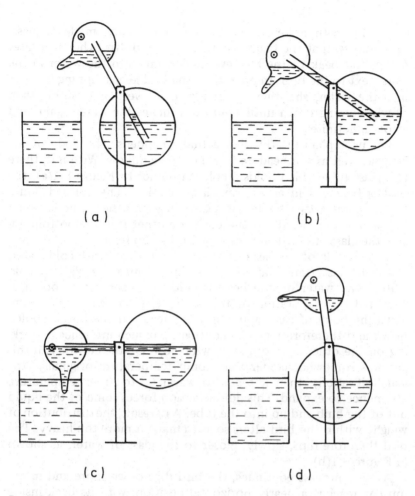

Figure 8.1

A schematic picture of a system in a limit cycle. To the left is a
glass of water, cooler than the surrounding air. To its right, a "bird"
is pivoted so it can dip into this water. Successive pictures (a), (b),
(c), and (d) show positions of the bird, with an indication of the
position of the fluid inside the bird's body. In positions (a), (b), and
(d), but not in position (c), the fluid separates the body of air in
the bird's head from the other body of air in the bird's bottom bulb.

nonlinear system, it is *not* true that boundedness implies local sta-
bility.

As an example of the way in which nonlinear systems can be-
have, consider the noneconomic system depicted, with a good deal
of artistic license, in Figure 8.1. This system consists of the figure

of a bird with a long beak and a hollow body, made of glass, mounted so that the figure can rotate up or down. When it rotates down, the beak of the bird eventually dips into the water in the glass next to the bird. In operation, the bird keeps dipping its beak into the water, shooting up rapidly into a vertical position, then slowly coming down until the beak touches the water again, and so on, indefinitely.

Let us explain briefly what actually happens. The body of the bird, as well as the head and the beak, are hollow. Within it, there is a glass tube which holds a colored liquid. In Figure 8.1(a), the bird is balanced in an intermediate position. The colored liquid then separates two bodies of gas from each other: One is up on top within the "head" of the bird; the other is at the bottom, inside the glass bulb which forms the bird's "body."

The outside of the beak of the bird is covered with cold water, from the last time that the beak dipped into the glass of cold water. The water on the beak is cold itself, and more cooling is provided by evaporation of this water into the air of the room. Thus the body of gas trapped in the "head" of the bird is cooled down and therefore tends to contract. No such influence is working on the other body of gas, down below. On the contrary, if this gas was somewhat colder than room temperature originally (the usual situation), then it tends to warm up to room temperature and hence to expand. This double action forces some of the liquid out of the bulb and up into the tube. As a result, the distribution of weight within the bird alters so as to make it more top-heavy. The bird therefore dips, slowly, closer to the glass of water, as shown in Figure 8.1(b).

As this process continues, the bird dips down more and more, until it reaches a nearly horizontal position, with its beak inside the cold water, as shown in Figure 8.1(c). In this position, the two bodies of gas (the cold one near the beak, and the warmer one near the tail) can communicate with each other, being no longer separated by a layer of liquid. As soon as these bodies of gas do communicate, their pressures and temperatures are equalized rapidly. The liquid, which is now no longer subject to a pressure differential, collects again in the glass bulb at the bottom. This weighs down the bottom of the bird, so that the bird rapidly assumes an upright position, as shown in Figure 8.1d. In this position, and at this moment, the two volumes of gas are separated from each other by liquid, but they are at equal temperature (slightly below room temperature) and at equal pressure.

However, this balance does not last. Since the outside of the beak has been dipped into cold water, some cold water adheres to

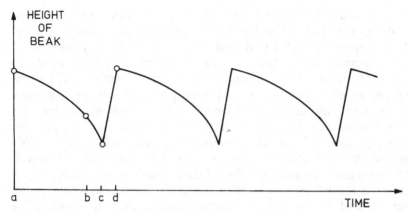

Figure 8.2

A schematic plot of the position of the bird, as indicated by the height of its beak above ground level, as a function of time. The times corresponding to positions (a) to (d) of Figure 8.1 are labeled a, b, c, and d on the time axis. Note the lack of symmetry in time: the bird dips down slowly, but rises very rapidly.

the beak. This proceeds to cool the upper volume of gas, both directly and through evaporation of the water into the air of the room. Thus the whole process repeats.

If we take the tip of the beak as our reference point, we may plot its height above the table, as a function of time. This plot is shown, schematically, in Figure 8.2. In this figure, we have indicated the states corresponding to Figures 8.1a to 8.1d by points labeled a to d on the time axis.

This motion is a special example of what is called a *limit cycle*. "Cycle" means that the motion repeats indefinitely. It is a "limit" cycle if the same motion is approached eventually, no matter how we start off the system initially.

Let us now list a number of properties which are typical of this, and many other, limit cycles:

1. The ultimate motion in a limit cycle does not depend on how the system is started off initially. Rather, the same eventual motion is approached from a large number of different initial conditions.

2. The motion maintains itself intact, but it is not a state of equilibrium. It is *a stable motion but not a stable point*.

3. The motion is *fixed in scale*. It can be neither scaled up nor scaled down without thereby becoming a motion impossible for the system to perform (i.e., a motion inconsistent with the equations of motion of the system).

4. The motion is *unsymmetric in time*. The time taken for the tip of the beak to rise from its lowest point (in the water) to its

highest point is very short, compared to the time for the reverse motion. This lack of symmetry in time between "going up" and "going down" is not a universal feature of all limit cycles—some have it, some do not. But when a repetitive motion does happen to be unsymmetrical in this sense, then this is a clear indication that the underlying system is a nonlinear system. It is a mathematical theorem that *all* linear systems give rise to symmetrical cycles.

5. To the casual observer, the bird appears to be a "perpetuum mobile," continuing to go through its motion without any supply of energy from outside. This impression is misleading, however. The operation depends on there being a difference in temperature between the cold water in the glass of water and the air surrounding the bird. In the absence of such a temperature differential, the motion stops. Thus, the bird is a simple heat engine, with heat energy used to combat the frictional effects which would stop the motion otherwise. A static, or point, equilibrium can be maintained without any external supply of energy. But *a limit cycle requires energy from outside to keep operating.*

6. In Figure 8.1a, the position shown is one of constrained, or limited, equilibrium. If the temperature and pressure levels in the two bodies of gas could remain unchanged, then this position of the bird is in balance, even in stable balance (displace the bird slightly, and it tends to return to that position). Similarly, the positions shown in Figures 8.1b and 8.1d are constrained equilibria. This is not true for *all* temporary positions within this limit cycle: Figure 8.1c is in disequilibrium, even locally; rapid changes occur there. The point we wish to make is this: *The appearance of positions of (constrained) local equilibrium cannot be used as an argument against the existence of an overall limit cycle motion.* Such positions can occur easily within a limit cycle.

7. In spite of their relative unfamiliarity to economists, *limit cycle motions are by no means rare or unusual.* On the contrary, all man-made engines run on limit cycles! They perform repetitive motions, based on an external supply of energy (be it electricity, or chemical energy from burning some fuel, or nuclear energy, or solar energy); the eventual motion is regular and stable and does not depend on how it was started off; nor can it be scaled freely. It is only in the abstract world of applied mathematicians, not in the real world, that linear systems rule the roost.

Although we are stressing the limit cycle as a possibility in nonlinear systems, it is by no means the only possibility unexpected from a study of linear systems. One particularly intriguing type of motion was discovered as late as 1963 (Lorenz 1963); it is called "strange attractors." The motion appears to approach one limiting

state (call it A); but then it suddenly veers off and proceeds to approach a second, quite different, limiting state (call that one B); but before it reaches that state, it suddenly veers off once more and starts to approach state A again; and so on and on, ad infinitem. The "veering off" times are essentially unpredictable, even though the equations of motion are mathematically deterministic: The precise times depend crucially upon the tiniest changes in initial conditions. For more about this, see Hellman (1980), Holmes (1979), and Leipnik (1981). We shall encounter strange attractors once more, briefly, in section 9B. But we doubt that they are likely candidates for the description of realistic dynamic economic systems.

C. The nineteenth-century trade cycle

In chapter 7 we demonstrated local instability of the balanced growth path of a competitive economy practicing "perfect thrift."[2] The model used was a linear model, and we now know that instability of a linear model's equilibrium means that the linear approximation is not adequate. A nonlinear model of some sort is required.

For example, one of our system specifications in chapter 7 was that the auctioneer must see to it that the market clears. But if the market can clear only when a negative quantity of iron is produced next year, then the market cannot clear, no matter what the auctioneer does. Thus, at this stage at the very latest, but probably much sooner than that in practice, the system specification *must* alter. The auctioneer must be instructed what to do if market clearing is no longer possible. This is a "nonlinear" instruction: It applies if and only if the deviations from equilibrium are large and is irrelevant for small deviations. We do not go into details, since the whole system is insufficiently realistic. But nonlinear effects must come in, somehow.

Once we leave the realm of linear systems, all sorts of possibilities open up. The occurrence of a limit cycle is one possibility, but by no means the only one. Yet, before embarking on complicated theoretical speculation, it is reasonable to first take a look at the historical reality for competitive economic systems, to see whether we can detect anything which looks similar to a limit cycle. If we can find behavior of that type within historical data, then it is an incentive to explore the possibilities of a limit cycle in economics, from the theoretical point of view.

[2] Perfect thrift is admittedly an extreme assumption, but gets rid of many problems.

The history we shall look at is nineteenth-century history. In the nineteenth century, particularly in the United Kingdom, capitalism had been largely freed from the earlier state interference associated with the mercantile system. Indeed, the governments of that day were so imbued with the virtues of free trade and "laissez faire, laissez aller" that they failed to interfere even to save human lives: In the Irish potato famine of the "hungry forties," the British government refused to supply food because this would have been an interference with the free market. In the other direction, the nineteenth century was largely free of the influence of monopolies and oligopolies, which are so prevalent in the twentieth century. The Standard Oil Company, the first of the big "trusts," was formed around 1880; this marks the end of the historical period which can be compared validly with a simple competitive model of the economy. After the worldwide depression of the 1870s, business leaders tended to reject unrestricted competition, more and more.

Looked at on an overall scale, the nineteenth century was a period of enormous economic growth. But this growth was by no means steady and balanced. On the contrary, there existed a clear and pronounced "trade cycle" ("business cycle" in America). Periods of slowly, and then more rapidly, increasing prosperity were followed by wild speculative booms, ending in a "panic." Then the cycle started up again.[3]

We shall concentrate on the British economy, because: (1) it was the dominant economy of the nineteenth century; (2) the British government (unlike the French, for example) was committed to laissez-faire.

The British economy went through a panic in 1816, following the conclusion of the Napoleonic wars. The subsequent recovery was rapid and led to a boom, which was terminated by the panic of 1825. This panic seems to have been triggered off by wild speculation in loans to the new governments of the South American republics, and in stocks of raw materials used by British export industries. Next, there was a period of depression and panics from 1836 to 1839. Britain's difficulties in that period may have been exacerbated by the actions of President Andrew Jackson in the United States, especially his withdrawal of government deposits from the second Bank of the United States, an action which effec-

[3]"Panic" was the word used then, and a very accurate descriptive word, too. Our modern penchant for weasel-wording has led to, in turn, "depressions," "recessions," and even "growth pauses" (Galbraith 1975, p. 103). Sometimes a technical distinction is made between a monetary liquidity crisis ("panic") and the ensuing depression. We mean the crisis stage here.

tively destroyed that institution's status as a central bank.

The subsequent recovery was rather slow and did not really get well under way until about 1843. Railway building started to boom, but this boom did not extend to the cotton industry, and the potato blight of 1844 in Ireland was a major disaster. A fierce speculation in the cereal market of early 1847 was followed by an unexpectedly good harvest in the summer. The resulting fall in prices ruined many speculators. Their bankruptcies led to suspension of payments by some banks, and that in turn led to a full-scale panic. This 1847 panic was particularly striking, since the British government under Sir Robert Peel had passed, only three years earlier, the 1844 Bank Charter Act, which was supposed to prevent panics once and for all. Now the government had to eat its words. It had to authorize the Bank of England to break the law of England, giving the Bank the authority to issue whatever volume of bank notes might be required to stem the panic (Ward-Perkins 1950). It is entirely possible that the panic of 1847, which extended well beyond the British economy, was at least in part responsible for the "year of revolutions" in Europe, the year 1848.

The next panic came in 1857. It may have been triggered off by wild speculation in railway company shares, particularly of U.S. railways.

Not so the panic of 1866: that one was triggered off right within Britain, by the collapse of the "bill-broking" house of Overend and Gurney in London. The "bills" were commercial bills of exchange, usually rather short-term (three months was typical). In this specialized financial market, Overend and Gurney had built up a leading position. But this company had extended its operations into other fields, including some very unsound speculative investments. On "black Friday" (11 May 1866) the panic was so bad that the reserves of the Bank of England, normally between 10 and 20 million pounds in gold, fell by 4 million pounds in one day! Once more, the government was forced to authorize the Bank of England to issue bank notes freely, in defiance of the Bank Charter Act.

While the 1866 panic was set off by "domestic" events in Britain, the 1873 panic followed another wild spree in U.S. railway shares. Another factor in that panic was money paid by France to Imperial Germany, following the French defeat in the war of 1870; the French reparations payments to the Germans went via the London money market, thereby making that market more unstable and less able to resist shocks.

We shall stop our super-abbreviated potted history here. Enough has been said to make it clear that the uncontrolled competitive

economy of the nineteenth century was by no means the smooth
paradise envisaged by some of our modern economists who blame
all troubles on government interference with the economy
and would have us go back to an uncontrolled "free market."
There was *no* government interference with the free market in
those days; yet panics were by no means exceptional, unexpected
events. On the contrary, the trade cycle with its recurrent panics
was the *normal pattern* of nineteenth-century economic develop-
ment.[4]

If we take the period from the end of the 1816 depression to
the panic of 1873, we can count 6 full cycles in approximately 57
years, an average of 9 to 10 years per cycle. The actual intervals
between panics ranged from a low of 7 years, to more than 11
years. Thus the nineteenth-century trade cycle was by no means as
regular as our mechanical example. But, and this is much more im-
portant for us, neither was nineteenth-century growth at all steady
or balanced. Periods of growth alternated with sudden panics in
which the rate of growth declined sharply, and even became nega-
tive for short periods.

In our brief historical summary, we have mentioned some of the
explanations of the various panics found in the literature. These
supposed causes range from aftereffects of a war to excessive spec-
ulation in U.S. railway shares. They differ from one panic to the
next. We do not wish to dispute these explanations as such. But
we cannot help but be terribly dissatisfied with this whole kind of
explanation, which treats each panic as a separate, entirely new
and distinctive event, which must be "explained" by a cause all
its own. Actually, nineteenth-century panics were a recurrent, re-
peated, and practically predictable occurrence. Special explana-
tions may, and probably do, enable us to understand just what
caused an inherently unstable and overextended state of the econ-
omy to collapse suddenly into wild panic.

But these special explanations fail completely to explain the
much more important fact that the economic system developed
from aftermath of a panic, through prosperity, boom, and asso-
ciated speculation, to reach another inherently unstable and over-
extended state, time and time again with absolute regularity. What
we must look for is not special causes peculiar to each panic, but
general causes for this general development of a competitive econ-
omy without government interference.

[4] We have taken much of our abbreviated account from Flamant (1968). The
literature on this topic is enormous, e.g., Matthews (1959), Rostow (1948),
and references within those books. Some economists, e.g., Brems (1977), are
so willing to ignore obvious facts as to quote nineteenth-century data as an
example of the validity of neoclassical balanced growth theories!

D. A program for dynamic economics

At this stage of the argument, we feel free to offer a *conjecture*: The repeated development of an unstable state of the economy is associated with, and indeed is an unavoidable consequence of, the local instability of the state of balanced growth.

In chapter 7 we demonstrated that, under the most favorable assumptions for stability, balanced growth is unstable locally. Small deviations from balance tend to grow. We do not maintain, and indeed we do not believe, that the precise nature of the imbalance of our oversimplified model (imbalance between outputs of various commodities) is the most important in reality. The model was constructed deliberately to exclude all sorts of possibilities which might lead to instability in the real world, so as to produce a model biased in favor of stability. In the real world, these other sources of instability (for example, in financial markets[5]) are present and must not be ignored. Thus, the actual type of imbalance may differ quite significantly from the simple model. But what the model does show is that we *must* expect instability of balanced growth.

Now, if balanced growth is unstable, then actual growth will normally be unbalanced. As unbalanced growth continues for some time, it is bound to lead to a more and more unbalanced state of the economy as a whole. Such an unbalanced state is necessarily unstable and can collapse easily into a state of panic when subjected to even a slight shock, such as collapse of a major bank, failure of an important crop, or else an unexpectedly successful harvest, etc. etc. In this view, *the repeated development of an unstable state of the economy is a consequence of the instability of balanced growth.*

Since the economic system is much more complex than any simple mechanical example, the motion of the economic system is not completely regular or strictly repetitive. In particular, it is impossible to predict just what event will set off the next panic, or just when it will strike. But strike it will, since the state of the economic system becomes steadily more and more removed from balance and stability as time goes on. Something must break eventually.

From this point of view, *the trade cycle is not a mere fluctuation superimposed on a state of steady, balanced growth; rather, the trade cycle is part of the very process of growth in a competitive economy.* We intend to accept this picture as our working hypothesis in what follows, and we shall investigate existing the-

[5] Minsky (1977).

ories of the trade cycle from this point of view. Let us now list some of the implications of such a program of theoretical research:

1. The state of balanced growth, which has been studied so extensively, is uninteresting (since it is unstable). Actual growth is cyclical in nature and is not at all similar to balanced growth.

2. The argument which has been shown to be invalid (in section A) must be "stood on its head." The correct argument reads: "Historical experience with a competitive system indicates that such a system goes through a regular trade cycle. Any theoretical model with a stable balanced growth path fails to show this observed type of behavior and must therefore be excluded. Thus, the appearance of *stability of the balanced growth path is a sign of failure of the theoretical model.*"

3. Since no linear theory can lead to a limit cycle (this is a mathematical theorem), *any realistic economic model must be essentially nonlinear.* Far from being an advantage, strict linearity of an economic model is a fatal drawback which cannot be tolerated. (Note: This refers to strict mathematical linearity; an otherwise linear model with "floors" and/or "ceilings" is nonlinear, from a mathematical point of view.)[6]

4. Since balanced growth is locally unstable, investigations of "growth equilibrium" are of no scientific interest in economics. The state so found may exist, but it cannot maintain itself for any length of time. *Economic theories based upon growth equilibrium plus small deviations from that state are unsuitable as a basis for explaining reality.*

By now, we see that our working hypothesis has cut quite a swathe through the conventional economic literature. By the time we discard all systems with a stable equilibrium (static or growth equilibrium; it does not matter), all linear systems, and all time-independent systems, there is mighty little left. It is a consequence of our working hypothesis that the science of economics must be started afresh.

The main foundation for dynamic economics, to which we can, and will, return is the Tableau Economique of Francois Quesnay (1760). This picture of the economic system as a circular flow survives, since it does not assume stability or equilibrium, but rather is capable of describing states far removed from either. The more one reflects on the history of economic thought, the more one is

[6] The best-known economic model with ceilings and floors is the Hicks (1950) model, which we shall discuss at some length in a later chapter. Also, the importance of nonlinearity and the idea of a "limit cycle" has been stressed very strongly by R. M. Goodwin (1967, 1972). This work deserves much more attention than it has received so far. The Goodwin model is discussed in section 10C. An early suggestion of limit cycles was made by Samuelson (1939 a).

impressed by the towering genius of Quesnay.

E. A digression on natural price

The instability of the balanced state of the economy has some interesting consequences for a long-standing controversy in economics, namely, the theory of "natural price" or "exchange value." The essentials of these concepts were used by Adam Smith (1776), by Ricardo (1821), and by Marx (1867). Adam Smith defines his "natural price" as follows (p. 55):

> There is in every society or neighbourhood an ordinary or average rate both of wages and profit in every different employment of labour and stock. . . . There is likewise in every society or neighbourhood an ordinary or average rate of rent. . . . These ordinary or average rates may be called the natural rates of wages, profit, and rent, at the time and place in which they commonly prevail. When the price of any commodity is neither more nor less then what is sufficient to pay the rent of the land, the wages of the labour, and the profits of the stock employed in raising, preparing, and bringing it to market, according to their natural rates, the commodity is then sold for what may be called its natural price.

The advantage of such a concept for theoretical economics is stressed ably by Ricardo (1821, p. 50):

> Having fully acknowledged the temporary effects which, in particular employments of capital, may be produced on the prices of commodities, as well as on the wages of labour, and the profits of stock, by accidental causes, without influencing the general price of commodities, wages, or profits, since these effects are equally operative in all stages of society, we will leave them entirely out of our consideration whilst we are treating of the laws which regulate natural prices, natural wages, and natural profits, effects totally independent of these accidental causes. In speaking, then, of the exchangeable value of commodities, or the power of purchasing possessed by any one commodity, I mean always that power which it would possess if not disturbed by any temporary or accidental cause, and which is its natural price.

It is this natural price, or exchange value, not the momentary current market price, which was the main concern of the classical economists. To the extent that more recent economists accept stability of general equilibrium, the general equilibrium price becomes a similar pivot about which current market prices are supposed to move and therefore assumes the role of a neoclassical substitute for the classical notion of "natural price."[7]

All this is fine if, but only if, the "natural price" is *stable*, in

[7] We do *not* maintain that neoclassical equilibrium prices are equivalent to classical natural prices, merely that the two concepts fulfill similar roles in enabling theorists to circumvent discussion of time-dependent effects.

the sense that actual market prices tend, of themselves under the action of free competition, to return to this natural price after any deviation.

However, one of the constituents of the "natural price" is the ordinary or average rate of profit. Historically, this rate shows no stability whatsoever. On the contrary, over the course of the trade cycle, profits exhibit enormously strong, entirely systematic variations. The size of these variations is as big, or bigger, than the average level of profits (averaged over the entire cycle). These profit fluctuations are by no means random, from one enterprise to the next. Rather, they pervade the entire economy at once, including all enterprises within it. When "trade is good," everyone makes good profits; when "trade is bad," even otherwise sound enterprises may find themselves unable to meet their bills. In many instances, profits turn negative during and immediately following a panic. The current level of profits, in turn, influences prices of capital goods, share market prices, etc. etc. Thus, the repercussions extend throughout the economy.

Under such conditions, the concept of a "natural price" becomes of very questionable value. A "natural price" which is *not* the center around which actual prices revolve, except in a long-term average of ten years or so, is not suitable to be used in the way that Ricardo and other economists want to use it. The "temporary effects" by which prices deviate from such artificial "natural prices" are neither "accidental" nor "without influence on the general price of commodities, wages or profits." From our point of view, there is nothing "accidental" about the trade cycle —it is an inherent property of the economic system under discussion; and one must be deliberately blind to fail to note the influence of this trade cycle on "the general price of commodities, wages, or profits." In spite of Ricardo's strong words, the deviations from his "natural price" are *not* "temporary or accidental" and must *not* be left "entirely out of our consideration." They are not accidents of economic life—they are an essential part of it.

No realistic theory of economic behavior can be built by starting from a long-term average, when the deviations from that average are entirely comparable to the average value itself and are furthermore decidedly systematic in nature. To the extent that "natural price" or "exchange value" is taken to have the properties postulated for it by the classical economists, we are forced to the conclusion that this concept is one of the famous "empty boxes" of economics: a theoretical concept to which there is no counterpart in real economic life. There is a market price, sure enough; and, in any short period of time, there exists an average market

price for each commodity, with actual prices fluctuating about this average in the short term. But these average prices are *not* constant in time but rather vary with time systematically and significantly, as the trade cycle proceeds on its course.

After two hundred years of often violent debate over competing theories of exchange value or natural price,[8] it is likely to come as an anticlimax of massive proportions to find that the very concept of exchange value, as used by the classics, is nothing but an "empty box." Nonetheless, there is no way to escape this conclusion.

Of the various classical schools of economics, only the physiocrats, starting with Quesnay, had a plausible reason for ignoring trade cycle fluctuations. Ever since the disastrous outcome of John Law's "Mississippi bubble" speculative schemes (the bubble burst in 1720), commercial speculation had a very bad name in eighteenth-century France and was kept under the strictest control. The economy of France, as a result, was much less subject to recurrent booms and panics than was the economy of eighteenth-century Britain. The French economy pursued an even, regular course by comparison. Steadily and surely, without faltering on its way, it descended into ultimate disaster.

It is highly ironic that the one school of classical economics which had good cause to ignore fluctuations and instabilities was exactly the school which produced the only suitable method for handling such problems: the Tableau Economique. All the other schools have reasoned in terms of a basically stable system, with an associated stable "natural price" for each commodity.

Exactly through this form of reasoning, by "leaving entirely out of our consideration" some highly important effects, these schools of economics have tended to lose touch with economic reality. Ricardo denied the very possibility of a "general glut" of goods, in spite of absolutely overwhelming contemporary evidence that the phenomenon he was denying was occurring under his very nose. His logically plausible grounds were that general overproduction cannot occur in a balanced system which is stable. Indeed, it cannot; unfortunately, the actual system does not possess the properties which Ricardo assumed.[9]

[8] See, for example, Hunt (1972), Harris (1978), Pasinetti (1977), Samuelson (1973), Walsh (1980).

[9] It is widely believed that a long-term (ten-year) average over trade cycle fluctuations can be described correctly by ignoring the fluctuations altogether, i.e., by equilibrium theory. *This is wrong mathematically*: The average over a limit cycle is *not* equal to the value at the unstable equilibrium point within the limit cycle. In chapter 14, we return to this point in more detail, in connection with Ricardo's predictions for the relative position of landlords and industrialists in the long run.

From our point of view, the essential aspect of an economic theory is not its concept of exchange value or natural price, but rather the attitude taken toward the Tableau Economique and its implications. Theories which take into account the circular flow of goods and of money, and only those theories, allow one to go beyond the markets for goods to the system of production and circulation of these goods, and hence to make real progress in dynamic economics.

Schematic trade cycle models: part I

A. Introduction: the acceleration principle

In this and the next chapter, we introduce the main schematic models of the trade cycle in the literature. Much of this material can be found in the excellent little book by Nicholas Rau (1974), but, as becomes evident, we do not always agree with the conclusions in the literature.

All these "schematic" models have certain common properties.

1. The models are highly "aggregated" or "macroeconomic" in nature, working with "total output" Y, "investment" I, "consumption" C, "stocks" (also called "inventories") S, and so on. All these are sums over rather disparate things. For example, "consumption" includes various food commodities, items of clothing, motor cars, etc. They are aggregated in terms of total value, either at current prices, or at "constant" prices.

2. Therefore these crude models find it difficult to handle *both* quantities and prices. Largely for this reason, the analysis, such as it is, proceeds in "purely real" terms; i.e., price changes are ignored by means of reduction to "constant" prices.

3. The usual models all use period analysis; i.e., time is divided into fixed periods. The period is sometimes one year, more often a quarter of a year. Aggregates at time t, thought of as the end of period number t, are related to the same, and other, aggregates one or more periods earlier. As a result, the choice of the period is important in understanding and analyzing each model.

To introduce the basic concepts, let us consider the relationship between consumption demand $C(t)$ at time t and national income Y. Consumption is expected to increase with income. Over a not

too wide range of incomes, we should then be able to approximate this relationship by a straight line:

$$C = C_0 + mY$$

where C_0 and m are constants. The quantity m is the "marginal propensity to consume" of Keynes (1936) and is expected to lie between zero and one, rather closer to the upper limit. A small increase dY in national income results in an increase $dC = m \times dY$ in consumption; the rest, $(1 - m)dY$, appears as savings, that is, is not spent on consumption.

The consumption-income relationship must be taken with some caution. First, it is at best a rough approximation, valid only (if at all) for a narrow range of incomes Y. In particular, it is *not* permitted to set $Y = 0$ in this relationship, so that C_0 is interpreted as that level of consumption corresponding to zero national income. The straight line is an approximation valid only over a limited region of Y-values and must be modified long before we reach $Y = 0$.

The second caution refers to time lags. People need time to adjust to a change in income. Thus, consumption demand $C(t)$ in period t should be related to income Y in an *earlier* period. To keep things simple for now, let this earlier period be the one immediately before, so that we write:

$$C(t) = C_0 + mY(t-1)$$

This is our *consumption equation*.

Next, we require an investment equation. Some investment is needed to replace capital stock which has worn out. This "replacement investment" is *not* counted as part of net investment. On the other hand, if we wish to, or expect to have to, plan for *increased* output in the future, then we must invest in an increased capital stock to make this possible. As the simplest imaginable case, assume that there exists a simple proportional relationship between the current stock of capital K^1 and the level of output Y which can be achieved with this stock of capital:

[1] There are enormous, probably insurmountable, difficulties in the way of defining this quantity K unambiguously (Robinson 1954, Harcourt 1972). Capital can be "aggregated" only in terms of values, but the value of a piece of capital equipment depends on such things as the rate of return. The simple schematic models discussed here are not robust enough to be subjected to such fundamental criticism. Let us aggregate K by valuing each "machine" at its cost price, perhaps corrected to "constant prices" by some price index. More searching questions must be avoided by the process of firmly closing both eyes. In practical work, but not in theory, this difficulty can be circumvented by working with incremental, not total, quantities (Eichner 1980, p. 173-176).

$$K = vY$$

Here v is a constant, which will turn out to be the so-called "acceleration coefficient." This term was introduced by John Maurice Clark (1917). If output is to increase by δY in the next period, we require an increase of $v\delta Y$ in the capital stock; this extra capital stock represents net investment. If the constant v exceeds unity (the usual case) then increases in expected or desired output imply larger increases in necessary capital stock, and hence substantial net investment. In the simplest form of the acceleration principle,[2] we anticipate an output increase, during period t, of $\delta Y = Y(t-1) - Y(t-2)$ (the actual increase of the most recent past), and we therefore schedule an investment $I = \delta K = v\delta Y$ to cover this anticipated extra demand. In addition, there will be some "autonomous" net investment I_0 which is not related directly to immediate changes of demand. We put these together to obtain the *investment equation*:

$$I(t) = I_0 + v[Y(t-1) - Y(t-2)]$$

Here I_0 and v are constants, called "autonomous investment" and "accelerator," respectively.

Before proceeding further, it is desirable to take a careful look at this "accelerator" constant v. In the relationship $K = vY$, K is a stock whereas Y is a flow. Hence $v = K/Y$ has the dimension of a *time*. As a crude first approximation, v is that time (measured in units of the "period" of our period analysis) needed to replenish the entire stock of capital K if the entire current rate of output Y is used for no other purpose. In modern developed economies, the capital stock could not be replaced in less than two years, with perhaps four years as a more realistic estimate. On the other hand, the relationship $K = vY$ is much too crude and is not really required for the investment equation. Actually, the v which appears in the investment equation represents the *marginal* increase in capital for a marginal increase in output. This is likely to be somewhat smaller than the average ratio K/Y. Thus, on a very crude basis, two years or thereabouts might be a reasonable rough estimate for v. Since this time must be measured in units of the "period" of our model, $v = 2$ for an annual model, $v = 8$ for a quarterly model, and so on. We emphasize that these are only very rough estimates, with no claim to precision.

Our final model equation is for the national income $Y(t)$. The consumption demand $C(t)$ and the investment demand $I(t)$ are *de-*

[2] For fuller discussion, see Chenery (1952), Knox (1952), Matthews (1959), Lovell (1961).

mands for output; if the economy is able to meet these demands upon it, then the actual output is equal to their sum:

$$Y(t) = C(t) + I(t)$$

which is our *output equation*. It is important to emphasize that this is *not* an accounting identity, but rather represents an assumption about the real world which the model is intended to approximate to. This assumption may turn out to be true or false. For example, if the demand for output is very high, as it is in wartime, the economy is unable to meet all these demands. Then actual output is less than the sum of all demands, some of the demands remaining unfulfilled. For now, however, we shall assume that the capacity of the economy is sufficiently high to make our simple output equation valid.

B. The accelerator-multiplier model

The three equations, for consumption, investment, and output, respectively, which we wrote down in section A provide the essence of the famous accelerator-multiplier model of Samuelson (1939).

Let us first dispose of the simple case of equilibrium; i.e., all quantities appearing in the model are constant in time. We denote equilibrium levels by a bar over the letter, e.g., \bar{Y} is the equilibrium level of Y, etc. If we replace all time-dependent quantities by their equilibrium values, the three equations become:

$$\bar{C} = C_0 + m\bar{Y} \quad \bar{I} = I_0 + 0 \quad \bar{Y} = \bar{C} + \bar{I}$$

We substitute the values of \bar{C} and \bar{I} from the first two equations into the third:

$$\bar{Y} = (C_0 + m\bar{Y}) + I_0 = (C_0 + I_0) + m\bar{Y}$$

and we solve this last equation for the equilibrium output level \bar{Y} to get:

$$\bar{Y} = (C_0 + I_0)/(1 - m)$$

This is the famous "multiplier" equation of Keynes (1936), the "multiplier" being the factor $1/(1 - m)$. This multiplier effect was first suggested by Kahn (1931), in connection with employment, and was then used by Keynes for national income.

For the sake of illustration, take a specific value of the marginal propensity to consume, say $m = 0.75$. Out of each extra dollar of income, on the average 75 cents is spent on consumption; 25 cents is saved. Then the multiplier equals $1/(1 - 0.75) = 4$. Hence each

extra dollar of new expenditure generates, other things being equal, four dollars of additional national income. The mechanics of this process can be related to the mathematical expansion:

$$1/(1 - m) = 1 + m + m^2 + m^3 + \ldots +$$

This is interpreted as follows: Start with one extra dollar spent, which shows up as income in the hands of, say, a merchant. This is the "1" in the series. In the "first round," this merchant spends a fraction m of the dollar he has received, thus generating the term m in the series. This income accrues to someone in the "second round," who then spends a fraction m of his receipts, leading to the term m^2 ; and so on, round after round.

This simple expression for equilibrium national income \bar{Y} is at the heart of the well-known Keynesian policy recommendations for getting out of a depression. We should encourage consumers to spend more and save less, because this raises m and, with it, the value of the multiplier. We should inject extra spending power into the economy, i.e., raise C_0 so as to raise the entire consumption curve, thereby generating a "consumer-led recovery." We should encourage businessmen to invest more, thereby (it is hoped) raising the basic level of investment I_0 and, as a result, national income, in an "investment-led recovery." Governments should be prepared to add to the national debt for these purposes, and they can afford to do so, because for each dollar they inject into the economy a much larger number of dollars is added to the national income. Some of this extra income can then be recovered by the government through normal proportional taxation.

Our only comment, for now, is to point out that all this is based on an *equilibrium* value of the national income. There is a tacit assumption that the system has a natural tendency to approach this equilibrium. The question is: Does it have such a tendency in reality?

To investigate this question, let us now look at the system of three equations (consumption, investment, and income) in the general case, away from precise equilibrium. Let us combine the three equations into one, by substituting the value of $C(t)$ from the consumption equation, and the value of $I(t)$ from the investment equation, into the output equation. When we do so, and collect like terms, we obtain:

$$Y(t) = (C_0 + I_0) + (m + v)Y(t-1) - vY(t-2)$$

Hence, if we know the values of the national income in the two preceding periods [the values of $Y(t-1)$ and of $Y(t-2)$], then we can calculate the national income in period t, $Y(t)$. Starting

from known or assumed values $Y(0)$ at time $t = 0$ and $Y(1)$ at time $t = 1$, we can work forward to get $Y(2)$. From the now known values of $Y(1)$ and $Y(2)$, we can work forward to get $Y(3)$; and so on, indefinitely.

In Table 9.1, we carry out three such calculations, with parameters chosen as follows:

$$C_0 + I_0 = 25, \quad m = 0.75, \quad Y(0) = Y(1) = 101$$

$$v = 0.9 \text{ (first column)},$$
$$v = 1.5 \text{ (second column)},$$
$$v = 3.0 \text{ (third column)}$$

With $C_0 + I_0 = 25$ and $m = 0.75$, the equilibrium value of national income is $\bar{Y} = 100$; the values of $Y(0)$ and $Y(1)$ are taken as one percent above this, equal to 101.

Let us now discuss the results in Table 9.1. For $v = 0.9$ the national income $Y(t)$ oscillates around the equilibrium value $\bar{Y} = 100$, the oscillations becoming smaller as time goes on. One complete cycle takes approximately 12 of these "periods" (for example, from the peak at $t = 13$ to the next peak at $t = 25$). For this value of the accelerator coefficient v, the model is stable; i.e., the equilibrium value is approached eventually.

This is not true for larger values of v. With $v = 1.5$ we get oscillations, again, but now the oscillations increase in strength as time goes on. It is then only a matter of time before we get completely impossible values from the model—for example, a negative value of national income (!) at time $t = 23$. With even larger values of the accelerator constant, say $v = 3.0$, we lose the oscillations, but we retain the trend to impossible values. The national income predicted by the model becomes more and more negative (we have stopped giving numbers after $t = 17$, when we have exceeded a negative million after starting from a positive 101).

The mathematical treatment in section D leads to the following *general results*:

1. The equilibrium state is stable if v lies between 0 and 1, unstable if v exceeds 1. (The case $v = 1$, exactly, is of no interest, since the precise value of v depends on what we choose to be our time "period." If $v = 1$, exactly, for some choice of period, it becomes different from unity by choosing a period 0.01%, say, smaller.)

2. For values of v fairly close to unity (on either side) the behavior is oscillatory; i.e., one gets a "cycle" in the national income. This cycle is "damped" for v less than unity, "explosive" for v greater than unity (see column 2 of Table 9.1, $v = 1.5$, for the meaning of an "explosive cycle").

3. For v considerably larger than unity (precisely how much lar-

Table 9.1

Time Development of National Income

Table 9.1 assumes the accelerator-multiplier model with
m = 0.75, Y = 100, and various values of the acceleration
coefficient v, namely, v = 0.9, 1.5, and 3.0. The initial
values of income are 1 percent above equilibrium level.

Time *t*	National income *Y(t)*		
	v = 0.9	*v* = 1.5	*v* = 3.0
0	101.00	101.00	101.00
1	101.00	101.00	101.00
2	100.75	100.75	100.75
3	100.34	100.19	99.81
4	99.88	99.30	97.05
5	99.50	98.14	89.49
6	99.28	96.86	69.44
7	99.27	95.74	16.94
8	99.44	95.11	−119.81
9	99.73	95.40	−475.09
10	100.06	96.98	−1,397.17
11	100.34	100.10	−3,789.11
12	100.51	104.76	−9,992.65
13	100.54	110.57	−26,080.11
14	100.43	116.63	−67,797.47
15	100.22	121.57	−175,975.17
16	99.98	123.58	−456,489.47
17	99.77	120.71	−1,183,885.00
18	99.64	111.22	−
19	99.61	94.19	−
20	99.68	70.09	−
21	99.83	41.42	−
22	100.00	13.06	−
23	100.16	−7.75	−
24	100.26	−12.02	−
25	100.29	9.59	−
26	100.24	64.59	−
27	100.14	155.96	−
28	100.01	279.01	−
29	99.89	418.84	−
30	99.82	548.87	−
31	99.79	631.71	−
32	99.82	623.03	−
33	99.90	479.25	−
34	99.99	168.78	−
35	100.07	−314.12	−

ger depends on the marginal propensity to consume m) the motion is unstable but no longer oscillatory. An example is the case $v = 3.0$ in Table 9.1. Once the income starts decreasing, it continues doing so, more and more rapidly, getting into ever more negative values before long. If the income starts by increasing, it also continues doing *that*, more and more rapidly. In that case, no negative values of income occur, but the positive values soon exceed all reasonable bounds, in particular the bounds set by the total productive capacity of the economy.

It is apparent that the actual value of the accelerator constant v is of paramount importance. Since this, in turn, depends on the time "period" chosen for our model, we must discuss the considerations involved in choosing a "correct" time period for such crude models.[3]

In the consumption equation, $C(t)$ is supposed to depend on $Y(t-1)$, the income in the immediately preceding period. To make this a sensible approximation, the length of our time period should be equal to the time delay in consumer reaction to a change in income. This time has been estimated from U.S. data by Lloyd Metzler (1948) to be very short indeed, certainly less than three months.

However, such a short "period" is not well adapted to our investment equation. Here $I(t)$ is assumed to depend on the difference $Y(t-1) - Y(t-2)$. This difference is a rough measure of the rate of change of national income at a time 1.5 periods before time t. The time delay between a rise in national income and the resultant induced investment cannot be very short. Producers must first be sure that the rise is not just temporary; then they must make an investment decision; additional time then elapses before this decision results in actual output of investment goods. The rather long time lag expected on this basis is confirmed by the data quoted in Metzler (1948), where he arrives at a delay time between one year and six quarters, roughly. If we set this delay equal to 1.5 of our "periods," as we should, then the length of one "period" is between eight months and one year.

We are therefore faced with strongly conflicting requirements! The best choice of period for consumption is one thing (less than 3 months); for investment it is quite different (between 8 and 12 months). The actual choice is bound to be an unhappy compromise; probably half a year is close to the best we can do, but it is not at all very good.

Earlier, we estimated that the accelerator coefficient v is of the

[3] This point has been emphasized by Duncan Foley (1975).

order of two years at a minimum, probably rather larger. With a time period of half a year, this means the numerical value of v is at least 4, probably larger. Thus, *with the best compromise estimates for the coefficients, the accelerator-multiplier model of Samuelson is not only violently unstable, but does not even lead to oscillations of any sort.*

One might think that the reason for this lies in the conflicting requirements for the choice of the time period. It is easy enough to modify the model so as to avoid this conflict. Since the time lag for consumption is so much shorter than for investment, the simplest procedure is to ignore the consumption time lag altogether, so that the revised consumption equation becomes:

$$C(t) = C_0 + mY(t)$$

This is *not* a "bogus equation" (Rau 1974), in spite of the apparent instantaneous response of consumption to income; the actual adjustment is not instantaneous, but the time lag is so short that it can be neglected compared to other lags. The resulting system of equations is studied in the mathematical appendix. This revised system turns out to be stable only if the accelerator coefficient v is less than $1 - m$. With $m = 0.75$, this means $v < 1/4$ as a condition for stability. With our unit of time between 8 months and a year, and v at least two years, the numerical value of v is equal to two at the very minimum, well and truly removed from the stability limit $1/4$. We conclude that the instability is *not* due to the difficulties in choosing a time period suitable for such a model.

Quite apart from the choice of parameters in this model, or even the choice of the structural equations (e.g., the two alternatives for the consumption function listed above), we now point out that *no linear model can form the basis for a theory of the trade cycle*. Linear models have a very limited repertoire of possible solutions:

1. stable solutions which are not oscillatory (approaching the equilibrium values in a regular, one-sided way);

2. stable solutions which are oscillatory, such as the case $v = 0.9$ in Table 9.1;

3. unstable solutions which are oscillatory (see $v = 1.5$ in Table 9.1); and

4. unstable solutions which are not oscillatory (see $v = 3.0$ in Table 9.1).

These are the *only* possible solution types for linear models (we ignore some peculiar special types which depend upon particular numerical relationships between the parameters of the model, relationships which could hold, if at all, only by an accident).

No matter how complicated a linear model may be in detail, there are no other types of solutions, and the general solution is always a linear superposition of solutions of these types. But *none* of these solution types, and no linear superposition of them, gives rise to an acceptable model of the trade cycle: Stable solutions approach equilibrium, so the cycle "dies down," contrary to observation; and unstable solutions soon become impossible economically.

In spite of its undoubted historical importance, the linear Samuelson model is quite unsuitable as a model of the trade cycle.

In another paper later that same year (Samuelson 1939a), Samuelson suggested nonlinear modifications of his model, in particular emphasizing the curved relationship between consumption and income. He also suggested the possibility that such a model might give rise to a limit cycle. Much later, other possibilities have become apparent; in particular it is possible that the nonlinear Samuelson model can, for some values of the parameters, give rise to "strange attractors" (see section 8B). In spite of these interesting mathematical possibilities, the nonlinear Samuelson model has not received much attention in the literature. The probable reason is that economists have felt that nonlinear effects other than those stressed by Samuelson (effects on investment and on total national income, rather than on consumption) must be taken into account first. We exhibit such a model in section 10A.

C. The inventory cycle

There is considerable evidence that actual trade cycles are not all of the same kind. Economic historians distinguish between "minor" and "major" cycles; some suggest the existence of (roughly 20-year) "building cycles" (Derksen 1940, Isard 1942) and of "long waves" of economic activity (roughly 50 years). There is no kind of unanimity. The "long waves" of Kondratiev (1922) are particularly controversial.

However, there is universal agreement on the existence, and nearly universal agreement on the interpretation, of the "minor cycle," of duration around three to three and one-half years. We quote Matthews (1959):

> Between 1919 and 1956 there were six occasions (apart from the postwar reconversion year 1946) when gross national product fell for one year and then recovered: 1921, 1924, 1927, 1938, 1949, 1954. On these occasions the fall in inventory investment accounted on the average for no less than 75% of the fall in total investment. In the more prolonged contraction of 1929-32, on the other hand, the fall in inventory invest-

ment was only 27% of the fall in total investment. In the seven peace-time expansion phases of gross national product (1921-1923, 1924-1926, 1927-1929, 1932-1937, 1938-1941, 1949-1951, 1954-1956) inventory investment accounted on the average for 47% of the rise in total investment. On the other hand if cyclical expansions are measured on a broader basis, disregarding one-year contractions and so yielding three expansion phases only (1921-29, 1932-41, 1949-56), inventory investment accounts on the average for no more than 26% of the rise in total investment.

Thus, the short, "minor" cycle seems to have very much to do with investment, voluntary or otherwise, in "inventories," i.e., stocks of finished or partially finished goods, work in progress, and stocks of raw materials for production. This kind of "working capital" has been ignored in the model of section B. The "invest-ment" which we have denoted by $I(t)$ is not differentiated into investment in fixed capital (plant and machinery) and inventory investment (working capital). We must now make that distinction.

Fixed capital includes the factory buildings, machines installed therein, perhaps a privately owned spur line connecting the factory to the nearest railway line, trucks and other motor vehicles, etc. These items are not procured lightly or without a deliberate investment decision. Nor are they items which can be disposed of easily on the market, at least not without taking catastrophic losses.

Working capital includes stocks of finished articles, of raw materials, and work in process, as the main items. Such stocks *must* be maintained if the business is to run profitably. It is impossible to rely on making everything "to order" if and when an order is received. Customers value quick delivery and will go to the competition if we maintain no stocks out of which to fill orders. Suppliers of raw materials do not respond to our orders immediately. The factory cannot work efficiently on a "stop and go" basis. Thus, inventories must be maintained.

But, unlike fixed capital, inventory levels can alter without any deliberate investment decision by management. Normally, production is planned for some time ahead, in expectation of future sales. If actual sales in this "production planning period" turn out to agree with the sales forecast, nothing happens to the level of inventories. But now suppose that sales exceed the forecast. To increase production immediately, the manufacturer must order more raw materials, may have to run the factory overtime, may have to hire more labor—and all this may be a complete waste of funds if the increase in sales was just a temporary fluctuation. Thus manufacturers prefer to wait a while before taking such steps. If produc-

tion levels are *not* altered right away, then the very welcome increased level of orders must be filled by running down the inventories of finished goods. Thus, unexpected extra sales lead to *unintended* (negative) inventory investment.[4] Conversely, actual sales less than the forecast result in equally unintended, but very much less welcome, positive inventory investment: we are facing a continuing growth in the stock of unsold goods.

Thus, while investment in fixed capital is normally planned and deliberate, inventory investment may contain an unplanned, unintended component of sizable amount. The essential factor causing this is the *time lag* between a change in the rate of sales and the resultant, induced, change in the level of production.

In section B we allowed for a time lag between receipt of extra income and the increase in consumption demand (this is called a "Robertson lag"), but not for a time lag between a change in demand and the resultant change in the volume of production (called "Lundberg lag"). The absence of a Lundberg lag showed itself in the income equation, where income $Y(t)$ was taken to adjust itself instantaneously to the demand for this income, $C(t) + I(t)$, in the *same* period t. This procedure is justified if the Robertson lag is much larger than the Lundberg lag. However, Metzler (1948) gives data which contradict this relationship. According to Metzler, the Robertson lag is less than a quarter, whereas the Lundberg lag is of the order of one "production planning period," typically four to six months.

We must therefore modify the theory of section B in (at least) two ways:

1. We must keep track of the level of stocks, called $S(t)$, and

2. We must allow for the Lundberg lag (but may forget about the Robertson lag).

The "period" of the resulting model is one "production planning period."

We shall continue to use the symbol $I(t)$ for "investment," but now it means investment in fixed capital *only*. Actual inventory investment in period t is simply the difference $S(t) - S(t-1)$, where $S(t)$ stands for the level of stock at the *end* of period number t. Consumption demand in period t is still called $C(t)$, but we also introduce *predicted* consumption demand $C^*(t)$, *desired* level of stocks at the end of the period $S^*(t)$, and *predicted* (fixed capital) investment demand $I^*(t)$. All these predictions are made at the end of the period $t-1$ and influence the level of production cho-

[4] It is important to distinguish clearly between "inventory" (the *level* of the stock) and "inventory investment" (the *rate of change* of this level).

sen, and then maintained, within period t. This level of production in turn determines (real) national income $Y(t)$ during period t. The production decision is assumed to be made as follows:[5]

1. Production to cover expected sales
 of consumption goods $= C^*(t)$.
2. Production to cover expected sales
 of investment goods $= I^*(t)$.
3. Production to bring stocks to the
 desired level $= S^*(t) - S(t-1)$.

Hence our *income equation* reads:

$$Y(t) = C^*(t) + I^*(t) + S^*(t) - S(t-1)$$

The second equation is the stock balance: Actual stock at time t, $S(t)$, is equal to desired stock $S^*(t)$ *if* actual consumption $C(t)$ equals predicted consumption $C^*(t)$ and actual investment demand $I(t)$ equals expected investment demand $I^*(t)$. To the extent that actual demands differ from expected demands, the desired stock level will not be attained. Hence the *stock balance equation* reads:

$$S(t) = S^*(t) + C^*(t) - C(t) + I^*(t) - I(t)$$

These are two basic equations, but we need more. We must make some assumptions about desired and actual levels of consumption, about desired and actual levels of investment, and about the desired level of inventories.

In the theory of the *pure inventory cycle* we ignore, deliberately, possible fluctuations in investment in fixed capital (the accelerator effect). Thus, for now we *assume* a constant, autonomous level of fixed capital investment:[6]

$$I(t) = I^*(t) = I_0$$

To get the simplest possible version of the inventory cycle, we make the following purely provisional assumptions:

$C(t) = C_0 + mY(t)$ Consumption equation, Robertson
 lag ignored

$C^*(t) = C(t-1)$ Predicted consumption = actual
 consumption in last period

$S^*(t) = S_0$ Desired stock level constant

If we think of quantities at earlier times, such as $S(t-1)$, as

[5] Our account of inventory cycle theory leans strongly on the original work of Lloyd Metzler (1941, 1946, 1947, 1948).
[6] This can be obtained from our earlier investment equation, formally, by setting the accelerator constant v equal to zero.

Table 9.2

The Pure Inventory Cycle, Simplest Case

We assume $C_0 = 25$, $m = 0.75$, $I_0 = 0$, $S_0 = 50$,
and initial values $Y(1) = 105.00$, $S(1) = 50.00$.

Time	$C^*(t)$	$S^*(t) - S(t-1)$	$Y(t)$	$C(t)$	$S(t)$
1	–	–	105.00	103.75	50.00
2	103.75	0.00	103.75	102.81	50.94
3	102.81	−0.94	101.87	101.41	51.41
4	101.41	−1.41	100.00	100.00	51.41
5	100.00	−1.41	98.59	98.95	51.05
6	98.95	−1.05	97.89	98.42	50.53
7	98.42	−0.53	97.89	98.42	50.00
8	98.42	0.00	98.42	98.81	49.60
9	98.81	0.40	99.21	99.41	49.41
10	99.41	0.59	100.00	100.00	49.41
11	100.00	0.59	100.59	100.44	49.56
12	100.44	0.44	100.89	100.67	49.78
13	100.67	0.22	100.89	100.67	50.00
14	100.67	0.00	100.67	100.50	50.17
15	100.50	−0.17	100.33	100.25	50.25
16	100.25	−0.25	100.00	100.00	50.25
17	100.00	−0.25	99.75	99.81	50.19
18	99.81	−0.19	99.62	99.72	50.09
19	99.72	−0.09	99.62	99.72	50.00
20	99.72	0.00	99.72	99.79	49.93

known, then there are seven unknowns: $Y(t)$, $I(t)$, $C(t)$, $S(t)$, $I^*(t)$, $C^*(t)$, and $S^*(t)$, and we now have seven equations for them.

The resulting system of equations is discussed in the mathematical appendix. The *equilibrium income* is exactly the same as in section B, namely $\bar{Y} = (C_0 + I_0)/(1 - m)$. This is to be expected, since equilibrium implies that the actual stock level $S(t)$ agrees with the desired level $S^*(t)$, both being constant in time. Hence there is no inventory investment (change in stock level) in equilibrium, so that equilibrium income is not altered by allowing for inventories.

To see what happens out of equilibrium, we present, in Table 9.2, a special case, namely $C_0 + I_0 = 25$ and $m = 0.75$ (exactly as in Table 9.1), but now of course $v = 0$ (no acceleration effect). We choose a desired inventory level $S^*(t) = S_0$ equal to one-half of

the equilibrium sales per period; i.e., S_0 = 50. We start the model at time t = 1 with precisely this desired level of stocks as actual stocks, but with national income five percent higher than equilibrium income; i.e., $Y(1)$ = 105 rather than \bar{Y} = 100.

Let us go through the first lines of Table 9.2. At the start of the second time period, we estimate consumption demand from actual demand in period number 1; hence $C^*(2)$ = $C(1)$ = 103.75, the latter value arising from the consumption equation $C(1)$ = C_0 + $mY(1)$ = 25 + 0.75 × 105 = 103.75. At the start of period 2, the actual inventory level, $S(1)$ = 50 (assumed) agrees with the desired level S_0 = 50; hence no production is scheduled "to stock." The total scheduled production $Y(2)$ = 103.75 now appears as national income in period 2. The resulting consumption demand is $C(2)$ = C_0 + $mY(2)$ = 25 + 0.75 × 103.75 = 102.81, *less* than the predicted demand $C^*(2)$. The difference, $C^*(2)$ − $C(2)$ = 103.75 − 102.81 = 0.94 shows up as *unintended inventory investment*, making the inventory level at the end of period 2 equal to $S(2)$ = 50.94.

Since this exceeds the desired level, 50, by 0.94, we schedule a (negative) amount −0.94 for "production to inventory" in period 3; i.e., the production scheduled equals expected consumption demand minus 0.94. Thus: $Y(3)$ = $C^*(3)$ + $S^*(3)$ − $S(2)$ = 102.81 + 50.00 − 50.94 = 101.87.

Thus manufacturers have scheduled, deliberately, less production than the sales demand which they anticipate, the purpose being to bring down the excessive level of inventories. But do they succeed in this aim? Not at all! Inventories at the end of the third period stand at $S(3)$ = 51.41, *higher* than the already high $S(2)$ = 50.94. The reason, of course, is that actual sales in period 3 are much below expected sales, leading to an *unintended* positive inventory investment which more than cancels the intended inventory disinvestment. It is this possibility of unintended investment which produces the "cycle" which appears so clearly in Table 9.2. Looking at the table, we see that the complete inventory cycle (peak to next peak) takes 12 time units. The cycle is *stable*; i.e., the peaks get progressively smaller, and equilibrium is approached eventually.

However, this stability is rather precarious, since it disappears when one makes even slightly more realistic assumptions about expectations and desired stock levels than we have made so far. The following changes, at the very least, are desirable:

1. Desired stock levels should bear some relationship to expected sales. If the expected sales volume is high, one requires higher stock levels, also. Within a not too wide region we can approximate this with a linear relationship:

$$S^*(t) = S_0 + wC^*(t)$$

where S_0 and w are constants. The latter plays a role in this theory similar to the role of the accelerator coefficient v in the Samuelson model; it is therefore often called the "inventory accelerator" coefficient. Just as that of v, the numerical value of w depends on the length of time chosen as the "period" of our model.

It is most unlikely that predicted sales $C^*(t)$ are based purely and entirely on actual sales in the preceding period, $C(t-1)$. A reasonable man pays some attention to past sales trends as well, i.e., to the amount by which actual sales have altered between periods $t-2$ and $t-1$. Metzler suggests a "coefficient of expectation" η as a new constant, to be used in the predictor equation:

$$C^*(t) = C(t-1) + \eta\{C(t-1) - C(t-2)\}$$

If $\eta = 0$ we get the old prediction rule. If $\eta = 1$, the apparent trend is assumed to continue on into the future, unaltered in strength. A cautious man is likely to use a value of η between zero and 1, probably well below 1.

The resulting theory, with the new equations for S^* and C^*, is analyzed in the mathematical appendix. We find there a certain condition for stability of the oscillations, involving the values of m, the marginal propensity to consume; w, the inventory accelerator coefficient; and η, the coefficient of expectation. Let us take the following rather conservative values for illustration:

$$m = 0.75 \qquad w = 0.3 \qquad \eta = 0.2$$

Here $w = 0.3$ means that a predicted increase in sales is reflected in desired stock increase of 30 percent of that amount; $\eta = 0.2$ lies between 0 and 1, much closer to zero than to 1; hence expectations are quite conservative. These values are enough to make the oscillations *unstable*.[7]

However, this likely instability of the inventory cycle model is much less worrisome than the instability of the Samuelson model. The inventory cycle is intended as a theoretical description of the "minor" cycles. "Major" cycles, of period roughly ten years, do exist, and thus the major cycle must be superimposed on the inventory cycle. A mild instability of the inventory cycle is then

[7]We do not reproduce numerical values here, but these can be constructed easily from the equations, if desired. For an example comparable to Table 9.2, take the following input values: $C_0 = 25$, $I_0 = 0$, $m = 0.75$, $S_0 = 20$ (not 50), $w = 0.3$, $\eta = 0.2$, and starting values $Y(0) = Y(1) = 105$, $S(1) = 50$, $C(0) = C(1) = 103.75$. The resulting inventory cycle is still of length 12 periods, approximately, but now successive peaks *increase* in their deviation from equilibrium.

bearable. Long before the inventory cycle by itself can lead to nonsensical results (negative values of output, etc.), the instability associated with investment in fixed capital takes over and gives rise to the next "panic." In the aftermath of that event, the minor cycles (inventory cycles) start afresh. In our schematic model in this section, we have suppressed the major cycle deliberately, by ignoring the accelerator effect in the investment equation; but in reality, the pure inventory cycle discussed here is only a "wave of adaptation" (Metzler 1946) to the presence of more basic phenomena in the economy. The minor cycle represents a "technical" effect, clearly present in the data, and well explained theoretically, but not in any sense fundamental. As Metzler (1946) puts it: "The ultimate cause of cyclical fluctuations must therefore be sought in the investment motives of the business world or, in other words, in the causes of a fluctuating propensity to invest" (in fixed capital).

D. Mathematical appendix

We start with the *Samuelson model*, which has the basic equations:

$$C(t) = C_0 + mY(t-1) \qquad \text{Consumption equation} \quad (9.1)$$
$$I(t) = I_0 + v\{Y(t-1) - Y(t-2)\} \quad \text{Investment equation} \quad (9.2)$$
$$Y(t) = C(t) + I(t) \qquad \text{Income equation} \quad (9.3)$$

Substitution of (9.1) and (9.2) into the right side of (9.3) yields:

$$Y(t) - (m+v)Y(t-1) + vY(t-2) = C_0 + I_0 \qquad (9.4)$$

Let \bar{Y} be the time-independent equilibrium value of Y. Putting $Y(t) = Y(t-1) = Y(t-2) = \bar{Y}$ in (9.4) gives the equilibrium result:

$$\bar{Y} = (C_0 + I_0)/(1-m) \qquad (9.5)$$

Define $y(t)$ to be the deviation of $Y(t)$ from its equilibrium value; i.e.,

$$Y(t) = \bar{Y} + y(t) \qquad (9.6)$$

Substitution of (9.5) and (9.6) into (9.4) gives:

$$y(t) - (m+v)y(t-1) + vy(t-2) = 0 \qquad (9.7)$$

This is a linear, homogeneous difference equation for y, of order two (since y-values at times t and $t-2$ both appear in the equation). To solve such equations, one assumes that there exists a solution of the form $y(t) = Az^t$ where A and z are constants, possibly complex numbers. Substitution of this form into (9.7) leads to the following quadratic equation for the unknown constant z:

$$z^2 - (m + v)z + v = 0 \qquad (9.8)$$

with the two roots:

$$z_1 = (m + v)/2 + \sqrt{(m + v)^2/4 - v} \qquad (9.9a)$$

$$z_2 = (m + v)/2 - \sqrt{(m + v)^2/4 - v} \qquad (9.9b)$$

The *general solution* of (9.7) is a linear superposition of solutions with these two values of z; hence:

$$y(t) = A_1(z_1)^t + A_2(z_2)^t \qquad (9.10)$$

where A_1 and A_2 are constants which must be adjusted so as to fit the initial conditions, i.e., to make (9.10) agree with given values of $y(0)$ and $y(1)$, say.

If the argument of the square root in (9.9) is positive, the square root is real; so are z_1 and z_2. Then A_1 and A_2 are also real numbers, and the formal solution (9.10) can be used as it stands. The motion is then nonoscillatory (also called "exponential") in nature. An example is the third case in Table 9.1.

If the argument of the square root is negative, then the quantities z_1 and z_2 are complex numbers, conjugate to each other. We write them in polar form:

$$z_1 = u \exp(ia) \qquad z_2 = u \exp(-ia) \qquad (9.11)$$

An easy calculation yields:

$$u = |z_1| = |z_2| = \sqrt{v} \qquad \text{(oscillatory region)} \qquad (9.12)$$

In order that $y(t)$, (9.10), be real, the constants A_1 and A_2 must also be complex conjugate numbers, say

$$A_1 = B \exp(i\beta) \qquad A_2 = B \exp(-i\beta)$$

Putting all this together gives the following real form for (9.10)

$$y(t) = 2B(u)^t \cos(at + \beta) \qquad \text{(oscillatory region)} \qquad (9.13)$$

We now turn to the question of stability. If the motion is oscillatory, (9.13) applies and indicates that the oscillations die down if $(u)^t$ dies down, i.e., if $u < 1$. Comparing with (9.12), we conclude that the oscillations die down if $v < 1$, but increase in size (instability) if $v > 1$. The other case, exponential motion, is resolved by looking at the larger of the two real roots, i.e., the root z_1 (9.9a). If this root is below unity, the motion is stable; otherwise, unstable.

The argument of the square root in (9.9) is called the "discriminant" D. Positive D gives exponential motion; negative D gives oscillatory motion. The dividing line occurs when $D = 0$, which is

the condition:

$$D = (m + v)^2/4 - v = [v^2 + (2m - 4)v + m^2]/4 = 0 \qquad (9.14)$$

Solving for the critical values of the accelerator v, we get the two roots:

$$v_a = 2 - m - 2\sqrt{1 - m} \qquad v_b = 2 - m + 2\sqrt{1 - m} \qquad (9.15)$$

Since $0 < m < 1$, it is true that $0 < v_a < 1 < v_b$. The discriminant D is positive for $0 < v < v_a$ and for $v > v_b$; it is negative for $v_a < v < v_b$. We summarize the situation as follows:

Region of v	Stability	Nature of motion
$0 < v < v_a$	Stable	Exponential
$v_a < v < 1$	Stable	Oscillatory
$1 < v < v_b$	Unstable	Oscillatory
$v > v_b$	Unstable	Exponential

Samuelson (1939) suggested the third of these cases, unstable oscillatory behavior. Our estimates of the likely values of v and (less importantly) of m indicate that we are more likely to be in the fourth region.

Next, turn to the *modified Samuelson model*, with the time lag in the consumption equation ignored. That is, equation (9.1) is replaced by:

$$C(t) = C_0 + mY(t) \qquad (9.16)$$

This produces no change in the equilibrium income (9.5), and hence no change in Keynesian arguments which are based on this equilibrium value. But the time-dependence is now different. (9.7) is replaced by

$$(1 - m)y(t) - vy(t - 1) + vy(t - 2) = 0 \qquad (9.17)$$

and (9.8) is replaced by

$$(1 - m)z^2 - vz + v = 0 \qquad (9.18)$$

From the standard solution of a quadratic equation, we find that there are two real roots if $v > 4(1 - m)$ and two complex conjugate roots if $0 < v < 4(1 - m)$. In the first case, the larger of the two real roots has a value in excess of 2, so that the motion is unstable.

In the second (oscillatory) case, the absolute value of z is given by:

$$|z|^2 = v/(1-m) \quad \text{when} \quad 0 < v < 4(1-m) \quad (9.19)$$

For stability, this must be less than unity. This happens if and only if:

$$v < 1 - m \quad \text{Stability condition} \quad (9.20)$$

For reasonable values of m and v, this condition is strongly violated.

Finally, we turn to the *inventory cycle model* of Metzler. The basic equations are:

$$Y(t) = C^*(t) + I^*(t) + S^*(t) - S(t-1) \quad \text{Income equation} \quad (9.21)$$

$$S(t) = S^*(t) + C^*(t) - C(t) + I^*(t) - I(t) \quad \text{Stock balance} \quad (9.22)$$

$$C(t) = C_0 + mY(t) \quad \text{Consumption, no lag} \quad (9.23)$$

$$C^*(t) = C(t-1) + \eta\{C(t-1) - C(t-2)\} \quad \text{Expected consumption} \quad (9.24)$$

$$S^*(t) = S_0 + wC^*(t) \quad \text{Desired stock} \quad (9.25)$$

$$I(t) = I^*(t) = I_0 \quad \text{Autonomous investment only} \quad (9.26)$$

We get the equilibrium solution by setting all time-dependent quantities equal to constant values. The results are: \bar{Y} as in (9.5), and

$$\bar{C} = (C_0 + mI_0)/(1-m) \quad \bar{S} = S_0 + w\bar{C} \quad (9.27)$$

We use small letters to denote deviations from equilibrium values:

$$Y(t) = \bar{Y} + y(t) \quad S(t) = \bar{S} + s(t) \quad C(t) = \bar{C} + c(t)$$
$$C^*(t) = \bar{C} + c^*(t) \quad S^*(t) = \bar{S} + s^*(t) \quad (9.28)$$

Substitute (9.28) into (9.23) through (9.25) to obtain:

$$c(t) = my(t) \quad (9.29)$$

$$s^*(t) = wc^*(t) \quad (9.30)$$

$$c^*(t) = c(t-1) + \eta\{c(t-1) - c(t-2)\} = m(1+\eta)y(t-1) - m\eta y(t-2) \quad (9.31)$$

and hence

$$c^*(t) + s^*(t) = ay(t-1) - \beta y(t-2) \qquad (9.32)$$

where

$$a = m(1 + w)(1 + \eta) \qquad \beta = m(1 + w)\eta \qquad (9.33)$$

Substitution of all this into (9.21) and (9.22) gives:

$$y(t) = ay(t-1) - \beta y(t-2) - s(t-1) \qquad (9.34a)$$

$$s(t) = ay(t-1) - \beta y(t-2) - my(t) \qquad (9.34b)$$

In this form, the equations can be solved iteratively. We start from assumed values of $Y(0)$, $Y(1)$, and $S(1)$, and assumed parameters values m, w, η, C_0, I_0, and S_0. We determine $y(0)$, $y(1)$, and $s(1)$ from (9.27) and (9.28). Thereafter, we get $y(2)$ from (9.34a) and $s(2)$ from (9.34b); then $y(3)$ from (9.34a), $s(3)$ from (9.34b), and so on.

For analytical discussion, it is better to eliminate $s(t)$ altogether from equations (9.34). We write (9.34b) with time t changed to $t-1$:

$$s(t-1) = ay(t-2) - \beta y(t-3) - my(t-1)$$

and substitute this into (9.34a) to get:

$$y(t) = (m + a)y(t-1) - (a + \beta)y(t-2) + \beta y(t-3) \qquad (9.35)$$

This is the difference equation in Metzler (1947), his equation (A10), except for trivial changes of notation.

Using the standard procedure for linear difference equations (this one is of order three), assume a solution of form $y(t) = Az^t$ and substitute into (9.35) to obtain:

$$z^3 = (m + a)z^2 - (a + \beta)z + \beta \qquad (9.36)$$

Since this is a cubic equation, writing down the three roots is awkward (though possible). However, we can determine the condition for stability without that. Let us suppose that there exists one real root z_1 and two complex conjugate roots q and q^*, where the asterisk denotes the complex conjugate. The standard relationship between the roots of a polynomial and the coefficients of that polynomial then yields:

$$z_1 + q + q^* = m + a; z_1(q + q^*) + qq^* = a + \beta; z_1 qq^* = \beta$$

Solve the first equation for the sum $q + q^*$; substitute this into the second equation. This yields two equations for the two *real* unknowns z_1 and qq^*, namely:

$$z_1(m + a - z_1) + qq^* = a + \beta \qquad z_1 qq^* = \beta \qquad (9.37)$$

The complex conjugate roots q and q^* are associated with oscillatory behavior. The oscillations become unstable when $qq^* > 1$. We therefore look at the dividing line where $qq^* = 1$, exactly. This is the boundary between stability and instability. When $qq^* = 1$, the second of the two equations (9.37) leads to $z_1 = \beta$. With reasonable parameter values, the value of β [see equation (9.33)] turns out to be well below unity, thus verifying ex post facto our initial assumption that the real root z_1 does not lead to instability first, before the complex roots. Now substitute $z_1 = \beta$ and $qq^* = 1$ into the first of the two equations (9.37). This yields an equation involving m, a, and β, only. This is the stability condition, which holds with equality at the boundary between stability and instability. The direction of the inequality can be checked easily enough, for example, by taking the limiting case $\eta = 0$, thereby making $\beta = 0$; hence, (9.36) becomes equivalent to a quadratic equation for z, which can be solved straightforwardly. We do not go through the detailed steps and just write down the result. In this result, we have used (9.33) to express a and β in terms of the basic parameters of the model. The *stability condition for the pure inventory cycle* reads:

$$m(1 + w)\{1 + 2\eta - m\eta(2 + w)\} < 1 \qquad (9.38)$$

For the initial, simpleminded model discussed in section C, we have $w = 0$ and $\eta = 0$; hence, the condition becomes $m < 1$, which is always satisfied. Thus the simpleminded model is always stable.

On the other hand, the values assumed afterwards, namely, $m = 0.75$, $w = 0.3$, and $\eta = 0.2$, make the left-hand side of (9.38) equal to 1.029, indicating that we are already in the unstable region, though not by much. That is, the amplitude of the oscillations of the pure inventory cycle increases, but does so rather slowly.

One can reintroduce the "major" cycle into these equations by replacing the simple investment equation $I(t) = I_0$ (9.26) by the accelerator equation (9.2) and providing some suitable guess for the expected investment $I^*(t)$. However, the resulting equation system gets to be too complicated to discuss in this book; furthermore, since the resulting equations, at this stage, are still linear equations, they cannot serve as a suitable model of the real trade cycle in any case.

Schematic trade cycle models: part II

A. The Hicks model

No choice of parameters in the linear accelerator-multiplier model can fit the actual nature of trade cycles. If the parameters are such that the model yields stable oscillations, then these oscillations die down eventually, whereas the trade cycle continues. Conversely, if the parameters are such that the oscillations, or at least some of them, are unstable, then eventually the model gives rise to impossible results (e.g., negative values of output).

In view of the crude estimates of the parameters m and v, particularly of v, presented in section 9B, it is sensible to start from parameter values which make the oscillations *unstable*. We then have no need to worry about how the oscillations can be maintained. Rather, we must modify the theory to prevent the oscillations from becoming unreasonably, and eventually infinitely, large.

In a second paper Samuelson (1939a) suggested several nonlinear modifications of his original linear model (Samuelson 1939) and pointed out that the tendency of the consumption function to bend downward as income increases has the effect of preventing income from growing beyond all bounds. However, Samuelson's nonlinear model has been discussed very little since then, perhaps because other nonlinear effects (on investment and on total income) are generally felt to be more important than the curvature of the consumption function. Without doubt the most widely used nonlinear trade cycle model is the one suggested by Hicks (1950), and it is the one which forms the basis of our discussion in this section.

Hicks pointed to the obvious fact that oscillations cannot possibly become infinitely large, in any actual economy. In the *down-*

ward direction, there is a limit to what can happen to investment in fixed capital $I(t)$.[1] Gross investment must be zero or positive. Net investment, which is what is normally meant by the symbol $I(t)$, can go negative if gross investment is insufficient to keep up the replacement of that fraction of the capital stock which has depreciated during the period. But this means a lower limit (negative), or *floor level*, of net investment, given in essence by the rate of depreciation of the current capital stock. We shall call this floor level of net investment I_f.

In the *upward* direction, the economy cannot produce indefinitely large values of the output $Y(t)$. As we try to increase output more and more, we run into various limits: capital stock is limited, land is limited, labor supply is limited, raw materials are limited, etc. etc. If a wild "boom" continues long enough, eventually one or another of these limits must be reached. Thereafter, income cannot increase further, in the short run. In a short-run theory, therefore, we may postulate a *ceiling level of income* which we shall denote by the symbol Y_c. If the demand for output, that is, the sum of consumption demand $C(t)$ and investment demand $I(t)$, exceeds this ceiling, then the economy cannot meet this total demand. The actual income is then not equal to $C(t) + I(t)$, but rather is equal to the income ceiling Y_c.

There is some question whether actual booms do run up against such "hard" ceiling levels. It is at least possible, and many feel even likely, that the true factors bringing a boom to its end are more psychological in nature, a downturn of "business confidence" rather than, say, insufficient raw materials. We shall leave this question open for the moment. Within the theoretical model suggested by Hicks, it is possible to choose the ceiling level Y_c to be so large that the economy turns down "of its own accord" (i.e., as a result of the multiplier-accelerator mechanism built into that model) before the ceiling income Y_c is reached.

But, whatever may be true of the ceiling, there can be no doubt of the reality, and of the importance, of the floor. During observed trade cycles, very little investment is initiated during the postpanic phase (though some investment projects commenced before the crash are continued on). The floor not only is there in principle but is actually reached.

In writing down the basic postulates of the Hicks model, we shall use the symbol Max(a, b) for the larger one of the two quan-

[1] Inventory investment and the inventory cycle will be disregarded here. But, of course, there also fluctuations are limited. For example, inventory disinvestment cannot exceed the limit set by getting rid of the entire stock of goods in a single period.

tities a and b. For example, Max(5, 9) = 9, Max(9, 5) = 9, Max(-10, 3) = 3, and Max(-10, -15) = -10. Similarly, the symbol Min(a, b) denotes the minimum, i.e., the smaller one, of the two quantities a and b; thus, Min(5, 9) = 5, Min(-10, 3) = -10, and Min(-10, -15) = -15.

With this notation, the *equations of the Hicks model* are[2]

Consumption equation

$$C(t) = C_0 + m Y(t-1)$$

Investment equation

$$I(t) = \text{Max}\,[I_f,\, I_0 + v\{Y(t-1) - Y(t-2)\}]$$

Output equation

$$Y(t) = \text{Min}[Y_c,\, C(t) + I(t)]$$

These equations are based directly on the accelerator-multiplier model, the consumption equation being identical. The investment equation asserts that the accelerator prediction of investment demand is to be used if and only if the demand so predicted exceeds the floor level of investment I_f. Otherwise, the accelerator analysis is to be ignored, and net investment is given by I_f instead. The output equation asserts that actual output $Y(t)$ equals the demand for output $C(t) + I(t)$, if and only if this demand is less than the maximum or ceiling level of output Y_c. Otherwise, output equals the ceiling level.

Since this set of equations contains ceilings and floors, it is not linear in the mathematical sense of this term. It is no longer possible to "scale up" a possible path of deviations from equilibrium so as to obtain an equally possible path. The scaling up will, eventually, run afoul of the floor or of the ceiling, or both.

If the parameters of the model (the values of m and v, in particular) are such that the equilibrium state is dynamically stable (if v is less than unity), then it turns out that the ceiling and floor make very little difference to what happens. The reason is this: The system, started off in some arbitrary state, may strike up against the ceiling, or down against the floor, initially during the first oscillation. But, with assumed stability, the amplitude of the oscillations decreases as time goes on. Thus, in later oscillations, the system no longer reaches either the floor or the ceiling, so that the existence of floor and/or ceiling makes substantially no difference in the long run.

[2] These are not the precise equations in Hicks (1950). Rather, we use a simplified version of this model, suggested by Rau (1974) for didactic purposes.

Table 10.1

Hicks Model Income, Consumption, and Investment

Table 10.1 assumes a simplified Hicks model with marginal propensity to consume m = 0.75, C_0 = 25, I_0 = 0; hence, equilibrium income Y = 100. The floor level of investment is taken as I_f = −10; the ceiling level of income as Y_c = 120 (20 percent above equilibrium). Initial values of income are Y(0) = Y(1) = 101. Figures are given for acceleration coefficients v = 1.5 and v = 3.0.

| Time | v = 1.5 | | | v = 3.0 | | |
	Income	Consumption demand	Investment demand	Income	Consumption demand	Investment demand
0	101.00	–	–	101.00	–	–
1	101.00	–	–	101.00	–	–
2	100.75	100.75	0.00	100.75	100.75	0.00
3	100.19	100.56	−0.38	99.81	100.56	−0.75
4	99.30	100.14	−0.84	97.05	99.86	−2.81
5	98.14	99.47	−1.34	89.49	97.79	−8.30
6	96.86	98.60	−1.74	82.12	92.12	−10.00*
7	95.74	97.65	−1.91	76.59	86.59	−10.00*
8	95.11	96.80	−1.69	72.44	82.44	−10.00*
9	95.40	96.33	−0.94	69.33	79.33	−10.00*
10	96.98	96.55	0.43	67.67	77.00	−9.33
11	100.10	97.73	2.37	70.76	75.75	−4.99
12	104.76	100.08	4.69	87.36	78.07	9.28
13	110.57	103.57	6.99	120.00*	90.52	49.78
14	116.63	107.92	8.70	120.00*	115.00	97.93
15	120.00*	112.47	9.09	115.00	115.00	0.00
16	120.00*	115.00	5.06	101.25	111.25	−10.00*
17	115.00	115.00	0.00	90.94	100.94	−10.00*
18	103.75	111.25	−7.50	83.20	93.20	−10.00*
19	92.81	102.81	−10.00*	77.40	87.40	−10.00*
20	84.61	94.61	−10.00*	73.05	83.05	−10.00*
21	78.46	88.46	−10.00*	69.79	79.79	−10.00*
22	74.61	83.84	−9.23	67.55	77.34	−9.79
23	75.20	80.96	−5.76	68.96	75.66	−6.71
24	82.27	81.40	0.87	80.93	76.72	4.21
25	97.31	86.70	10.61	120.00*	85.70	35.92
26	120.00*	97.99	22.57	120.00*	115.00	117.21
27	120.00*	115.00	34.03	115.00	115.00	0.00
28	115.00	115.00	0.00	(repeats t = 16)		
29	(repeats t = 18)			(repeats t = 17)		
30	(repeats t = 19)			(repeats t = 18)		

* Ceilings or floors.

As a result of this argument, the only case of interest with the Hicks model is the case of instability, i.e., v in excess of unity. This is the case where the linear Samuelson model leads to nonsensical results eventually (e.g., to negative output). It is the case assumed by Hicks and is also, from our estimates in section 9B, the most likely case in reality.

From the three equations which we have written down, we can deduce that values of the national income $Y(t)$ at times $t = 0$ and $t = 1$ suffice to determine the entire future behavior of the model. Suppose we know $Y(0)$ and $Y(1)$. Then $C(2)$ is determined from the consumption equation, $I(2)$ is determined from the investment equation, and hence $Y(2)$ is determined from the output equation. Now we know $Y(1)$ and $Y(2)$; by the same chain of reasoning, we then deduce, in turn, $C(3)$, $I(3)$, and $Y(3)$; and so on and on and on.

Table 10.1 shows the time development of income Y, consumption C, and investment I for two cases, both of which are unstable for the simple accelerator-multiplier model, namely, $v = 1.5$ and $v = 3.0$.[3] The parameters chosen are such that they correspond precisely to the second and third column of Table 9.1; but now, the solutions can no longer go out of bounds, because of the floor level of investment $I_f = -10$ and the ceiling level of income $Y_c = 120$. In Table 10.1, asterisks are placed next to values which are affected by floors and/or ceilings. Since we start from initial income levels close to equilibrium, the results for the first few time periods agree precisely with the ones in Table 9.1 (only values of $Y(t)$ are shown in that table, but $C(t)$ and $I(t)$ agree also). But this changes as soon as we hit a ceiling or a floor.

For $v = 1.5$, this happens first when $t = 15$. At this time, $C(15) = 112.47$ and $I(15) = 9.09$, so their sum, 121.56, exceeds our assumed ceiling $Y_c = 120$. This latter value therefore appears as $Y(15)$ in Table 10.1, followed by an asterisk to indicate that here is where a ceiling came into play. Similarly, at $t = 16$, we have $C(16) + I(16) = 115.00 + 5.06 = 120.06$, so the ceiling $Y_c = 120.00$ comes into play once more. Thereafter, the economy goes into decline. Investment decreases and becomes negative at $t = 18$.

[3] This table is oversimplified on several grounds, two of which follow. (1) Since consumption demand and investment demand are only demands, not necessarily met in full from output, a question arises how the deficit in income, if any, is distributed between consumption foregone, and investment foregone. This issue has been avoided. (2) On economic grounds, the floor level of investment I_f and the accelerator coefficient v should be related to each other at least roughly, so that a higher value of v should be associated with a numerically higher value of I_f. This point, also, has been ignored, so as to be able to make simple comparisons.

Now look at the figures for $t = 19$. At this time, the accelerator mechanism predicts the following "desired" investment level:

$$I_0 + v\{Y(18) - Y(17)\} = 0 + 1.50 \times (103.75 - 115.00) = -16.88$$

This is more negative than the floor level $I_f = -10$. Hence actual investment outlay does not drop down to -16.88, but rather only down to -10, which is (by assumption) the most rapid rate of disinvestment possible in this economy.

Investment stays at this floor level for three full periods ($t = 19$, 20, and 21). By the end of that time, the drop in income has slowed down enough to allow an investment-led recovery to get underway. Investment increases slowly at $t = 22$ and $t = 23$ and then accelerates in a rush for $t = 24$ and $t = 25$. By time $t = 26$, we are once more up against the ceiling on income!

Now note that $Y(26)$ and $Y(27)$ repeat, precisely, the income values $Y(15)$ and $Y(16)$, all these being at the ceiling level. Since two successive income values determine the entire subsequent behavior, we conclude that the same cycle repeats precisely ever thereafter. The repetition period is 11 time units. Thus *the system goes through a limit cycle*. The initial approach to this limit cycle depends upon how the model is started off [on the values of $Y(0)$ and $Y(1)$]. But once we get into the limit cycle proper, this same cycle repeats precisely, with the shape of the cycle quite independent of initial conditions.

Now look at the other case, $v = 3.0$. The Samuelson model shows no oscillations at all for this value of v, as can be seen from Table 9.1. But the Hicks model results in Table 10.1 are not only oscillatory in nature, entering the limit cycle at $t = 13$, but the shape and nature of this limit cycle are very similar to those of the limit cycle for $v = 1.5$! To show this similarity explicitly, we have plotted, in Figure 10.1, the income $Y(t)$ versus t, with time measured from the start of the limit cycle (from $t = 15$ for $v = 1.5$, and from $t = 13$ for $v = 3.0$). Looking at Figure 10.1, we see that the initial decline from the ceiling income is almost identical for these two values of the accelerator constant v. Later on, the limit cycle for $v = 3.0$ continues its decline for two extra periods, but then ascends into a more rapid boom, so that the full repetition period differs by only one time unit. Major differences in the Samuelson model have, therefore, become quite minor differences in the Hicks model. The following features of these results are worth noting:

1. The nature of the limit cycle *cannot* be inferred from the behavior of the linear Samuelson model. With the equilibrium position unstable, the behavior of the model in the region close to

equilibrium does *not* give adequate information about the overall behavior.

2. If the model has both a ceiling and a floor, we get a limit cycle whenever the equilibrium is unstable ($v > 1$). If we retain the floor I_f but give up the income ceiling Y_c (i.e., assume Y_c is infinitely large), then we get a limit cycle provided the value of v exceeds unity *and* is low enough to get oscillations at all [see the discussion in section 9D, following equation (9.15)]. But if the accelerator constant v is too large, then the Hicks model requires a ceiling in order to obtain reasonable behavior. Without a ceiling, the income eventually keeps increasing indefinitely. A model of this type needs some mechanism to bring a wild boom to an end. This mechanism need not be a firm ceiling on income, but some type of "brake" is needed for a runaway boom.

3. The *shape* of the limit cycle is worrisome. In Figure 10.1, the downswing is slow and extends over a long time interval; the subsequent recovery and boom are extremely rapid. This is the exact opposite of the observed behavior of trade cycles.

4. The simple Hicks model leads to a limit cycle which repeats itself *precisely*. Actual trade cycles, though showing a kind of family resemblance to each other, are by no means precisely repetitive.

Point 3 was noted, of course, by Hicks. He suggested that the reason for the discrepancy is the neglect, in the simple model, of money and credit. At the turning point of the boom there is a rapid loss of confidence by businessmen and investors, leading to credit tightness and, quite often, to a panic on the money market. It is not surprising that an oversimplified model without any money market or business confidence in it leads to the wrong shape for the trade cycle. We conclude that *a realistic theory of the trade cycle must include, within the model, a financial sector sensitive to "business confidence."*

By contrast, point 4 can be handled by a quite minor modification of the simple model, a modification which we now describe.

The unwanted precise repetition is due to the fact that we have assumed, in the simple model, that consumption and investment are perfectly predictable and depend only on known, past values of the national income. This is a strong oversimplification for consumption and is wildly wrong for investment.

Investment decisions involving fixed capital are not made entirely mechanically merely by looking at past levels of sales demand (or of national income in the simple model). Rather, every investment decision, by its very nature, is "forward-looking" and therefore depends on the businessman's estimate of what future

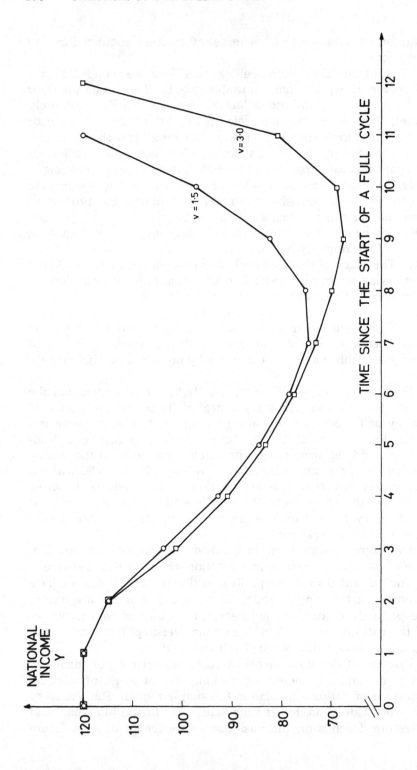

economic conditions are likely to be.

Of course, any sensible person is influenced in his guesses about the future by what has happened in the past. But his views of the future are by no means just a mechanical extrapolation of past conditions. If the economy has been in the doldrums lately, he *may* assume that this sorry state will continue. But he may feel, instead, that the time is about ripe for resumption of economic activity. If he feels that way, then the present moment, while costs of labor and materials are still low, may seem just right for initiating an investment project. Conversely, if a boom is underway, the businessman *may* assume that boom conditions will continue. But he may instead become edgy and worried about the possibility of a downturn fairly soon. In that case, he is not likely to start an investment project to meet predicted future demands, since he distrusts the prediction.

"Business confidence" is thus an extremely important factor for investment. But this factor is very hard to include in any model consisting of some set of equations. One way out, though by no means the best way, is to think of business confidence as a "random variable" $u(t)$ which cannot be predicted precisely and which may take on positive or negative values. This random variable is then added to the purely mechanical investment prediction of the accelerator mechanism. Thus, the investment equation of the Samuelson model is altered to read:

$$I(t) = I_0 + v\left\{Y(t-1) - Y(t-2)\right\} + u(t)$$

where the first two terms on the right are predictable, but the term $u(t)$ is a random variable. The corresponding change for the Hicks model reads:

Figure 10.1

The limit cycle of the Hicks model, for two different values of the accelerator coefficient v, namely, $v = 1.5$ and $v = 3.0$. National income $Y(t)$ is plotted against the time elapsed since the start of the cycle (thus $t = 0$ in this figure corresponds to the following time values in Table 10.1: to $t = 15$ for $v = 1.5$, and to $t = 13$ for $v = 3.0$). The values of $Y(t)$ are taken from Table 10.1. Only Y-values at the marked points (at integral values of the time coordinate) are meaningful. The straight line segments connecting these points in the figure are only to aid the eye and have no economic significance in the Hicks model. In spite of the vast difference between $v = 1.5$ and $v = 3.0$ in the linear case (in the Samuelson model), there is rather little difference for the nonlinear case (the Hicks model).

$$I(t) = \text{Max}[I_f,\ I_0 + v\big\{Y(t-1) - Y(t-2)\big\} + u(t)]$$

That is, the random variable affects the "desired" level of investment, but not the floor level.

The effect of this change on the behavior of the Hicks model is quite minor. There is still a continuing, self-sustained, endogenous cycle with income hitting the ceiling, and investment striking the floor, from time to time. The (deliberately intended) difference is that there is now no longer precise repetition of behavior from one cycle to the next.

This state of affairs provides an answer to those critics of the Hicks model who discount it because it is "deterministic" (predictable) rather than "stochastic" (containing random variables). We shall have more to say about stochastic models in the next chapter. For now, suffice it to say that introduction of random variables is *not* always a terribly important or major change. In particular, if there is a limit cycle in the deterministic model, introduction of random variables makes very little real difference.

B. The Frisch model

Random variables, however, *can* be of major importance in other circumstances. Above, we discarded the simple accelerator-multiplier model with a *stable* equilibrium (with acceleration coefficient *v* below unity) on the grounds that any oscillations which may be present at the initial time tend to die down in such a model, whereas actual trade cycles keep on recurring.

Long before Hicks developed his model, Ragnar Frisch (1933) published a famous article entitled "Propagation Problems and Impulse Problems in Dynamic Economics." In this article, he called attention to the fact that oscillations do *not* die down if the system is subjected to recurrent random shocks, even if the system, in the absence of such shocks, is stable. The recurrent random shocks never give the economy a chance to settle down quietly into its equilibrium state.

Rather, the system is subjected to new shocks continually and is therefore set into motion again, long before the oscillations from old shocks have had a chance to die away completely. The old motion and the new motion add (remember, the simple accelerator-multiplier model is a *linear* system, without ceilings or floors). The resultant overall motion depends upon both:

 1. The nature of the inherent motions of which the system is capable in the absence of disturbances (the "propagation"), and

 2. The nature of the shocks (the "impulses").

These two effects interact. The resulting overall motion is not,

in general, at all similar to the pattern of the shocks which are the first cause of that motion. Ragnar Frisch quotes a homely but graphic simile: If you continue giving random kicks to a rocking horse, the motion of the rocking horse looks much more regular and smooth than the series of kicks. Indeed, if the rocking horse is heavy and its undisturbed oscillations die down only slowly (are only little damped), then the "forced" motion of the rocking horse under a series of kicks looks much more similar to the "free" motion without kicks than to the set of kicks. The only essential difference is that the forced motion, unlike the free motion, never dies down entirely. This essential difference is just what we need for trade cycle theory.

We therefore have a second, essentially different type of model for the trade cycle, which we shall call the *Frisch-type model*. This includes the original model of Frisch (1933) as well as many other, more elaborate versions of the same basic idea. In a Frisch-type model, the economy is assumed to be basically stable. In the absence of "shocks," any initial oscillations die down of their own accord until the model reaches a state of equilibrium, which then continues forever. There are no ceilings or floors. But there *are* random "shocks" which influence what happens to various economic quantities, particularly to investment. Under the influence of these shocks, the economy is driven away from permanent equilibrium into a roughly cyclical behavior.

As an extremely simple example of a Frisch-type model, consider the following set of model equations:[4]

Consumption equation

$$C(t) = C_0 + mY(t-1)$$

Investment equation

$$I(t) = I_0 + v\left\{Y(t-1) - Y(t-2)\right\} + u(t)$$

Output equation

$$Y(t) = C(t) + I(t)$$

These are the same equations as in section 9B, the accelerator-multiplier model, modified only by the "random shock term" $u(t)$ in the investment equation. Thus C_0, m, I_0, and v are the same constants as before, m being the marginal propensity to consume and v the accelerator constant. This latter constant is now taken to be less than unity, so that the model has a stable equilibrium.

[4] These are not the equations of Frisch (1933) but rather a simplified version introduced by Rau (1974). No essential point is lost, however, in this simplification.

In such a model, it is necessary to say something about the nature of the random variable $u(t)$. Since $u(t)$ is, by definition, not predictable, we must say something about its statistical distribution function, not about actual values. It is usual to make some extremely simple assumptions (we shall have more to say about this in the next chapter). The simple, purely ad hoc assumptions are:

1. The mean value (expected value) of $u(t)$ is zero, for each time t.

2. At two different times t and t', $u(t)$ and $u(t')$ are statistically independent; i.e., there is no correlation between them.

3. The distribution of each separate $u(t)$ is a normal (Gaussian) distribution, with mean zero and standard deviation σ independent of time.

We do not suggest, nor do we believe, that these assumptions are realistic for a random term to describe, inter alia, the effects of business confidence on investment behavior. For example, if business confidence was high at time t, then there is a considerable likelihood that it will still be fairly high at time $t' = t + 1$. Thus $u(t)$ and $u(t + 1)$ should show some positive correlation, contrary to assumption 2. But these are the simplest assumptions one can make in such a "stochastic" theory; furthermore, just these assumptions are often made by people who construct economic models.

In Table 10.2 we show a "stochastic simulation" of this model, with $v = 0.9$ and all other parameters the same as in the deterministic simulation (no shocks) of Table 9.1. We start off the system with $Y(0) = Y(1) = 101$, one percent above the equilibrium value, and we allow the shocks to start in period $t = 2$. We must specify one more parameter, namely, the standard deviation of the distribution of the shock terms; we have chosen this parameter to be $\sigma = 1.0$. The income values from Table 10.2 are plotted graphically in Figure 10.2, for easier inspection.

Let us now compare the stochastic simulation of Table 10.2 and Figure 10.2 with the deterministic Samuelson model for the same parameter $v = 0.9$, i.e., with the first column of Table 9.1.

There are oscillations in both cases, and they do not look all that different. But in the Samuelson model (no shocks) the oscillations are completely regular and they die down gradually but steadily. In the Frisch model, with shock mean square sizes assumed here, the amplitude of the oscillations actually increases to start with and then reaches a fairly regular level. The average amplitude of the oscillations in the long run is determined by the assumed average shock size (the parameter σ in the model). The oscillations in the Frisch model are no longer precisely regular,

Table 10.2

Stochastic Simulation of a Frisch-type
Model of the Trade Cycle

*In Table 10.2 the parameters are $C_0 = 25$, $m = 0.75$, $I_0 = 0$,
$v = 0.9$, and $\sigma = 1.0$ (this last is the standard deviation of
the shocks around their mean, zero). The equilibrium national
income is $Y = 100$, and we start with incomes, in the first two
periods, 1 percent above this.*

Time t	Shock $u(t)$	Income $Y(t)$	Time t	Shock $u(t)$	Income $Y(t)$
0	—	101.00	31	−0.72	95.17
1	—	101.00	32	0.79	96.39
2	−1.55	99.20	33	−0.70	97.70
3	0.51	98.29	34	0.65	100.10
4	0.36	98.25	35	0.76	103.00
5	0.14	98.80			
6	−1.56	98.03	36	−1.40	103.45
7	−0.09	97.73	37	−0.99	102.01
8	−1.34	96.70	38	0.47	100.68
9	−0.14	96.45	39	0.95	100.27
10	−0.90	96.21	40	0.13	99.95
11	−0.37	96.57	41	1.25	100.93
12	1.39	99.15	42	1.11	102.69
13	0.47	102.16	43	−2.41	101.20
14	−0.57	103.75	44	0.05	99.61
15	0.94	105.19	45	−0.32	97.95
16	−1.74	103.45	46	−0.45	96.52
17	3.56	104.59	47	0.47	96.57
18	1.08	105.55	48	0.98	98.45
19	−0.95	104.07	49	0.98	101.52
20	−0.55	101.18	50	0.50	104.39
21	2.66	100.93	51	1.10	106.98
22	0.07	100.55	52	−0.23	107.33
23	−0.45	99.62	53	−0.27	105.55
24	−1.18	97.69	54	0.18	102.74
25	0.98	97.51	55	1.02	100.55
26	−0.29	97.68	56	0.01	98.44
27	0.15	98.57	57	0.90	97.84
28	−1.44	98.29	58	−0.19	97.65
29	−1.20	97.27	59	1.01	99.07
30	−1.02	96.02	60	1.15	101.73

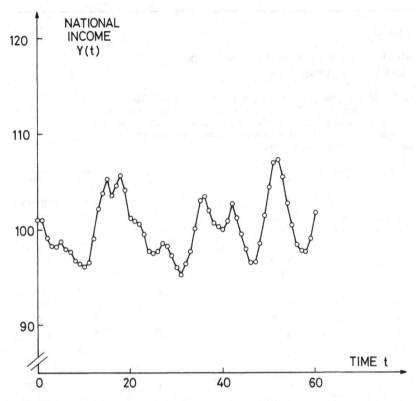

Figure 10.2

National income in the Frisch model, as a function of time. This is a stochastic simulation, with the shocks starting to operate in period 2; the system is started off with $Y(0) = Y(1) = 101$, which is 1 percent above the equilibrium value, 100. The system goes into oscillations, which do not die down, nor do they explode into ever larger sizes. The oscillations in the Frisch model are not precisely regular but are recognizably oscillations, whereas the shocks which give rise to this behavior are entirely irregular in appearance (see the column labeled "Shock" in Table 10.2).

but they are regular enough to be clearly recognizable as oscillations. This is true in spite of the fact that the actual shock terms in this simulation, i.e., the assumed values of $u(t)$, which are also shown in the Table 10.2, are not at all regular or oscillatory in character. This is the basic idea of the Frisch model: irregular blows to a "rocking horse" have the ultimate effect of throwing the rocking horse into very nearly simple oscillatory motion.

We make the following comments at this stage:

1. The Frisch idea requires that the economy, in the absence of shocks, is locally stable about its equilibrium path. In the simple model discussed here, this means $v < 1$. This requirement is strongly in conflict with our crude estimates of likely values for v, in section 9B.

2. The three statistical assumptions made about the probability distribution of the sequence of shocks $u(t)$ are *not* at all reasonable. We mentioned already that one should expect correlations between $u(t)$ and $u(t + 1)$, on economic grounds. If $u(t)$ represents, in part at least, the effect of "business confidence" influencing investment decisions, then absence of correlation between $u(t)$ and $u(t + 1)$ is a highly unlikely supposition about the behavior of business confidence. However, this particular difficulty can be handled theoretically. One may postulate the presence of "auto-correlation" in the sequence of shock terms $u(t)$. When this is done, the resulting simulations tend to look even more like regular oscillations, so that auto-correlated shocks give "better" results than the ones shown in Table 10.2. But there are other statistical effects, not included in this theory nor in any of the usual econometric models, which are almost certain to be present in reality. We mention just two of them: Assume that confidence is high and we are in the middle of a boom. Then the likelihood of this confidence's continuing into the next period depends on where we are within this boom. Initially, after confidence has revived to start the boom, it is likely that confidence will continue. But after the boom has been going for some considerable time, people are much more likely to question the continuance of such buoyant conditions. Though easy to describe in words, it turns out that this effect is very hard to include in any simple way, mathematically. A second point is that when confidence does "break," it tends to do so sharply, from a high level to a strongly negative level, in a very short time. Nothing in the statistical assumptions which we have made, and which are the ones commonly made, permits this kind of effect to show up in the theory. Yet the effect itself is only too painfully evident in real panics.

3. Although the stochastic simulation (Table 10.2 and Figure 10.2) shows the general appearance of oscillations which do not die down, these oscillations are *not* similar to actual trade cycles. The oscillations of the model are much too regular and symmetrical for that purpose. In the model, the time taken for an upswing is equal, on the average, to the time taken for a downswing. In real life, upswings are slow; downswings go with a mighty rush. In the words of Galbraith (1975, p. 104):

The usual image of the business cycle was of a wavelike movement, and

the waves of the sea were the accepted metaphor. Prices and production rose gradually, then more rapidly, reached an apex and then subsided. One measured the length of the cycle from crest to crest or trough to trough; thus again the wave. The reality in the nineteenth and early twentieth centuries was, in fact, much closer to the teeth of a ripsaw which go up on a gradual plane on one side and drop precipitately on the other. Or, if a wave, it was the long mounting roll and then the sharply breaking surf.

There is no "ripsaw" in the Frisch model.

4. From a more fundamental view, the explanation of the trade cycle by means of the Frisch model is not an explanation at all, but rather begs the question. The first cause of the cyclical behavior is taken to be the series of random "shocks" to the economy. But what explains the random shocks? Far from having found, *within* economic reasoning, a consistent explanation of the observed cyclical fluctuations of a competitive economy, all that the Frisch model does (at best, that is, if we ignore point 3 above) is to explain how random shocks which look not at all cyclical can give rise to observed behavior which looks like a trade cycle (provided we do not look too closely). But this leaves the supposed real cause of the phenomenon, namely, the shocks themselves, quite unexplained.

C. The Goodwin model

The models of Hicks (1950) and Frisch (1933) are the basis of most of the published discussion on trade cycle theory. These simple, schematic models contain the essence of what are usually considered to be the main competitors in this area; realistic models must be more complicated, of course, and they will be discussed in chapter 11. But most, if not all, of the "realistic" models studied to date are qualitatively either of the Hicks type or of the Frisch type.

It would be misleading, however, to leave the reader with the impression that these two types are the best available among the schematic models. This is quite wrong. We now turn to a much less well-known model, that of Goodwin (1967, 1972). In our view, Goodwin's type of model is greatly preferable to the ones studied so far.

The Goodwin model is "post-Keynesian" in outlook, not neoclassical.[5] As a result, one moves into a quite different world. There

[5] Also not Marxist: The "homeostatic mechanism" of Goodwin conflicts directly with Marx's claims of progressive immiseration of the workers. In the Goodwin model, the workers' share is *constant* in a long-term average over many trade cycles.

is no longer some implication of full employment; and the distributive shares of output going to capital and labor, respectively, play a major role in determining what happens. Goodwin's thesis

> is that the very structure of capitalism constitutes a homeostatic mechanism which functions by means of variations in distributive shares but does so in such a way as to keep them constant in the long run. If real wages go up, profits go down: if profits go down, savings and investment lag, thus slowing up the creation of new jobs. But the labour force is continually growing both through natural increase and through men "released" by technological progress. The reserve army of labour grows, wages lag behind the growth of productivity, profits rise, and accumulation is accelerated back up to a high level. This in turn gradually reduces unemployment, wages rise, and so it goes on, indefinitely (Goodwin 1972, p. 442).

Note how greatly different this economic world is from the one of Hicks or of Frisch. Investment is tied to profits, not to past trends in output. Wages are related to the fraction of workers unemployed, tending to increase if this fraction becomes small, decrease when there is a lot of unemployment.

Let us now go through the admittedly "starkly schematized and hence quite unrealistic" assumptions of the Goodwin model, one by one:

1. There is steady technical progress (in labor productivity, due to better machines). That is, the labor productivity, defined as the ratio of output $Y(t)$ to the amount of labor used (employed) $L(t)$, is assumed to go up steadily:[6]

$$a(t) = Y(t)/L(t) = a_0 \exp(at)$$

Here a, i.e., the growth rate of labor productivity, is assumed to be a constant. (A more realistic model might relate productivity growth to wages, but it is quite reasonable to neglect this for a first exploration).

2. There is assumed to be a steady growth of the labor force $N(t)$:

$$N(t) = N_0 \exp(\beta t)$$

where N_0 and β are constants. Note that there is no presumption that this entire labor force $N(t)$ will be employed. Rather, we shall work with the "employment fraction"

$$\lambda(t) = L(t)/N(t)$$

Full employment means $\lambda = 1$; this limiting case is never reached in the model. The fraction unemployed at any time is equal to

[6] We use our own symbols for consistency, not the symbols of Goodwin (1972). For technical progress in growth theory, compare Kennedy (1972).

$1 - \lambda(t)$. Assumption 2, though schematic, is entirely adequate for such a model.

3. There are only two "factors of production," namely, labor and "capital" (plant and equipment). Both these "factors" are taken to be homogeneous and nonspecific. "Homogeneous" means that we ignore differences of skill between workers (or we assume that such differences have been corrected for at an earlier stage, so as to reduce all "labor" to a homogeneous entity), and similarly for plant and machinery. "Nonspecific" means that a worker can shift from production in one area to that in another, instantaneously and without penalty, and the same is assumed, very unrealistically, for plant and machinery. Here, then, is the point at which the model becomes very "schematized" indeed——but no more so than the models of sections A and B! There also we worked in terms of a completely homogeneous and nonspecific "output" $Y(t)$, with not even a distinction between output of consumption goods and output of investment goods. Thus, Goodwin is right within the mainline tradition in making such assumptions. We shall call the capital stock $K(t)$, as before. The same caution regarding its far-from-clear definition applies as did before (see Robinson 1954, Harcourt 1972).

4. All quantities are taken net and "real"; i.e., price changes are ignored and stocks of capital, for example, are taken net of depreciation. The wage rate $w(t)$ is therefore a "real wage," not a "nominal wage." This approach is common to most of the "schematic" models. The wage w is a flow variable[7] (real claim on output per unit time per worker employed); hence the flow of product to the employed workers is given, at any time t, by the product $w(t)L(t)$. (Unemployed, in this model, receive nothing at all and live on air.) The *share* of the workers in total output is then the fraction:

$$\text{Workers' share} = w(t)L(t)/Y(t) = w(t)/a(t)$$

where the labor productivity $a(t)$ was defined under point 1. Since this share is of major importance in what follows, we introduce a symbol for it:

$$\omega(t) = w(t)/a(t)$$

The rest of the output, with only two "factors of production" present, of necessity goes to "capital," so that the *share of profits* in output is given by $1 - \omega(t)$.

5. Workers consume all their wages; capitalists *save and invest* all their profits. Note that the possibility, emphasized by Keynes, of some profits' being saved but *not* invested immediately (but rather

[7]This is so because we have defined employment $L(t)$ as a stock.

held as money or other financial assets) is ignored in this theory. This is not an arbitrary and artificial assumption, but rather follows from the nature of these schematic models: In the absence of any financial sector or of money, a model phrased entirely in "real" terms has no way of allowing for people's hoarding money or financial assets. Note that this picture of the investment process is entirely different from the one used by neoclassical theorists such as Hicks or Frisch. The amount invested in new plant and machinery is simply equal to the entire (real) profit (i.e., excess of output over that part of output going to the workers) gained by the capitalists. There is no pretense that this assumption is completely realistic. But, also, there can be no doubt that actual investment outlays are strongly tied to the current net cash flow of business, much more so than to long-range projections of output trends. Thus, if one wishes to work with a highly schematized model at all, then a model of the Goodwin type is much better than the ones we studied before.

6. The capital stock $K(t)$ is related to the output level $Y(t)$ by a constant proportion: $K(t) = vY(t)$. This is the by now familiar "accelerator" assumption. It is made here for simplicity, mainly. A more complicated relationship between output and capital stock could be introduced, but at the cost of greatly complicating the equations of the model.

7. The rate of real wages $w(t)$ is not constant in time, but rather is sensitive to the employment fraction $\lambda(t)$. If there is much unemployment—i.e., if $\lambda(t)$ is considerably less than 1—then wages tend to drop (unions are less able to maintain their bargaining position). Conversely, when $\lambda(t)$ approaches 1 closely (when there is nearly full employment), then wages tend to rise. This effect is commonly known by the name "Phillips curve," after Phillips (1958)[8] but really dates back to Karl Marx (1867) with his "reserve army of labor." The resulting model equation appears in the mathematical appendix.

The mathematical treatment resulting from these assumptions is in the appendix. The treatment is rather more complex than for either the Hicks or Frisch models. The Goodwin model is much more strongly nonlinear than the Hicks model (the Frisch model, of course, is entirely linear), and highly nonlinear theories are inevitably more complex mathematically. As usual, everything has its price, and the price of a much more realistic and sensible model is a higher degree of mathematical complication.

Let us now turn to *results from this model.*

[8] See also Brunner (1976), Pierson (1968), Van Order (1976), and Perry (1964).

First, the model does have the possibility of equilibrium growth, with constant values of the employment fraction λ and of the workers' share ω. The equilibrium value of λ, which we call $\bar{\lambda}$, is slightly higher than the value λ_P at which the Phillips curve crosses the horizontal axis, the more so the higher the rate of growth of labor productivity. The equilibrium value of ω, called $\bar{\omega}$, is given by a simple formula:

$$\bar{\omega} = 1 - v(a + \beta)$$

This is below unity, naturally, the more so the higher the accelerator constant v and the growth rates a and β. If the system is started off at time $t = 0$ with $\lambda(0) = \bar{\lambda}$ and $\omega(0) = \bar{\omega}$, then these values never change thereafter.

This equilibrium is neither stable nor unstable, but rather it is a *neutral* equilibrium, a term which we shall now explain. Consider a book resting on a flat tabletop. It is at rest and in equilibrium. But it would be equally at rest and in equilibrium at any other point on that tabletop. If we displace the book from its equilibrium position to some neighboring point, there is no tendency for the book to return to the earlier position; hence this equilibrium is not "stable." But neither is there a tendency for the departure from the earlier position to increase; hence the equilibrium is not "unstable," either. This type of equilibrium is called neutral.

In the present instance, there is only one equilibrium point, the one we have described above. If the system is displaced from this point, for example, if $\omega(0) < \bar{\omega}$, then there is no tendency whatever to return to equilibrium. Rather, the system then proceeds to carry out a *closed cycle* in the λ-ω plane, returning after some time T to the point it started from and repeating that cycle indefinitely. The possible cyclical motions are nested inside each other, with the equilibrium point being the innermost point of all these concentric cycles. The cycles are by no means perfect circles in the λ-ω plane, however. Which of these cycles will be traversed by the system depends upon the initial values $\lambda(0)$ and $\omega(0)$. In Table 10.3 we give results for one such cyclical motion, started off with $\lambda(0) = \bar{\lambda}$ but $\omega(0) = 0.75$, which is less than $\bar{\omega} = 0.895$ for the assumed parameters ($v = 3.0$, $a = 0.015$, $\beta = 0.020$).

The following features of Table 10.3 deserve comment:

1. The system returns to its initial point (same values of λ and ω, exactly), though of course the steady growth in population and labor productivity means that neither total output nor output per worker nor real wages per worker return to initial values. (This illustrates the advantage of using the fractional variables λ and ω.) Precise repetition in λ and ω is of course unrealistic, but one can

Table 10.3

A Trade Cycle in the Goodwin Model

The parameters are: Rate of growth of labor productivity
$a = 0.015$
Rate of growth of labor force
$\beta = 0.020$
Accelerator coefficient
$v = 3.0$
Phillips curve crosses zero at $\lambda_P = 0.96$;
goes to -0.04 for $\lambda = 0$.

Equilibrium values are: $\bar{\lambda} = 0.966$ (employment fraction)
$\bar{\omega} = 0.895$ (labor's share).

Starting values are: $\lambda(0) = 0.966; \omega(0) = 0.750$.

Time t	Employment fraction λ	Labor's share ω	Current rate of return (in percent)	Index of output	Index of real wage
0.00	0.966	0.750	8.33	1.000	1.000
0.50	0.988	0.791	6.96	1.041	1.063
1.00	0.982	1.040	−1.33	1.053	1.408
1.50	0.957	1.055	−1.84	1.044	1.439
2.00	0.933	1.038	−1.26	1.036	1.426
2.50	0.912	1.015	−0.51	1.031	1.405
3.00	0.896	0.991	0.30	1.030	1.382
3.50	0.884	0.967	1.11	1.034	1.358
4.00	0.875	0.943	1.91	1.042	1.334
4.50	0.870	0.919	2.71	1.054	1.311
5.00	0.868	0.896	3.48	1.070	1.287
5.50	0.869	0.873	4.24	1.091	1.264
6.00	0.874	0.851	4.97	1.117	1.241
6.50	0.882	0.830	5.68	1.147	1.219
7.00	0.894	0.809	6.36	1.182	1.198
7.50	0.908	0.790	7.01	1.222	1.178
8.00	0.925	0.772	7.60	1.268	1.160
8.50	0.946	0.757	8.11	1.319	1.146
8.943	0.966	0.750	8.33	1.368	1.144
Average	0.912	0.895	3.50	−	−

Notes: 1. Output declines for a short period, between $t = 1$ and $t = 3$.
2. Wages rise rapidly initially and decline steadily after $t = 1.50$. Thus, real wages are low during prosperity (Bodkin 1969).
3. The rate of return equals $(1 - \omega)/v = (1 - \omega)/3$ and is given for convenience. It is negative when $\omega(t)$ exceeds unity. But it is positive on the average.
4. Since we start with $\lambda(0) = \bar{\lambda}$, the starting value of ω is the true minimum over the entire cycle.
5. The average value of λ differs from $\bar{\lambda}$ but the average of ω equals $\bar{\omega}$.

introduce random shocks into the Goodwin model quite easily, just as in the Hicks model; after that, the cycle is no longer precisely repetitive.

2. The average value of $\omega(t)$ over one full cycle works out as $\omega_{ave} = 0.895$, which is exactly equal to the equilibrium value $\bar{\omega}$. This is a general theorem for this model, proved in the appendix. No such theorem holds for the employment fraction λ. The time average of $\lambda(t)$ is $\lambda_{ave} = 0.912$, whereas the equilibrium value is higher, $\bar{\lambda} = 0.966$. Thus, one effect of the trade cycle is to decrease time average employment below the equilibrium value.

3. The employment fraction λ stays between zero and 1, at all times, but not so the workers' share ω. For example, at time $t = 1$ we have $\omega(1) = 1.040$, higher than one. However, this favored position of the workers is short-lived. On the average, over the whole cycle, the workers' share is no more than it would be in equilibrium; i.e., $\omega_{ave} = \bar{\omega} = 0.895$, for the case here.

4. The motion of the system is unsymmetrical between going up and going down. Looking at the workers' share $\omega(t)$, we see that it increases for the first 1.33 years, then decreases steadily (but much more slowly) for the next 7.62 years, giving a time $T = 8.95$ years for the entire cycle. Not only is the motion unsymmetrical, but (unlike the Hicks model) the asymmetry is in the *right* direction. Since ω represents the workers' share, *profits* are going *down* for 1.33 years, then the subsequent recovery in profits takes 7.62 years. (What is meant by "going up" and "going down" depends on who asks the question.)

In summary, the results are highly encouraging. Without doing violence to any of our qualitative estimates (for example, of the accelerator constant v, as well as likely values of productivity and population growth rates) we have arrived at quite sensible values for the length of the trade cycle and for the way this divides up into periods of upward and downward phases. Considering the extreme crudity of some of the assumptions underlying this model, this success is remarkable.

Of course, the model is far from perfect. In particular, we feel that the existence of an equilibrium which is not unstable (it is neutral) is a flaw in this model; so is the possibility of arbitrarily large cycles. The first flaw can be remedied in several ways: (1) introduction of more disaggregation in the nature of the output, e.g., separate outputs of consumer goods and investment goods; (2) introduction of a financial sector, including money and credit as well as some index of business confidence. Either or both of these changes are likely to make the equilibrium point locally unstable, as is desirable.

The second flaw, the absence of an upper limit to the overall size of the set of cycles possible in the Goodwin model, may be remedied by the introduction of a floor level for net investment, similar to the one in the Hicks model. In the Goodwin model, the workers' share of the product may exceed unity over part of the cycle. During such periods, the model implies the existence of disinvestment, the stronger the more the workers' share exceeds unity. If the size of the cycle becomes very large, the necessary rate of disinvestment also becomes large, larger than the maximum rate of disinvestment attainable by letting capital goods run down without replacing them. In such a situation, assumption 5 (that capitalists invest all their profits, positive or negative) conflicts with the existence of a floor level to net (dis)investment. Thus, assumption 5 must then be modified. The effect of this change is likely to be an upper limit to the size of the cycles possible in the modified model.

The changes just discussed may suffice to produce a true limit cycle of defined magnitude, rather than the infinity of possible cycles in the original model. But, while it is obvious that much work remains to be done, we have no doubt that the Goodwin model is the most promising of all the "schematic models" of the trade cycle and well deserves further investigation. A good start in that direction has been made by Alfredo Medio (1975); there also can be found further references to the literature on the theory of the trade cycles.

In concluding this section on schematic models of the trade cycle, we call attention to the fact that by no means all such models have been included. We have presented only five models, of which the first four are most prominent in the standard literature, and the fifth (Goodwin) model is the one we consider most hopeful. This does not mean, and is not intended to mean, that other models can or should be ignored. It merely means that limited space forces us to restrict our coverage much more severely than we should have liked and forces the reader to consult the vast original literature, for example, Arrow (1960), Duesenberry (1958), Goodwin (1955), Harrod (1939, 1948, 1973), Kaldor (1940, 1954, 1957, 1960, 1961, 1962), Kalecki (1937, 1943, 1954), Laing (1978a, 1980), Lucas (1975), Lutz (1961), Pasinetti (1974), and Schwartz (1961).

D. Mathematical appendix

This appendix is devoted entirely to the Goodwin model. The Hicks model is rather intractable mathematically, though easy

enough to follow through numerically. There is, of course, a great deal of formal mathematics associated with the Frisch-type models, involving a part of mathematical probability theory, called "stochastic processes." It can get very complicated. For reasons which become apparent in chapter 11, we do not consider it worthwhile to enter into this field.

The treatment of the Goodwin model which follows is different in detail from Goodwin (1972), though of course identical in spirit. The Goodwin paper is rather condensed, and we expand on it considerably here.

The productivity of labor assumption 1 reads:

$$a(t) = a_0 \exp(at) \qquad a_0, a \text{ are constants} \qquad (10.1)$$

where $a(t)$ is related to output $Y(t)$ and employment $L(t)$ by:

$$Y(t) = a(t)L(t) \qquad (10.2)$$

In this theory, causation runs *from* output *to* employment, not the other way round. Capitalists determine how much output they want to produce and then employ the required number of laborers. The total labor supply, by assumption 2, grows steadily:

$$N(t) = N_0 \exp(\beta t) \qquad N_0, \beta \text{ are constants} \qquad (10.3)$$

We shall be interested particularly in the fraction employed:

$$\lambda(t) = L(t)/N(t) \qquad (10.4)$$

We note, for later use, that $\lambda(t)$ must lie between zero and 1, always. The fraction of *un*employed is $1 - \lambda(t)$.

In section C, under point 4, we derived the expression for the workers' share of the product:

$$\omega(t) = w(t)/a(t) \qquad (10.5)$$

where $w(t)$ is the real wage rate, per worker per unit time. The share of the capitalists in output is the fraction $1 - \omega(t)$, and their (real) profits are this fraction times the total output $Y(t)$. If this entire amount is reinvested, the rate of increase of the capital stock becomes

$$dK/dt = \left\{1 - \omega(t)\right\} Y(t) \qquad (10.6)$$

The acceleration principle assumption, 6, takes the form:

$$K(t) = vY(t) \qquad (10.7)$$

where the constant v is the usual accelerator. Causation here also runs from left to right. Capitalists determine the rate of growth of capital stock, in accordance with their profits—equation (10.6).

Equation (10.7) then decides how much output there will be; this, in turn, through equation (10.2), decides employment.

The "Phillips curve" assumption 7 is embodied in the wage change equation:

$$dw/dt = f(\lambda)w \qquad (10.8)$$

that is, the fractional rate of change of real wages $(1/w)(dw/dt)$ is a function $f(\lambda)$ of the fraction employed. This function is negative if unemployment is large (if λ is small). It increases with increasing λ. For some λ in the permissible range $0 < \lambda < 1$ the function is zero, and it becomes positive for higher employment fractions. Finally, in the limit as λ approaches 1 (full employment), the function $f(\lambda)$ becomes indefinitely large, so that real wages start shooting up beyond all bounds at that point. In Goodwin (1972) this function is approximated by a straight line, but we prefer (when we need an explicit expression, which is not often) to use the following schematic assumption:

$$f(\lambda) = A/(1 - \lambda)^2 - B \qquad A, B \text{ positive constants} \qquad (10.9)$$

The requirement that $f(0) < 0$ implies the condition $A < B$.

Let us now proceed to derive the basic equations of this model. These will turn out to be two coupled differential equations in the two unknowns $\lambda(t)$ and $\omega(t)$. They are differential equations, rather than difference equations, because we have worked with a continuous time variable t throughout; for example, see (10.6) and (10.8).

We combine (10.6) and (10.7) to get:

$$dY/dt = (1/v)(dK/dt) = \left\{ (1 - \omega)/v \right\} Y \qquad (10.10)$$

We now use this, (10.1), and (10.2) to obtain:

$$dL/dt = d/dt(Y/a) = (1/a)(dY/dt) - (Y/a^2)(da/dt) =$$
$$(dY/dt - aY)/a \qquad (10.11)$$

At this stage, use (10.4) to derive:

$$d\lambda/dt = d/dt(L/N) = (1/N)(dL/dt) - (L/N^2)(dN/dt) =$$
$$(dL/dt - \beta L)/N \qquad (10.12)$$

and now put it all together:

$$d\lambda/dt = [(dY/dt - aY)/a - \beta L]/N$$
$$= [(1 - \omega)/v - a)(Y/a) - \beta L]/N$$
$$= [(1 - \omega)/v - a - \beta](L/N) \qquad (10.13)$$

where, obviously, the final factor in parentheses is just λ itself.

Before writing this equation in its final form, let us derive the

equation for $\omega(t)$. We combine (10.4) and (10.8):

$$
\begin{aligned}
d\omega/dt = d/dt(w/a) &= (1/a)(dw/dt) - (w/a^2)(da/dt) \\
&= (dw/dt - aw)/a \\
&= [\,f(\lambda)w - aw\,]/a
\end{aligned}
\tag{10.14}
$$

from which final form one can obviously extract a common factor $w/a = \omega$.

Equations (10.13) and (10.14) provide the basic equations of the model; we now write them out in convenient form. For this purpose, we define the new constant γ by:

$$
\gamma = (1/v) - a - \beta
\tag{10.15}
$$

With this definition, the *final equations* become:

$$
d\lambda/dt = (\gamma - \omega/v)\lambda
\tag{10.16a}
$$

$$
d\omega/dt = \left\{ f(\lambda) - a \right\} \omega
\tag{10.16b}
$$

We now start to exploit these equations, so as to derive useful results. To begin with, let us decide what are the *equilibrium values* of the variables λ and ω. In equilibrium, these variables are constant in time; hence their time derivatives (10.16) must vanish. Setting $d\omega/dt = 0$ yields the equilibrium condition:

$$
f(\bar\lambda) = a
\tag{10.17a}
$$

where $\bar\lambda$ is the equilibrium value of λ. Setting $d\lambda/dt = 0$ gives:

$$
\bar\omega = v\gamma = 1 - v(a + \beta)
\tag{10.17b}
$$

If we use the form (10.9) for $f(\lambda)$, then we can solve (10.17a) to get the explicit value:

$$
\bar\lambda = 1 - \sqrt{A/(B + a)}
\tag{10.18}
$$

We note that, from the assumed properties of $f(\lambda)$, equation (10.17a) implies that $\bar\lambda$ always exists and has a value less than 1, and greater than the point λ_p for which $f(\lambda_p) = 0$; this latter point itself lies between 0 and 1. These predictions are borne out by the explicit formula (10.18): Since $A < B$ is a necessary condition, and $a \geqslant 0$, the right-hand side of (10.18) always lies between 0 and 1. Also: $\bar\lambda \geqslant \lambda_p = 1 - \sqrt{A/B}$.

Next, we derive a conservation law, that is, a first integral of the equations of motion (10.16). We divide (10.16b) by (10.16a) to obtain:

$$
d\omega/d\lambda = (d\omega/dt)/(d\lambda/dt) = \omega \left\{ f(\lambda) - a \right\} /\lambda(\gamma - \omega/v)
\tag{10.19a}
$$

We can rewrite this in the "separated" form:

$$
\left\{ (\gamma/\omega) - (1/v) \right\} d\omega = (1/\lambda) \left\{ f(\lambda) - a \right\} d\lambda
\tag{10.19b}
$$

We get our "conservation law" by integrating both sides of this equation. We define the new functions:

$$\Psi(\omega) = \int \left\{ (\gamma/\omega) - (1/v) \right\} d\omega = \gamma \log(\omega) - \omega/v \quad (10.20a)$$

$$\begin{aligned} \Phi(\lambda) &= \int (1/\lambda) \left\{ f(\lambda) - a \right\} d\lambda \\ &= (A - B - a)\log(\lambda) \\ &\quad + A/(1 - \lambda) - A \log(1 - \lambda) \end{aligned} \quad (10.20b)$$

where the final form of (10.20b) is valid if we use the particular function (10.9). When we integrate both sides of equation (10.19b), the two indefinite integrals can differ only by a constant, which we shall denote by the letter E. This gives the conservation law.

$$\Psi(\omega) - \Phi(\lambda) = E \quad (10.21)$$

This result implies that the "path" of the system in the λ-ω plane is restricted to points which satisfy equation (10.21). Given the initial values $\lambda(0)$ and $\omega(0)$ at time $t = 0$, the value of E can be calculated from (10.21). The only values of λ and ω which can be reached subsequently are such that (10.21) remains true, with the same value of E. In practice, this means a *closed curve* in the λ-ω plane, that is, a repetitive cycle. The equilibrium values (10.17) define a point in this plane which lies inside the closed curve. There is a whole family of such closed curves, one for each value of E. These curves lie inside one another, and they do not intersect. The same situation occurs in the Volterra theory of the varying populations of "prey" and "predator" in an ecological system (Volterra 1931). As explained in section C, we consider this picture unsatisfactory in economics and would prefer a true limit cycle with a strictly unstable equilibrium point enclosed within it.

Next, we establish theorems concerning averages over a complete cycle. Let us write (10.16a) in the equivalent form:

$$d/dt \log(\lambda) = \gamma - \omega/v$$

We integrate both sides of this equation over one full cycle, from $t = 0$ to $t = T$. Since λ, and hence also $\log(\lambda)$, must return to the initial values, the integral on the left is zero. We therefore obtain:

$$0 = \gamma T - (1/v) \int_0^T \omega(t) \, dt$$

and thus the average of ω over one complete cycle is given by:

$$\omega_{ave} = (1/T) \int_0^T \omega(t) \, dt = v\gamma = \bar{\omega} \quad (10.22)$$

One may be tempted to conclude from this that averages over a complete trade cycle are always equal to equilibrium values. This comfortable, and unfortunately quite widespread, belief is entirely

wrong. Let us write (10.16b) in the equivalent form:

$$d/dt \log(\omega) = f(\lambda) - a$$

As before, we integrate both sides over a complete cycle. The same argument gives:

$$< f(\lambda) >_{ave} = (1/T) \int_0^T f\{\lambda(t)\} dt = a \qquad (10.23)$$

Thus the average value of $f(\lambda)$, *not* the average value of λ itself, obeys a simple rule. Since the Phillips curve function $f(\lambda)$ is quite different from a straight line—see equation (10.9)—it follows that λ_{ave} is quite different, in general, from the equilibrium value $\bar{\lambda}$. For instance, in Table 10.3, $\lambda_{ave} = 0.912$ whereas the equilibrium value is $\bar{\lambda} = 0.966$.

This merely confirms something we know quite well already: It is not possible to deduce, from equilibrium values at an equilibrium point, what will happen in a limit cycle which contains this equilibrium as an interior point.

Econometric models
of cyclical behavior

A. The need for models

Although schematic models of the trade cycle give a considerable amount of insight, the questions raised by the existence of fundamentally different models cannot be decided within the framework of the simple models themselves. Yet these questions, particularly the question of dynamic stability or instability of the system equilibrium, are of crucial importance not only for trade cycle theory, but for all of economic theory and economic policy.

In section 9B, we derived equilibrium expressions for such things as the national income \bar{Y}. The formula for \bar{Y} contained the "multiplier" factor $1/(1-m)$ where m is the marginal propensity to consume. Such formulas are at the very basis of the Keynesian policy recommendations for getting out of a depression. Yet, these formulas hold only in equilibrium. One may employ these formulas only on the (all too often tacit) assumption that the system has a natural tendency to return to the equilibrium state, i.e., on the assumption that this equilibrium is locally stable. (Note that the term "equilibrium" here means *long-run* equilibrium, not the short-run market balance between supply and demand; the latter is assumed always.)

It follows that *the entire range of Keynesian policy recommendations is doubtful if the actual equilibrium is unstable; for then these policies may lead to entirely unexpected, and usually very much unwanted, results. The same caution applies to non-Keynesian policy recommendations, for example, to monetarist ones.* These monetarist recommendations also are framed in terms of an equilibrium analysis and are likely to be profoundly misleading if the actual equilibrium is locally unstable.

There is a world of difference between controlling a system

which is basically stable around its equilibrium and controlling a locally unstable system. Policies which work well for the stable system may be disastrous when applied to the unstable one.

When dealing with a locally stable system, one finds that the best, or "optimal," control policy is frequently a control of maximum permissible strength, applied for a very short time, that is, a "short, sharp shock." This kind of control tends to deflect the system from its original, presumably undesirable, path into a new direction, with least overall control effort. If the system has a stable equilibrium, it is not important to be excessively accurate about the precise strength of the shock applied; once the system is pushed back into the neighborhood of the equilibrium, the natural tendency to return to equilibrium takes over, and the desired result follows automatically.

This control policy, however, is completely unsuitable when dealing with a system whose equilibrium is locally unstable and which is subject to unforeseeable disturbances. Most of us are perfectly familiar with controlling one such system, namely, an automobile in motion. To see that the desired path is unstable, all you need to do is take your hands off the steering wheel; and all drivers know that they must be ever on the alert for unforeseen, and unforeseeable, external influences. We know, because we do it ourselves, that such a sytem can be controlled quite effectively. But the optimal control policy is quite different from any "short, sharp shock." A good driver does *not* jerk the steering wheel sharply. Rather, he makes continuous, slight adjustments so as to keep the car along the desired path with minimum control effort; and he slows down deliberately, and keeps a deliberate distance from the car ahead, so as to have adequate time to react to unforeseen disturbances. He does *not* assume that he can control the car so finely that he can judge, precisely, its behavior when subjected to a short, sharp shock. On the contrary, when faced with having to drive an unfamiliar car, the sensible driver goes through a learning period so as to acquire a "feel" for this car, that is, a feeling of how this car reacts to his control.

All this is necessary because a car is both an unstable system and one subject to unforeseen disturbances. A driver who controls a car on the assumption that this is a stable system does not stay a driver for long. Short, sharp shocks simply will not do.

Yet, exactly this type of policy is being advocated, and employed, in controlling economic systems. In 1974, the Australian Treasury explicitly advocated that a "short, sharp shock" be administered to the Australian economy, so as to return this economy to a preferred path. The government of the day took this advice. The results have been about as desirable as in the case of a

motor car. Many years later, we are still not out of the ditch. We are paying bitterly indeed for basing our control efforts on an incorrect view of the nature of economic equilibrium.[1]

In recent years, there has developed a considerable literature on the application, to economic systems, of the mathematical discipline called "optimal control theory."[2] *In our view, this entire development is premature, and highly dangerous.* Before one attempts to control any system, to say nothing of controlling it optimally, it is first necessary to be quite sure about how this system acts in the absence of control. At the present time, this knowledge is sadly inadequate for dynamic economic systems. Rather than rushing into optimal control theory, economists should first make quite sure that they know what sort of system they are trying to control, in considerable detail. At the very least, they should ascertain whether the system is locally stable, or locally unstable, about its equilibrium path.

To make sure of this fundamental point, the simple schematic models are not enough. One must make a detailed analysis of data on actual economies. The conventional way to do this is through *econometric models.*

We distinguish between: (1) economic theories, (2) detailed models, and (3) taxonomic schemes of description. In the trade cycle area, economic *theories* provide an explanation of the causation of cycles: such explanations can be, and usually are, expressed in terms of the schematic models which we have discussed already. By contrast, *detailed models* are systems of equations, containing adjustable parameters, designed to represent actual economic behavior; we explain these in section B. Finally, taxonomic schemes are purely descriptive—for example, a set of more or less arbitrary rules to decide when a trade cycle is at its peak position.

The question we wish to investigate, stability or instability of the equilibrium state, is a theoretical question, in one sense, but it is also an empirical question. A theoretical model, such as the multiplier-accelerator model, may be compatible with either answer: If, in that model, the accelerator constant v is less than unity, the equilibrium is stable; otherwise, it is unstable. The question therefore becomes an empirical one—what value of v is appropriate for the actual economy. Or, more accurately (since there is no reason to believe that something as simple as this model actually applies

[1] For the United States, the "Carter shock" of 1980 might be a similar example.

[2] See Arrow (1968, 1970), Chow (1975), Garbade (1974), Hadley (1971), Pitchford (1977), Turnovsky (1977), and Wells (1977), to mention just a few. For a critical view, see, for example, Salmon (1977) and Young (1974, 1976).

to any real economy), can we find out enough about the real economy, by building an elaborate model of that economy and fitting parameters of that model to observed data, to decide whether the actual economy is stable?

Of course, when we use an econometric model to draw such conclusions, we must assume that the model is good enough to reproduce actual economic behavior in the economy being modeled. This does not mean the model must be perfect—no model is that. But the model must be pretty good, certainly much more realistic than the schematic models of chapters 9 and 10.

In this chapter, we describe the main features of econometric models and the results obtained from such studies in relation to stability of the economic system; we conclude with a critical discussion of these results.

B. Econometric models

We confine ourselves here to a few words about what such models look like, and then go straight on to results. However, a critical discussion of econometric *theory* is given in chapter 16.

The equations which we have written down for our simplified Frisch model in section 10B, namely, a consumption equation, an investment equation, and an output (or national income) equation, are actually an example of a "baby" econometric model. Each equation describes the time development of an economic variable, for example, of investment, in terms of:

1. Values of other, or the same, economic variables, either at the same time t or at earlier times like $t - 1$ or $t - 2$.

2. Certain constants, such as I_0 and v in the investment equation, which are called "parameters" of the model. These are not known to start with; rather their values must be "estimated" by fitting the model to actual economic data.

3. A "disturbance" or "random shock" term $u(t)$ which is treated like a random variable in mathematical statistics: Actual values are unknown; only statistical information is assumed and/or deduced [for example, we may be interested in the mean value of $u(t)$ or in its variance, or in correlation coefficients between $u(t)$ and $u(t - 1)$, say].

One feature of our baby model is *not* typical of econometric models in general: In our baby model, the economic variables of the model (consumption C, investment I, income Y) all have equations associated with them and are therefore in principle determined by the model. This determination is subject, of course, to the influence of the random shock terms which prevent precise

prediction of the future, but that is not the point here. Rather, in larger econometric models, there are usually fewer model equations than there are economic variables. Variables for which there are model equations are called "endogenous" variables; their values are in some sense predicted by the model. But there are other variables, called "exogenous," for which there are no equations at all within the model. For example, an econometric model of Australia may treat the level of world prices for wool as an exogenous variable. This variable affects the Australian economy but is not determined within that economy. The actual values of exogenous variables must be obtained from outside ("exo") information. If we are looking at the past, values of exogenous variables are taken from historical data. If we wish to say something about the likely future, the values of exogenous variables at future times must simply be guessed, by some form of crystal-ball gazing. Clearly, the more exogenous variables there are in a model, the less secure are forecasts of the future obtained from the model.

The equations of our baby model are *linear*. This is not a necessary feature of econometric models in general; indeed many practical models are nonlinear in the mathematical sense. However, the usual nonlinearity is of rather simple type: For example, to obtain a "real" quantity from the money value of that quantity, the money value is divided by a "price deflator." This division of one model variable (money value) by another (price deflator) makes the model nonlinear. Or else, the model may be linear in the logarithms of some variables, rather than actual values. It is fair to say that, with some exceptions, such nonlinearities are not nearly as complicated, or as important, as the ceilings and floors in the Hicks model.

The linearity, or near-linearity as described above, of a model becomes important when we come to *parameter estimation*. The actual values of the parameters which enter into the model equations, for example, v and I_0 in the investment equation of our baby model, are not known to start with. Yet these parameter values can be of crucial importance. A great deal hinges on whether v exceeds unity or is less than unity. Econometric theory allows us to "estimate" those parameter values which yield a "best fit," in some specific sense, to known historical data. This theory also claims to be able to tell us how "good" this fit is and how closely the best parameter values are determined by the data (i.e., by how much the parameters can be varied without affecting the quality of the fit significantly).

We discuss these claims later on, in chapter 16. For now, however, we note that the usual method of parameter estimation in

econometrics is well adapted to models which are linear, or which are "nearly linear" in the sense discussed earlier. But econometric methods of parameter estimation lead to very difficult, and largely unsolved, computational problems when the model is as highly nonlinear as, say, the Hicks model. For this reason, it is conventional to avoid ceilings and floors when *specifying* (i.e., writing down the model equations of) an econometric model. This does make the econometrics much simpler. But, if there really are ceilings or floors, or both, in the economy being modeled, then the model has been *mis-specified*. Since no model can be better than its basic specification, the results deduced from a mis-specified model are highly suspect.

Econometric models come in many sizes. "Small" models have between twenty and eighty, say, endogenous variables. "Medium-size" models have between one hundred and five hundred. Anything at all goes for "large" models: Six thousand equations are by no means unheard of. This is the reason we have called our three equations a "baby" model.

Let us now suppose a model, of whatever size, has been *specified*, it is hoped without major specification errors, and let us suppose that the parameter values in the model equations have been *estimated*, by comparison of the model with known historical data. One may then hope that these model equations, with these parameter values, provide a reasonably accurate representation of the economy to which the model has been fitted. We are then in a position to do several things:

1. We may attempt to use the model to *predict the future* course of the economy. This task is made difficult by two things: (a) future values of exogenous variables must be guessed in some way, having nothing to do with the model, and (b) since the model contains random shock terms, whose future values are not known, predictions from the model are only probabilistic in nature, contingent upon what actual values of the shock terms will be realized in the future. In practice, forecasts based upon econometric models have *not* been notably successful; indeed they are usually only marginally better than forecasts based upon simpleminded extrapolation of present trends. Sometimes they are worse.

2. We may use the model for *policy* studies: Suppose our government is considering a new type of tax and wishes to know the likely yield from such a tax. The proposed tax can be incorporated within the model, and the model can be "run" on the computer to answer the question.

3. Finally, and perhaps most importantly, the model can be used to *further our understanding* of how the economy itself oper-

ates. For example, we may ask: Is the economy described by this model locally stable about its equilibrium path? We cannot experiment with the actual economy; but we can experiment with the model—say, by trying out different initial conditions at time $t = 0$. If the model turns out to be locally stable, then the hope is that the actual economy is also locally stable, and vice versa.

It is this third use of a model which interests us here.

The classic paper on this subject is "The Dynamic Properties of the Klein-Goldberger Model" by Irma and Frank Adelman (1959).[3] The Klein-Goldberger model of the U.S. economy is a "small" model, with a mere twenty-five endogenous variables. The dynamic properties of this model were studied by means of a number of "simulations," i.e., runs of the model under various different assumptions:

1. In a *deterministic simulation*, all random shock terms are set to zero. In such simulations, starting from a nonequilibrium initial state, the model solutions approach equilibrium (growth equilibrium, of course) rapidly. Thus, this model is *stable*.

2. If one introduces sudden disturbances in the values of some of the exogenous variables of the model but still keeps the random shock terms equal to zero, the system is subjected to "type 1 shocks" in the terminology used in Adelman (1959). Such shocks do produce deviations from the equilibrium path, but these deviations turn out to be small and rather unlike typical trade cycle behavior.

3. In a *stochastic simulation*, the random shock terms are allowed to operate; actual values of random shocks are generated by "random number generators," in accordance with the assumed statistical distribution of these shock terms. Table 10.2 is a typical stochastic simulation. (Random shocks of this type are called "type 2 shocks" in Adelman (1959), but "stochastic simulation" is the more usual term.) According to Adelman (1959), stochastic simulation of the Klein-Goldberger model yielded results which showed "startling agreement with the National Bureau cycle." The reference is to the U.S. National Bureau for Economic Research (N.B.E.R.), the main agency for correlation of trade cycle information in the United States.

These results provide strong confirmation of the theoretical ideas underlying the Frisch (1933) type of trade cycle model. In the absence of "shocks" the economy is seen to be stable. The random shocks force the economy into behavior which looks very much like the observed trade cycle.

These early results have been confirmed by subsequent econo-

[3] See also Goldberger (1959), Bowden (1972), and Howrey (1971, 1972).

metric work, to the fullest possible extent. For example, there exists a two-volume conference report on "Econometric Models of Cyclical Behavior" edited by B. G. Hickman (1972). There is absolutely perfect consensus among the econometricians. We quote from the discussion by Professor Saul Hymans (Hickman 1972, pp. 536-541): Either

> (i) the models contain extreme specification errors. A more nearly correct specification would produce endogenous cycles even with smooth exogenous variables; or (ii) the business cycle is not endogenous; rather it is the result of a normally stable, or damped system reacting to external influences.
>
> I suggest that the time has come to admit that the weight of reasoned evidence is on the side of the latter. There is simply no clear evidence to support the view that the business cycle results from the endogenous interaction of consumption and investment spending as they are *normally* determined in an industrialized market economy free of external shocks.

This is as definite as one can be. The experts have spoken, the case has been decided. The economy under which we live has a stable equilibrium path. All wild conjectures to the contrary have been thrown out of court, by careful, detailed, and repeated analysis of hard empirical evidence. Later work has confirmed this; for example, see Sims (1977).

One cannot argue against hard facts, and it appears that these hard facts support conventional equilibrium economic theory and the (associated) Frisch model of the trade cycle and reject far-out speculations about instability, limit cycles, and the like.

Nonetheless, we shall now proceed to show that these very firm, and firmly believed, conclusions are wrong. In this book, we do not wish to contest the economic data (the "hard facts" or perhaps the not quite so hard facts) on which the conclusions have been based. But we do contest, most decidedly, the way in which these data have been analyzed by the econometricians.

C. Inconsistency of the econometric analysis

In this section, we demonstrate that the method of analysis used by the econometricians indicates apparent stability even in circumstances where we know, for certain, that the "true" economy is unstable. The conclusion of stability is merely a consequence of the method of analysis employed. This method is invalid for this purpose and in effect gives no information whatever about stability or instability of the underlying economic system, to which the model has been fitted.

In order to establish these assertions it is neither necessary nor

desirable to consider actual economic data, or to use big, complicated econometric models. The basic logical point is exhibited most clearly by working with purely artificial "data" and analyzing these by means of a super-simple "baby" model. If this leads to a clear and obvious inconsistency, then the logical point has been established: the method of analysis has been shown to be inadequate.

We take as our "data" the income values $Y(t)$ shown in column 2 of Table 10.1 on page 192. These income values are generated by the Hicks model with acceleration coefficient $v = 1.5$. Since v exceeds unity, the "underlying economy" responsible for these "data" is definitely unstable around the equilibrium point. Also, this underlying economy is deterministic, without any random shocks.

Following standard econometric methods (Johnston 1972) we start by postulating a linearized model involving endogenous variables, their values at earlier times ("lagged" values), some unknown parameters A, B, and C, and a "random shock" term $u(t)$. This assumed model is:

$$Y(t) = A + BY(t-1) + CY(t-2) + u(t)$$

The random shocks $u(t)$ are assumed to have mean value zero, constant variance, and no auto-correlation (no correlation between $u(t)$ and $u(t')$ for $t \neq t'$). The parameters A, B, and C of this model must be "estimated" by comparison with our "data."

Let us compare this assumed model with the simplified Frisch model of section 10B. This model contains three equations. However, we can combine these three into a single equation for $Y(t)$. All we need to do is to substitute the consumption equation for $C(t)$ and the investment equation for $I(t)$ into the output equation. The resulting single equation reads:

$$Y(t) = (C_0 + I_0) + (m + v)Y(t-1) - vY(t-2) + u(t)$$

This is exactly the same *form* as our assumed econometric model equation. By comparing the coefficients of $Y(t-1)$ and $Y(t-2)$, we obtain the realationships:

$$B = m + v \quad \text{and} \quad C = -v$$

These relations allow us to deduce "best-fit" values of the marginal propensity to consume m and of the acceleration coefficient v. To avoid confusion, we shall affix an asterisk to such "best-fit" values; i.e., we shall call them $m*$ and $v*$, respectively, so as to distinguish them from the "true" values m and v which were used in the Hicks model to construct the "data." We obtain:

$$v^* = -C \quad \text{and} \quad m^* = B + C$$

In fitting our "data," we are free to choose the time interval T over which we perform the fit. The underlying "true" economy has a perfect limit cycle; hence, the "data" simply keep repeating, with a repetition time of 11 time units, once the limit cycle has established itself (see Table 10.1). There is therefore no problem in generating "data" for any chosen length of time T. In Table 11.1, we show the results of such an econometric analysis for three choices of the fitting interval, namely, for $T = 30$, $T = 40$, and $T = 50$ of our time units.

Table 11.1

Econometric Fits to an Unstable Economy

Values of fitted coefficients A, B, C, of implied marginal propensity to consume (m) and implied acceleration coefficient (v*), for "data" taken from Table 10.1. R^2, DW, and H represent tests of how good the fit is (DW should be near 2; H below 1.65).*

Fitting time T	Fitted coefficients			m^*	v^*	R^2	DW	H
	A	B	C					
30	28.5	1.600	−0.887	0.713	0.887	0.92	2.17	0.56
40	29.9	1.561	−0.866	0.695	0.866	0.91	2.25	0.96
50	30.4	1.543	−0.855	0.688	0.855	0.91	2.28	1.23

Let us now draw conclusions from these results.

1. The fits are uniformly "good": The Durbin-Watson statistic DW is acceptably close to the desired value, 2.0. The alternative Durbin statistic H is well below the danger point, 1.65. Most of the observed variation of $Y(t)$ is "explained" by the assumed econometric equation, with less than 10 percent of the variation attributable to the "shocks." There is no doubt that these fits would be accepted by econometricians as being quite satisfactory, by their own criteria of goodness of fit. Yet, the econometric model used is *qualitatively different* from the "underlying economy": The latter has no random shocks at all!

2. Those parameters which are important for *equilibrium* properties of the economy are fitted reasonably well. The true value of m is 0.75; the fitted values m^*, though not equal to 0.75, are not all that far away. Similarly, the "true" value of the coefficient A

should be $A = C_0 + I_0 = 25 + 0 = 25$. The fitted values of A are in the correct general region.

3. However, that parameter which is all important for the *dynamic* behavior of the economy, namely, the acceleration coefficient v, is a *disaster*. The true value of v is 1.5, well above the dividing line ($v = 1$) between stability and instability. The fitted values v^* are, one and all, well *below* unity. If we wish to take these fits seriously (as, by point 1, we should), then we *must* conclude that the economy described by this model is stable.

This, however, amounts to a *reductio ad absurdum* of the entire procedure! We know what the "underlying economy" is here, and we *know* that it is unstable in the neighborhood of equilibrium. By using the econometric method of analyzing data from this economy, we have been forced to the conclusion that this economy is stable, contrary to fact.

This contradiction discredits this type of analysis. *An argument which leads to an utter contradiction in a simple model is invalid and must not be trusted when used with real data and more complex models.*

The method of analysis fails because it amounts to a basically unfair test. By assuming our simple model equation, at the very beginning of the analysis, we have implicitly excluded the very possibility of a limit cycle of the type occurring in the Hicks theory. It is no surprise, thereafter, that the "test" shows that there is no instability and no limit cycle. Exactly this criticism applies to all the econometric models used for cyclical analysis, such as the ones reported in Hickman (1972).

We do not agree with, and we reject explicitly and emphatically, the view that "the time has come to admit that the weight of reasoned evidence is on the side of the latter," i.e., of models of the Frisch type. The so-called empirical evidence against theories of the limit cycle type is the result of the faulty method of analysis used and does not warrant any conclusion whatsoever concerning the stability or instability of the underlying economic system which is being modeled (Blatt 1978).

D. An alternative analysis

We now report on a different type of data analysis which was developed deliberately to distinguish between cycles induced by random shocks on a stable system and other kinds of cycles such as limit cycles (Blatt 1980). We define what we mean by "theories of the Frisch type," and we assert that *all* theories of this type are *excluded* by known economic data on trade cycles.

Such a strong statement seems surprising. After all, there are infinitely many models of the Frisch type. They differ in the number of endogenous variables, in the structural equations of the model, in the parameters in these equations, in the postulated properties of the random shock terms, etc. etc. Suppose we disprove one of these models, or tens of them, or hundreds of them—there are infinitely many others left, still of the Frisch type.

However, let us suppose that we can find a general feature which is true of this entire class of models, but is not necessarily true for models of the limit cycle type. Suppose, further, that this general feature is *not* observed in historical data on trade cycles. Then *all* models of the Frisch type have been excluded at one fell swoop.

There does exist such a general feature. It is the symmetrical relationship between the upswing and the downswing of the trade cycle, in all models of the Frisch type. We shall show that all such models predict that the upswing takes, on the average, the same length of time and is traversed with the same average slope as the downswing.

Let us now define *Frisch-type models*. The actual model used by Frisch (1933) was extremely simplified; for example, it abstracted from systematic time trends, such as growth, of the economic system. The essential idea of Frisch was that trade cycles are caused by the interaction of a set of random shocks, with a basic system which would run smoothly and stably in the absence of these shocks. Our "Frisch-type models" retain this basic idea but are much more general than Frisch's own model. Our definition includes, we believe, all models which have been suggested and/or tested in the literature and which derive from Frisch's basic idea. Our conditions for a "Frisch-type model" are:

1. The time-path generated by the model in the absence of random shocks must be *locally stable*. That is, an initial small deviation from this path must tend to become smaller as time goes on, so that the system returns to the long-run equilibrium time-path of its own accord.

2. The time-path generated by the model in the absence of random shocks must be "smooth," in the sense that it does not give rise to systematic, trade cycle type oscillations in the absence of shocks. [This requirement excludes the Hicks model and also excludes models in which oscillations are caused by some external factor, such as sunspots (Jevons 1884) or systematic fluctuations in foreign trade. Such models exist, but they are not models of the Frisch type.]

3. The random shocks must be sufficiently small so that all deviations from the stable path can be treated adequately by an ap-

proximation linear *in these deviations* (discussion follows later).

4. The statistical distribution of the random shocks must be such that the probability of getting a particular series of shocks $\{u(1),\ u(2),\ \ldots,\ u(T)\}$ is exactly the same as the probability of getting the *reversed* series of shocks $\{-u(1),\ -u(2),\ \ldots,\ -u(T)\}$. In the reversed series, every positive shock has been replaced by a negative shock of the same size, and vice versa.

Let us now discuss these conditions, in particular condition 3. This condition is more subtle, and much less restrictive of the type of model permitted, than might appear at first sight. First of all, condition 3 is *not* a condition on the structural equations at all. Rather, it is a condition on the maximum permissible size of the shocks. Conditions 1 and 2, between them, already ensure that condition 3 will be fulfilled *if* the shocks are small enough in size. By conditions 1 and 2, we can write the actual path of the system as being the stable path plus a power series in deviations around this. If the shock terms are small enough, then it suffices to keep only the leading (linear) terms in this power series; and that is all we require in condition 3. In particular, we do *not* require that the structural equations themselves be linear, or that the stable path generated by these equations be a simple exponential growth. All we need is that the system can be linearized in *deviations* from this stable path, i.e., that the shock sizes are not excessively large.

Our definition of "Frisch-type theories" does *not* exclude all nonlinear theories with random shocks. Rather, we exclude only those nonlinear theories which violate our conditions 1 and 2, or which satisfy 1 and 2 but have enormous shock sizes. This allows room for a whole host of nonlinear theories with random shocks to be included in our analysis. In particular, there is *no* requirement that the underlying stable path produced by the model in the absence of shocks be a simple exponential growth with constant growth rate. On the contrary, the stable path may be of much more complicated type, including different types for different endogenous variables of the system. All that we require is (1) local stability and (2) smoothness.

The meaning of "smooth" must be understood in relation to the typical time scale of trade cycle fluctuations, that is, a few years. Whatever form the underlying trend curve may take, it must not itself exhibit rapid fluctuations on this time scale. A theory of the trade cycle must not subtract, as part of some "trend," the very phenomenon it is trying to explain. The idea of Frisch is that trade cycles are caused by shocks, not by the basic system in the absence of shocks. Having cyclical oscillations *within* the "trend" curve runs directly counter to that idea.

Condition 4, the symmetry condition for the shock terms, is satisfied by nearly all econometric models ever proposed in the literature. This condition does *not* exclude auto-correlated shocks, or other more complicated assumptions about the distribution of the series of shocks. There may be auto-correlations within the shocks, of any order. All we require is that the reversal operation specified in condition 4, for this entire series, leave the probability of that series's being realized the same as before.

In addition to these four assumptions about the model, we also need an assumption about the rules used to identify the peaks and troughs (the turning points) of the trade cycle. The condition reads:

5. Let the turning point identification rules, whatever they may be, be applied, first, to an economic time series[4] $\{y(1), y(2), \ldots, y(T)\}$ and, second, to its reversed series $\{-y(1), -y(2), \ldots, -y(T)\}$. Then the *same* turning points should be identified, with the peaks for the first series being the troughs of the second, and vice versa.

Intuitively, this requires that the turning point identification rules are symmetrical between identifying a peak, and a trough, of any time series. The identification rules used by the U.S. National Bureau of Economic Research (N.B.E.R.) have been spelled out in full detail by Bry and Boschan (Bry 1971). These rules are *not* simple, since the actual data show considerable "noise" and must be "smoothed" before one can decide where the turning points are. But the Bry-Boschan rules are indeed symmetrical between identification of peaks and troughs, and that is the only property which we require of such rules.

In the mathematical appendix, we show that *assumptions 1 to 5 have as a necessary consequence that the upswing and the downswing of a cycle are completely symmetrical on the average.* In any one cycle, the upswing may be faster than the downswing, or vice versa. But if one takes an average over many cycles, then the average upswing looks exactly similar to the average downswing. It takes, on the average, the same time span, and it proceeds, on the average, with the same slope (positive for upswings, negative for downswings, of course, but the same numerical value.)

At this stage, we are ready for a comparison with historical data on the trade cycle. We take our data from the monumental study by Burns and Mitchell (Burns 1947). We require average values for the slopes of upswings, and of downswings, for data from which long-term trend effects have been removed. Just such values can be

[4] The $y(1)$, $y(2)$, etc. are intended to be *deviations* from an underlying smooth trend curve, not actual measured data. Such deviations should be as often positive as negative.

Table 11.2

Average Slopes of Upswings and Downswings (Burns and Mitchell)

Quantity	Number of full cycles	Average slope of upswing	of downswing
Deflated clearings	13	0.64	1.93
Frickey's clearings	9	0.69	1.65
A. T. & T. index	9	1.12	1.79
Pig iron production	15	2.49	4.02
Electricity output	2	0.48	0.69
Railroad bond yields	16	0.62	0.65

found in Table 97, page 291 of Burns (1947). In Table 11.2, we reproduce an extract from that table, containing all "corresponding" cycles (i.e., cycles which show up both in the raw and in the trend-adjusted data; this is a severe requirement).

According to the Frisch theory of cyclical fluctuations, the average slopes of upswing and downswing should be equal, for each of these quantities. The observations summarized in this table are in clear contradiction to this expectation. With the exception of railroad bond yields (a purely financial quantity) the average slope of the downswing is much higher than for the upswing. The disparity is particularly strong in the series of indices of bank clearings; it is still very pronounced in the (wider-ranging) A. T. & T. index of general business activity, and in figures for pig iron production.

A particularly interesting case is electricity output (even though the data are based on only two corresponding cycles). In the United States, during the period covered, electricity production had a very strongly rising basic trend. *Before* elimination of this trend effect, the raw data give a slope of 0.97 for the upswings, 0.80 (i.e., lower) for the downswings. But this effect is due purely to the long-term trend. When this trend effect is eliminated, the detrended data give the figures shown in Table 11.2, i.e., 0.48 for upswings, and the larger value 0.69 for downswings.

The summary data shown in Table 11.2 are enough to convince any reasonable person that the difference between the rapidity of the upswing and of the downswing is a real effect, not just a statistical fluctuation. But, for those who demand a proof of the statistical significance of the obvious, such a proof can be, and has been, provided by a fully detailed study of the original data on pig

iron production, one of the series listed above. It turns out that the hypothesis that the difference between the two slopes, 2.49 and 4.02, in Table 11.2 is due entirely to a statistical fluctuation can be excluded at a confidence level of two percent (Blatt 1980).[5]

Theories of the Frisch type must lead to symmetry. The data show that a pronounced lack of symmetry is the rule. We are therefore able to assert unequivocally that *no theories of the Frisch type can fit the data on trade cycles.* The failure of such theories is not just a minor matter, but is a fundamental deficiency inherent in the very nature of these theories.

We have now reached the end of book III, on theories of the trade cycle. This is a good point for summing up what we have found.

The standard view of the economic system of competitive capitalism is this: The system is locally stable about a smooth balanced equilibrium growth path. The trade cycle is explained well by the interaction of a set of random shocks, with a basically stable underlying system. Theories which postulate instability of balanced growth and a limit cycle type of behavior are not only quite unnecessary, but they are positively excluded by the data.

The actual situation, in our view, is the precise opposite. We have seen in chapter 7 that there is every reason to believe that the underlying system has an equilibrium balanced growth path which is locally *unstable.* This is true when every one of the usually assumed sources of instability is artificially excluded from our model and is therefore even more likely to be true when these other factors are included in a more elaborate model. We have looked (section 7B and 7D) at the stability literature and have found no reason to modify these views. The claimed stability is either sim-

[5] In order to make our analysis more conservative, we have accepted the N.B.E.R. classification of cycles, which is actually inappropriate for our purpose. In the N.B.E.R. classification, no distinction is made between major and minor (inventory) cycles. For our analysis, it would be much more suitable to adopt an alternative classification in which "cyclical expansions are measured on a broader basis, disregarding one-year contractions" (Matthews 1959, as quoted in section 9C earlier). In such an analysis, the asymmetry between upward and downward slopes is very much more pronounced: We slope upward for, say, eight to nine years out of every ten-year major cycle, downward for the remainder. We avoided this type of analysis, primarily to obviate detailed discussion of just how one should define a major cycle in operational terms. But it is clear that introducing more realism into the analysis makes the rejection of the Frisch type of theory even more decisive.

Note also that the existence of a strong upward trend in output, etc. does *not* invalidate the analysis, nor does this trend work in such a direction as to produce more asymmetry of the type we see. The very contrary is the case, as we pointed out in connection with data on electricity output: Before correction for the trend, the raw data give asymmetry in the *opposite* direction. Thus the existence of the trend does *not* produce our asymmetry; it hurts it.

ply mistaken, or it arises from the introduction of irrelevancies like a central planning board.

The standard view of the economy, as a stable system, is consistent with the Frisch type of theory of the trade cycle. That theory, however, is contradicted by trade cycle data.

At this stage, we can lay to rest, once and for all, the conjecture suggested by Ragnar Frisch in 1933, a conjecture which has become the conventional wisdom of the entire trade cycle literature since then. There is no doubt that this was a brilliant piece of work and a very striking idea indeed. But——it is directly contrary to the data.

Finally, let us return briefly to the discussion in section A of this chapter. We remarked there that the entire range of policy recommendations by Keynesians, monetarists, and all other economists who work from a stable equilibrium model of some sort are highly suspect if the balanced equilibrium growth state is *not* locally stable. With instability extremely likely, everything we said there about controlling a locally unstable system, as opposed to controlling a stable system, becomes directly and immediately relevant to our actual situation! It is not surprising, therefore, that policy recommendations by economists have so often produced undesirable results. The equilibrium picture, on which these recommendations have been based, is a profoundly faulty view of the actual economic system. Trying to make policy on this basis is closely analogous to driving a car by taking your hands off the steering wheel and trusting to the car's inherent tendency to return to the desired stable path. The results range from disappointing to disastrous. Perhaps the most frightening thing of all is the possibility that politicians may start to take these economic models, with all their faults, entirely too seriously (Bray 1978, 1979).

E. Mathematical appendix

We start by describing the econometric data analysis of the "data" generated by the Hicks model, as given in Table 10.1. The analysis starts from the assumed equation

$$Y(t) = A_1 + A_2 Y(t-1) + A_3 Y(t-2) + u(t) \qquad (11.1)$$

where $A_1 = A$, $A_2 = B$, and $A_3 = C$ are the three parameter values to be determined. Let us use an asterisk for particular assumed values of these parameters (including, later on, for the "best-fit" values). The *residuals* of the fit are given by:

$$E(t) = Y(t) - [A_1^* + A_2^* Y(t-1) + A_3^* Y(t-2)] \qquad (11.2)$$

If the chosen A_i^* are equal to the "true" values A_i, then these residuals just equal the random shock values $u(t)$ in equation (11.1). But, of course, there is no guarantee that the "best-fit" (or any fit) values A_i^* are going to be precisely equal to the true values; to the extent that they differ, the residuals $E(t)$ differ from the random shock terms $u(t)$.

The usual procedure to get a best fit is to take the sum of squares of the residuals:

$$S = \sum_{t=2}^{T} [E(t)]^2 \tag{11.3}$$

which is a function of the A_i^* and to minimize this sum of squares with respect to the unknown parameters:

$$\text{Minimize } S = S(A_1^*, A_2^*, A_3^*) \text{ with respect to} \\ \text{the parameters } A_i^* \tag{11.4}$$

(We note, incidentally, that the sum S in (11.3) starts with $t = 2$, not $t = 1$; the reason is that, by assumption, our "data" start in period $t = 0$, and we must know $Y(t - 2)$ in order to compute the value of the residual $E(t)$ at time t; this means $t = 2$ is the first one we are able to compute.)

We perform the minimization (11.4) by differentiating (11.3) with respect to each of the parameters A_i^* in turn and then setting the resulting partial derivatives equal to zero. The easiest way to write down the outcome is in terms of the matrix equation:

$$\sum_{j=1}^{3} M_{ij}A_j^* = b_i \quad \text{for } i = 1, 2, 3 \tag{11.5}$$

We define:

$$x_1(t) = 1 \quad x_2(t) = Y(t-1) \quad x_3(t) = Y(t-2) \quad w(t) = Y(t) \tag{11.6}$$

and use this notation to write down expressions for the matrix M and the vector b in (11.5):

$$M_{ij} = \sum_{t=2}^{T} x_i(t)x_j(t) \quad b_i = \sum_{t=2}^{T} w(t)x_i(t) \tag{11.7}$$

Equations (11.5) to (11.7) give a set of three linear simultaneous equations for the three unknown parameter values which satisfy (11.4). If we start from data values $Y(0)$, $Y(1)$, $Y(2)$, ..., $Y(T)$, then everything is calculable, and the final result is a set of "best-fit" values for the three parameters A_i^*.

Having obtained best-fit values of the parameters, let us turn to the econometric tests for how good this fit is. One simple test is to compute the root-mean-square value of the residuals

$$R = [S/(T-4)]^{1/2} \tag{11.8}$$

and compare this with the range of variation of the $Y(t)$ values; R, we hope, should be considerably smaller than this range of variation, so that most of the actual variation is "explained" by the systematic, rather than by the random, parts of equation (11.1).

The other two tests are for possible auto-correlations between the residuals $E(t)$. The Durbin-Watson (1950, 1951) statistic is defined by:

$$DW = \sum_{t=3}^{T} [E(t) - E(t-1)]^2 / S \tag{11.9}$$

If $E(t)$ are perfectly positively correlated—i.e., if $E(t) = E(t-1)$ for all t—then DW = 0. If the $E(t)$ values are perfectly negatively correlated—i.e., $E(t) = -E(t-1)$ for all t—then DW is approximately equal to 4 (recall that S is defined by (11.3)). If $E(t)$ and $E(t-1)$ are uncorrelated with each other, then DW is approximately equal to 2, and a "good fit" is indicated by DW values close to 2.

However, in their original paper Durbin and Watson warned against applying this statistic to evaluate fits in which some of the explanatory variables are lagged values of the variable which is to be explained. This is precisely the situation here, since the explanatory variables $Y(t-1)$ and $Y(t-2)$ are both lagged values of the variable $Y(t)$ which we wish to explain.

In a later paper, Durbin (1970) has proposed a better test. The test statistic is defined in terms of two other quantities:

$$r = \sum_{t=3}^{T} E(t)E(t-1) / \sum_{t=2}^{T-1} [E(t)]^2 \tag{11.10}$$

$$V = S[M^{-1}]_{2,2} / (T-3) \tag{11.11}$$

where the second quantity, which involves the (2,2) element of the matrix inverse to M, represents the sampling variance of the parameter A_2^*, which is the coefficient of the singly lagged variable $Y(t-1)$. In terms of r and V, the Durbin statistic H is:

$$H = |r| \left\{ (T-1)/[1-(T-1)V] \right\}^{1/2} \tag{11.12}$$

In his paper, Durbin shows that a satisfactory (at the 5 percent

confidence level) value of H means that H is less than 1.645.

In the chapter, the values of the coefficients A, B, C, of DW and H were computed from these formulae.

Let us now turn to the analysis of the average slopes of upswings and downswings, on the basis of the Frisch model, or rather of models of the Frisch type. Here we shall need to go into a bit more detail, since the published paper (Blatt 1980) contains no mathematics at all. Let us start by showing how one separates the time series from a simple linear econometric model into a "systematic" and a "fluctuating" part, with the latter fluctuating about zero. We take the basic model equation for the vector $x(t)$ of n endogenous variables $[x_1(t), x_2(t), \ldots, x_n(t)]$ in the form:

$$x(t + 1) = Ax(t) + B\xi(t) + u(t) \tag{11.13}$$

where $\xi(t) = [\xi_1(t), \xi_2(t), \ldots, \xi_s(t)]$ represents a vector of exogenous variables and $u(t) = [u_1(t), u_2(t), \ldots, u_n(t)]$ represents a vector of random shocks, A is an n-by-n matrix, and B is an n-by-s matrix. Any linear econometric model can be written in this form, if necessary by allowing some of the $x_i(t)$ to be lagged values of other components of this same vector. In addition to equation (11.13), we must specify: (a) the initial state, i.e., the vector $x(0)$; (b) the values of all exogenous variables at all times t of interest; and (c) the joint probability distribution of all the random shocks.

As an example of specification (c), more restrictive than we require, let us give the usual specification: The joint probability distribution of the shocks $u_i(t)$ is a Gaussian multivariate normal distribution, with all expected values equal to zero, with no autocorrelations in time, and with given variance-covariance coefficients V_{ij} between different shocks $u_i(t)$ and $u_j(t)$ at the same time t; that is:

$$E[u_i(t)] = 0 \quad \text{all } i = 1, 2, \ldots, n \quad \text{and all } t = 0, 1, 2, \ldots, T \tag{11.14a}$$

$$E[u_i(t)u_j(t')] = \delta_{tt'}V_{ij} \tag{11.14b}$$

where $\delta_{tt'}$ is the Kronecker delta (0 if $t \neq t'$; 1 if $t = t'$) and V_{ij} is a symmetric nonnegative matrix. This matrix is usually *not* positive definite, since some of the components of the vector $u(t)$ are often zero by definition (for equations representing identities). We emphasize that our theorems are *not* restricted to this specification.

Rather, the restriction which we need, restriction 4 in the chapter, is directly on the probability density function of the shock terms; call it P:

$$P[u(0), u(1), \ldots, u(T)] = P[-u(0), -u(1), \ldots, -u(T)] \tag{11.15}$$

That is, we want invariance of this density function under the "reversal" operation which replaces every component of every shock by its negative value. Property (11.15) is certainly true of the multivariate normal distribution with specification (11.14), but it is also true of many other distributions for these shocks.

Let us now show how one makes the separation into systematic and fluctuating part of the time series $x(t)$. We define the systematic part $z(t)$ as the solution of:

$$z(t + 1) = Az(t) + B\xi(t) \tag{11.16a}$$

$$z(0) = x(0) \tag{11.16b}$$

These two conditions determine $z(t)$ completely for all t. There is no stochastic element in $z(t)$.

We then define the fluctuating part $y(t)$ of the time series of vectors by:

$$y(t) = x(t) - z(t) \tag{11.17}$$

Substitution of this definition of $y(t)$ into earlier equations leads to:

$$y(t + 1) = Ay(t) + u(t) \tag{11.18a}$$

$$y(0) = 0 \tag{11.18b}$$

If we now take expected values on both sides of (11.18a) and assume zero expected value for all the shocks [i.e., assume equation (11.14a) but not necessarily equation (11.14b)], then we obtain the result:

$$E[y_i(t)] = 0 \qquad \text{all } i = 1, 2, \ldots, n$$
$$\text{and all } t = 0, 1, 2, \ldots, T \tag{11.19}$$

We have therefore separated off, from the original time series $x_i(t)$, a fluctuating part $y_i(t)$ which fluctuates about a mean value of zero.

There is one minor trouble with the particular form of separation which we have chosen here, and that is the initial condition (11.16b); hence, (11.18b) also. This initial condition selects the time $t = 0$ as a very special time. In order to avoid this difficulty, we shall analyze all mathematical time series by starting the analysis at a suitably chosen initial time $t_0 > 0$, rather than starting at time $t = 0$. The "suitable choice" of t_0 depends on the matrix A in (11.13). We assume (for a Frisch-type model!) that the model is stable around its equilibrium path $z(t)$; i.e., all eigenvalues of A have absolute values less than unity. This implies that the "memory" of the initial conditions becomes more and more attenuated as

time goes on, until eventually the time series y(t) settles down to a stochastic behavior which is essentially independent of initial conditions. Let g denote the absolute value of the largest eigenvalue of A. Then the attenuation factor after t time periods is g^t. We choose t_0 so that this attenuation factor is sufficiently small for our purposes at all times $t \geqslant t_0$, for example, such that $(g)^{t_0} = 0.1$. If we do our analysis for $t \geqslant t_0$ only, then turning points, slopes of ascending and descending phases, and all other quantities become independent, practically speaking, of the initial conditions on the vector y at time $t = 0$.

In the terminology of Adelman and Adelman (1959), their "type 1 shocks" are sudden variations in exogenous variables $\xi_j(t)$. With our method of separation, these type 1 shocks change the systematic part z(t) of the time series, but not the fluctuating part y(t). Since Adelman and Adelman assert that type 1 shocks are in any case inadequate to explain trade cycle fluctuations, we shall simply ignore type 1 shocks altogether and restrict ourselves to the analysis of "type 2 shocks," i.e., the effects of the random shock terms u(t); these effects are purely on the fluctuating part y(t).

So far, we have assumed a strictly linear econometric model, (11.13). However, there is no need to do so. As long as the shock terms are sufficiently small so that all deviations from the stable path in the absence of shocks remain small throughout, we can linearize the model in deviations $y_i(t)$ between the stable path $z_i(t)$ and the actual path $x_i(t)$. Equations (11.16) are changed, of course, but (11.17) remains the same. In equation (11.18a), the matrix A may now turn out to be time-dependent—i.e., $A = A(t)$—rather than just independent of time; but this affects nothing in what follows.

Let u(t) be any time series of vectors (not necessarily of random shocks). We assume that this time series is the result of some stochastic process—for example, the process (11.18). We say that the time series has the *reflection property* if the probability density of the "reversed" (in sign) time series is the same as for the original series, that is, if (11.15) is satisfied for the density function. It is then an easy matter to prove the theorem.

THEOREM

If the time series u(t) of the random shocks has the reflection property and if the fluctuating part of the model time series y(t) satisfies (11.18), perhaps with time-dependent but nonstochastic matrices $A(t)$, then the vector time series y(t) also has the reflection property.

Proof: By inspection.

Note that this theorem does *not* depend on (1) the size of the model, i.e., the number of vector components n of the vector y; or (2) the absence of auto-correlations of the shocks, i.e., the assumption (11.14b); or (3) the full linearity of the underlying model; nonlinear models are allowed, as long as the shocks are small enough so that all deviations from the equilibrium path remain small and nonlinear terms in these deviations (but *not* in the equilibrium path itself) can be ignored.

Now let us go on to the *symmetry theorems*. Let y(t) be a time series of vectors satisfying the symmetry property. We nominate some specific positive time t_0 as our initial time for analysis. For each component $y_i(t)$ separately, we determine specific cycle turning points (peaks and troughs) by using an objective set of rules, for example, the rules of Bry and Boschan (1971). The rules we use are symmetrical between peaks and troughs. Starting at time t_0, we go forward in time until we have identified exactly $2N + 1$ turning points for the specific series $y_i(t)$. This means we have covered exactly N full cycles, where N is a number nominated beforehand. Each of these N specific cycles (note that we are *not* interested in the "reference cycles" defined by the N.B.E.R.) has an ascending phase and a descending phase. We denote the slope of the ascending phase of the k'th cycle in component $y_i(t)$ by the symbol $m_+(i, k)$. Similarly, let $m_-(i, k)$ denote the slope of the descending phase of the k'th cycle in this component, but with the negative sign ignored.

In N.B.E.R. terminology, these slopes are called "per-month amplitudes." Each slope is obtained straightforwardly by connecting two adjacent turning points by a straight line and measuring the slope of this straight line (in the case of descending phases, the negative sign of the slope is ignored).

Our counting of cycles differs slightly from N.B.E.R. practice. They analyze cycles on a peak-to-peak, or sometimes trough-to-trough, basis. We, on the other hand, nominate a starting time t_0 for the analysis and consider the N cycles under investigation to be those cycles enclosed by the first $2N + 1$ turning points reached, no matter whether the first of these turning points is a peak or a trough. Our choice is necessary to prove symmetry theorems: we cannot afford to discriminate in any way between peaks and troughs, but rather we must treat them entirely symmetrically.

Having analyzed our time series of vectors:

$$Y = \left\{ y(0), y(1), y(2), \ldots, y(T) \right\} \tag{11.20}$$

we can then determine numerical values for all the slopes $m_+(i, k)$ and $m_-(i, k)$, for $i = 1, 2, \ldots, n$ and $k = 1, 2, \ldots, N$ (n is the

number of endogenous variables; N is the nominated total number of full cycles being analyzed). Since the underlying econometric model is stochastic rather than deterministic, the time series (11.20) consists of random variables, and everything (such as slopes) determined from that time series is itself a random variable. Thus, the same econometric model gives rise to many different realizations of the stochastic process Y and hence to many realizations of the set of slopes. Let one such realization be:

$$\text{Set } M: m_+(i, k) = a_{ik} \qquad m_-(i, k) = b_{ik}$$

$$i = 1, 2, \ldots, n \qquad k = 1, 2, \ldots, N \qquad (11.21)$$

where a_{ik} and b_{ik} are a set of *numbers*. Associated with the set M of slopes is a probability density, which can be deduced from the model, of getting precisely those slopes. Now consider the *reversed set* in which the slopes of upswings and downswings have been interchanged:

$$\text{Set } M': m_+(i, k) = b_{ik} \qquad m_-(i, k) = a_{ik}$$

$$i = 1, 2, \ldots, n \qquad k = 1, 2, \ldots, N \qquad (11.22)$$

THEOREM
The probability density for the two sets of slopes M and M' is always the same, provided only that the time series generated by the econometric model has the reflection property and that the turning point identification rules have the reflection property.

Proof: Let the time series of vectors Y defined by (11.20) be realized in such a way that the slopes of set M, (11.21) result from analyzing it. Now consider the reversed time series Y':

$$Y' = \left\{ -y(0), -y(1), -y(2), \ldots, -y(T) \right\} \qquad (11.23)$$

First of all, by the reflection property of the model, this reversed series occurs with the same probability as the original series (11.20). Second, by the reflection property for turning point identification rules, the same actual times are identified as the times of turning points in the two series, but with peaks and troughs changing place. When we then compute the slopes of upward and downward phases of each cycle, we get exactly the same numerical values (apart from signs), but with the meaning of upward and downward slopes interchanged. Thus, if time series Y leads to the set M of slopes, then times series Y' leads to the reversed set M' of slopes. Since the two time series occur with equal probability, they contribute equally to the final probability density function for the slopes. Since all possible time series can be so arranged into pairs giving equal and opposite results, the theorem follows. Q.E.D.

This is the basic symmetry theorem for Frisch-type models. The

particular comparison in which we are interested is for the average value of positive slopes $m_+(1, k)$ and negative slopes $m_-(1, k)$ for $i = 1$ (first endogenous variable; the numbering is arbitrary) and averaged over $k = 1, 2, \ldots, N$.

Let s_+ be the average upward slope, s_- be the average downward slope:

$$s_+ = \sum_{k=1}^{N} m_+(1, k)/N \qquad s_- = \sum_{k=1}^{N} m_-(1, k)/N \qquad (11.24)$$

If we integrate the probability density function for *all* the slopes over everything except the random variable s_+, we get a density function for s_+—call it $Q_+(s_+)$—which tells the probability of finding a particular value of s_+ to be realized. Similarly, if we integrate the probability density function for all the slopes over everything except the random variable s_-, we get a density function $Q_-(s_-)$ for the random variable s_-.

THEOREM
The probability density functions Q_+ and Q_- have the same functional form, so that the average slope variables s_+ and s_- are governed by identical probability distributions.
Proof: By inspection, from the basic symmetry theorem.

From this theorem, it follows in particular that the *expected values* of s_+ and s_- are necessarily equal for all Frisch-type models. This is the comparison which we have presented in Table 11.2 and which has failed so miserably.

The facts of the matter are so obvious that we consider it not worthwhile to waste space describing, in detail, the analysis which we have carried out to establish that the comparison of Table 11.2 is statistically significant for at least one of the quantities, to wit, pig iron production. Let us just say very briefly what we did. (1) We took the historical figures for monthly production of pig iron between January 1877 and December 1929 and fitted a trend curve to the logarithmic values. This fit was

$$\log T(t) = 0.71978 + 3.86345 \times 10^{-3}\, t - 2.8816 \times 10^{-6}\, t^2 \quad (11.25)$$

where T stands for "trend" and t is the time in months, with $t = 1$ being January 1877. (2) The logarithmic deviation $y(t)$ for pig iron production is then defined by:

$$y(t) = \log P(t) - \log T(t) \qquad (11.26)$$

where $P(t)$ is actual production and $T(t)$ is given by (11.25). (3)

We then performed a "seasonal adjustment" on these figures, using the method recommended by Burns and Mitchell (1947). (4) We next identified all turning points and computed m_+ and m_- slopes for each of the fifteen full cycles contained in the data from 1879 to 1933. (5) We finally used a standard statistical test to see whether these two sets of slopes could be the result of two drawings from the same statistical distribution function. This hypothesis could be rejected by the Cramer-von Mises test (Conover 1971) at a confidence level of 2 percent.

BOOK IV

Economics of Uncertainty

In a system undergoing a trade cycle, the key to its behavior is investment. This was first emphasized by John Maynard Keynes.

We therefore ask what is known about investment, in particular about how businessmen evaluate investment projects so as to come to a decision whether to proceed, or draw back. The overwhelmingly important fact about investment is that it is forward-looking in time. The returns, if any, are received in the future. The investment outlays must be made now.

But the future is unknown, dark and uncertain. Thus any valid theory of investment *must* start from the economics of uncertainty.

In chapter 12, we discuss the standard economic theory of uncertainty, the so-called "expected utility theory." This theory is shown to have severe faults, as soon as some of the possible future outcomes are *disasters*, such as death or bankruptcy. Since all neoclassical investment theories either are based on expected utility, or ignore uncertainty of the future altogether, all these theories are highly suspect.

It is not surprising, therefore, that these theories give very poor results. On the microeconomic level, neoclassical investment theories have no place for the method of investment evaluation most commonly, indeed almost universally, used by practical businessmen: the "pay-back time" method. On the macroeconomic level, it is well known that the investment equation of an econometric model is usually the worst equation, or one of the worst, of the whole model; in many cases it does not even give a fit in a qualitative sense, or it gives such a fit only with coefficients of the opposite sign to the one expected from theory.

Keynes's own theory of investment evaluation is contained in his formula for the marginal efficiency of capital, chapter 11 of

the *General Theory* (Keynes 1936). Keynes admitted that this gave him a great deal of difficulty: "And last of all, after an immense amount of muddling and many drafts, the proper definition of the marginal efficiency of capital linked up one thing with another" (Keynes 1936, Royal Society reprint, page xv). Without this, the *General Theory* could not have been completed.

Yet Keynes's formula *cannot* be accepted at face value. It requires that the "series of prospective returns" from an investment are *known* to the investor at the time of the evaluation. Keynes himself was fully aware of the large uncertainty attached to all such guesses about the future and allowed for it in his literary reasoning (see chapters 12 and 22 of the *General Theory*, in particular). But Keynes's formal, mathematical expression contains *no* correction for uncertainty and is therefore seriously deficient. What is needed is a formula for investment evaluation which makes *explicit* allowance for the fact that the future is highly uncertain; that formula, not Keynes's own, should then be used within the *General Theory* and elsewhere.

In chapter 13, we present a new theory of investment evaluation, allowing for uncertainty and the risk of disaster to the project, but not based on expected utility ideas. The pay-back time method of investment evaluation emerges from this theory as a simple special case, in a completely natural fashion.

The themes of book IV comprise new material, not only in the sense of not being part of the neoclassical literature, but also in the sense of being strongly opposed to that literature.

The utility of being hanged
on the gallows

A. Risk and uncertainty

All the growth theories discussed in book II, and most of the trade cycle theories discussed in book III, start from the assumption that the future is known with certainty. A given set of inputs at the start of the production period will, at the close, result in a perfectly determined set of outputs. The one apparent exception to this, the "random shocks" theory of Ragnar Frisch (1933), postulates a stable system, so that the shocks, while indeed preventing perfect forecasting of the future, do not throw the system into states far from equilibrium, states which might be rather unpredictable. In theories including discretionary demand, all tastes and preferences are assumed known, not only at present but also at all times in the future.

All of this is wildly at variance with the real world in which we live. The "dark forces of time and ignorance" (Keynes 1936) throw a pervasive shadow: in that shadow we live, we work, we plan for the future to the extent that planning makes sense, and we pray or trust to luck where planning makes no sense at all.

The area of economics most affected by uncertainty of the future is investment in plant and machinery. We shall present a new theory of investment evaluation under uncertainty in chapter 13. But before doing so, we find it necessary, unfortunately, to discuss the conventional so-called economics of uncertainty. This is the purpose of the present chapter.

Let us first be clear why some sort of economics of uncertainty is absolutely indispensable. To see this, consider for a moment the calculation of growth in an input-output model, as done in chapter 7 for the general (not necessarily balanced growth) case. In section

7B, we demonstrated that the system is unstable about its balanced growth path and becomes impossible (negative quantities of some commodities needed) after a number of periods. This was deduced from the assumptions of perfect thrift and perfect market clearing.

However, why should producers be so extremely short-sighted as to insist on markets clearing in each separate annual market, when the result of this insistence is a *predictable, foreseeable* disaster for everyone? Furthermore, this predictable disaster can be *prevented* at a trivial cost: In Table 7.1, there is, at the start, a very slight excess amount of corn, compared to the available amount of iron. If the corn producers agree, right at that moment, to burn up this excess corn (0.1 percent, i.e., 148.2 quarters out of a total of 148,250.6 quarters) rather than placing it on the market, then they, and everyone else, can calculate with perfect certainty that the subsequent path of this economy will be the perfectly balanced growth path, for ever and ever until Kingdom come, amen.

Under these circumstances, the rational thing to do is just that —destroy this slight excess amount of corn. The alternative is the catastrophe shown in Table 7.1, an outcome from which no one profits.

Yet, the same approach which insists that "economic man" is rational also makes him close his eyes to *predictable* disaster! There is an *internal inconsistency* in any economic theory which postulates rationality and perfect foresight of the future, yet makes an auctioneer clear only the *current* market. If people did have perfect foresight of the future, they should give quite different instructions to their auctioneer (assuming that highly mythical individual to exist, just for the sake of the argument). *The neoclassical theory under the assumption of certainty of the future is not only wildly unrealistic; it is not even internally consistent.*

Of course, this pretense of foresight of the future is utterly at variance with the real world of men and affairs. The future cannot be foretold with mathematical precision; indeed not with any precision at all. No matter what the economic system, our future is uncertain. To have any claim to realism at all, an economic theory *must* come to grips with the economics of uncertainty.

Sometimes, in certain contexts, uncertainty of the future can be compensated for. This is true when the future, though uncertain for the individual, can be predicted accurately for a large group of people. An example is life insurance. Any one person does not know how long he will live. But given a group of, say, one hundred thousand persons of similar age and state of health, the insurance

company can predict, with only a small error, the fraction who will still be alive ten years from now. If the events themselves (the deaths) are independent of each other,[1] fluctuations tend to cancel for a sufficiently large group. The insurance company is therefore able to calculate an economic premium to charge for a life insurance policy.

In his classic treatise *Risk, Uncertainty, and Profit*, Frank H. Knight (1921) distinguished sharply between that type of situation, which he called "risk," and another situation altogether, to which he gave the name "uncertainty." Let us take Knight's own illustration for the latter (p. 226 of the reprint):

> A manufacturer is considering the advisability of making a large commitment in increasing the capacity of his works. He "figures" more or less on the proposition, taking account as well as possible of the various factors more or less susceptible of measurement, but the final result is an "estimate" of the probable outcome of any proposed course of action. What is the "probability" of error (strictly, of any assigned degree of error) in the judgment? It is manifestly meaningless to speak of either calculating such a probability *a priori* or of determining it empirically by studying a large number of instances. The essential and outstanding fact is that the "instance" in question is so entirely unique that there are no others or not a sufficient number to make it possible to tabulate enough like it to form a basis for any inference of value about any real probability in the case we are interested in.

This is what Knight labels *uncertainty* and distinguishes sharply from *risk*. In *both* cases, the actual future outcome is not predictable with certainty. But in the case of risk, the *probabilities* of the various future outcomes are known (either exactly mathematically, or from past experience of similar situations). In the case of uncertainty, the probabilities of the various future outcomes are merely wild guesses, if that. As Keynes says in his *General Theory* (Keynes 1936, p. 149):

> The outstanding fact is the extreme precariousness of the basis of knowledge on which our estimates of prospective yield have to be made. Our knowledge of the factors which will govern the yield of an investment some years hence is usually very slight and often negligible. If we

[1] This proviso is important. If the entire group lives in one city and this city contains a nuclear reactor which blows up, the resulting deaths are not at all independent, statistically speaking, and the insurance company will go bankrupt. This is the reason that private insurance companies are not prepared to underwrite the risk from nuclear reactors. The economic comparisons, so-called, between nuclear power and other forms of power would look very different indeed if nuclear power stations had to bear the realistic cost of their insurance, rather than being able to throw that cost onto the taxpayer, unlike their competitors.

speak frankly, we have to admit that our basis of knowledge for esti-
mating the yield ten years hence of a railway, a copper mine, a textile
factory, the goodwill of a patent medicine, an Atlantic liner, a building
in the City of London amounts to little and sometimes to nothing; or
even five years hence.

In his book, Knight (1921) makes an excellent case for concen-
trating on the effects of true uncertainty, on the grounds that
cases of mere "risk," in his sense of the word, are so similar to ab-
solute certainty as to make little practical difference. Mere "risk"
can be insured against, such risks can be pooled, diversified, etc.
etc., to the point that the effects of such risks on business decision
making are very minor indeed. The insurance premium is one of
the costs, a perfectly well-known cost at that, and that is all there
is to it.

But true uncertainty, in the sense of Knight, is something else
again. According to Knight, the main function of the "entrepre-
neur" is to bear the brunt of this uncertainty of the future. The
profits of enterprise ("pure profits" over and above interest pay-
ments on debt capital and/or dividend payments to shareholders)
can be traced to being a reward for facing uncertainty. One does
not need to accept this argument (we do not) in order to be
convinced that true uncertainty is an extremely important, fun-
damental factor in economics.

The importance of uncertainty in this sense was recognized very
early by Keynes (1921) and has been stressed particularly by
Shackle (1967, 1974). However, the difficulties of making an ade-
quate treatment of true uncertainty in theoretical economics have
proved daunting, and, while Knight's classic is often quoted with
approval, it is seldom followed up in practice.

B. Expected utility theory

Quite another strand, at present the dominant strand, in the eco-
nomic theory of uncertainty was started as long ago as 1738, not
by economists, but by professional mathematicians. It is a truly re-
markable spectacle that economists have accepted, for over two
centuries, the superiority of the economic intuition of pure mathe-
maticians, accepted it with a faith which is positively touching,
but in our opinion entirely unwarranted.

In 1738, the mathematician Daniel Bernoulli (1738) suggested a
solution to the "Saint Petersburg paradox." The paradox involves
a gambling game with bets on the throws of a coin. The payoffs
are arranged in such a way that the mathematical expectation of
the return from the game is infinitely big. Thus, a gambler should

prefer playing this game to receiving some amount of money with certainty, no matter how big the amount of money in question. In fact, however, few gamblers could be induced to make that choice if the certain money sum is really big.

Bernoulli suggested that it is the *utility* of a sum of money, not the sum itself, which matters. One extra ducat means a great deal when added to a base amount of only two ducats. It means much less (relatively) to a wealthy man who already owns a million ducats. Thus, Bernoulli said that one should work out the mathematical expectation, not of the sum of money, but rather of the utility of that money. By making a rough, but reasonable, assumption about $U(M)$, the utility of an amount of money M as a function of M, Bernoulli showed that the Saint Petersburg game has a finite, not an infinite, expected utility of the returns. Thus the alternative of a definite sum of money promised with certainty will be selected by the gambler if the utility of this money sum exceeds the expected utility of the returns from playing the game. The paradox therefore disappears (for details, see the mathematical appendix).

In classical economics, utility considerations tended to be pushed aside. After the rise of the neoclassical school, utility became important, since one of the "two blades of the scissors," namely demand, was correlated with utility.

There is a distinction between "cardinal utility" and "ordinal utility." In "ordinal utility," we are allowed to say that two events are equally "utile," or that event A is more utile than event B, or vice versa. But we are not allowed to ask whether event A is twice as utile, or three times as utile, as event B. It can be shown that a restriction to ordinal utility makes almost no difference at all to the effects of utility maximization under conditions of certainty (see chapter 15). But the situation changes radically once there is uncertainty (or risk: we shall ignore the distinction for the time being, and shall return to it later). If we wish, with Bernoulli, to work out the mathematical expectation of the utility of the returns from a gamble, ordinal utility is not enough. We must be able to assign actual numerical values to the utilities; i.e., we require what is called "cardinal utility."

Once more, a pure mathematician entered the scene. In 1944, John von Neumann (the same one responsible for the growth theory of chapter 4), working in collaboration with the economist Oskar Morgenstern, published a book *Theory of Games and Economic Behavior* (von Neumann 1944). In the second edition (von Neumann 1947) they set up certain initial assumptions (axioms) which are claimed to apply to all reasonable men. Starting from

these axioms, they then prove mathematically that one can assign a *cardinal* utility to every event, or "gamble." Gamble G is preferred to gamble G' if and only if the expected utility of gamble G is higher than the expected utility of gamble G'. The proof is given in the mathematical appendix. Here we merely list the axioms, in the form given by Borch (1968).

Borch describes the axioms in terms of a gamble or "lottery" G, in which a prize x_1 of money can be won with probability p_1, a prize x_2 can be won with probability p_2, \ldots, a prize x_n can be won with probability p_n. There is a finite number n of possible outcomes. All the prizes x_1, x_2, \ldots, x_n are positive sums of money, except that x_1 may be zero.

A special case, of importance, is the "binary lottery," in which there are only two outcomes: $x_1 = 0$ and $x_2 = M$, a large "grand prize." With these concepts understood, here then are the *axioms*:

1. To every lottery G there exists a "certainty equivalent," which is a sum of money for which we are prepared to sell our lottery ticket (or, equally, the largest sum of money which we are prepared to pay for a ticket).

2. In a binary lottery with probability p of winning the grand prize, the certainty equivalent is zero if $p = 0$; it is M (the value of the grand prize) if $p = 1$. For intermediate values of p, the certainty equivalent is an increasing function of p.

3. The third axiom is hard to state in words alone (it is stated mathematically in the appendix). The idea is that a general lottery with n prizes, the lowest being $x_1 = 0$ and highest being $x_n = M$, can always be converted to an "equivalent" binary lottery with prizes 0 and M, only. This conversion is quite definite (i.e., the probability p of winning the grand prize in the binary lottery can be calculated from the prizes and probabilities of the original lottery).

Given these three axioms, it is possible to derive mathematically the existence of a utility function, a *cardinal* utility function $u(x)$, such that the "expected utility" of every lottery can be computed once and for all by a simple formula (in the appendix). If the lottery tickets for lotteries G and G' cost the same, then lottery G is preferred if and only if the expected utility of G exceeds the expected utility of G'. Any one person may make the opposite choice; but if he does so, he is simply being irrational. The mathematical reasoning is exact.

Initially, the economics profession was reluctant to accept this contention. Hicks, for one, had argued cogently against the concept of cardinal utility in his *Value and Capital* (Hicks 1939). There seemed to be no reason that cardinal utility should be resurrected in the context of uncertainty, when it had been dismissed

so firmly in the presumably simpler context of full certainty. The fact that expected utility cannot be computed from ordinal utility, and needs cardinal utility to work at all, may be a reason why one might prefer to be allowed to work with cardinal utility, but hardly a reason to introduce cardinal utility by the back door through cleverly chosen axioms.

Rather surprisingly, though, this (in our view entirely justified) initial hesitation did not last.[2] At present, expected utility theory is the accepted, conventional wisdom in the entire standard literature of the economics of uncertainty; for example, see Borch (1968), Arrow (1965), and Hirschleifer (1970). According to Borch, the three axioms listed above are "conditions which the rule [of preference] ought to satisfy if it was to be acceptable to intelligent logical people." Also, "there may exist persons with more or less 'perverse' preference orderings who do not fit our model, but we can ignore them as long as we do not set our level of aspiration too high."

These are strong claims indeed. Anyone who has a scale of preference not in accordance with these axioms is, by that very fact, declared to be unintelligent, or illogical, or both.

C. Criticism of expected utility theory: a first look

We cannot agree with these assertions of expected utility theory and devote the remainder of this chapter to its criticism.

First of all, the proponents of the theory themselves have doubts. For example, Borch (1968) gives a simple instance to contradict the theory he supports:

Consider a set of market baskets each containing a number of dollar bills and a number of tickets in the Irish Sweepstake. A person may always prefer more cash to less cash, independently of the number of lottery tickets in the two baskets. Only when the two baskets have exactly the same amount of cash in them will he opt for the one with the larger number of lottery tickets.

This kind of preference ordering is called "lexical ordering" for the following reason: In a lexicon (dictionary) words are ordered by the first letter if the first letters differ. When the first letters are

[2] Friedman (1948) and Marschak (1950) were early converts to expected utility. Ellsberg (1954) argued that the von Neumann notion of utility is basically different from the neoclassical (he called it "classical") notion of utility, and thus cardinal von Neumann utility is not in conflict with strictly ordinal neoclassical utility. However, this is *not* an argument for accepting von Neumann's axioms, since the argument starts from these axioms. Ellsberg makes no attempt, even, to justify the axioms themselves. He merely elucidates the meaning and consequences of these axioms.

the same, the words are ordered by the second letter. When first letters and second letters are the same, the words are ordered by the third letter; and so on. This type of ordering can be shown to be inconsistent with expected utility theory.

Now, by what peculiar process of reasoning is a man with this preference ordering declared to be "unintelligent" or "illogical"? All of us have met such people who prefer hard cash to any number of lottery tickets. We may think of them as being cold fish, unimaginative, excessively hardheaded (and perhaps hardhearted as well). But what makes them "irrational"? Here, then, is a first instance of perfectly rational people *not* ordering their preferences in line with the axioms of expected utility theory.

The second example comes from deliberate experiments of Allais (1953, 1979), designed precisely to test these axioms. Businessmen were presented with certain imaginary choices between "projects" and were asked to state their preferences. Let us look at two of these choices:

1. Project A gives a certain return of $1 million. Project B has an 88 percent chance of giving 1 million, an 11 percent chance of giving 5 million, but also a 1 percent chance of utter failure (return = 0). Faced with this choice, the overwhelming majority of the businessmen chose project A.

2. Project C has a 12 percent chance of returning 1 million and 88 percent of returning nothing. Project D has an 11 percent chance of returning 5 million and an 89 percent chance of returning nothing. Here, the overwhelming majority of the businessmen opted for project D.

In the appendix, we prove that this set of preferences is *inconsistent* with expected utility theory. From this theory, it can be deduced that a "rational" person must either opt for projects A and C, *or* for projects B and D. The actual choice of the businessmen, A and D, contradicts expected utility theory.

From the point of view of expected utility theory, there are *two* difficulties here:

1. These businessmen, whose judgments disagree with expected utility so consistently, must be "perverse" or "irrational." But on what grounds are they perverse? The respondents are practical men who have proved their ability to survive in the hard world of business reality. In that world, anyone who is truly irrational or perverse is likely to go bankrupt before long. These men have not gone bankrupt.

2. But let us suppose that, on some grounds or other, these people can all be called irrational. *How does this help?* The theory of expected utility is put forward as an *economic* theory, as a descrip-

tion of how "economic man" makes his decisions in the face of uncertainty. If a representative sample of successful businessmen disagrees with this form of decision making, what good does it do to brand them as "irrational"? These *are* our "economic men" par excellence. If *they* are irrational, then it should be our concern to find out the precise nature of this irrationality and to incorporate it into economic theory. It is no answer at all to call our economic men irrational and leave it at that. *If an economic theory of decision making is not applicable to typical successful businessmen, then it is no good.* Rationality or irrationality does not come into it. A bad theory cannot be revived by magical incantations or name calling.

D. Criticism of expected utility theory: the gallows

Let us now present a "gamble" in which the axioms of expected utility theory turn out to be inapplicable.

Our gamble is an illegal venture, say importing heroin into Singapore, which is highly profitable if undetected, but leads to the death penalty upon discovery. Let us use the symbol p for the probability of being caught, and hence swinging on the gallows. The probability of not getting caught is then equal to $1 - p$.[3]

Let us ask what are the preferences of people concerning this gamble? Clearly, this depends upon the person. There are some (we hope, many) law-abiding people who refuse to consider such a venture, because it is illegal. But we all know that there exist other, less law-abiding individuals. It is well known that the death penalty is by no means an absolute deterrent to crime.

Next, given that the person's respect for the law is somewhat less than perfect, how does he react to such a prospect? For the moment, assume the money gain M is unchanged, but the probability p of getting caught varies. When $p = 0$, there is no risk, just a certain gain of M. Let $u(M)$ be the degree of preference (the "utility") of the sum of money M, for our person.

If p is not exactly zero, but quite small, we expect such a person will still take the gamble, even though he might lose his life. It is a rare criminal indeed who is deterred by the gallows when the chance of swinging on them is, say, less than one in a million.

Equally true, however, most criminals *are* deterred by the gal-

[3] We are fully aware of Borch's caveat: "Questions of life and death . . . would then be considered as . . . outside the narrow subject of economics proper." We shall return to this point at the end of this section, but we ignore it for now.

lows when they reckon that the probabilty p of hanging is too high; that is, once p becomes large enough (larger than some p_{max}), then no amount of money M will induce them to take the gamble. People differ in their degrees of recklessness, when the promised gain is really high. For some people, p_{max} may be $1/2$. For others, the gamble is still accepted (given sufficiently large incentive M) for p up to 0.9; even more reckless ones might be induced to gamble their lives even when p is as large as 0.99. But sooner or later, the probability of survival, $1 - p$, becomes too small for the game to be worth the candle.

Let us *define* a class of persons called "greedy but cautious criminals," abbreviated GCC, by the following properties:

1. A GCC is "greedy" in the sense that his utility of money $u(M)$ increases without any upper bound as M is made larger and larger. Not all people are greedy in this sense, but many are. We all know wealthy people who assign a positive, nonzero utility to *doubling* their current wealth, no matter how much money they own already.

2. A GCC is "cautious" in the sense that he will not accept our gamble, no matter how large the promised gain M, if the probability p of being hanged exceeds some maximum value $p_{max} < 1$.

3. A GCC is "criminal" in the sense that he accepts the gamble for small enough, but still positive, p.

For our subsequent argument, we need not assert that all rational people are GCCs, or even that many are. All we shall require is that *some*, perhaps only a few, perfectly rational people are GCCs. This can hardly be denied, from common observation.

Let us draw, from common sense, a rough schematic plot of our GCC's degree of preference for this prospect, for fixed M but varying p. This is shown as Figure 12.1. For p near zero, the degree of preference is $u(M)$, the utility of M. The curve goes downward as p increases, first gradually, then more and more rapidly. For large enough p, the degree of preference becomes infinitely negative. The prospect is refused for all p such that the degree of preference is negative (i.e., for p larger than the value at which our curve crosses the horizontal axis). This value of p depends on M, of course. But there is a larger value of p (where the curve tends to minus infinity) for which the gamble is refused absolutely, no matter how big the promised money gain M.

You or I may disagree with the details of this curve; but some such curve appears to be a reasonable schematic representation of the preference scale of our GCC.

Yet, *every* such curve, as opposed to a straight line, is inconsistent with expected utility theory. For the venture in question, this theory gives:

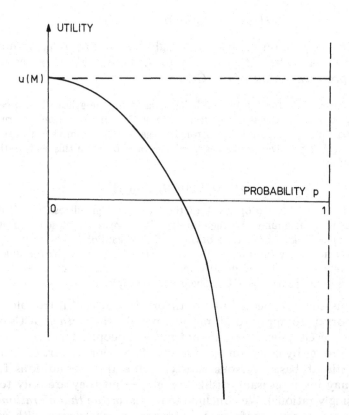

Figure 12.1

A schematic plot of the degree of preference ("utility") of a prospect promising the sum of money M if successful, but the gallows if unsuccessful, as a function of the probability p of getting caught. For $p = 0$, the degree of preference is $u(M)$, the utility of the money sum M with certainty. As p increases, the degree of preference drops, slowly at first, then ever more rapidly. When the curve crosses the horizontal axis, the degree of preference turns negative, so that the gamble is refused. The value of p at which this happens is likely to depend somewhat on M. However, there is a larger value of p for which the curve cuts off altogether (the degree of preference becomes minus infinity), and for probabilities p in excess of this the gamble is always refused, no matter how big the promised money sum M. This curve is based upon common sense, but disagrees with expected utility theory, because the latter insists that only a straight line dependence will accord with "rationality." Yet, *no* straight line can represent the preference scale of a "greedy but cautious criminal" who is perfectly rational.

$$E(U) = (1 - p)u(M) + pu(G)$$

In its dependence on p, this is a straight line, not a curve. We now *assert* that *every straight line of this form is incapable of representing the preference scale of our GCC.*

Proof: Either $u(G)$, the "utility of being hanged on the gallows" with certainty, is finite, or else it is negatively infinite. Take the two cases in turn.

1. $u(G)$ finite (though possibly strongly negative). The gamble is accepted when $E(U)$ is positive,[4] and an easy calculation shows that this leads to the condition:

$$p < p^* = u(M)/[u(M) - u(G)]$$

Now increase M; by property 1 of the GCC (his "greediness") $u(M)$ increases without bound, and therefore p^* also increases, as close to 1 as we please. This *violates* property 2 of the GCC (his "caution").

2. $u(G)$ negatively infinite. In this case, $E(U)$ as given by the formula is negatively infinite for all positive values of p, no matter how small. This *violates* property 3 of the GCC. The proof is complete.

At this stage, expected utility theory is in dreadful trouble. If this theory is to apply to all rational people, then *either* GCCs do not exist *or* GCCs exist but are not rational people. The first assertion is wrong, by common observation. The second assertion is utterly without basis. Persons satisfying the three conditions for GCCs may be unpleasant, dislikable, etc.——but they are only too depressingly rational. We conclude that it is *untrue that all rational persons must have preference orderings in accordance with expected utility theory.* Some may; others, equally rational, do not.

What has broken down here is axiom 1 of expected utility theory, the axiom which asserts that "everything has its price." If the prospect contains a high probability of being hanged on the gallows, then no amount of money makes it acceptable. Thus axiom 1 is not universally true for all rational persons. We are equally doubtful about axiom 3, but one axiom suffices for our argument.

To close this section, let us return to the objection that "questions of life and death [are] outside the narrow subject of economics proper." A businessman who stays within the law is not threatened with the gallows, only with bankruptcy. This, it is claimed, is hardly such an ultimate catastrophe.

[4] This is merely a definition of what we mean by zero utility level. The argument does not depend on what level of expected utility is taken to correspond to acceptance of the gamble. Note also that the proof uses only the three defining properties of a GCC; it does *not* depend on accepting Figure 12.1 as realistic.

But if you think so, listen to Adam Smith (1776, p. 325): "Bankruptcy is perhaps the greatest and most humiliating calamity which can befall an innocent man. The greater part of men, therefore, are sufficiently careful to avoid it. Some, indeed, do not avoid it; as some do not avoid the gallows." The analogy between the gallows and bankruptcy is not our invention——it dates all the way back to Adam Smith.

When Charles Dickens was a child, his father became bankrupt. Young Charles's education was terminated instantly, and he was sent to work in one of those dreadful sweatshops where children were forced to work fourteen hours a day under utterly inhuman conditions. Young Charles survived, though he was marked for life by the experience. How many other children, in similar circumstances, failed to survive?

Throughout the nineteenth century, bankruptcy continued to be an utter calamity. It was not always a physical death sentence (though it was that often enough) but it spelled death *as a capitalist*. The bankrupt lost his standing within his social class. No credit was extended to him. He had to go to work in some despised, menial occupation, for years and years, until such time (if ever) that he had repaid his creditors.

The analogy between bankruptcy and the gallows is by no means farfetched. For what matters here, they have this in common: Both are disasters from which it is extremely hard (or impossible) to recover.

E. Avoiding irrationality

The most striking difference between Figure 12.1 and the result from expected utility theory is that the former is a curve, the latter is a straight line, as a function of the probability p of getting caught. Expected utility always leads to a *linear* dependence of its choice criterion $E(U)$ on the probabilities p_i of all possible events i. Indeed, from a mathematical point of view, this is the *only* significant statement made by expected utility theory: The theory does not tell us what the separate utilities u_i of the various events are; indeed, these are subjective matters which differ from one individual to another.

Thus, the essential claim of expected utility theory is that the criterion for choice of preferences in the presence of uncertainty is linear in all relevant probabilities. Only an irrational person, it is claimed, could ever arrive at a curve such as is shown in Figure 12.1. Let us investigate their argument (Bernstein 1981)!

Consider a man who has a choice between several "projects," in

the sense of being able to trade his ownership of shares in these projects on the organized money market. Let us suppose that each project is characterized by two numbers:

1. the expected money return from the project, suitably averaged over all possible outcomes from the project; for project number k, this is denoted by E_k; and

2. the probability of "disaster" (meaning no return and loss of the principal) for project number k. We denote this probability by D_k.

Let us also suppose that our investor is ordering his preferences according to the following figure of merit Q:

$$Q_k = (1 - D_k)^4 E_k$$

For example, if the average expected return from project 1 is $E_1 = 9,112,500$ dollars, and the disaster probability is $D_1 = 1/3$, then $Q_1 = (2/3)^4 \times 9,112,500 = 6,075,000$. We note that $Q_k = E_k$ for a project with disaster probability zero, and $Q_k = 0$ for a project sure to end in disaster ($D_k = 1$). In between, however, this figure of merit is *not* a straight line function of the probability of disaster D_k, but very much a curved function. It should therefore lead to "irrational" results.

We now list four projects. The first three can have only two outcomes each. One outcome is disaster, with probability D_k; the other outcome is success, with probability $1 - D_k$ and money return R_k. The expected (averaged) money return is then given by: $E_k = (1 - D_k)R_k$. All these values are listed in Table 12.1, along with the figure of merit Q_k for each of the projects.

Table 12.1

Project numbers k	Return if successful R_k	Disaster probability D_k	Expected return E_k	Figure of merit Q_k
1	9,112,500	1/3	6,075,000	1,200,000
2	1,610,510	1/11	1,464,100	1,000,000
3	32,000,000	1/2	16,000,000	1,000,000
4	–	13/44	8,732,050	2,151,554

We shall discuss the nature of project 4 shortly. First, however, note that our investor, with this preference scale, is happy to pay a money fee to convert one share in project 1 to one share in project

4. He is indifferent between owning shares in projects 2 and 3, but is willing to pay a money fee to convert either one of those shares to a share in project 1.

Now let us state how project 4 has been constructed. The project consists of a fair coin which is thrown once. If it comes up heads, project 2 is undertaken forthwith; if it comes up tails, project 3 is undertaken. It is easily checked that the values of D_4 and E_4 have been constructed correctly for this interpretation, namely: $D_4 = (D_2 + D_3)/2$ and $E_4 = (E_2 + E_3)/2$. There is no unique value of R_4, since there are now *two* successful outcomes: R_2 with probability 5/11, and R_3 with probability 1/4.

Now comes the "rationality" argument: On Monday, our investor starts with one share in project 1. He trades it in, for a fee, to obtain instead one share in project 4. On Tuesday, the coin is thrown, so that it is now known which project, 2 or 3, will actually be carried out in practice. It does not matter which way the coin falls, since both these projects have the same figure of merit, $Q_2 = Q_3 = 1,000,000$. On Wednesday, our investor trades once more, paying a second fee to convert his share (which is now a share in either project 2 or project 3) to one share in project 1.

But now he has wound up holding, after payment of two separate fees, the very same share (in project 1) which he held at the beginning! Since the same process can be repeated, week after week, our investor has become a "money pump." This is clearly irrational behavior and therefore invalidates our claim that the figure of merit Q_k used here is consistent with rationality.

Exactly the same argument can be made, using appropriately constructed projects 1 through 4, for *every* figure of merit Q_k which is a curve, rather than a straight line, function of D_k. All figures of merit based on curves make the investor into a money pump. Only the straight line behavior avoids this, and it is thus the only rational behavior. We are indeed back at expected utility theory!

At first sight, this argument may appear irrefutable. Yet, let us have another look.

Two quite distinct activities are often called "investment":

1. Trading pieces of paper, called "shares," on the money market. This activity is called "placement" by Joan Robinson (1956).

2. Erecting factory buildings, installing machines therein, etc. We shall call this "investment proper."

The money pump argument is concerned with placement, not with investment proper. Anyone who believes that these are equivalent must also believe that a rational man will use exactly the same criteria for choosing a mistress as for choosing a wife. One

commitment can be altered without major penalty; the other cannot. The money pump argument requires trading in shares, and therefore applies quite properly to evaluation of placements. *For placement, a preference scale nonlinear in the probability of disaster D may be suspect.*[5]

But the money pump argument cannot be used for investments proper. Any attempt to trade out of the latter, say to sell the machines on the open market, may lead to catastrophic losses. Thus, a preference scale for investments proper *need not* be linear in the disaster probability.

Still, there remains a degree of uneasiness about this rebuttal. Suppose we now consider the projects as investments proper, not as placements; the figure of merit Q is being used by a business management to decide whether to undertake an investment proper, not by a wealthy man to decide which shares to buy. Even then, though, the following question arises: How can projects 2 and 3 rate 1,000,000 each on the preference scale, and yet project 4, which is merely a 50-50 superposition of projects 2 and 3, rate more than twice as much? Is there not something inherently irrational about such a preference ordering, even if we never do any trading at all?

The rationale behind this depends on two things: (1) uncertainty of the future, and (2) the desire of management to take a longer view than merely the outcome of the very next project.

Suppose that management desires to stay in business for at least the next four projects, to be carried out sequentially. Suppose also that exactly the same projects (not in the material sense, but in the sense of having the same values of E_k and D_k) will be available for choice at each choice point, the one now and the three choice points in the future. We can then compute, for each choice criterion, the probability of survival for four projects, and the money return (total) in case we survive. For example, for project 1, four times over, the survival probability is $(2/3)^4 = 0.1975$, and, if we do survive, the total money return is $4 \times 9,112,500 = 36,450,000$. Exactly similar calculations can be done for choice 2 and choice 3. The calculation for choice 4 is a bit more complicated and is given in the appendix. The outcomes are listed in Table 12.2.

[5] Even for placements, the "money pump" argument is *not* airtight. It depends upon the probabilities' of the various outcomes of any one project being *known*, with certainty, to the "investor." In the context of gambling on the share market, this is a most unrealistic assumption.

Table 12.2

Effect of Various Policies for Four Investment (proper) Projects

Policy adopted	Survival probability over full time	Expected return if we survive
A. Project 1, four times	0.1975	36,450,000
B. Project 2, four times	0.6830	6,442,040
C. Project 3, four times	0.0625	128,000,000
D. Project 4, four times	0.2464	49,575,000
E. Projects 2 and 3, alternately	0.2066	67,221,020

Looking at this table of outcomes (Table 12.2) who could assert with conviction that management is irrational in giving the same figure of merit to policies B and C, or in giving a higher figure of merit to policy D? Policy B is safe but with very low return. Policy C promises high return, but is exceedingly unsafe. Policy D is a not unreasonable compromise between these two requirements of safety and return upon success. Furthermore, policy D is superior to policy A on *both* counts.

But how is it possible that the wealthy man who makes placements can be turned into a "money pump" by a figure of merit nonlinear in probabilities, while that same figure of merit now appears to be quite reasonable for investment proper?

The answer is simple: The business management has to see each project it starts to its conclusion, and its policy must be such that it retains a reasonable chance of surviving in business for longer than just the very next project. The man making a placement is under no such obligation. He can trade his shares the day after he has bought them. The very existence of a financial market makes it unnecessary for him to take the long view. To quote Keynes (1936):

> It might have been supposed that competition between expert professionals, possessing judgment and knowledge beyond that of the average private investor, would correct the vagaries of the ignorant individual left to himself. It happens, however, that the energies and skill of the professional investor and speculator are mainly occupied otherwise. For most of these persons are, in fact, largely concerned, not with making superior

long-term forecasts of the probable yield of an investment over its whole life, but with foreseeing changes in the conventional basis of valuation a short time ahead of the general public. They are concerned, not with what an investment is really worth to a man who buys it "for keeps," but with what the market will value it at, under the influence of mass psychology, three months or a year hence. . . . It is not sensible to pay 25 for an investment of which you believe the prospective yield to justify a value of 30, if you also believe that the market will value it at 20 three months hence.

There remain two questions: (1) Intuitively, how does it come about that project 4, four times over, is not just a simple average of projects 2 and 3? (2) If the rationale behind management's figure of merit is such a "look-ahead" criterion, why don't they just evaluate a "lifetime expected utility" of some sort, and maximize that?

Question 1 can be answered by looking at policy E, strict alternation between projects 2 and 3; i.e., the four projects undertaken are 2, 3, 2, 3, in that order. The survival probability is $(1 - D_2)^2 (1 - D_3)^2 = 0.2066$ and the return in case of survival is $2R_2 + 2R_3 = 67{,}221{,}020$. This policy is rather close, in its ultimate outcome, to policy D and could well be judged, by management, as superior to either of policies B or C. The merit of throwing a coin to decide the next project is *not* the uncertainty so generated, but rather the merit arises from avoiding the two extreme choices of policies B or C and opting for a compromise instead. The coin throwing is merely one way (not necessarily the best way) of achieving such a compromise.

The answer to question 2 is *uncertainty of the future*. The projects available for choice *now* are known, and management can make some not unreasonable guesses about disaster probability and expected return for each project. But substantially nothing is known about choices which management will face after this project has been completed, or the one after, or the one after that! Our simple assumption, that exactly the same number of projects, with the same values of D_k and E_k, will be the ones we must choose between, at each future choice point—this simple assumption has enabled us to make a calculation for our various policies A to E; but it flies in the face of all reason and probability to take such an assumption seriously.

Thus, lifetime expected utility *cannot* be calculated. The best management can hope for is some figure of merit $Q(R_k, D_k)$ which depends on the characteristic of the projects to be chosen *now*, but which also has the property that it gives reasonable results for best lifetime utility *if* the simple assumptions about future choices

should happen, by an almost incredible coincidence, to be not too far from the truth. A figure of merit nonlinear in the disaster probability D_k is then entirely appropriate.

We conclude that placements are quite different from investments proper. In particular, if the probabilities of all short-term outcomes for a placement are known to the "investor," then his preference scale should be linear in all these probabilities, including the probability of disaster. By contrast, a reasonable preference scale for management in looking at investments proper not only can be, but almost certainly should be, highly nonlinear in the disaster probabilities D_k. No wonder that businessmen in real life pay very little attention to share market values when deciding between alternative projects for investment proper. The criteria which are reasonable in the share market are most unreasonable for business management.

F. Criticism of expected utility theory: summary and conclusions

For choosing between investment projects proper, rather than placements, a preference scale which is nonlinear in the probability of striking disaster is eminently rational. The constraints which must be imposed upon rational behavior for placements make no sense for investments proper.

It is the mathematical axioms of pure mathematicians, such as John von Neumann, not the behavior of real businessmen, which must be declared to be "irrational" whenever the two conflict. Indeed, the mathematical axioms only appear rational at all because the discussion is restricted to "prospects where all gains are nonnegative and finite" (Borch 1968). By this proviso, "for simplicity," all true disasters are excluded once and for all. Would that we could do so in real life!

Let us return to the Allais example in section C to see whether we can make rational sense of the expressed preferences of the businessmen. Suppose a return of zero is considered to be a "disaster," in the sense of leading to bankruptcy. When we compare gambles A and B, project A gives certainty of a modest return, while project B contains a small, but definitely nonzero, probability of disaster. Hence our businessman prefers A to B. Now look at projects C and D. Both are dreadful prospects, 88 percent disaster probability for C, 89 percent for D. No sensible businessman would touch either of these projects with a ten-foot pole. But when he is *forced* to express a choice between these two awful prospects, he concludes, quite rationally, that he may as well be

hung for a sheep as for a goat, and thus opts for project D, which offers a much larger gain in the unlikely event of success. The mathematical expectation of that gain (or of the utility of that gain) is of no interest at all: The overwhelming expectation is not of gain, but of disaster, bankruptcy, and being thrown out of the game altogether.

Far from having to explain why businessmen answer Allais's questions irrationally, we should ask ourselves what makes theoretical economists so irrational as to fail to see the obvious considerations which move perfectly sensible men to give the reasonable answers which they do give.

Until now, we have presented, and discussed, the conventional economics of uncertainty largely in its own terms, as an assignment of a preference ordering between gambles or lotteries in which the available prizes, and the probabilities of getting them, are fully known in advance. This, however, is entirely too kind and forbearing toward this so-called "economics of uncertainty." Let us now recall Frank Knight's distinction between "risk" and "uncertainty." A lottery in which all prizes and probabilities are known in advance is a *risky* prospect, but it is *not an uncertain* prospect.

The entire standard economic theory of uncertainty is irrelevant: it deals with risk and ignores true uncertainty. To understand the importance of this neglect, let us listen to Keynes (1937, his italics throughout, our italics on the final sentence):

> By "uncertain" knowledge, let me explain, I do not mean merely to distinguish what is known for certain from what is only probable. The game of roulette is not subject, in this sense, to uncertainty.... The sense in which I am using the term is that in which the prospect of a European war is uncertain, or the price of copper and the rate of interest twenty years hence.... About these matters there is no scientific basis on which to form any capable probability whatsoever. We simply do not know. Nevertheless, the necessity for action and for decision compels us as practical men to do our best to overlook this awkward fact and to behave exactly as we should if we had behind us a good Benthamite calculation of a series of prospective advantages and disadvantages, each multiplied by its appropriate probability, waiting to be summed.
>
> How do we manage in such circumstances to behave in a manner which saves our faces as rational economic men? We have devised for the purpose a variety of techniques, of which much the most important are the three following:
>
> 1. We assume that the present is a much more serviceable guide to the future than a candid examination of past experience would show it to have been hitherto. In other words we largely ignore the prospect of future changes about the actual character of which we know nothing.

2. We assume that the *existing* state of opinion as expressed in prices and the character of existing output is based on a *correct* summing up of future prospects, so that we can accept it as such unless and until something new and relevant comes into the picture.

3. Knowing that our own individual judgment is worthless, we endeavor to fall back on the judgment of the rest of the world, which is perhaps better informed. That is, we endeavor to conform with the behavior of the majority or the average. The psychology of a society of individuals each of whom is endeavoring to copy the others leads to what we may strictly term a *conventional* judgment.

Now a practical theory of the future based on these three principles has certain marked characteristics. In particular, being based on so flimsy a foundation, it is subject to sudden and violent changes. The practice of calmness and immobility, of certainty and security, suddenly breaks down. New fears and hopes will, without warning, take charge of human conduct. The forces of disillusion may suddenly impose a new conventional basis of valuation. All these pretty, polite techniques, made for a well-panelled board room and a nicely regulated market, are liable to collapse. At all times the vague panic fears and equally vague and unreasoned hopes are not really lulled and lie but a little way below the surface.

Perhaps the reader feels that this general philosophical disquisition on the behavior of mankind is somewhat remote from the economic theory under discussion. But I think not. Though this is how we behave in the market-place, the theory we devise in the study of how we behave in the market-place should not itself submit to market-place idols. *I accuse the classical economic theory of being itself one of these pretty, polite techniques which tries to deal with the present by abstracting from the fact that we know very little about the future.*

Following Keynes, Keynesians have placed heavy emphasis on uncertainty (Shackle 1940, 1967, 1974). Indeed, the attitude toward this issue is one of the touchstones by which one may distinguish between Keynesian and neoclassical economists. To quote Shackle (1974, p. 38), concerning the passage from Keynes quoted above:

Keynes' expositors, commentators and critics either contrive, for the sake of their peace of mind, to leave this passage unread, or else they turn aside as men who have looked over the edge into the abyss and must endeavour to blot this dreadful vision from their mind. For this passage pronounces the dissolution of the view of business conduct as rational, as the application to men's affairs of fully-informed reason. Yet it is the assumption that men act by fully-informed reason that underlies the whole of value-theory; that underlies what, until forty years ago, was virtually the whole of economic theory. . . . "Equilibrium is blither" he [Keynes] once orally remarked.

No wonder neoclassical economists feel uneasy about the con-

cept of uncertainty; it is destructive of their whole way of looking at, and analyzing, the world of men and affairs! Some have criticized uncertainty as being poorly defined (Arrow 1951), or have tried to reduce it to compound probabilities (Hart 1942). Many, following a line of thought suggested by Savage (1954), have denied the very existence of uncertainty. For example, Milton Friedman (1976) is prepared to reject, outright, the concept which made the fame of his own teacher, Frank Knight: "I have not referred to this [risk vs. uncertainty] distinction because I do not believe it is valid. I follow J. L. Savage in his view of personal probability, which denies any valid distinction along these lines. We may treat people as if they assigned numerical probabilities to every conceivable event."

A clear discussion of the "personal probability" idea can be found in Hicks (1980). It is, of course, just another of these "pretty, polite techniques" scorned by Keynes. Maybe Professor Friedman does assign numerical (!) probabilities to every conceivable (!) event. The rest of us are well aware of the difficulty of even enumerating all possibilities (how often do we fail to include the actual eventual outcome?), to say nothing of assigning numerical probabilities to each and every one of them. This is merely playing children's games, as reliable as divining from tea leaves or the entrails of birds. Milton Friedman, and prophets of God, may be absolutely certain of their own estimates of the future; more usual men and women know quite well what real uncertainty is and have no difficulty distinguishing it from the risk in a charity lottery in which "all gains are nonnegative and finite."

To a Keynesian, a particularly interesting development is the resurgence, in the late 1970s, of the "theory of rational expectations" (Muth 1960, 1961). "Rational" expectations are expectations which are based on the fullest available information, including a fully developed economic model, and which turn out to be correct, at least on the average. With economic agents anticipating, in such a perfect fashion, everything that will happen in the future, government economic policy becomes largely ineffective since every move by the government in the economic sphere will be anticipated, and counteracted, by interested private agents (Lucas 1980, 1981, McCallum 1980, Fellner 1980).

Clearly, "rational" is a misnomer; "prophetic" is what is meant. Equally clearly, men and women, even the smartest and best-informed business people, are far from being prophets. As for the prophetic propensities of economic models, a horselaugh is the only proper response (Smyth 1975). Economic expectations are very frequently mistaken in fact, individually as well as on the

average (think of the 1929 crash!). Apart from Professor Fried-
man, perhaps, human beings are well aware of their fallibility and
hence do not place unduly heavy weight on their own expecta-
tions.

There is therefore no basis whatever for this "theory of rational
expectations." The fact that such a peculiar hypothesis could be-
come so fashionable among economic theorists may be related to
two factors: (1) any theory which predicts that government in-
tervention in economic life is useless and self-defeating pleases
those rich and powerful interests whose activities might be af-
fected by such intervention, and (2) economic theorists who are
wedded to neoclassical ideas of the perfection of the free market
are only too eager to grasp at every straw, no matter how frail and
shaky, which might pull them out of the torrent of the river of un-
certainty, so destructive of their theories.

There have been attempts at experimental work in this area, for
example, Ellsberg (1961), MacCrimmon (1968, 1977), Becker
(1964), and Stone (1979). But the results are in dispute. Real un-
certainty, practically by definition, is difficult to capture within
any *controlled* laboratory experiment; as it is difficult to capture
within any formal theoretical or mathematical framework (Samuel-
son 1952, Laing 1978).

When there is true uncertainty, expected utility theory is useless,
since it is then impossible to calculate the expected utility. For
this calculation, one must know not only the (cardinal) utility of
each possible outcome, but one must also know the probability
of getting that outcome. But the very definition of true uncertain-
ty asserts that these probabilities are *not* known, in fact are inher-
ently unknowable.

One reaction, sometimes encountered in the literature, is to say
this: If we do not know the probabilities of the various outcomes,
let us simply assume that all outcomes are equally likely. This is a
possible rule, of course. But it is a fools' rule. Fools who follow
that rule are soon parted from their money.

The sensible man does *not* react to true uncertainty by invent-
ing "personal probabilities" when the actual probabilities are un-
known and unknowable. Rather, he reacts by ordering his affairs
so that he survives no matter which of the outcomes actually
comes to pass. This is the ideal, and a prudent man will accept
much lower profit to attain this ideal, if at all possible. *The golden
rule is "safety first"* (Roy 1952).

Note that "safety first" is quite different from "avoid all risky
projects." Rather, if a project is risky and you want to go into it
nonetheless, make sure that someone else gets stung if it fails.

The expansion of the U.S. railway system in the mid-nineteenth century was a highly risky proposition, and plenty of people got stung; but not the promoters of the major railway companies. It was common practice to form two companies: (1) a railway company proper, which issued and sold shares, mostly in London, and (2) a railway construction company, in which the shares were closely held by the promoters. The railway company, having raised capital in London, commissioned the railway construction company to construct a railroad. By no accident at all, the construction turned out to be extremely expensive, so the railway company paid out huge sums to the railway construction company. In due course, the railway company went bankrupt, the shares were worthless, the English investors had lost their money; the American promoters had their railroad *and* the money.

Speculative builders who put up blocks of flats for future sale commonly set up a new limited company for each new building. This company borrows money and/or sells equity shares. If the building fails to make a profit, this particular company goes bankrupt. But the builder survives the disaster, because his many other companies are unaffected. He can view the bankruptcy of the one company with considerable equanimity, since little, if any, of his own money is tied up there.

It is a good general rule that the prudent man reacts to true uncertainty by attempting to make others bear the consequences. To a sensible businessman, the effects of uncertainty are not something to be calculated by some theory. They are something to be avoided like the plague. Safety first and survival under all eventualities—these are the name of the game. Risk taking is for suckers.

Let us now turn to the argument of Frank Knight (1921) concerning the relationship between true uncertainty, in his sense, and pure profit, in the sense of neoclassical economics. According to Knight, the origin of profit is its function as a reward for facing uncertainty. The entrepreneur is the fearless hero who dares to stare uncertainty in the face, and pure profit is his just reward.

The truth, we believe, is considerably less heroic. The successful businessman is one who knows how to shift the burden of uncertainty onto others, investors and/or creditors, in such a way that he himself will survive without going bankrupt, no matter what happens.

It is not always true that the burden of uncertainty can be so shifted. There are inevitably times when share market and lender confidence are so low that nothing can be floated on the exchange, and money cannot be borrowed at any reasonable rate, for new enterprise. The "investors" and lenders have lost heavily not

so long ago and are "running scared." Under such conditions, does our heroic businessman assume the burden of uncertainty himself, with his own cash? No fear! Extreme caution now becomes the rule, even more so, much more so, than under boom conditions. Our hero pulls in his horns, crawls back into his shell, and defers all investment projects to a better, more propitious time, when others may again be persuaded to take chances with *their* money, for *his* benefit.

All this is, or should be, so obvious as to preclude the need to say it. But economic theorists have accepted untenable axioms concerning uncertainty, as well as blatantly incorrect views of common business practice, to such an extent that our detailed and lengthy argument against these views seemed unavoidable. The theory of investment evaluation under uncertainty, presented in the next chapter, requires departure from expected utility theory. The almost automatic reaction of theoretical economists is to cry: "Irrational!" It was necessary, therefore, to establish that the expected utility theory, not a departure from it, is irrational.

G. Mathematical appendix

We start with the "Saint Petersburg game" of Bernoulli. In one run of the game, a coin is thrown until it comes up heads for the first time. Suppose this happens at throw number k. Then the player receives a prize of $x_k = 2^k$ ducats.

The probability of this event is, for a fair coin, given by $p_k = (1/2)^k$.

The mathematical expectation of the return from this game is:

$$E(x) = \sum_{k=1}^{\infty} x_k p_k = \sum_{k=1}^{\infty} 2^k (1/2)^k = 1 + 1 + 1 + \ldots = \infty \quad (12.1)$$

Hence, if a gambler is given a choice between playing this game and receiving a large sum M of money with certainty, he should rationally choose to play the game, no matter how big the sum of money M is. However, actual gamblers do not make that choice.

Now suppose that the *utility* of a sum of money x is given by some function $u(x)$ which increases, for large x, less rapidly than x itself. If a gambler looks at the *utility* of money to him, rather than at the money sum itself, he will compare the *expected utility from the game*

$$E(u) = \sum_{k=1}^{\infty} u(x_k) p_k \quad (12.2)$$

with the utility $u(M)$ of receiving the sum M with certainty. To see how this can alter the situation, take a particular function, namely

$$u(x) = \log x \tag{12.3}$$

The rationale for this function is that doubling your money, from whatever base level, produces the same increase in utility; but we use (12.3) primarily for illustration. Then the calculation of $E(u)$ goes as follows:

$$E(u) = \sum_{k=1}^{\infty} \log(2^k)(1/2)^k = \log 2 \sum_{k=1}^{\infty} k(1/2)^k$$

But:

$$\sum_{k=1}^{\infty} kx^k = x(d/dx) \sum_{k=0}^{\infty} x^k = x(d/dx)(1-x)^{-1} = x(1-x)^{-2}$$

Put $x = 1/2$ in this to get

$$E(u) = 2 \log 2 = \log 4$$

This is the (now finite, not infinite) utility of the gamble. This is to be compared with the utility $u(M) = \log M$ of a sum of money M to be received with certainty. The gambler [with this particular utility function (12.3)] therefore accepts the gamble in preference to the money if M is less than four ducats and accepts the money sum M if it exceeds four ducats.

This is the essence of Bernoulli's resolution of the Saint Petersburg paradox. Note, however, that some questions are left open by this. For example, suppose the prize x_k is not 2^k but $\exp(2^k)$; then the expected *utility* (12.2) with (12.3) turns out to be infinite, and the paradox is still there.

Next, let us define an *integer gamble G* as follows: There are prizes available of values 0, 1, 2, 3, ..., M dollars, where M is a very large number, and there is a given set of probabilities of getting each of these prizes, namely, p_0 is the probability of getting 0, p_1 is the probability of getting 1, ..., p_k is the probability of getting k, ..., p_M is the probability of getting M. Some of these probabilities may be equal to zero, in which case this particular prize is not actually available; we allow this for the sake of convenience in notation. In what follows, we shall consider the maximum prize M fixed and unchanging.

To each such gamble there corresponds a unique vector of probabilities:

$$G: \quad \mathbf{p} = (p_0, p_1, p_2, \ldots, p_M) \tag{12.4}$$

with

$$\sum_{k=0}^{M} p_k = 1 \qquad (12.5)$$

A special case of this definition is the *binary gamble* $B(\pi)$ in which there are only two possible outcomes, namely 0 and M, with probabilities $1 - \pi$ and π, respectively.

$$B(\pi): p_0 = 1 - \pi \quad p_M = \pi \quad p_k = 0 \quad \text{for } 1 \leqslant k \leqslant M - 1 \quad (12.6)$$

We are now in a position to state the *three axioms of expected utility theory*:

1. To every gamble G there exists a *certainty equivalent* $\bar{x}(G)$ such that the sum of money \bar{x} (which need not be an integer) received with certainty is considered a fair exchange for the chance to enter the gamble.

2. The certainty equivalent of the binary gamble $B(\pi)$ is a function $\bar{x}(\pi)$. This function is zero if $\pi = 0$, it is M if $\pi = 1$ (for then we are certain to win the money sum M), and in between it is a continuous and monotonically increasing function of π.

3. Let k be one of the prizes in gamble G, and let $B(\pi_k)$ be that binary gamble which has certainty equivalent equal to k; that is: $\bar{x}(\pi_k) = k$. By axiom 2, such a π_k exists for each k in the range $1 \leqslant k \leqslant M - 1$. Now let G^* be the gamble obtained from G by eliminating the chance of getting prize k (i.e., $p_k^* = 0$), and instead increasing the chances of getting prizes 0 and M in the right proportions to accommodate the equivalent binary gamble $B(\pi_k)$; this means:

$$G^*: p_0^* = p_0 + (1 - \pi_k)p_k$$

$$p_k^* = 0$$

$$p_M^* = p_M + \pi_k p_k$$

$$p_i^* = p_i \text{ for all other values of } i$$

Then gambles G and G^* have the same certainty equivalent: $\bar{x}(G) = \bar{x}(G^*)$.

We note: (1) In spite of contrary assertions in the literature, these axioms are by no means so "obviously true" that they can be taken as being self-evident. In particular, axiom 3 tends to be obscure, rather than self-evident, to ordinary people. And, while the *meaning* of axiom 1 is clear enough, its *truth* is not at all obvious, particularly if we permit outcomes which are disasters, rather than desirable prizes. What is the certainty equivalent of the

certainty of swinging on the gallows? Its *meaning* is a sum of money which we would be prepared to accept in exchange for this outcome. With most people, no such sum exists.

(2) This whole set of axioms makes sense *if and only if* the gamble G can be repeated many times. Then, and then only, does the replacement process in axiom 3 appear reasonable at all. If one thinks of these axioms in the context of a "once only" gamble, or (even more so) of a gamble in which one of the "prizes" is being hanged on the gallows, then there seems to be no reason whatever to accept axiom 3.

THEOREM 12.1

If these three axioms are accepted, then there exists a set of numbers u_0, u_1, ..., u_M, called the *utilities* of the outcomes 0, 1, ..., M, respectively, such that the preference ordering between different gambles is given by the mathematical expectation of its utility, formula (12.2) with $u(k) = \pi_k$.

Proof: Take any gamble G, with probabilities as in (12.4). Apply axiom 3, in turn, to the prizes $k = 1$, $k = 2$, ..., $k = M - 1$. The result is an *equivalent binary gamble* $B(\Pi)$ in which

$$\Pi = p_M + \sum_{k=1}^{M-1} \pi_k p_k = \sum_{k=0}^{M} \pi_k p_k \qquad (12.7)$$

The second equality comes about as follows: By axiom 2, $\pi_0 = 0$ and $\pi_M = 1$.

Now let us compare the desirability of this gamble G, and some other gamble G'. By the axioms, G is equivalent to the binary gamble $B(\Pi)$ with Π given by (12.7); by exactly the same reasoning, G' is equivalent to the binary gamble $B(\Pi')$ with

$$\Pi' = \sum_{k=0}^{M} \pi_k p_k' \qquad (12.8)$$

But, as between two *binary* gambles, the only thing that matters in a comparison is the probability of getting the prize M. Thus G is preferred to G' if and only if the probability Π of its equivalent binary gamble $B(\Pi)$ exceeds the probability Π' of the binary gamble $B(\Pi')$ equivalent to G'.

Our theorem then follows by making the definition: $u_k = \pi_k$. In words, the *utility of a prize k is defined as the probability π_k for a binary gamble $B(\pi_k)$ considered to be certainty equivalent to this prize k.*

Q.E.D.

Note that this utility $u_k = u(k)$ is not only cardinal, but severely restricted in range: $u(0) = 0$ and $u(M) = 1$, by axiom 2, and all other $u(k)$ lie between these limits.

We continue this appendix with a discussion of the Allais experiment mentioned in section C. All the "projects" are integer gambles in the sense of (12.4), with $M = 5$ (the unit being 1 million dollars). The probabilities for his projects A, B, C, and D are as follows:

Project	Values of probabilities					
	p_0	p_1	p_2	p_3	p_4	p_5
A	0	1	0	0	0	0
B	0.01	0.89	0	0	0	0.10
C	0.89	0.11	0	0	0	0
D	0.90	0	0	0	0	0.10

Let u_k be the utility (so far unknown) of outcome number k, $k = 0, 1, \ldots, 5$.

Most respondents prefer project A to project B. Hence the expected utility of A must exceed that of B, giving the following inequality:

$$u_1 > 0.01u_0 + 0.89u_1 + 0.10u_5 \qquad (12.9)$$

In comparing projects C and D, most of the respondents preferred D. Hence the expected utility of project D must exceed that of project C, leading to:

$$0.90u_0 + 0.10u_5 > 0.89u_0 + 0.11u_1 \qquad (12.10)$$

Let us now *add* these two inequalities to obtain:

$$0.90u_0 + u_1 + 0.10u_5 > 0.9u_0 + u_1 + 0.10u_5$$

This, however, is *self-contradictory*: a quantity cannot be strictly larger than itself!

Thus, if expected utility is the mark of a rational man, then the vast majority of Allais's respondents must be irrational. Conversely, if his respondents are normal rational people, as we believe, then the axioms of expected utility theory do *not* apply to all, or even to most, rational men.

Finally, let us present the calculation of the effects of policy D, project 4 carried out four times in succession, in section E. In Table 12.3, we list each possible outcome from throws of the coin, the probability of that outcome, the return from that outcome,

and the contribution this makes to the expected return upon success.

We recall that any one project can end in one of three ways: (1) *Disaster*, with probability 13/44; (2) *successful* attempt at project 2, probability = 5/11, money return R_2 = 1,610,510 dollars; and (3) *successful* attempt at project 3, probability = 1/4, money return R_3 = 32,000,000 dollars. We classify the *policy* outcomes for nondisaster cases (*none* of the four projects ends in disaster) by the number of times project 2, and project 3, were attempted successfully. Call these n_2 and n_3, respectively. We must have $n_2 + n_3 = 4$, since four projects are attempted. For $n_2 = 3$ and $n_3 = 1$, there are four ways this can come about: (2,2,2,3), (2,2,3,2), (2,3,2,2), and (3,2,2,2). Thus the probability of this case is four times the basic probability $(5/11)^3 (1/4)$ of each of these four separate outcomes. We assume that a disaster, happening to any one of the four attempts, is enough to knock management out of the game altogether.

Table 12.3

Outcome	Probability of this outcome	Return from this outcome	Contribution to expected return
Disaster	$1 - \left(1 - \dfrac{13}{44}\right)^4$	0	—

Sucess with				
n_2	n_3			
4	0	$(5/11)^4$	$4R_2$	275,000.0
3	1	$4(5/11)^3(1/4)$	$3R_2 + R_3$	3,459,009.2
2	2	$6(5/11)^2(1/4)^2$	$2R_2 + 2R_3$	5,208,240.2
1	3	$4(5/11)(1/4)^3$	$R_2 + 3R_3$	2,773,025.9
0	4	$(1/4)^4$	$4R_3$	500,000.0

The sum of all success probabilities is $[1 - (13/44)]^4 = 0.24639737$. The sum of the expected values for all *successful* cases (last column) is 12,215,275.3. The expected value *on the assumption of success* is therefore the ratio:

$$12,215,275.3/0.24639737 = 49,575,510.0$$

This is the number which appears in section E, for "policy D: Project 4, four times." In Table 12.2, on the effect of various policies for four investment (proper) projects, the success probability has been rounded to four figures and is given as 0.2464.

Investment evaluation
under uncertainty

A. Introduction

As Keynes (1936) has emphasized, investment is a crucial variable in macroeconomics. This variable is tied to the "state of long-term expectations" by the influence of the latter on the "marginal efficiency of capital." The "extreme precariousness of the basis of knowledge on which our estimates of prospective yield have to be made" ensures that this marginal efficiency of capital is a very volatile quantity indeed, subject to sudden and unexpected changes associated with the ebbs and tides of confidence.

This is a serious dilemma for economic theory. On the one hand, investment is clearly important, so that a theory of investment evaluation under uncertainty is needed badly. On the other hand, such a theory appears to be almost impossibly difficult to develop. We quote Solow (1963, p. 15): "The fundamental difficulty of uncertainty cannot really be dodged; and since it cannot be faced, it must simply be ignored."

In spite of this surprisingly frank admission of utter defeat, there is a considerable literature on this subject, both by economic theorists (Arrow 1965, Borch 1968, Hirschleifer 1970, Kemp 1976, Long 1975, and Meyer 1959, to mention just a few) and by management theorists (Banz 1978, Bower 1973, 1975, Pogue 1974, Robicheck 1965, Weston 1973, and many others). To the extent that uncertainty is allowed for at all, this is done by means of expected utility theory. Often uncertainty is modeled by changing the "price of capital," i.e., correcting the actual interest rate r to a modified, larger value r^* (Fisher 1930, Carmichael 1975), employing for this purpose certain money market valuation theories such as the Modigliani-Miller theory (Modigliani 1958, 1961, 1963, Brennan 1978, Stiglitz 1972) and the option pricing model

(Black 1973, 1976, Galai 1976, Merton 1973, 1974, 1976, Smith 1976). The outstanding fact is that there is no agreement whatever on how this "price of capital" is to be determined (Arditti 1977, Ben-Horim 1979, Boudreaux 1977, 1979, Ezzell 1979, Linke 1974, Nantell 1975, Shapiro 1979); we shall return to the reason for this at the end of section C.

Another set of theories is concerned with macroeconomic "investment equations," including the Jorgenson model (Jorgenson 1963a, 1967, 1967a, 1968, 1968a, 1969 and Thurow 1969) and its critics (McLaren 1977, Nerlove 1972, Rowley 1970, 1972, Wong 1975) and the "adjustment cost models" (Brechling 1975, Eisner 1960, 1963, 1974, Gould 1968, Nadiri 1973, Schramm 1970, Treadway 1969, 1970, 1971). Junankar (1972) and Helliwell (1976) give surveys. The outstanding fact is that none of these investment equations works (Blatt 1979a, Higgins 1976): "the results of asking firms what their short-term investment plans are, perform vastly better than any of the models" (Worswick 1972, p. 80).

Comparatively few investigators pay attention to the distinction between risk and uncertainty (Nickell 1977, Pope 1978, Roy 1952, Shackle 1949). Post-Keynesians, in addition to including true uncertainty, also allow for the existence of monopoly or oligopoly (Eichner 1973, 1974, 1975 1976, Harcourt 1976).

Thus, one could hardly complain of a shortage of theoretical work in this area of economics.

The conventional neoclassical academic wisdom on investment evaluation has, however, been given a cool reception by practical businessmen. We quote a complaint by Eisner (1956, p. 30): "The prevalence of formulas which involve annual operating profits and ignore prospective life of assets is frequently perplexing, if not exasperating."

In this chapter, we present an alternative theory of investment evaluation under uncertainty (Blatt 1979) which makes contact between theoretical economics and the techniques used by practical businessmen. We are not interested in calling these men "irrational." On the contrary, we start from the premise that techniques which have proved themselves over a century of practical business have a prima facie case for being accepted as rational. The people using these techniques may not be able to explain their rationale to a theorist, at least not in language that the theorist is prepared to listen to. However, theorists incapable of "facing the fundamental difficulty of uncertainty" might be well advised to show a bit of modesty and not just brush aside the practical men. Theorists should try to *understand* what lies behind the decision rules used by practical men, not ignore these decision rules.

The investment decision we have in mind is "investment proper," rather than "placement" of money in the share market (Robinson 1956). The difference has been discussed in section 12E.

Next, we wish to avoid the complications arising from monopoly or oligopoly in an industry. This is not to say that these are unimportant—far from it. But let us concentrate on one (very major) difficulty at a time. The influence of monopoly or oligopoly on investment evaluation has been discussed elsewhere (Eichner 1973, 1974, 1975, 1976, Harcourt 1976, and references quoted there). Here we wish to focus on the effects of uncertainty. Since uncertainty is clearly important in competitive conditions, with small producers who are price-takers, it is quite legitimate to study that case first, and that is what we propose to do. It follows that the theory given here must be modified before being applied to oligopolistic industries; in its present form, it should be applied to nineteenth-century, rather than twentieth-century, conditions.

Indeed, it can be argued that uncertainty is of *more* importance under truly competitive conditions than it is under oligopoly. The big advantage which men like John D. Rockefeller saw in working toward a "controlled market" was precisely the decrease in uncertainty under such an arrangement. Defeat of uncertainty, as much as immediately tangible monopoly profits, was a major aim of the movement toward conglomeration (Eichner 1969).

For simplicity, our "investment project" will be assumed to require just one initial capital outlay of I_0 dollars, all of which is spent in the very first period. Thereafter, we anticipate cash flows $x(t)$ in each future period t.

Let us start with certainty of the future. Then all the $x(t)$ are, by assumption, precisely predictable. However, money received in the future is worth less than money right now. One dollar, available right now, can be placed into risk-free paper (say, government bonds) at a rate of return r, the current risk-free rate of interest. This dollar will therefore grow to $1 + r$ dollars one period hence, $(1 + r)^2$ dollars two periods hence, and so on. Conversely, one dollar one period hence is worth only $1/(1 + r)$ dollars now; one dollar two periods hence is worth $1/(1 + r)^2$ dollars now; one dollar t periods hence is worth $1/(1 + r)^t$ dollars now. We may now multiply each future cash flow $x(t)$ by the "discount factor" $1/(1 + r)^t$ and add the results for all future periods so as to get a total. This total is called the "discounted present value" of the future cash flow stream in its entirety. We shall denote this total by $C(\mathbf{x})$ where \mathbf{x} is shorthand for the set of all $x(t)$. This discounted present value $C(\mathbf{x})$ is "gross." The "net discounted present value" is obtained by subtracting the initial (in the present) outlay I_0, and is therefore equal to $C(x) - I_0$.

An investment project is considered profitable if $C(x) - I_0$ is positive, unprofitable otherwise. Among a set of proposed investment projects, the one to go for is that one yielding the highest net discounted present value (at least, if the initial investment I_0 is the same for all projects (we shall assume that, for simplicity).

In a world of certainty of the future, or if "the fundamental difficulty of uncertainty . . . must simply be ignored" in the actual world, this theory is the only possible result.

But this result is clearly unacceptable. It produces a vast overestimate of the true worth of a set of future, uncertain, cash flows. A company management using this formula for choosing its investment projects is not going to survive in business for long.

The conventional response to this difficulty, that is, to "the fundamental difficulty of uncertainty," is to use the same formula, but with a "risk-adjusted rate of discount" r^* which is higher than the risk-free interest rate r. Sometimes r^* is equated to the "cost of capital"; indeed it is quite common to see "cost of capital" used as just another name for this r^*.

Since the conventional theory is not able to handle uncertainty directly, there is neither a rationale for this procedure for including uncertainty—why, for example, should we have a constant r^* rather than a time-dependent $r^*(t)$?—nor is there any agreement on how the actual value of r^* should be chosen.

The discounted present value $C(x)$ depends very strongly on the value of the discount rate r^* used in calculating $C(x)$. It is therefore a very serious matter that there is no agreement on how r^* is to be chosen. Without adequate theoretical guidance, all the businessman can be sure of is that r^* should be higher than the risk-free rate r, and should be higher for more "risky" projects than for less risky ones. For the rest, he is left to make his own guess, and guess is all it can be, concerning the value of r^* to be used for each of the proposed investment projects.

Not surprisingly, such a "theory" has found little acceptance among practical men. We quote from Bower (1973, p. 336): "Formal measures for risk-screening seldom have been put to use in the capital budgeting process. The reason for this may be that simple, useful measures which reflect risk and can be matched with acceptance criteria have not been available." And (p. 324): "the development of formal, operational, frequently used measures for risk-screening in these firms is not being held back by available data, complex calculations, or lack of sophistication in the organizations. It waits upon the development of measures and matching criteria which, however complex to assemble and calculate, translate into simple, straightforward concepts that senior executives can match with their intuition and experience."

This is the point of view of a theorist, clearly. Practical men *cannot* wait for some future theoretical developments; they need practical answers, and they need them today. What is more, they *have* them today. They do in fact use a "formal, operational . . . measure for risk-screening," one which "translate[s] into simple straightforward concepts that . . . match with . . . intuition and experience." This measure is called a "pay-back time limit." It is used not merely frequently, but practically universally; it has all the properties desired by Bower (1973).

But this measure, the pay-back time limit, does not follow from the conventional theoretical ideas. Hence the conventional theorists either ignore it altogether—for example, it is not even mentioned in Bower (1973)—or argue strongly against its use.

What is this pay-back time limit? Suppose the expected cash flow from a project is a steady $200,000 per annum, and the initial investment is I_0 = $800,000. Then it takes four years to "pay back" the initial investment. More generally, the pay-back time θ is such that the sum of all (undiscounted!) cash flows from time $t = 0$ till time $t = \theta$ just equals the initial investment I_0. The pay-back time limit θ_m is a permissible maximum value of θ, set by management. Projects with $\theta > \theta_m$ are rejected out of hand, as being too risky; projects with $\theta < \theta_m$ are considered seriously. We note:

1. This simple definition of the pay-back time involves no discounting of future cash flows. In practice, maximum allowable pay-back times are short, so this does not make much difference.

2. Cash flows expected to occur at times $t > \theta$ are simply ignored by this criterion. In Professor Eisner's words, the pay-back time criterion "ignores prospective life of assets."

3. The actual value of the maximum pay-back time θ_m varies from one businessman to another, and varies with time even for one businessman. We shall quote some survey values in section E. But for any one man, at any one time, the value of θ_m is quite clear in the businessman's mind. It is a highly important, and highly confidential, factor in the conduct of his business.

B. Some basic concepts

In chapter 12, we observed that the threat of disaster, i.e., bankruptcy, is a very important factor. The future is too uncertain to predict at all well, but a businessman wants to have a reasonable chance of avoiding disaster, not merely for the next project, but for his entire expected time before retirement. He must, therefore, choose between projects available right now in a sufficiently conservative fashion so that he retains a fair chance of not sitting in

the poorhouse or the debtors' prison at retirement age.

For any one project, we define its "downside risk" D as the *probability that the project will strike disaster*. The precise meaning of "disaster" can vary considerably: to a businessman, it is a loss so great that it drives him bankrupt; to a manager, employed by a firm, a much smaller loss than that can result in his being dismissed, without much of a chance of finding alternative employment as a manager. For the sake of simplicity and definiteness, we shall take "disaster" here to mean that the project fails to pay back its initial investment; but this should not be taken as an absolute definition, but rather as one adopted for convenience of discussion and easily altered in accordance with the actual situation of the business. The event "disaster" is defined "ex post," after the results are in: The project has failed to pay back if the discounted present value of the actual future cash flow is less than the initial investment. By definition, D is the probability that this sorry event may happen. Note, however, that D is an "ex ante" probability, an estimate which must be made at the time the project is under consideration. Following Knight (1921), we recognize that any such ex ante estimate of D is at best extremely crude, much more in the nature of a stab in the dark than a true mathematical probability.

If the downside risk is D, then the probability that we get through this one project without ultimate loss is equal to $1 - D$. If the entrepreneur can oversee only one project at a time, and expects to be able to oversee n projects before his retirement, then his probability of reaching retirement safely is $(1 - D)^n$, if projects of similar D are chosen each time.

Apart from this D, we shall suppose that our entrepreneur is interested mainly in the *expected present value $E(C)$* of a project. This quantity $E(C)$ is not the discounted present value $C(\mathrm{x})$ for the "most likely" future cash flow $\mathrm{x}(t)$, but rather $E(C)$ is a *weighted average of $C(\mathrm{x})$* for various cash flows $\mathrm{x}(t)$ which might happen, each $C(\mathrm{x})$ being weighted by the ex ante probability of actually getting this particular cash flow. Since all such probabilities are only crude guesses, it is highly desirable that our final investment evaluation formula should not depend too closely on details of such guesses. This will turn out to be true.

One can think easily of other measures which could well be of importance. For instance, the expected present value $E(C)$ averages not only over successful outcomes, but also over unsuccessful, disastrous outcomes. If $E(S)$ is the expected present value averaged only over successful outcomes and, $-E(L)$ the (negative) average over unsuccessful outcomes, then we have:

$$E(C) = (1 - D)E(S) - DE(L)$$

A businessman may well consider the separate averages $E(S)$ and $E(L)$ as more useful measures than the grand average $E(C)$.

Very general formulas containing all these things are given in the mathematical appendix. But here, we shall restrict ourselves to a *figure of merit* Q which depends only on the two quantities D and $E(C)$; that is, $Q = Q[D, E(C)]$. In a choice between two or more projects, management prefers the project with the highest value of Q. We expect Q to be an increasing function of $E(C)$, but a decreasing function of D.

Note that this specification *differs* from one often postulated in the literature, where Q is taken to depend on the mean value and the variance of the returns. $E(C)$ is the mean value, all right. But D is *not* equal to, or related simply to, the variance of the returns. The variance is associated with the "width of the peak" of the probability distribution for the returns, whereas D is the "area under the lower tail" of the distribution, that is, that part corresponding to zero or negative net returns. The relationship between D and the variance can be worked out if the precise probability distribution of the net returns is known. But of course, we have no such knowledge. The usual specification concentrates on events (outcomes) in the neighborhood of the most likely outcome. In that region, and only in that region, can one deduce things directly from the mean and the variance. Our specification includes the mean, but instead of the variance concentrates on the downside risk D, that is, the events (we hope far removed from the most likely outcomes!) corresponding to very bad, disastrous results.

As an example, admittedly oversimplified, of what such a figure of merit might look like, let us suppose our entrepreneur assigns a "utility" $u(M_f)$ to his final amount of money at retirement, unless he is then sitting in the poorhouse as the result of a disaster somewhere along the line. In that case, he assigns a large negative utility $-X$ to the event. If he expects to oversee n projects, all of similar downside risk D and similar expected present value $E(C)$ before retirement, his figure of merit might be:[1]

$$Q = Q[D, E(C)] = (1 - D)^n u[nE(C)] - [1 - (1 - D)^n] X$$

It is clear that this expression is highly *nonlinear* in the probability D and therefore inconsistent with expected utility theory. This was discussed in section 12E.

For $D = 0$, this formula gives $Q = u[nE(C)]$, the utility of this final amount of money with certainty. But as D increases from

[1] Actually, this is not too sensible: $E(S)$ should appear here, instead of $E(C)$, and the quantity called X might well depend somewhat on $E(L)$. Such complications are handled in the appendix.

zero, the figure of merit Q drops, first slowly, and then very sharply indeed.

For purposes of exposition, *only*, we shall replace this, or some similar realistic figure of merit formula, by a much cruder assumption, namely, $Q = E(C)$ if the downside risk is less than some maximum acceptable downside risk D_m, and $Q = -X$, a very large negative value, if $D \geqslant D_m$. This extreme choice is *not* reasonable, and the full theory (in the appendix) is *not* limited to this extreme choice. But the literary explanation becomes much less complicated, and easier to understand, if this choice is made.

This extremely simplified choice of Q leads to the following two rough and ready rules of thumb for investment evaluation under uncertainty:

Rule 1: If the downside risk D exceeds the maximum tolerable risk D_m, reject the project.

Rule 2: Rank the acceptable projects in order of the expected returns $E(C)$.

The literary discussion in the remainder of this chapter will be based upon these two rules. We emphasize, however, that the theory is *not* restricted to these rules; the full theory is in the appendix.

C. Types of uncertainty: the survival probability

Let us now classify the uncertainties concerning future cash flows into three main types:

1. *Windfall gains* may happen. But a conservative management using a "safety first" approach tends to ignore them in project evaluation. If windfall gains are realized, then the evaluation has been wrong. Management can then cry over their "misestimate" all the way to the bank.

2. *Moderate deviations from estimated cash flows*, in either direction, are bound to occur. These can be, and should be, handled by means of using "certainty equivalent" cash flow estimates $y(t)$ rather than the "most probable" estimates $x(t)$. The formal definition of certainty equivalence is irrelevant here, since it is in terms of essentially unknown probability distributions for future cash flows. But we can instruct the engineering and sales staff to prepare cash flow estimates $y(t)$ on the basis of "reasonable minimum under conservative assumptions," rather than estimates $x(t)$ on a "most likely" basis. We shall assume, henceforth, that this has been done, and we shall use $y(t)$ rather than $x(t)$ in the subsequent theory, throughout.

3. *Disasters to a project*, however, are not allowed for in such a procedure. Disaster may strike any project, in a number of ways, for example:

(a) The product, a new drug, turns out to have dangerous side-effects.

(b) The competition brings out a rival product at much lower sales price.

(c) There is a business cycle downturn, resulting in a slump of sales below forecasts.

(d) The investment, in a foreign country, is nationalized after a revolution.

This list can be extended quite a bit, but this will suffice. One or more of these contingencies may occur to any investment project, no matter how well planned.

Of these three types of uncertainty, by far the most important to a businessman is the third. Let us quote from Roy (1952, p. 432):

> A valid objection to much economic theory is that it is set against a background of ease and safety. To dispel this artificial sense of security, theory should take account of the often close resemblance between economic life and navigation in poorly charted waters or manoeuvres in a hostile jungle. Decisions taken in practice are less concerned with whether a little more of this or of that will yield the largest net increase in satisfaction than with avoiding known rocks of uncertain position or with deploying forces so that, if there is an ambush round the next corner, total disaster is avoided. *If economic survival is always taken for granted, the rules of behaviour applicable in an uncertain and ruthless world cannot be discovered* (our italics).

In full agreement with these views, the main thrust of our method of investment evaluation is to make explicit allowance for the risk of disaster to a project.

We start by introducing the idea of the *survival probability* $q(t)$, defined as the probability that the project will *not* strike disaster prior to time t. Clearly the definition implies that $q(0) = 1$ and that $q(t)$ is a decreasing function of t.

Next, suppose a disaster occurs at time $t = s$, say. Then for times $t > s$, after the disaster has struck, all initial bets are off: the estimated cash flow $y(t)$ is no longer relevant. We shall suppose that there is a *postdisaster cash flow function* $z(t - s)$, most likely strongly negative, with argument $t - s$, the time that has elapsed since the disaster struck. Only the crudest guesses can be made about this function z.

In the appendix we derive, from these assumptions, a rough formula for the expected present value $E(C)$. This formula differs from the certainty case as follows:

1. In place of the simple discount factor $1/(1 + r)^t$ there appears the expression $q(t)/(1 + r)^t$. The reason for the factor $q(t)$ is this: In calculating an expected value of returns, returns at time t are counted only if the project survives to this time t.

2. There is an additional, negative, term which comes from sub-tracting, from the modified formula of step 1, the discounted pres-ent value of future postdisaster losses, averaged over the time *s* at which the disaster strikes.

In order to use such formulas, it is necessary now to derive some estimate of the survival probability function $q(t)$. In the ap-pendix, it is shown how this $q(t)$ is related to the (simpler to talk about) concept of a "hazard rate" $u(t)$, defined as follows: On condition that the project has survived to time t inclusive, the probability that disaster strikes in the small time interval between t and $t + dt$ is given by $u(t)dt$ (Barlow 1965).

The simplest assumption about the hazard rate is $u(t) = a$, a con-stant value. This corresponds to an "act of God" disaster, which may happen at any time with equal probability. It turns out that disasters of this type can be allowed for by the simple process of altering the discount rate in the ordinary present value formula from the risk-free value r to the "risk-adjusted" value $r^* = r + a$. This is a justification, we believe the first, of this very common procedure.[2]

However, it is shown in the appendix that this procedure gives unreasonable results, no matter what value we use for r^*. If r^* is taken to be high, this means high hazard rate a and amounts to an overestimate of the chance of disasters in the early life of the project. If r^* is only slightly above r, the low value of a amounts to an overestimate of the chance of survival of the project into the distant future.

The trouble arises from the nature of the actual hazards facing a project. These are *not* equally likely to occur at all times t. Rather, the hazard rate depends on the length of time that the project has been underway. If our drug has been tested for safety before being thrown onto the market, it is most unlikely that dangerous side ef-fects can be established immediately. But as time goes on, such ef-fects have an increasing chance of being seen and established. Thus, initially at least, the hazard rate increases with time t. This trend does not persist forever, of course. If no side effects show up in the first ten years of use, the hazard rate thereafter tends to go down, not up; the drug has been tested for a significant length of time in common use. We conclude: (1) The hazard rate is a func-tion of time t; and (2) for small values of t, it is an increasing func-tion of t. The same conclusions are reached when considering the other examples of disasters listed at the beginning of this section.

Since the behavior of $q(t)$ for small t is of most importance for

[2] The justification is only partial, however. Changing r to r^* allows for correc-tion 1 above—introduction of the factor $q(t)$—but not for correction 2, postdisaster losses.

investment evaluation, we deduce $q(t)$ from the simplest expression for the hazard rate which has the property that it increases with increasing t, namely a straight line function of t. The resulting formula is given in the appendix. Its salient property for us, now, is that this new formula *cannot* be represented by use of *any* risk-adjusted discount rate r^*, or, if you wish, r^* must now itself be a function of the elapsed time $r^* = r^*(t)$. In our view, this explains fully why there is so much controversy about how to choose an (assumed constant, independent of t) appropriate value of r^*: no appropriate value exists! The entire controversy about the "cost of capital" is a debate over an empty box (Arditti 1977, Ben-Horim 1979, Boudreaux 1977, 1979, Ezzell 1979, Linke 1974, Nantell 1975, Shapiro 1979).

D. The pay-back time in relation to the downside risk

We have reached a rough and ready approximation for the survival probability $q(t)$. Let us now show how this $q(t)$ is related to the downside risk D, as defined in section B.

Let us assume, for simplicity, that estimated cash flows are never negative. Then the position of the project gets better and better, the longer disaster is delayed. If the time at which the disaster occurs, s, is early in the life of the project, then the discounted present value $C(x)$ will be less than the initial investment I_0; i.e., we are in the downside risk region. But a disaster occurring for large s, late in the expected life of the project, has no such extreme consequence. The discounted present value will be less than hoped for originally, but will still exceed the initial investment I_0.

There is a clear dividing line between these cases. This occurs at a time θ such that, if disaster strikes precisely at $s = \theta$, the discounted present value of the cash flow (*including* an allowance for discounted postdisaster losses!) is exactly equal to I_0. We shall call this time θ our *modified pay-back time*. Its precise definition is in the appendix. It has the same intuitive meaning, exactly, as the pay-back time concept used by practical businessmen, but it allows for two effects which are usually not included: (1) estimated postdisaster losses, and (2) discounting of cash flows, positive or negative as the case may be, which occur in the future. The second of these effects is of minor importance, but the first should, we feel, be included at least roughly in any realistic business calculation.

What, then, is the relationship between the downside risk D and the survival probability function $q(t)$? The downside risk is the probability that the project fails to return its initial investment cost, and we have now seen that this means the probability that

disaster strikes *before* the modified payback time θ has elapsed. The alternative event, no disaster before time θ, has probability equal to $q(\theta)$. One or the other of these two events *must* occur, and they are mutually exclusive events. Thus their probabilities must add up to unity:

$$D + q(\theta) = 1 \qquad \text{or equivalently} \qquad D = 1 - q(\theta)$$

We are now in a position to invoke rule number 1 from the end of section B: D must not exceed a maximum allowable downside risk D_m. It can be shown easily that this is equivalent to the statement that θ must not exceed a maximum allowable pay-back time θ_m (the proof is in the appendix). The relationship between maximum risk D_m and maximum pay-back time, or pay-back time limit θ_m, is simple: $D_m = 1 - q(\theta_m)$. Thus, if the value of D_m is known for this management (say, $D_m = 0.1$, or 10 percent, for a "conservative" management which dislikes risky projects), and if we have, as we do, a simple, though rough, formula for the function $q(t)$, we can deduce the value of the pay-back time limit θ_m used by this management, and vice versa.

We have therefore established a *theoretical basis for the pay-back time limit*. Note that we have *not* assumed such a limit. We have *derived* it from a more basic assumption, our rule 1 of section B.[3] The pay-back time limit has been criticized by theorists because it ignores profits which might accrue at later times. This criticism is unjust. The practical men are completely right. In a riskless world of certainty, future profits are precisely predictable and can be counted on. But in the real world of uncertainty, the payback time limit is a necessary precaution for survival. It is a direct consequence of the "safety first" maxim. No wonder, then, that nearly every responsible management uses this criterion (Carter 1971, Eisner 1956, Gole 1968, Harcourt 1968, 1972, 1976, Kaldor 1962, and innumerable other references).

E. The horizon of uncertainty

Since we have now understood the intuitive basis for the pay-back time limit θ_m, we can proceed to work backward from known, typical values of θ_m to deduce information about the so far unknown parameters which appear in our rough formula for $q(t)$. There are two such parameters: (i) a constant a, which is the value

[3] Of course, this rule itself is very rough. More subtle, and realistic, assumptions about the figure of merit Q can be used with the theory, but one then loses the simple intuitive connection with a pay-back time, taken by itself. But even then, the results are rather similar, though not identical, with what one gets from a pay-back time limit.

of the hazard rate $u(t)$ at time $t = 0$; and (ii) a positive constant b, which is the slope of $u(t)$ as a linear (assumed) function of t. [If the hazard is an "act of God," then $b = 0$.] The analysis is done in the appendix, with the following result: To a good first approximation, one may consider the constant a to be so small that it can be replaced by zero. We are then left with only one adjustable constant, the constant b. This has the dimension $1/(\text{time})^2$. Hence we set $b = 1/T^2$ where T has the dimension of a time. We call this time T the *horizon of uncertainty*. Intuitively, its meaning is this: Beyond time T, i.e., for $t > T$, the "veil of uncertainty" has become so thick that no prediction can be taken seriously any more. This includes, in particular, predictions of future cash flows.

The simple interpolation formula for the survival probability $q(t)$ under these assumptions is:

$$q(t) = \exp[-0.5(t/T)^2]$$

This equals 1 for $t = 0$ (as it must), then stays fairly high until $t \simeq T$, and thereafter drops extremely sharply. Once the horizon of uncertainty starts to close in, it is soon complete night. This formula is completely different from the one for an "act of God" hazard with constant hazard rate a, namely $q(t) = \exp(-at)$. There is no easy way to get from one to the other.

In terms of investment evaluation, i.e., the expected value $E(C)$, one can say it as follows: We may introduce a *time-dependent* "cost of capital" $r^* = r^*(t)$ by means of:

$$r^*(t) = r + 0.5t/T^2$$

where r is the risk-free rate and T is the horizon of uncertainty. To the (severely limited) extent that postdisaster losses can be ignored, this gives an appropriate estimate of $E(C)$ when inserted into the usual formula.[4] But it is clear that the "adjustment for risk," i.e., the difference $r^*(t) - r$, is not at all similar to a constant independent of time.

The horizon of uncertainty T would normally be the same for all projects under contemplation. To the extent that different projects have different degrees of "risk," the risk in question is associated with the variance of actual cash flows from predicted ones in the *absence* of disaster. This can be, and should be, allowed for by adjusting the "certainty-equivalent" cash flows $y(t)$ for these projects. This has nothing to do with the horizon of uncertainty, which refers to truly uncertain, unpredictable, future contingencies which may befall either project.

For this same reason, all projects are subjected to the *same* pay-

[4] Usual formula with continuous discounting, i.e., $\exp(-r^*t)$ rather than $1/(1 + r^*)^t$.

back time limit θ_m. The relationship between θ_m and the survival probability was worked out in section D. Letting D_m be the maximum allowable downside risk, as set by management, we then see that the relation is:

$$D_m = 1 - q(\theta_m) \simeq 1 - \exp[-0.5\,(\theta_m/T)^2\,]$$

The values of D_m and of T are the same for all projects; hence so is the value of the pay-back time limit θ_m. This accords with usual business practice.

But while a businessman normally uses the same pay-back time limit for all projects under consideration at a given moment, this pay-back time limit is by no means an invariable absolute constant. First of all, it varies quite significantly from one businessman to another, at a given moment of time. Different people set their maximum allowable risk D_m differently, and they also have different subjective estimates of the horizon of uncertainty T. We present in Table 13.1 the results of two surveys of U.S. businesses, quoted in Carter (1971, p. 45). One survey was made in 1947, the second in 1948.

Table 13.1

Pay-back time limit (years)	1947 survey (560 companies) percent	1948 survey (51 companies) percent
1	4	14
2	13	41
3	23	19
4	22	8
5	24	8
Over 5	14	10

The wide spread of these pay-back time limits is noticeable. Unlike "hard" quantities like labor costs or the interest rate, the pay-back time is a psychological quantity to a large extent, and such variability should not be overly surprising.

However, there is another kind of variability as well. The 1947 data are quite different from the 1948 data. Our source suggests that the difference is "apparently due to differences in the form of question asked" (Terborgh 1949, quoted in Carter 1971). This is possible, of course, but we can suggest another reason as well. The

year 1947 was a postwar boom year in the United States. In 1948, there was apprehension that the postwar boom was about to break, leading to a sharp depression similar to the downturn of 1921, three years after the end of World War I. In such circumstances, businessmen would be less confident of the future, more inclined to suspect disasters just round the corner. The decline in "business confidence" shows itself through systematically lower values of the pay-back time limit imposed on acceptable new projects.

An extreme case of this is reported, informally, from Hong Kong. It is said that Hong Kong businessmen, at the time of the communist takeover of China, had such low confidence in the future of the Crown colony that pay-back time limits sank down to half a year!

Volatile though the pay-back time limit may be in its function as an indicator of business confidence, and variable as it is between different businessmen, it is just one thing for any one businessman at any one time, a single criterion which is used for all projects under contemplation by this man at that time. As a result, the investment evaluation theory presented here is valid for true uncertainty in the sense of Knight (1921), not just for what Knight calls "risk." The value of the horizon of uncertainty T, from which everything else can be deduced, is the one "stab in the dark" which the businessman must make. Quantities, such as cash flows, referring to times t in excess of this horizon of uncertainty T then have substantially no influence on the investment decision. This is just what one should expect when there is true uncertainty in the picture. No formal rule or mathematical formula is available for this T. Under true uncertainty, the "dark forces of time and ignorance" (Keynes 1936, p. 155) forbid any such mechanical procedure.

Yet, this shakily known, almost purely guessed, horizon of uncertainty has the most significant effect on the evaluation of a new investment! In Table 13.2, we quote some theoretical results for the expected present value of a proposed investment project which promises constant cash flow $y(t) = y$ for all times $t > 0$ in the future. The quoted results allow for riskless discount rates $r = 0$, 0.04, and 0.05, and for horizons of uncertainty $T = 4$ years, $T = 5$ years, and infinite T (meaning certainty of the future).

This table shows that the horizon of uncertainty T, not the interest rate r on risk-free placements, is the *main* determinant of realistic investment evaluation. A huge change in the rate of interest, from $r = 0.04$ to $r = 0.05$ (this is a 25 percent change in r), produces very little effect, compared to an equally large change in T, from 4 years to 5 years. The table shows that full certainty is *not* a sensible "first approximation" to the real world, not at all. If one wants a very rough first approximation, one should retain the

horizon of uncertainty T and ignore (set to zero) the rate of interest r, *not* the other way round. *The influence of uncertainty is the main effect; the rate of interest is the minor correction.*

No wonder that surveys of businessmen find, with monotonous regularity, that these men pay very little attention to the money rate of interest r but very much attention to the state of "business confidence" in their evaluation of investment projects. This behavior is mysterious if one accepts the ordinary (under certainty) present value formula. According to this formula, for a project promising constant cash flow y in the entire future, we get $E(C) = y/r$. That is, r is all-important, and the state of confidence never even enters the formula. But this (the last column of the table) is a hopelessly misleading formula. It comes from ignoring uncertainty of the future.

The preferred evaluation, for finite and not very large horizon of uncertainty T, does indeed ignore the "prospective life of assets." What matters to a businesman is not the predicted life of his assets, but the extent to which he is prepared to trust this, or any other, prediction into the dark and unknowable future. If the predicted life of the assets exceeds the horizon of uncertainty T which limits all such predictions, then it is T, not the predicted life of the assets, which matters for our evaluation of the project. This is not "perplexing" at all, it is just common sense. *The theoretical men are wrong; the practical businessmen are gloriously right.*[5]

In closing, let us turn from the microeconomic to the macroeconomic implications of the new theory of investment evaluation, particularly in relation to the *General Theory* of Keynes (1936). Keynes's own formula for the marginal efficiency of capital in his chapter 11 cannot be accepted, since this formula makes no explicit allowance for uncertainty of the future. The formula is based on a "series of annuities Q_1, Q_2, ..., Q_3" which are "the returns expected from the capital-asset during its life." Uncertain-

[5] There is a flavor of high irony in all this. The main thrust of the neoclassical revolution in economics has been the increased attention paid to subjective factors such as utility. Yet, now that we have unearthed a subjective factor, the horizon of uncertainty T, of really major importance in economics, it turns out that this very factor is ignored in conventional neoclassical capital theory and valuation theory! Neoclassical theory which places so much emphasis on subjective factors in, say, the theory of consumer demand has nothing whatever to say about the much more important subjective factor in the theory of investment evaluation. This theory has failed to come to grips with "the fundamental difficulty of uncertainty." As a result, it is well and truly removed from contact with reality in the area of investment. It is merely "one of these pretty, polite techniques which tries to deal with the present by abstracting from the fact that we know very little about the future" (Keynes 1937).

Table 13.2

Risk-free discount rate r	Value of $E(C)$ for horizon of uncertainty		
	$T = 4$ years	$T = 5$ years	$T = \infty$
0.00	5.01y	6.27y	∞
0.04	4.43y	5.27y	25.0y
0.05	4.22y	5.19y	20.0y

ty enters, of course, but only *indirectly* through its effect on these expectations. What is missing from Keynes's expression is the concept of the "horizon of uncertainty" which distinguishes between short-range expectations held with considerable confidence and more long-range expectations which are so uncertain that they are ignored for the purpose of investment evaluation. In his literary reasoning, particularly in his chapter 22, Keynes is very much aware of such factors. But his formula in chapter 11 makes no allowance for them and therefore tends to overemphasize the importance of the long-term rate of interest (the main other factor).

Now that a new formula has been derived which allows for uncertainly *explicitly*, it should be possible to rework Keynes's *General Theory* using this new formula in place of his expression for the marginal efficiency of capital. The effect would be to give more immediate and direct prominence to "business confidence" (measured by the current economy-wide average value of the horizon of uncertainty) as a major causal factor in investment behavior, and correspondingly less prominence to the long-term rate of interest. We have not attempted this task here, first, because it is such a major project that it would have delayed publication of this work considerably, and second, because a mere substitution of an altered expression for the marginal efficiency of capital would still fail to come to grips with the difficulties pointed out in section 11A, in connection with the dynamic instability of the state of economic equilibrium.

In our view, real progress in theoretical macroeconomics requires not only the explicit inclusion of the effects of uncertainty (in the sense of Knight and Keynes), but also allowance for the essentially dynamic, nonequilibrium behavior of a competitive economy performing a limit cycle. This research program has not yet been completed.

E. Mathematical appendix

In this appendix we use a continuous time variable t, and hence continuous discounting, rather than period analysis; this is done for convenience, since the period analysis (though possible) turns out to be a bit more complicated. The standard expression for discounted present value of a future cash flow $x(t)$ is:

$$C(\mathrm{x}) = \int_0^\infty \exp(-rt)\, x(t)\, dt \qquad (13.1)$$

If the cash flow function $x(t)$ is not certain, but has probability $P(\mathrm{x})$ of occurring, then the expected present value is:

$$E(C) = \sum_{\{\mathrm{x}\}} C(\mathrm{x})P(\mathrm{x}) \qquad (13.2)$$

The "sum over x" in this formula is actually a very complicated functional of the function $x(t)$, but since the probability $P(\mathrm{x})$ is in any case very poorly defined, this does not matter. We shall have to approximate rather roughly, anyway.

The "downside risk" D is:

$$D = \text{probability that} \quad C(\mathrm{x}) < I_0 \qquad (13.3)$$

where I_0 is the initial investment for the project. We assume that projects are ordered in rank by a "figure of merit" Q and take as our first approximation a figure of merit which depends only on the values of D and of $E(C)$:

$$Q = Q[D, E(C)] \qquad (13.4)$$

As mentioned in section B, it is desirable to define conditional expected values:

1. $E(S)$ is the expected value on the condition that the project does *not* run into a loss, i.e., on the assumption that $C(\mathrm{x}) \geqslant I_0$

2. $-E(L)$ is the expected value of the loss if the project does make a net loss.

These quantities are not independent of $E(C)$ and D, but rather the following relationships hold:

$$E(C) = (1 - D)E(S) - DE(L) \qquad (13.5)$$
$$E(S) = [E(C) + DE(L)]/(1 - D) \qquad (13.6)$$
$$E(L) = [(1 - D)E(S) - E(C)]/D \qquad (13.7)$$

Thus, if D and any two of $E(C)$, $E(S)$, and $E(L)$ are known, so is the third.

We now turn to the possible cash flow functions $x(t)$ in the presence of disasters. To allow for possible variations apart from disasters, we replace the "most probable" cash flow $x(t)$ by the

"certainty equivalent" (lower) $y(t)$, from the start. Suppose that a disaster occurs at time $t = s$; then the actual cash flow can be represented by the certainty equivalent one till time $t = s$, and by a "post-disaster cash flow" (probably largely negative) $z = z(t - s)$ thereafter:

$$x(t) = y(t) \quad \text{for} \quad 0 \leqslant t < s \tag{13.8}$$
$$x(t) = z(t - s) \quad \text{for} \quad t \geqslant s$$

We assume that there is a probability $P(s, z)ds$ for the following event: The disaster strikes in the time interval $s < t < s + ds$, *and* the postdisaster cash flow is given by the particular function $z(t - s)$. To make the mathematics tractable, we now *assume* that there is statistical independence between these two factors, i.e., we assume:

$$P(s, z) = p(s)\omega(z) \tag{13.9}$$

where $p(s)ds$ is the probability of the disaster's striking in this time interval, and $\omega(z)$ is the probability of getting the particular post-disaster cash flow function z. Assumption (13.9) is at best a very rough approximation, but it is no rougher than all the other approximations which must be made in any case, particularly when we allow for true uncertainty of the future.

Probabilities must add up to unity, hence:

$$\sum_{(z)} \omega(z) = 1 \qquad \int_0^\infty p(s)ds = 1 \tag{13.10}$$

The survival probability $q(t)$ of the project to time t is equal to the probability that the disaster occurs at some time s larger than t; that is:

$$q(t) = \int_t^\infty p(s)ds \tag{13.11}$$

and therefore:

$$p(s) = -dq/ds \qquad q(0) = 1 \qquad q(\infty) = 0 \tag{13.12}$$

Let us now substitute (13.8) into (13.1). We *define* two integrals as follows:

$$\hat{C}(s) = \int_0^s \exp(-rt)y(t)dt \tag{13.13}$$

$$B(z) = \int_0^\infty \exp(-rt')z(t')dt' \quad (\text{where } t' = t - s) \tag{13.14}$$

to obtain the result, from (13.1) and (13.8):

$$C(x) = \hat{C}(s) + \exp(-rs)B(z) \qquad (13.15)$$

Next, we substitute (13.15) and the assumption (13.9) into the expected value formula (13.2), to obtain:

$$E(C) = \int_0^\infty ds \sum_{(z)} p(s)\omega(z)[\hat{C}(s) + \exp(-rs)B(z)] \qquad (13.16)$$

We define the "postdisaster expected cash loss" (discounted to the time at which the disaster occurs, *not* back to time $t = 0$) by:

$$F = - \sum_{(z)} \omega(z)B(z) \qquad (13.17)$$

It is that quantity, only, which needs to be estimated in some rough way by management. Actual postdisaster cash flows z or their probabilities $\omega(z)$ need not be estimated at all. An extremely simple, but we feel highly overoptimistic, estimate is of course $F = 0$; but management ought to be able to do a bit better than that, in our opinion. When we use (13.17) and the sum rule (13.10) for $\omega(z)$ in (13.16), we obtain:

$$E(C) = \int_0^\infty ds\, p(s)\, \hat{C}(s) - FH$$

where

$$H = \int_0^\infty \exp(-rs)p(s)ds = 1 - r \int_0^\infty \exp(-rs)q(s)ds \qquad (13.18)$$

—the second form follows from (13.12). In the first term, the integral, of $E(C)$ above, we really have a double integral, since $\hat{C}(s)$ is itself an integral; see (13.13). We change the order of the two integrations to obtain (after a bit of work) our final expected value formula:

$$E(C) = \int_0^\infty \exp(-rt)q(t)y(t)dt - FH \qquad (13.19)$$

This expresses the expected present value of the project, disaster-prone as it is, by means of: (1) the survival probability $q(t)$ to time t, (2) the risk-free discount rate r, (3) the "certainty equivalent" estimated future cash flow (in the absence of disaster) $y(t)$, and (4) the expected (estimated) value of the postdisaster loss F.

Conventional valuation formulas are of the form:

$$V = \int_0^\infty w(t)y(t)dt \qquad (13.20)$$

where $w(t)$ is some "weighting function" applied to future cash flows at time t; for example, we might take $w(t) = \exp(-r^*t)$, where r^* is a "discount rate adjusted for risk" or a "cost of capital." We see that such an evaluation is equivalent to our expression (13.19) if and only if:

1. Postdisaster losses are ignored; i.e., we put $F = 0$.

2. There is an *implied assumption* about the survival probability, namely:

$$q(t) = w(t)\exp(+rt) \tag{13.21}$$

For example, if the choice is $w(t) = \exp(-r^*t)$, then (13.21) gives the implied survival probability:

$$q(t) = \exp[-(r^* - r)t] \quad \text{if} \quad w(t) = \exp(-r^*t) \tag{13.21b}$$

Next, let us define what is meant by the "hazard rate" which we shall call $u(t)$. Consider the time interval from time t to time $t + dt$. Then $u(t)dt$ is the *conditional probability* that the disaster occurs in just this time interval, conditional upon survival of the project to time t inclusive. Simple probability arguments yield the relationship:

$$q(t + dt) = q(t)[1 - u(t)dt + \text{Order } (dt)^2] $$

hence:

$$dq/dt = -u(t)q(t)$$

This is a linear homogenous differential equation for $q(t)$ which can be solved by standard methods; when we take into account the condition $q(0) = 1$, the result is:

$$q(t) = \exp[-\int_0^t u(s)ds] \tag{13.22}$$

The simplest assumption about the hazard is that it is an "act of God," which may happen at any time with equal hazard rate; hence $u(t) = a$, some constant value. Substitution into (13.22) then gives:

$$q(t) = \exp(-at) \quad \text{for} \quad u(t) = a \tag{13.23}$$

Comparison with (13.21a) shows that this corresponds exactly to a risk-adjusted rate:

$$r^* = r + a \quad \text{for} \quad u(t) = a \tag{13.24}$$

This, therefore, is the way one might hope to derive, properly, the conventional method of allowing for risk. With the choice (13.23), the integral H (13.18) is evaluated to:

$$H = a/(r + a) = 1 - (r/r^*) \quad \text{for} \quad u(t) = a \tag{13.25}$$

and hence (13.19) gives the evaluation:

$$E(C) = \int_0^\infty \exp(-r^*t)y(t)dt - [1 - (r/r^*)]F \qquad (13.26)$$

This is, in essence, the conventional approach, improved by allowance for expected postdisaster losses F. At first sight, then, the situation appears quite satisfactory.

However, a second look proves disturbing. Given conventionally used values of r^*, the survival probability (13.21b) turns out to make no sense. Take $r^* = 0.25$ (a fairly low value) and $r = 0.10$ (a high value for a risk-free rate, in the absence of inflation). Then $r^* - r = 0.25 - 0.10 = 0.15$, and for two-year survival (13.21b) yields $q(2) = 0.74$. We are thus to believe that responsible company managers will embark willingly upon a project which has, in their own opinion at time $t = 0$, only a 74 percent chance of surviving the first two years. This is hard to accept, and the situation gets even worse if the value of the risk-adjusted rate r^* is made a bit more realistic (i.e., larger).

Conversely, suppose the managers insist that, in their own estimation, the project must have at least a 90 percent chance of surviving the first two years, or else they are not interested. They then insist upon projects for which the value of a in (13.23) is no higher than about 0.05. Quite apart from the fact that such projects may be quite hard to find, let us see what such values of a imply for survival to, let us say, 15 years into the future. Putting $t = 15$ and $a \leqslant 0.05$ in (13.23), we get $q(15) \geqslant 0.47$, i.e., a nearly 50 percent chance of the project's surviving for the next 15 years into the future. There may be managements with such a rosy view of their ability to predict the future and avoid disasters—but it is safe to ignore them, since they are bound to go bankrupt before long.

At this stage, we have struck a contradiction: No matter what value we pick for the constant a in (13.23), and hence for the risk-adjusted discount rate r^*, (13.24), we get unreasonable results: Either survival to time $t = 2$ is unreasonably improbable, or else survival to time $t = 15$ is unreasonably probable. What is wrong is not one or another choice of r^*, but the formula (13.23) itself, and the hazard rate $u(t) = a$ on which this formula is based.

In the chapter, we gave arguments to show that, for small times t at least, the hazard rate may be expected to increase with time. The simplest function which does this is the straight line:

$$u(t) = a + bt \qquad (13.27)$$

where both a and b must be nonnegative—$u(t)dt$ is a probability

and hence can never be negative. Substitution of (13.27) into (13.22) yields:

$$q(t) = \exp(-at - 0.5bt^2)\qquad(13.28)$$

Because of the t^2 term in the exponent, such an expression is *not* equivalent to any risk-adjusted discount rate r^*, no matter what (constant) value of r^* is chosen.

Next, turn to consideration of pay-back times. The conventional definition, which we shall denote by θ^* to distinguish it from ours, is given by:

$$\int_0^{\theta^*} y(t)dt = I_0 \quad \text{and} \quad \int_0^s y(t)dt < I_0 \quad \text{for} \quad s < \theta^*\qquad(13.29)$$

That is, the project just manages to pay back for the initial invest-ment I_0 at time θ^*, but at no earlier time $s < \theta^*$.

Our preferred definition of a "modified pay-back time," which we denote by θ, is in terms of the discounted present value of the project as given by formula (13.15), on the assumption that disas-ter strikes exactly at time s. However, since $B(z)$ is impossible to determine, or even guess at, we replace it by its expected value $-F$; see (13.17). This yields our pay-back time definition:

$$\hat{C}(\theta) - F \exp(-r\theta) = I_0 \quad \text{and}$$

$$\hat{C}(s) - F \exp(-rs) < I_0 \quad \text{for} \quad s < \theta\qquad(13.30)$$

This is equivalent to (13.29) if we ignore discounting (set $r = 0$) and postdisaster losses (set $F = 0$); but otherwise, it is an improved formula which we recommend to practical businessmen in spite of its apparent complexity (it is easy enough to write a computer program to evaluate θ for a wide range of assumptions concerning $y(t)$, r, I_0, and F, and such a program has been written).

If cash flows, on a certainty equivalent no-disaster basis, are al-ways positive, then the downside risk D is given by:

$$D = 1 - q(\theta) = 1 - \exp(-a\theta - 0.5b\theta^2)\qquad(13.31)$$

The condition $D < D_m$, of a maximum acceptable downside risk, is then equivalent to a pay-back time limit $\theta < \theta_m$, where

$$D_m = 1 - q(\theta_m) = 1 - \exp(-a\theta_m - 0.5b\theta_m^2)\qquad(13.32)$$

We may solve this equation for the constant a to get:

$$a = (1/\theta_m)\log[1/(1 - D_m)] - 0.5b\theta_m \leqslant$$

$$(1/\theta_m)\log[1/(1 - D_m)]\qquad(13.33)$$

Now, conventional pay-back time limits θ_m range from 2 to 5

years, mostly. If the management is "conservative," it is unlikely that it will be prepared to tolerate a high downside risk. Let us take D_m = 0.1, a maximum 10 percent downside risk, for such a management. Then the inequality in (13.33) gives $a < 0.053$ for θ_m = 2 years, and $a < 0.02$ for θ_m = 5 years. These are upper limits on a, which must not be approached closely (for then b becomes close to zero, and we are back to the "act of God" hazard which we know is faulty). We conclude that the constant a is always very small, rather less than conventional risk-free discount rates r. Since r and a always occur together in the combination $r + a$, it is a good first approximation to ignore a altogether; i.e., we propose, as a practical rule of thumb, to set $a = 0$ in (13.27) and (13.28), henceforth. The intuitive meaning of this approximation is that the managers feel that they are sure enough of the immediate future of the project (prior to its actual start!—this estimate may be unduly optimistic, in retrospect) that they can ignore the immediate hazard rate at time $t = 0$.

The parameter b has the dimension of $1/(\text{time})^2$, since bt^2 is in an exponent and therefore dimensionless. We define the "horizon of uncertainty" T by $T = 1/b^{1/2}$ and thus (13.28) with $a = 0$ becomes:

$$q(t) = \exp[-0.5(t/T)^2] \tag{13.34}$$

This must be substituted into (13.18) and (13.19), as well as into (13.32). The latter can then be solved for the horizon of uncertainty T in terms of the pay-back time limit θ_m and the maximum permissible downside risk D_m to get:

$$T = \theta_m [-2\log(1 - D_m)]^{-1/2} \tag{13.35}$$

Let us now show how the theory can manage more complicated figures of merit Q than the ones discussed in the chapter. Let Q depend, in any way desired, upon the following factors: (1) the initial investment I_0, (2) the expected present value $E(C)$ of the future cash flow, (3) the downside risk D of the project, and (4) the expected money loss on those projects which do strike disaster too soon to get into the black; we call this $E(L)$. Let, then,

$$Q = Q[I_0, E(C), D, E(L)] \tag{13.36}$$

be any function of these four quantities. An example might be:

$$Q = (1 - D)^n f[E(S) - I_0] - [1 - (1 - D)^n]g[E(L)] \tag{13.37}$$

where n is the number of projects before retirement and f as well as g are monotonically increasing functions, $g(0) = X$ is large, and $E(S)$ is defined by (13.6).

No matter what the functional form chosen (by management)

for (13.36), the figure of merit can be evaluated once the four quantities are known individually. I_0 is known by definition. For $E(C)$ we have, from (13.18), (13.19), and (13.34):

$$E(C) = \int_0^\infty \exp[-rt - 0.5(t/T)^2] y(t)dt - FH \qquad (13.38)$$

$$H = \int_0^\infty (t/T^2) \exp[-rt - 0.5(t/T)^2] dt \qquad (13.39)$$

For D we have, from (13.31) and (13.34):

$$D = 1 - \exp[-0.5(\theta/T)^2] \qquad (13.40)$$

Finally, we present, without proof, the formula for the expected money loss $E(L)$ conditional upon the project losing money. This is:

$$E(L) = (1/D)[I_0 - \int_0^\theta \exp[-rt - 0.5(t/T)^2] y(t)dt +$$

$$FG(r,\theta)] \qquad (13.41a)$$

$$G(r,\theta) = 1 - r\int_0^\theta \exp[-rt - 0.5(t/T)^2] dt \qquad (13.41b)$$

The integrals in (13.38) to (13.41) are nonelementary but can be evaluated easily in terms of tabulated functions (the so-called error integral) if $y(t)$ can be approximated by a piecewise linear function (which need not be continuous); this is quite good enough for practical use.

This shows, in the most explicit fashion possible, that our analysis is *not* restricted to the super-simple rules 1 and 2 of the chapter but can accommodate without difficulty almost any figure of merit Q that a businessman might care to choose.

Finally, we state, again without proof, the result for $E(C)$ when $y(t)$ is set equal to a constant value y and the postdisaster loss F is ignored. We refer to Comrie (1949) for the definition of the probability area function $a(x)$. Then:

$$E(C) = (\pi/2)^{1/2} Ty \exp[0.5(rT)^2][1 - a(rT)] \qquad (13.42)$$

This is the formula which we used for constructing Table 13.2. The proof that (13.42) reduces to $E(C) = y/r$ in the limit as T goes to infinity is best done by going back to (13.38) and (13.39) and letting T go to infinity in these expressions. The result is then immediate.

BOOK V

Deferred Topics

In order to expedite the flow of the argument, we have deferred several topics until later; all these topics could have been included earlier, but at the cost of slowing down the development. In this book, we return to these deferred topics.

Chapter 14 takes another look at the historical evidence on the behavior of an uncontrolled free enterprise system, something we did rather briefly in section 8C. We are particularly interested in the predictions of David Ricardo concerning the long-term future of the British economy and the relative position of landlords and industrialists within that economy. It is well known that these predictions turned out to be wrong. But the usual explanations for this do scant justice to Ricardo's insight and undoubted ability as an economic theorist. In our view, Ricardo's predictions failed because he based his theoretical analysis on the assumption of basic stability, which assumption allowed him to reason in terms of economic equilibrium. The actual economy was not stable, but rather cyclical. This factor completely altered the relative position of landlords and industrialists in the long run (averaged over many cycles).

Chapter 15 belongs very much earlier, logically as well as historically. The cyclical flow concepts of Dr. Francois Quesnay's Tableau Economique dominate our entire analysis. While we have mentioned this earlier, we have left it until now to give Quesnay the chapter which is very much his due. Our analysis of the physiocratic system is not just a rehash of the existing literature, nor merely an exposition of the physiocratic writings. Rather, we proceed analytically and algebraically, keeping prices and quantities separate throughout, so that we are able to develop a "physiocratic theory of value," something the physiocrats themselves did

not do. As a by-product, we gain some insight into the neoclassical marginal utility theory of value and into what is known as "welfare economics" (see section 15E).

The third deferred topic, left to chapter 16, is econometrics. We used econometric concepts in chapter 11, after a very brief descriptive explanation. Now we take a fully critical look at the foundations on which econometric theory is constructed. These foundations are shown to be desperately weak. The material in this chapter is new and controversial.

Notes on the nineteenth-century trade cycle

A. Introduction

From one point of view, it needs no apology to discuss the nineteenth century experience. Economic history is of interest in its own right, but it is not, however, the reason for this chapter. Rather, we wish to look at the nineteenth-century trade cycle for reasons of economic theory, for what this experience can teach us about economic analysis.

In many respects, nineteenth-century conditions in Britain were very different from those of today. It is fair to say, though, that most of these differences mean that conditions then were less complicated, more amenable to simple theoretical discussion, then are conditions now. The differences include:

1. The currency was based upon a metallic standard (silver at the beginning of the century, gold at its end). Thus "inflation," in its recent sense of depreciating value of a paper currency without metallic backing, simply did not exist.[1]

2. There was very little government regulation of, or interference with, free private enterprise. By present-day standards, what little regulation there was hardly counts at all.

3. There was no income tax at all between 1816 and 1842. Thereafter, income tax was levied, but at the rate of seven pence

[1] Inflation in another guise, namely, a rise in the value of other commodities relative to the value of gold, could and did happen on occasion. Sometimes it could be traced to the discovery of new gold mines; at other times to wartime scarcities of other commodities. But excessive printing of paper money, such as in the German hyper-inflation of the 1920s, was not, and could not be, a factor in the nineteenth century. We do not wish to enter into discussion of the meaning or definition of inflation of the twentieth-century type; all that concerns us is that no such thing happened in the nineteenth century.

in the pound! There were few taxes by our standards, and none of them even approached present-day levels. The government did not provide anything like the present amount of employment.

4. For a large part of the nineteenth century, commercial enterprises were generally small scale and competitive. The world of monopolies, oligopolies, advertising, strong trade unions, etc., only started to develop in the last quarter of the century.

5. If by a "major war" we mean one which interferes seriously with the normal commercial life of a nation, then Britain was not involved in a major war between 1815, the end of the Napoleonic wars, and 1899, the start of the Boer war.

No economist writing today maintains that *all* of the five factors listed above can be ignored in our day. Indeed, most economists tend to think that all, or nearly all, of these five points must be allowed for in any realistic theory. There can be little doubt that a theory in which these factors can be omitted as unimportant is easier and simpler than one which must take them into account.

Some economists of our day are convinced, or at least pretend to be convinced, that the root of all evil is interference with the working of a free market. The "interference" may come from the government, or from labor unions, or from environmentalists, or from a cartel of oil producers—but, wherever it originates, it is a bad thing. If only the free market could be left to operate undisturbed, all our troubles should be over.

In such a view, mid-nineteenth-century Britain should have been an economic paradise. The government of the day, from the Duke of Wellington to Mr. Gladstone, took freedom of the market practically as an article of faith. Labor unions were very weak by contemporary standards. The horrors of Victorian industrial towns testify to this day to the absence of all concern for the environment of ordinary people. There was no cartel of oil producers, because no oil was being produced; the fuel of the time was coal, not oil, and coal producers were as fully competitive as anyone could have wished.

To please monetarists, the "money supply" of nineteenth-century Britain was tied closely to gold. Peel's Bank Charter Act of 1844 was as tight a nondiscretionary rule as even Milton Friedman could have wished. It was so tight, in fact, that it had to be suspended by the British government in three separate panics (1847, 1857, and 1866) to prevent complete disaster and national bankruptcy!

To those who may think that a money supply rule is bad, not good, the United States is worth looking at. President Andrew

Jackson conducted, and won, a bitter fight against Nicholas Biddle of the Bank of the United States, which was attempting to set itself up as a central bank similar to the Bank of England. Ever since that victory (in 1836) and well beyond the end of the century, the United States exercised substantially no control at all over the issue of bank notes.

Thus, if a money supply rule can prevent panics, it should have done so in the United Kingdom. If an entirely free and uncontrolled money supply can prevent panics, it should have done so in the United States. If a free market in goods and labor can prevent panics, it should have done so in both countries.

It did not. The first lesson from the nineteenth century, therefore, is that *panics occur, in a nearly regular pattern, when the market is entirely free and untrammeled; and no matter what is done about the money supply.* Interference with the free market may, and probably does, affect the course of the trade cycle, modifying it here and there. But this interference does not *cause* the trade cycle. Tightly controlled money, or completely uncontrolled money, are in the same category: possible modifying influences, but not *causes* in any fundamental sense. If only economists were more prepared to look at well-known economic history, much current controversy should become moot.

B. Long-run predictions of Ricardo

In his original preface, Ricardo (1821) said: "The produce of the earth——all that is derived from its surface by the united application of labour, machinery, and capital, is divided among three classes of the community, namely, the proprietor of the land, the owner of the stock or capital necessary for its cultivation, and the labourers by whose industry it is cultivated. . . . To determine the laws which regulate this distribution is the principal problem in Political Economy."

Ricardo's personal predilections were with the "owners of the stock or capital," and against the "proprietors of the land." On page 225, we read "the interest of the landlord is always opposed to that of the consumer and manufacturer. . . . The dealings between the landlord and the public are not like dealings in trade, whereby both the seller and buyer may equally be said to gain, but the loss is wholly on one side, and the gain wholly on the other."

In spite of this, Ricardo's logic led him inescapably to conclusions which he must have disliked intensely, concerning the long-

run tendency of the economic system. The three classes should fare as follows in the long run:

1. The laborers are subject to the "iron law of wages," getting nothing but bare subsistence.[2]

2. The capitalists, however, do not manage much better. As the population increases, more land must be taken into cultivation to feed this population. The marginal land, on which (according to Ricardo) no rent is paid, is ever poorer land as time goes on. The rent on all the other land correspondingly increases, thereby squeezing the profits of the farmers, and, by equalization of profit rates in different enployments of capital, the profits of all other capitalists as well.

3. The landlords emerge as the winners (pp. 224-225) "all extraordinary profits are in their nature but of limited duration, as the whole surplus produce of the soil, after deducting from it only such moderate profits as are sufficient to encourage accumulation, must finally rest with the landlord. . . . All the advantages would, in the first instance, be enjoyed by labourers, capitalists, and consumers; but, with the progress of population, they would gradually be transferred to the proprietors of the soil."

Precisely because Ricardo himself disliked these conclusions intensely, they deserve additional respect from us. We may presume that he looked for fallacies in his own reasoning, which might make it possible for him to arrive at more palatable (to him) answers from his theory; and that he failed to find such fallacies.

Yet, the conclusion turned out to be wrong in fact. According to Ricardo, the proprietors of land should have gone from strength to strength in nineteenth-century Britain, collecting more and more of the surplus product of an increasingly prosperous economy, gaining all the time in wealth and power. This did *not* happen. When Ricardo wrote, the proprietors of land ruled Britain. Fifty years later, individual landed proprietors were still wealthy —but the real wealth and the real power had gravitated to the "owners of stock or capital."

Why did Ricardo's predictions fail? What was wrong with his reasoning?

The conventional answer is this: Ricardo underestimated the influence of technological improvements in agriculture, as well as the effect of opening up large areas of virgin land in the United States, Argentina, Australia, etc. These factors combined to keep land rents low, thereby invalidating Ricardo's predictions.

[2] Ricardo suggested, though, that what is called a minimum subsistence standard might improve slowly with time. This is not important for our argument.

In our view, this explanation is superficial and does scant justice to Ricardo. The evidence does not support this explanation.[3] According to E. A. G. Robinson (1954), the population of Britain in 1820 was 20.9 million, and six-sevenths of their food was produced internally, the rest imported. By 1870, the population was 31.5 million, with Britain supplying three-quarters of the food needed. Thus British agriculture was feeding 17.9 million people in 1820 and 23.6 million in 1870, a very substantial *increase*. Far from agriculture's being restricted more and more to the very best grades of land, some very poor tracts of land were being brought into cultivation.

As for technological improvements, it does not take much imagination to suggest Ricardo's answer to this argument: Improved technology can bring down the price of a quarter of corn, but not the rental of an acre of good land, as long as bad land is still being used, and as long as the technology does not decrease the proportions of the corn yields of good and bad land. The details are hard to know, and rents may have gone up, or down, somewhat as the result of technological factors; but the effect could hardly be very big, *on rents*.

There is no need to rely exclusively on such indirect reasoning. Direct evidence exists concerning the economic situation of landlords in normal times, in conditions of good trade. Walter Bagehot's *Lombard Street* (Bagehot 1873) appeared fifty years after Ricardo's *Principles*. On page 289, we read:

> Notwithstanding other changes, the distribution of the customers of the bill brokers in different parts of the country remains much as Mr. Richardson described it sixty years ago. For the most part, agricultural counties do not employ as much money as they save; manufacturing counties, on the other hand, can employ much more than they save; and therefore the money of Norfolk or of Somersetshire is deposited with the London bill brokers, who use it to discount the bills of Lancashire and Yorkshire.

It is clear that our landed proprietors were not suffering from inadequate rents. On the contrary, they had excess money to invest, and they did invest it; either directly, or more usually indirectly, through the London money market.

C. The trade cycle as a transfer device

What, then, was the mechanism in nineteenth-century Britain

[3] The author is not, and does not claim to be, an economic historian. Thus, the evidence quoted here is from secondary sources and is presented as suggestive and illustrative of the conclusions, not as firm proof. A full investigation by a properly trained and qualified economic historian is very desirable.

which acted to deprive the landed proprietors of the golden fruits promised them by Ricardo? In our view, it was the *trade cycle*:

1. In normal, prosperous times, the landed proprietors did reap the golden harvest predicted by Ricardo.

2. They then proceeded to invest their wealth through the London money market, so as to obtain a good rate of interest on their money. The investment—more properly, "placement," in the language of Joan Robinson (1956)—was made either by the landed gentleman himself, or by his local banker; it makes little difference.

3. As long as good trade continued, the landlords did obtain a good rate of interest, much better than by placing their money into Consols, and of course very much better than by hoarding gold or Bank of England notes.

4. But, for the reasons outlined in chapter 8, good trade did not last forever. Sooner or later, on the average once every ten years or so, it all ended in a panic. In the panic, creditors as a group lost not merely their interest entitlement, but their principal! Thus, averaged over the trade cycle, investment (placement) proved counterproductive for the landed proprietors, who were the main creditors. They would have done far better for themselves by hoarding gold!

A full proof of this hypothesis, and hypothesis is all this is, requires proper investigations in economic history, to draw up consolidated accounts for the landed class in Britain over at least one, preferably several, full trade cycles in the mid-nineteenth century. We have neither the ability nor the knowledge nor the time to do this, and can only hope that economic historians can be persuaded to look into the matter. Until then all we can do is to present some plausibility arguments. These, however, may be of some interest in their own right.

1. It may be objected that capitalists also lost in a panic, not merely their creditors. This is very true for individual capitalists. In the year 1826 alone, 3,300 businesses failed in Britain, with most of their former proprietors losing all they owned in this world. But the capitalist class as a whole did *not* lose; it gained! A bankrupt business with usable assets could be, and was, bought up for a song by some other capitalist, who thereby gained what the first capitalist had lost. The business was *not* bought up by a landed gentleman, who after all would not have known what to do with a bankrupt enterprise. In this way, the landed class as a whole lost; the capitalist class as a whole gained. The effect of every panic was a major transfer of wealth from the creditor (landed proprietor) class, to the capitalist class.

2. It may be objected that our hypothesis requires that investors were being fooled systematically for several generations, contrary

to Abraham Lincoln's view: "You can fool all the people some of the time, you can fool some of the people all the time, but you can not fool all the people all the time." We have several answers to this objection:

(a) Not all investors were fooled, not by a long shot. Andrew Carnegie boasted of building his steel mills at half cost, by waiting until after the next panic before commencing actual construction. But it is highly unlikely that these smart investors included many landed proprietors—a few of them, undoubtedly; but these few do not affect our conclusions.

(b) There is some evidence that investors did remember earlier panics, and tried, unsuccessfully, to avoid being caught the same way. Matthews (1959) argues that the nineteenth-century British cycle was *not* a simple cycle, but a superposition of two separate cycles, each of roughly 18 years' duration, out of phase with each other. One 18-year cycle was for foreign investment (U.S. railroads, Argentinian farms and mines, etc.), the other for home investment within Britain. We accept Matthews' data, but suggest an alternative interpretation. Consider a landed proprietor with money to invest in, say, the year 1861. He is likely to remember that his neighbor, or his uncle, lost all he had in the panic of 1857, caused by the crash of American investments. So, he decides to place his money in a safe, sound British enterprise, for example the bill broking house of Overend and Gurney—which crashed in 1866. (If the placement is made by the gentleman's rural banker, rather than by the gentleman himself, the ultimate effect is the same.) Another landed gentleman with money to invest in, say, 1870, recalls the 1866 crash distinctly, so he places his money into the current U.S. "growth industry," the transcontinental railroads. He is then wiped out in the crash of 1873. In our view, the interlaced cycles of Matthews can be understood simply as a single 9-year cycle of investment confidence and disappointment, together with the observation that investors are likely to have a very sharp memory of the immediately preceding panic, but a much vaguer memory of earlier panics.

(c) Let us suppose that investors did remember all earlier panics. How would this enable them to avoid being caught in the next one? A landed gentleman with money was under enormous pressure to invest it *somewhere.* Starting with Adam Smith, all political economists unanimously lauded the virtues of "investing" (placement) and deplored the unmitigated vice of idle hoarding of currency or gold. Nor did they scruple to invoke religion in their cause. When Jesus pronounced the parable of the prodigal son, he surely did not intend the use nineteenth-century capitalists would

make of that story—but use it they did, with gusto, for their own selfish ends. The hoarder of money was depicted as an evil sinner who acts so as to decrease, rather than augment, the wealth of the nation. It would have required an iron fortitude to withstand the combination of high promised rates of interest together with the ample threats and curses of political economy and religion in full alliance—to withstand them all and hoard cash. In effect, then, whenever a landed gentleman was afflicted with excess money, this money was burning holes in his pocket. He needed to place it somewhere, if only as a deposit with his local bank. But once he did place it, not matter where or how, he was caught. He, and his banker, were much too far from the nerve center of the commercial world to know when to pull out; and the advice given to them was often highly self-serving. In late September 1929, Bernard Baruch was quoted in the press to the effect that the U.S. share market was safe and sound. So it was—for him! He was busily liquidating all his shares prior to the impending crash. Those who did as he said, rather than as he did, lost all they had in the panic which started a few weeks later. If such things happen in the twentieth century, in the age of mass communications, what were the chances of a landed gentleman in some sleepy hamlet of nineteenth-century Britain?

3. The mechanism we have outlined here is in the nature of a "class struggle"; i.e., one class benefits at the expense of another. But the two classes in question are the capitalists and the landlords, *not* the working class. A great London banker, Alexander Baring, declared in Parliament (Heilbroner 1972, p. 79) "the labourer has no interest in this question [the corn laws]; whether the price be 84 shillings or 105 shillings a quarter, he will get dry bread in the one case and dry bread in the other." The working class was a helpless, downtrodden bystander in *this* class struggle.

If we accept this view of the trade cycle, what then was Ricardo's mistake of reasoning? Ricardo was *not* guilty of overlooking such glaringly obvious factors as technological improvement and the opening of new lands. Under the conditions he postulated, of steady trade at prices fluctuating about "natural prices" (labor values), his logic was and is impeccable, and his predictions must follow. The factor which he failed to allow for was much more subtle. He may well be forgiven for his error, because this same factor is still being overlooked and ignored today, more than one hundred and fifty years later. *The missing factor is the fundamental influence of economic dynamics, coupled with uncertainty of the future, in falsifying predictions based on economic equilibrium.*

Note that this means much more than the truism: "No actual

economic system is ever in a state of precise equilibrium." Rather, *the departures from economic equilibrium in nineteenth-century Britain were systematic, were inherent in the working of the economy, and acted in such a way as to yield results directly contrary to what was deduced from considerations of a hypothetical steady state.*

The transfer mechanism of this section depends completely upon the *absence* of equilibrium. This mechanism could not function in the ideal world of the equilibrium theorists, a world in which all prices are stable and all expectations are "rational." In the actual world of Victorian Britain, the expectations of investors turned out to be utterly mistaken except in the very shortest run. In the long run, investors not only failed to get the interest they expected—they lost their principal. The contrast between the predictions of Ricardo and the actual outcome is a most salutary reminder of how hopelessly wrong one can be when reasoning from the assumption of a stable equilibrium in our actual, nonequilibrium world.

In section 8B, we mentioned that a mechanical limit cycle requires a "source of energy" to keep it going; otherwise, frictional effects lead to a dying down of the motion. The economic limit cycle of nineteenth-century Britain also required a source of energy. In order to keep investing money, and losing it, the landed proprietors must keep *making* money, somehow. In our view, this is the point at which Ricardo's mechanism enters the picture. The unearned income of the landlords through Ricardo's differential rent mechanism is a part of the "energy" which fuels the trade cycle. (Technical progress is another.)

But Ricardo, who explicitly denied the very possibility of a "general glut," was in no position to appreciate the transfer mechanism pointed out in this section, and therefore his predictions turned out to be very far from the truth.

In closing this section, we repeat that this transfer mechanism has the status of a hypothesis, not of a proven theory. Its proof, or disproof, depends upon future work by economic historians.

D. Implications for trade cycle theory

The nineteenth-century trade cycle clearly had some features which differ greatly from the trade cycle in the twentieth century. Landed proprietors are of minor importance, at best, nowadays. Nothing in this, or earlier, chapters is a theory of present-day trade cycles, or pretends to be such a theory. But a few things can be said, nonetheless.

The essential point appears to be the existence of *un*realized investment (or at least, placement) expectations. If this is still true, then the *gestation period* of an investment project (i.e., the time between commencement of the project and the first significant cash flows from it) becomes of prime importance. If the gestation period is short, there is little room for unrealized expectations— it is then not too hard to form a fairly accurate estimate of eventual returns. To generate the amount of uncertainty which is needed for an understanding of the trade cycle, the relevant projects must be projects of long gestation time.

The actual areas of investment in the nineteenth century were canals, railroads, and major building projects, commercial as well as residential. For *all* these, gestation times were long, perhaps five years at the least, rather more on the average.

Furthermore, speculative booms and crashes at much earlier times were also associated with long gestation times. John Law's Mississippi Company, to dig gold out of the Mississippi delta, as well as the British South Sea Company, to transport slaves from Africa to the Spanish colonies in South America, both involved long gestation times. Neither project involved significant amounts of fixed capital (the supposed essential factor in some trade cycle theories).

From this point of view, the acceleration principle (see section 9A) is only an incidental, not an essential, part of the mechanism of the trade cycle. A relationship between changes in national income and investment in fixed capital may be important in some trade cycles. But it was clearly completely inoperative in the South Sea bubble, and largely inoperative in the U.S. railroad bubbles of the nineteenth century. The railroads were not, to a large extent, the result of existing demand. Rather, railroads were laid down across empty land, in the hope that towns and, with them, demand for railway services, would spring up along the railway line. The investment was done in anticipation of demand, not induced by demand. Fixed capital and the accelerator appear to have a role in some, but not in all, of the historic trade cycles. Long gestation times and their consequences, speculation and unrealized expectations, seem to be present in *all* trade cycles.

On this view, *any "purely real" theory of the trade cycle fails to come to grips with the essence of the phenomenon.* This can be seen most clearly when one considers the sheer sudden speed of the crash. In late August 1929 the U.S. share market was in full boom. Two months later, the panic was on, and by the end of November 1929 the economy was well and truly embarked on ten years of depression. No "real" factors change with such speed.

Capital stock depreciates, of course, but not in two months! Yet, in two months, the total valuation of the capital stock of the United States had dropped to approximately two-thirds its initial amount. No "real" factor could possibly explain such a rapid drop. But a psychological factor, of "business confidence," is quite capable of changing at such a rate. To quote Keynes (1936, p. 315): "It is of the nature of organised investment markets, under the influence of purchasers largely ignorant of what they are buying and of speculators who are more concerned with forecasting the next shift of market sentiment than with a reasonable estimate of the future yield of capital-assets, that, when disillusion falls upon an over-optimistic and over-bought market, it should fall with sudden and even catastrophic force."

In many ways, the speed of the crash is the acid test of any theory of the trade cycle. Most of the currently prominent theories fail that test. The much too slowly descending phase of the Hicks model (Hicks 1950) has already been discussed, in section 10A. A theory which has not been discussed earlier, that of Schumpeter (1935, 1939), breaks down at just this point. The theory relies upon "waves of innovation" and suggests that the trade cycle is the price we must pay, and must be prepared to pay, for continued progress. The voluminous evidence piled up by Professor Schumpeter is indeed impressive; but it fails to convince, for two reasons:

1. The association between trade cycles and innovations is frequent, but not at all universal. Canals and railroads may be innovations, but what about residential and commercial building in the nineteenth century? Those who have seen the results in Britain wish fervently that the Victorian builders had been just a tiny bit innovative. Their structures are much inferior to those of Roman Britain; the ancient Romans, but not the Victorians, at least insisted on central heating, baths, and toilets in their homes! And, to go back to an earlier panic, what was innovative about the project of the South Sea Company? The project was for one of the oldest trades in the world, the slave trade.

2. A "real" cause, such as innovation, is quite incapable of explaining the crash. Of course, a wave of innovation peters out after a while, when it has been adopted universally. After the railroad network has been substantially completed, we must wait for automobiles, or airplanes, for the next big innovative push to the economy. But how does that effect produce the railroad panic of 1873?

From our point of view, the conventional trade cycle theory which comes closest to the essence of the phenomenon is the much disparaged "monetary" theory of Hawtrey (1926, 1928).[4]

[4] For a modern, post-Keynesian view of monetary instability, see, for example, Minsky (1977).

He pays very much attention to the state of current expectations, to the state of credit. But Hawtrey emphasizes, we believe mistakenly so, the *causative* role of trading banks in altering the cost and availability of credit, thereby affecting the state of current expectations. In nineteenth-century Britain, bankers were largely middlemen, just as stockbrokers are today. Stockbrokers and bankers would be only too happy to control the state of business confidence, and they often try to affect it by means of issuing public or semipublic statements, optimistic circulars, and the like. But it is highly doubtful whether such efforts amount to much; they seem to be successful only when business confidence would be high even without them. Of course, unlike stockbrokers, bankers can do something more positive than merely issuing statements. They can grant, or withhold, credit. But there is scant evidence, if any, that the withholding of bank credit is the real cause of panics. A famous contrary instance is the 1929 crash: It is likely that the crash would have come much earlier than it actually did, namely, in March 1929, had it not been for the action of the banks, with the National City Bank as their leader, to extend credit at that time, thereby positively encouraging, aiding, and abetting further speculation (Galbraith 1955).

The eventual crash, in October and November, cannot be blamed on the banks. It came from the much delayed realization by investors that shares had been bid up to levels which were completely inconsistent with likely, or even conceivable, future profits of the companies issuing those shares. The crash in share market confidence came first; it was not itself caused by any action of the banks. To the extent that the banks did anything, they delayed the crash; they did not cause it.

Some of the very best work on trade cycles can be found in books which aim to be descriptive and suggestive, rather than fully theoretical. Besides the well-known early work of Mitchell (1913) and the "Notes on the Trade Cycle" in Keynes (1936), there exists a much less well-known, excellent little book by Lavington (1922); all of these should be required reading for economists interested in trade cycles. It is striking that the people who have studied the phenomenon most closely all agree on emphasizing the psychological factor of business confidence as being overridingly important. Perhaps it is best to close this chapter by quoting an earlier but equally astute observer, Walter Bagehot (1873, pp. 131, 138-139, and 160):

> Credit—the disposition of one man to trust another—is singularly varying. In England, after a great calamity, everybody is suspicious of everybody; as soon as that calamity is forgotten, everybody again confides in everybody.

The fact is, that the owners of savings not finding, in adequate quantities, their usual kind of investments, rush into anything that promises speciously, and when they find that these specious investments can be disposed of at a high profit, they rush into them more and more. The first taste is for high interest, but that taste soon becomes secondary. There is a second appetite for large gains to be made by selling the principal which is to yield the interest. So long as such sales can be effected the mania continues; when it ceases to be possible to effect them, ruin begins.

When we understand that Lombard Street is subject to severe alternations of opposite causes, we should cease to be surprised at its seeming cycles. We should cease too to be surprised at the sudden panics. During the period of reaction and adversity, the whole structure is delicate. The peculiar essence of our banking system is an unprecedented trust between man and man; and when that trust is much weakened by hidden causes, a small accident may greatly hurt it, and a great accident for a moment may almost destroy it.

Notes on the Tableau Economique

A. Background and importance

In the year 1760, the king of France was Louis XV, great-grandson of that Louis (XIV) who had said "L'etat, c'est moi!" Louis XV was living happily with Madame Pompadour. Her household physician was Dr. Francois Quesnay.

By any reckoning, Quesnay was one of the greatest geniuses in the entire history of economic thought. He was the founder and inspiration of a school of economists called the "physiocrats," who had a brief spell of notoriety in the France of the ancien régime, roughly between 1760 and 1770. But his importance for economics extends way beyond this rather limited success. In our view, Quesnay initiated that way of looking at the economy of a nation which is, to this day, the best and perhaps the only method which can be used under truly dynamic conditions, where equilibrium concepts are not applicable.

As a physician, Dr. Quesnay was interested in the circulation of blood in the human body. Whether this suggested his study of circulation in the body social, or whether it was merely used by him as an illustration is not clear. But he certainly did consider the circulation of commodities and money in the economic system and developed his Tableau Economique to explain his ideas. The Tableau Economique appeared in several editions in the years 1758 to 1760. The third edition is reprinted, with an English translation, in Kuczynski (1972). A number of the writings of Quesnay, as well as of later physiocrats, are available in English in the delightful book by the late Professor Ronald L. Meek, "The Economics of Physiocracy" (Meek 1963).

The contribution of Quesnay to economic science is overwhelm-

ingly important and is insufficiently appreciated by many economists today. One main purpose of these notes is to present the basic ideas in a form, different from the tabular form used by Quesnay himself, which may be of more appeal to modern economists, in the hope of aiding and advancing the appreciation of Quesnay's genius by the profession. From the point of view of dynamic economics, the Tableau Economique is infinitely more relevant than the general equilibrium system of Walras. Unlike that system, the Tableau Economique is capable of handling dynamic, nonequilibrium situations on a macroeconomic scale. In these notes we shall confine outselves to stationary situations, for the sake of simplicity. But the dynamic theory of chapter 7 was based directly on the ideas of Quesnay.

The economic system which we shall postulate below is an extremely rough simplification of the French economy under the ancien régime, and our interpretation of the views of Quesnay differs from that of Professor Meek, particularly as regards the meaning of the *produit net* (net surplus). We do not maintain that our interpretation is better, in the sense of being closer to the historical truth; but it is a possible interpretation, which allows us to develop the theory in a clearer fashion. The actual writings of Quesnay are not always terribly clear; there is a strong suspicion that this was to some extent deliberate. The ancien régime had rather unpleasant ways of dealing with people who put unpopular (with the king) views too plainly.

As soon as an economy is capable of producing a surplus, over and above the inputs needed for next year's production at the same level, the usual three questions arise: (1) Who gets the surplus? (2) How is the surplus used? (3) If (the usual case) there is some choice about what is produced, and how, who makes these choices, and on what basis?

In eighteenth-century France, ultimate power resided in the aristocracy with the king as its absolute head. Whatever surplus the French economy was capable of yielding, this class appropriated to themselves. The most important method of appropriation was the levying of rent for the use of land. The aristocrats themselves were concentrated at Versailles, under the eye of the king; Louis XIV had seen to that, and his great-grandson maintained that system. Unlike the contemporary British aristocracy, the French aristocracy had little direct interest in the land they owned. All they cared for was the rent, which was collected for them by rent collectors, from an ever more impoverished peasantry. This is the answer to question one.

Nowadays, we tend to take it for granted that much of any sur-

plus should be used as *investment*, so as to be able to produce a larger output in the future. But back in eighteenth-century France, investment was far from the minds of the ruling class. What mattered to them was personal consumption, including much ostentation, and the glory of war. The entire surplus, and at times amounts in excess of that, was spent that way. It is against this background that one has to understand the nearly contemporary insistence of Adam Smith on growth and development and investment.

Finally, whatever choices exist are decided by the aristocratic class, to please themselves. No one else has a "vote" in that "election."

For simplicity, we shall assume a steady state, with a constant amount of land, L acres of it, used every year, and constant outputs of corn and iron. There seems to be some evidence that output was actually decreasing slowly; i.e., the aristocrats took more out of the system than the system was able to provide under steady-state conditions. But the decrease, if real, was slow, and the steady-state assumption makes the theory much simpler. Here we shall work with just two commodities, corn and iron. But the generalization to N commodities is given in the mathematical appendix.

B. Quantities

As usual, and quite realistically for eighteenth-century conditions, we assume a fixed coefficient Leontief technology. However, unlike our use in chapter 3, we must now allow for a nonproduced input, namely, *land*. The other difference from chapter 3 is that there is neither investment nor growth. Our input-output scheme is:

Land (acres)		Corn (quarters)		Iron (tons)		Output
1	+	0.90	+	0.05	⟶	1 quarter corn
0	+	0.60	+	0.20	⟶	1 ton iron

Note that land is an input but not an output (or, alternatively, we may think of the first process as joint production, the outputs being 1 quarter of corn *and* 1 acre of land; but this makes no real difference subsequently). The limited amount of land available, L

acres by assumption, thus puts an upper limit on total production.

In order to produce y_1 quarters of corn, we need y_1 acres of land, $0.9y_1$ quarters of input corn, and $0.05y_1$ tons of input iron. In order to produce y_2 tons of iron, we need no land, $0.6y_2$ quarters of input corn (to feed the iron workers), and $0.2y_2$ tons of input iron.

What is the *net* amount of corn produced, i.e., the excess of corn output over total corn input? We call this amount r_1. It is given by:

$$r_1 = y_1 - (0.9y_1 + 0.6y_2) = 0.1y_1 - 0.6y_2$$

We call this the *produit net* of corn, r_1 quarters of it. The *produit net* of iron is, by a similar argument:

$$r_2 = y_2 - (0.05y_1 + 0.2y_2) = -0.05y_1 + 0.8y_2$$

These are the net amounts available for consumption by the aristocrats.

In this section, we shall confine ourselves to two extreme cases for the consumption preferences of aristocrats:

Case A: The aristocrats maintain menial servants (who eat bread made from corn) but no fancy equipages (which require iron for their construction).

Case B: The aristocrats take all their *produit net* in the form of equipages (iron) and have no desire for a net product in the form of corn (no servants).

Clearly, these extreme preferences are unrealistic, and we shall allow for a wider range of choices in section E.

If case A holds, then the aristocrats want no net product of iron at all; i.e., things must work out in such a way that $r_2 = 0$. Using our formula for r_2, we see that this means $0.05y_1 = 0.8y_2$, or $y_1 = 16y_2$. Thus, to achieve zero *net* output of iron, the *gross* outputs must be in the ratio 16 quarters of corn for every ton of iron. However, not only is this ratio known, but we also know the absolute amount of (gross) output corn which can be produced by this economy: It is simply $y_1 = L$, since by assumption it requires one acre of land for every quarter of output corn, and there are L acres of land altogether. Thus, our solution for case A is, using the formula for r_1:

Case A

Gross: $y_1 = L$, $y_2 = L/16$ Net: $r_1 = y_1/16 = L/16$, $r_2 = 0$

In looking at this solution, we note that, of the entire gross output of corn, 15/16 must be plowed back (as seed corn and food

for the working population), and only the remaining sixteenth is available as *produit net* to feed the menial servants of the aristocrats.

Take case B next. The aristocrats want no net product of corn (no servants); hence we must have $r_1 = 0$. Our formula for r_1 then leads to $0.1y_1 = 0.6y_2$, or $y_1 = 6y_2$. The gross outputs y_1 and y_2 are now in the ratio 6:1, *different* from the 16:1 we got for case A. The consumption preferences of the aristocrats have affected the gross output of iron from the economy. With land limited as before, the total output of corn is still given by $y_1 = L$, and so (using the formula for r_2) we have the results:

Case B

Gross: $y_1 = L$, $y_2 = L/6$ Net: $r_1 = 0$, $r_2 = 0.5y_2 = L/12$

Now the entire output of corn is plowed back (net product of corn $= 0$), and half the iron output is plowed back. The other half is available to make equipages for aristocrats at Versailles.

From the point of view of the aristocrats, it is purely a matter of taste whether they prefer their share of the surplus, i.e., all of it, in the form of surplus corn or surplus iron. But these preferences do have an effect on the behavior of the economy as a whole—in our simplified example, an effect on the total output of iron. We get more iron output in case B than in case A. The underlying reason is that people who were unproductive menial servants in case A have become productive workers in case B. But, while they are "productive" workers in the sense of generating a tangible product, extra iron, this product does *not* serve to cause economic growth; rather, it is wasted on showy equipages for aristocrats.

What we have now shown is that output quantities, both gross and net, are determined in this system and are influenced by aristocratic consumption preferences.

C. *Metayers* and *fermiers*

Much more important than this small difference in total iron output between our cases A and B is the underlying constancy, and paucity, of agricultural output. No matter what the aristocrats prefer, this economy produces the same small amount of corn and can support only the same small population. It would be most misleading to discuss the Tableau Economique without mentioning the major concern of the physiocratic school, namely, to make French agriculture more capital intensive and hence more productive.

In the France of the ancien régime, there were two main forms of land cultivation:

1. by *metayer* (share cropper), a primitive form of agriculture using oxen rather than horses and very little capital equipment of any sort; the rent to the aristocratic landlord was levied in kind, as a (large) fraction of the harvest, usually half or more; and

2. by *fermier* (entrepreneur farmer), who employed significant amounts of capital, rented larger parcels of land, and farmed them by more modern, larger scale methods so as to obtain a much better yield per acre, both gross and net; the rent was paid in money, not in kind.

The main thrust of the physiocratic argument was in favor of *fermiers* against *metayers*. This argument was directed, not to either *fermiers* or *metayers*, but rather to the aristocratic ruling class, pointing out to them that it was in their direct interest to permit, even to encourage, more efficient methods of land cultivation.

We can reproduce the essence of this argument by means of our super-simple model. Let us change the input-output table to envisage a more efficient form of agriculture, in which one quarter of corn can be produced on half an acre, rather than a full acre, of land, and with input of only 0.25 quarters (rather than 0.90 quarters) of corn. The input of iron (machinery) must be larger, now, however; let us say 0.15 tons of iron rather than 0.05 tons. Our new input-output table reads:

Land (acres)		Corn (quarters)		Iron (tons)	Output
0.50	+	0.25	+	0.15 ⟶	1 quarter corn
0	+	0.60	+	0.20 ⟶	1 ton iron

Note that we have assumed no change in the technology of iron manufacture; i.e., the second line of the table is unchanged.

We can now go through exactly the same calculation as before, for the two separate cases A and B. We forego the details, and just state the results:

Case A

Gross: $y_1 = 2L$, $y_2 = (6/16)L$ Net: $r_1 = (51/40)L$, $r_2 = 0$

Case B

Gross: $y_1 = 2L$, $y_2 = (5/2)L$ Net: $r_1 = 0$, $r_2 = (17/10)L$

The improvement is striking, particularly in the net outputs, which are what the aristocrats collect. In case A, the *produit net* of corn has jumped from $L/16$ to $(51/40)L$, a ratio of $816/40 = 20.4$. This is a better than twentyfold rise in net product, from a twofold rise in the amount of corn producible by one acre of land. It is easily seen that, in case B, there is a similar rise in the *produit net* of iron. An aristocrat might well be tempted by a twentyfold (!) increase in his consumption possibilities. We note, in passing, that there is no benefit at all to the common people; all of them are still at bare subsistence level. The economy can maintain more of them (higher gross output of corn), but all that does is to produce more cannon fodder for the wars of the aristocrats.

Returning to these aristocrats, one would think that a promise of such an enormous improvement in their consumption possibilities would make an unbeatable case for the policy being advocated. However, historically it failed to convince them, and the physiocratic recommendations were tried only halfheartedly and for a short while, then abandoned. What makes the case so imperfect? One can think of two reasons:

1. There is a hidden contradiction between the assumptions that the entire *produit net* is collected by the aristocrats, but *fermiers* (i.e., capitalist farmers) are used to generate that *produit net*. In the absence of any net profit to them, the *fermiers* have no incentive to invest capital and lease land from the aristocrats. The physiocrats did not admit the concept of profit, proportional to invested capital, as a category of income (Adam Smith was the first there); although some of the physiocrats did attempt to smuggle something akin to profit into their system, by various backdoor methods.

2. As is so usual with strictly economic arguments, this one pays no attention to some very important likely social and political consequences of the policy being advocated. A clever aristocrat, or one with merely a gut feeling about popular response, might well conclude that this whole line of argument is terribly subversive of his interests. The more clearly and directly one argues this case, the more obvious does it become that the aristocratic landlords (the "proprietor class" of Quesnay) have no productive function at all. They are merely unproductive consumers who do nothing for the society on which they live as parasites. Objectively, this is true no matter whether agricultural production is carried on by *metayers* or *fermiers*. But, in the short run at least, the aristocrats

are safer with poor wretched *metayers* who are too ignorant and disorganized to do anything about their condition, than with wealthy *fermiers* who could, and did before long, question the fundamentals of the system.

Be it for either of these reasons, or merely because of the innate conservatism of a powerful landed aristocracy, the physiocratic policy recommendation was not implemented, and the country continued wretchedly under the old system. Louis XV was a poor king by any reasonable standard, but no one can fault his powers as a prophet. He was the one who said: "Après moi, la déluge."

It is interesting to observe that advice by economists is not always faulty. In this, one of the earliest cases of advice by a group of economists to a government, the economists were entirely right. The politicians must be blamed for the inaction which led to utter catastrophe a mere thirty years later.

D. Prices

So far, we have determined all quantities produced, but we have no prices.

We return to the first input-output table, in section B. Let p_1 be the price of a quarter of corn; p_2 of a ton of iron. Now consider the iron producers. For each ton of iron that he brings to market, the producer gets p_2. In order to maintain next year's production at the same level, he must purchase inputs to produce one ton of iron, namely, 0.6 quarters of corn and 0.2 tons of iron, at a total cost of $0.6p_1 + 0.2p_2$. His net gain per ton of iron is the difference between his incomings and his outgoings. But, in the physiocratic system, this net gain must be zero! The iron producer is not a member of the "proprietor class" (the aristocrats), but rather of the "sterile class" which consists of (to quote Quesnay) "manufactured commodities, houseroom, clothing, interest on money, servants, commercial costs, foreign produce, etc." In the physiocratic system, it is assumed that the entire *produit net* goes to the "proprietor class"; none of it to either of the other two classes (the "sterile class" and the "productive expenditure class," the latter working on the land). Since the net gain must be zero, we obtain the equation:

Net gain of iron producers per ton $= p_2 - (0.6p_1 + 0.2p_2) = 0$

This is equivalent to $0.6p_1 = 0.8p_2$, or $3p_1 = 4p_2$. Prices *must* adjust themselves so that four tons of iron exchange for three quarters of corn. At this ratio, and only at this ratio, is it true that the iron producers break even, exactly, without net gain or loss.

Note that this price ratio is completely independent of the preferences of the aristocrats as between corn and iron for their *produit net*. Whether they prefer servants to equipages, or vice versa, the same price ratio between corn and iron prevails in the market.

There is a third price in this system, namely, the rental of an acre of land, which we shall denote by R. To get this, consider the situation of the corn producers (we ignore the fact that the *metayers* were actually share croppers who paid rent in kind, not in money). For each acre of land rented, the producer must pay R in rent. He produces one quarter of corn from this acre, which he sells at price p_1. He must purchase productive inputs for the next year, namely 0.9 quarters of corn and 0.05 tons of iron. His net balance, which must be zero in the physiocratic system, is then:

$$-R + p_1 - (0.9p_1 + 0.05p_2) = 0$$

so that, using $p_2 = 0.75p_1$, we find that

$$R = 0.1p_1 - 0.05p_2 = 0.1p_1 - (0.05 \times 0.75)p_1 = (1/16)p_1$$

Thus, we conclude that the rental of an acre of land is 1/16 of the gross money yield from farming that land and, of course, equal to the *entire* net money yield from that activity.

All prices are now determined, except for a common numeraire, and these prices have turned out to be independent of the consumption preferences of the aristocrats, under our assumptions (in particular, constant coefficient technology).

We now proceed to show that another set of aristocratic preferences, namely, the method used to collect the value equivalent of the *produit net*, does matter for the price system. So far, we have assumed that collection of rent was the only method. Historically, there were at least two others of importance: (1) the *corvee*, direct labor service by the tenant on the lord's land, and (2) the *gabelle*, a commodity tax on an essential consumption good (on salt). To make our point, we now introduce a *gabelle* into our model. To keep to just two commodities (the general case is treated in the appendix) we levy a tax, at rate T, on corn. That is, if p_1 is the price of a quarter of corn prior to the tax, then the buyer has to pay a total of $(1 + T)p_1$ for this quarter, of which sum p_1 is retained by the seller, and Tp_1 goes to the king at Versailles.

How does this tax affect the price system? The money balance equation for iron producers is now changed to:

$$\text{Net gain of iron producers per ton} =$$
$$p_2 - \{0.6(1 + T)p_1 + 0.2p_2\} = 0$$

Thus the price ratio p_2/p_1 changes, from the earlier 3/4 to the present $(3/4)(1 + T)$.

In working out the value balance for the corn producers, we find that a question arises concerning the taxation, if any, on the amount of corn needed to start next year's production of corn. If the corn producers are foolish enough to bring that corn onto the open market and then buy it back themselves, then of course they must pay the tax on it. But we shall assume that they are sensible enough to avoid doing that. Rather, they simply withhold that amount of corn from the market, thereby cheating the tax collector. (The actual *gabelle* was on salt, not on corn; since one needs very little salt in order to operate a salt mine, this issue was never of any importance in practice.)

Under these assumptions, the value balance for the corn producers reads:

$$-R + p_1 - (0.9p_1 + 0.05p_2) = 0$$

This is the *same* equation as before (it is changed if a tax is levied on iron as well). But since the ratio p_2/p_1 has altered, the final result for the rent R is altered also, and turns out to be:

$$R = (1/16)(1 - 0.8T)p_1$$

One effect of the commodity tax, therefore, has been to decrease, by a fractional amount $0.8T$, the rental of an acre of land expressed in corn units.

However, this must not be confused with Ricardo's much later views on the desirability of taxing rents. The aristocratic class does *not* suffer any diminution in its total disposable income. It still collects the entire net product of the economy. All that has changed is the method of collection, and the price system.

E. Marginal utility and welfare

In section B, we assumed that the aristocrats have such a decided preference for one particular commodity that they want their entire *produit net* in the form of that commodity (corn in case A, iron in case B). We now wish to relax that extreme assumption, to allow a preference for some mixture of these commodities.

In the usual neoclassical theory of consumer preferences, one assumes that there is a *utility function* $U = U(r_1, r_2)$ which gives the utility, to consumers, of a quantity r_1 of corn and r_2 of iron. Net rather than gross quantities enter, since only the net quantities are available for consumption.

This utility function is taken to be a function of actual quanti-

ties consumed, not of any prices. Thus this theory *assumes* that, unlike real people either today or then, these French aristocrats of economic fiction are never tempted to consume anything *because* it is expensive and thereby shows off their wealth. On this assumption, a gorgeous court robe was ordered solely because of the intrinsic aesthetic satisfaction the lady obtained from wearing it, never, oh never, to bolster the social standing of her husband or protector through indicating his wealth and power. For, if the cost of the consumption good is of itself a part of its utility, then the utility function has to be taken as a function of prices as well as quantities; that is, $U = U(r_1, r_2, p_1, p_2)$ rather than $U = U(r_1, r_2)$ only, and the theory about to be developed is no longer valid.

On the reasonable assumption that "more is better," $U(r_1, r_2)$ is an increasing function of r_1 (for constant r_2) and of r_2 (for constant r_1). But neither r_1 nor r_2 can be increased indefinitely. They are restricted by the input-output table (we take the one at the start of section B) and by the total quantity of land L. In section B, we worked out relations for r_1 and r_2 in terms of gross products, and we repeat them here for convenience:

$$r_1 = 0.1y_1 - 0.6y_2 \qquad r_2 = -0.05y_1 + 0.8y_2$$

For our present purpose, it is better to think of the net products r_1 and r_2 as the independent variables. Solving for y_1 and y_2 gives:

$$y_1 = 16r_1 + 12r_2 \qquad y_2 = r_1 + 2r_2$$

The conditions which must be satisfied are then:

1. that r_1 and r_2 must be positive or zero; otherwise the economy cannot continue to yield the same outputs the year after,

2. that y_1 and y_2 must be positive, and

3. that the amount of land needed ($= y_1$ in our case) must not exceed L.

The problem of the aristocrats is to maximize their utility $U(r_1, r_2)$ subject to these three restrictions.

We can assume from the start that r_1 and r_2 are nonnegative. The formulas for y_1 and y_2 then show that these will be nonnegative also. Hence restrictions 1 and 2 cause no difficulty. The real limitation is the third condition. We may assume right away that all the available land is used, since there is no advantage to aristocrats in not doing so. Since $y_1 = L$ for our input-output table, the maximization problem takes the form:

Maximize $U(r_1, r_2)$ subject to $16r_1 + 12r_2 = L$

This is a standard problem to which the answer is well known. One draws "indifference curves" in the (r_1, r_2) plane, these being curves

along which $U(r_1, r_2) = $ constant. One also draws the sloping line $16r_1 + 12r_2 = L$ (for the given value of L). The optimal point is the one at which this line is tangent to an indifference curve; under reasonable assumptions about the utility function U (see appendix), this optimal point is unique and well determined.

At this optimal point, the marginal utilities $\partial U/\partial r_1$ and $\partial U/\partial r_2$ must be proportional to the coefficients, 16 and 12 respectively, in the equation of the slanting straight line which represents the production possibility constraint. Letting t stand for the common factor in this proportionality, we therefore get:

$$\partial U/\partial r_1 = 16t \qquad \partial U/\partial r_2 = 12t$$

We are therefore looking for a (we hope, only one) point P on the line $16r_1 + 12r_2 = L$ for which both these relationships are satisfied, for some suitable value of t. This is then the desired point of tangency, and thus the optimal point for the desires of the ultimate consumers in this economic system.

All this looks very similar to standard marginal utility theory. However, the similarity is more formal, mathematical, than economic. In the standard theory, the constraint is one of *wealth* and therefore involves prices. If our consumer has an amount of money M available for consumption spending, the constraint is:

$$r_1 p_1 + r_2 p_2 = M$$

Mathematically, this is of the same, linear form as the constraint we imposed, $16r_1 + 12r_2 = L$. But economically, they are quite different. The meaning of the coefficients 16 and 12 is not prices, but rather *marginal amounts of land* needed to get a unit increment of extra net product: If we wish to produce one more quarter of wheat, *net*, then the condition $16r_1 + 12r_2 = L$ implies that we must bring into cultivation 16 extra acres of land (to increase r_1 by 1 without change to r_2). Marginal amounts of land, *not* market prices, come in here.

But how is this possible? Why aren't our ultimate consumers limited by money? The answer is simple: Political power! Our ultimate consumers are the aristocratic class, the rulers of this economic system. Money is no limitation at all; it is not even a serious consideration. Should the money raised from rents and taxes be insufficient to purchase the entire *produit net* of the economy, they simply decree increases in rents or taxes, or both, until the money *is* enough.

One should not be confused by the fact that, in the absence of commodity taxes, the price ratio $p_2/p_1 = 3/4$ is identical with the ratio of marginal amounts of land, 12/16. By introducing a new

factor of proportionality s, we can therefore also write our earlier marginal utility equations in the form:

$$\partial U/\partial r_1 = sp_1 \qquad \partial U/\partial r_2 = sp_2$$

or in words: In the absence of "distortion" of the price system by commodity taxes, the equilibrium market prices p_1, p_2 are directly proportional to the marginal utilities of the (net) quantities r_1, r_2 of the corresponding commodities to the ultimate consumers.

Stated in this way, the result is completely consistent with neo-classical marginal utility theory. However, this statement is highly misleading, for two reasons:

1. The appearance of prices is accidental, not essential; as soon as there are commodity taxes, the price ratio p_2/p_1 is no longer equal to the ratio 12/16 of the marginal amounts of land, and it is the latter, *not* the price ratio, which defines the ratio of marginal utilities.

2. While marginal utility is important, particularly in determining quantities, there is *no marginal utility theory of value* here. The values (prices) are determined independently of the *consumption* preferences of the aristocrats. Given the input-output table (p. 317) and the table of taxation rates, prices are determined. Marginal utility is used, independently, to decide on *quantities* (gross as well as net) of the various commodities to be produced so as to maximize the satisfaction of the ultimate consumers. Price ratios do *not* enter into this at all, since the aristocrats are not limited by any money constraint as such.

In economics, there is a distinction between "positive economics," which seeks to describe the economic system as it actually is, and "welfare economics," which attempts to lay down "optimum" conditions so as to maximize "welfare." It will be of some interest to see what welfare economics might have to say about our present system. The problem has been: Maximize the utility of the ultimate consumers in this economy, subject to the unavoidable constraints imposed by the production technology and the available resources (land, in particular). It was by following up this maximization problem that we were led to introduce marginal utility.

Having posed, and then solved, a maximization problem, we see that the solution so found is clearly optimal. It has been constructed so as to maximize consumer utility. Obviously, then, everything is for the best in this best of all possible worlds.

But wait a minute! This is the world which exploded into violent and bloody revolution within one generation of 1760. Clearly, some people in this society must have been unconvinced that they

were living under ideal conditions. Indeed, when revolution broke out in 1789, these malcontents formed the overwhelming majority of the population of France.

Is our simple model good enough to encompass this aspect of historical truth? Yes, indeed; it is quite easy. One merely needs to look at *whose* utility is being maximized. Our $U = U(r_1, r_2)$ is the utility function of the aristocrats. They collect the entire net products, r_1 of corn and r_2 of iron. Their preferences, and their preferences alone, decide what is being produced in this economy. No one else has a single "vote" in this "election." The only "sovereign consumers" are consumers of the *produit net*, the very ones who do nothing whatever to earn their keep in this society. No wonder everyone else is just waiting to revolt.

We conclude that *maximization of the utility of the ultimate consumers is no guarantee of true social welfare.* On the contrary, it is entirely consistent with the possibility of long-continued extreme social misery.

Welfare economists might reply that they are aware that income distribution issues are an important factor which should not be ignored. But all too often, having made that statement, they then proceed to ignore "distributional questions." This is an entirely illegitimate and misleading procedure. *The formal questions of maximization of utility functions pale into insignificance compared to questions of distribution, when we wish to say something normative about true social welfare.* If anyone thinks that "distributional questions" are of minor importance, then our example from 1760 is as strong a reductio ad absurdum as a man could require.[1]

We conclude this chapter with some brief comments on the interpretation of the Tableau Economique and the *produit net*. Professor Meek (1963) accepts the Marxist interpretation of the physiocrats as forerunners and promoters of capitalism and consequently of the *produit net* as a forerunner of Marx's surplus value. The problem with this is the poor position of the capitalist farmers (*fermiers*) in the tableau. The entire *produit net* goes to the proprietor class (the aristocracy); the physiocrats allow none of it

[1] We mention, in passing, an equally important point: "Utility" is by no means just a function of quantities of consumption goods, certainly not to captains of industry. John D. Rockefeller was noted for his abstemious living. If all he had desired was an adequate, for him, level of consumption goods, he should have stopped work many, many years before his actual retirement. This was not his motivation at all, or at most to a very minor extent. His real motivation was obviously elsewhere, in such areas as power, influence, the sheer love of winning a fight, etc. We have never seen these factors in any utility function. But if utility is to be taken seriously, just these factors most certainly have to be included. As it is, utility theory cannot be taken seriously at all.

to go to either the "productive expenditure class" (farmers who pay rent for land) or the "sterile class" (everyone else). The Marxist explanation is that the physiocrats perceived the *produit net* purely in terms of a *physical* surplus of output over input. Such a surplus is directly visible in agriculture but tends to be concealed in the "sterile" trades. But this argument fails to explain why the "productive expenditure class," which does work on the land, does so poorly for itself in the physiocratic scheme of things.

Our interpretation is different. It makes the physiocrats appear more as "reactionary" defenders of the status quo than as "progressive" precursors of capitalism. In our view, the *produit net* is simply the entire net physical product of the economy, in whatever form it may arise (the actual form, corn or iron or both in some proportion, being decided by the consumption preferences of the aristocrats). This interpretation is not at all obvious by looking at the Tableau Economique, because the Tableau is expressed in terms of *values* rather than *quantities*. If the aristocrats collect the value equivalent of the *produit net* entirely through imposition of rent payments, and if rent is paid by farmers for the use of productive land, then it follows that the *value* of the *produit net* is paid to the aristocrats purely by that class which pays rent: the "productive expenditure class" of the physiocrats.

In our view, this provides a natural explanation of the physiocratic distinction between "sterile" and "productive" expenditure. "Sterile" expenditure produces no rent payments; this is what makes it sterile from the point of view of the aristocrats. "Productive" expenditure produces rent. This is the goose that lays the golden eggs.

We do not insist on this interpretation, in the sense of asserting that it is a historically accurate view of the physiocratic system. Indeed, since the physiocrats did not have an explicit theory of value (such as, say, our theory of section D) it is hard to decide just what their views were. All we wish to maintain is that ours is a possible view of their system, a view which suits our purposes better than the conventional Marxist interpretation.

F. Mathematical appendix

Assume that there are n commodities labeled $i = 1, 2, \ldots, n$. The output of commodity i is y_i taken gross, and r_i taken net. We assume Leontief technology, which requires an input of a_{ij} units of commodity j in order to produce unit output of commodity i. In addition to ordinary commodity inputs, we may also need an input of *land*, which is not itself a produced commodity, nor is it

used up during the production process. We shall use the symbol b_i to denote the amount of land (in acres) needed to produce one unit of commodity i.

The relation between the net products r_j and the gross products y_j is:

$$r_j = y_j - \sum_{i=1}^{n} y_i a_{ij} \tag{15.1}$$

It turns out to be convenient to introduce the matrix (n-by-n) \mathbf{V} through:

$$\mathbf{V}_{ij} = \delta_{ij} - a_{ij} \tag{15.2}$$

where $\delta_{ij} = 1$ if $i = j$; $\delta_{ij} = 0$ if $i \neq j$. With this notation, (15.1) becomes:

$$r_j = \sum_{i=1}^{n} y_i \mathbf{V}_{ij} \tag{15.3}$$

It will be convenient to start with the extreme case in which the aristocrats want the entire *produit net* in the form of just one commodity, say commodity number k. In that case, the equations which determine the outputs of all commodities, gross, are:

$$\sum_{i=1}^{n} y_i b_i = L \qquad \text{(Total land use} = L) \tag{15.4}$$

$$\sum_{i=1}^{n} y_i \mathbf{V}_{ij} = 0 \quad \text{for all } j \neq k \quad \text{(Zero } produit \ net \text{ for } j \neq k) \tag{15.5}$$

These equations are $1 + (n - 1) = n$ equations in the n unknowns y_i and can therefore be solved under reasonable assumptions about the matrices involved. In particular, let us assume that the matrix \mathbf{V} has an inverse, which we shall call \mathbf{W}. (Such an inverse must exist if the economy is "productive" in the sense used in, and defined just prior to, theorem 3.10.)

Let t be an arbitrary scale factor, to be determined later. The $n - 1$ equations (15.5) then have the general solution:

$$y_i = t \mathbf{W}_{ki} \qquad (i = 1, 2, \ldots, n) \tag{15.6}$$

This can be verified directly by substituting (15.6) into (15.5) and using the fact that the matrices \mathbf{V} and \mathbf{W} are inverses of each other; i.e.,

$$\sum_{j=1}^{n} V_{ij}W_{jm} = \delta_{im} \quad \text{and} \quad \sum_{i=1}^{n} W_{ki}V_{ij} = \delta_{kj} \qquad (15.7)$$

We now determine the scale factor t in (15.6) by substituting this into (15.4) and solving for t. This procedure yields:

$$t = L \left(\sum_{i=1}^{n} W_{ki}b_i \right)^{-1} \qquad (15.8)$$

The combination of (15.6) and (15.8) provides the desired solution for all quantities p_i, if the aristocratic consumption preferences run entirely to one particular commodity k. We shall consider more general consumption preferences later.

To obtain prices, we assume that land rent is R per acre and that commodity i sells for unit price p_i, on which a tax at rate T_i is levied. The producers of commodity i can avoid the tax on their own use of i for input, but they must pay the tax on all their other input needs. To produce one unit of commodity i, they must pay rent for b_i acres of land and purchase a_{ij} units of commodity j at a unit price of $p_j(1 + T_j)$. When they sell this one unit of i, they receive p_i for it. And (since they are not aristocrats) their net gain must be exactly zero. This gives the balance equation:

$$-Rb_i + (1 - a_{ii})p_i - \sum_{j \neq i} a_{ij}(1 + T_j)p_j = 0 \qquad (i = 1, 2, \ldots, n) \qquad (15.9)$$

We introduce the matrix V' by the following definitions:

$$V'_{ii} = 1 - a_{ii} \quad \text{and, for all} \quad j \neq i, \quad V'_{ij} = -a_{ij}(1 + T_j) \quad (15.10)$$

We note that, in the absence of taxation ($T_j = 0$, all j), V' is just the same as our previous V, equation (15.2). With this notation, (15.9) can be rewritten as:

$$\sum_{j=1}^{n} V'_{ij}p_j = Rb_i \qquad (i = 1, 2, \ldots, n) \qquad (15.11)$$

If we denote the inverse matrix to V' by W', the solution of (15.11) is immediate:

$$p_i = R \sum_{j=1}^{n} W'_{ij}b_j \qquad (15.12)$$

This shows how the unit price p_i of every commodity is related to

the rent of one acre of land R and to coefficients which are partly technical (b_j) and partly a combination of technical and taxation policy (W'_{ij}). We note that this entire price system is independent of the consumption preferences of the aristocrats (of the particular commodity k in which they desire to receive their *produit net*).

The effect of commodity taxation on prices is rather intricate. The taxation rates T_j enter linearly into the definition of the matrix V', (15.10), but therefore enter in a highly complicated, nonlinear way into its inverse W', which is needed for (15.12).

Let us now turn to utilities, section E. First, let $r = (r_1, r_2, \ldots, r_n)$ be a vector (a set) of attainable net products, and let $r' = (r'_1, r'_2, \ldots, r'_n)$ be another attainable set; and let s be any number in the range $0 \leqslant s \leqslant 1$. Because of the linear nature of the assumed Leontief technology, it then follows that the vector

$$r'' = sr + (1 - s)r' \qquad (15.13)$$

is also attainable, without exceeding available resources (of land). The set of attainable net products is therefore a "convex set" in mathematical terms.

We wish to impose a condition on our utility functions to the effect that the utility of a mixture of commodities is no less than the weighted average utility obtained by taking the utilities of the separate commodities. Mathematically, this means that we want the utility function $U(r) = U(r_1, r_2, \ldots, r_n)$ to be a *concave* function defined as follows:

If r, r', r'' satisfy (15.13), then $U(r'') \geqslant sU(r) + (1 - s)U(r')$ (15.14)

For example, let $r = (r_1, r_2) = (30,0)$ be 30 quarters of corn and no iron. Let $r' = (0,40)$ be 40 tons of iron and no corn. Take $s = 1/5$, which is between 0 and 1. Then $r'' = (1/5)r + (4/5)r' = (6,32)$, i.e., 6 quarters of corn and 32 tons of iron. Then (15.14) asserts that this combination is at least as "utile" to an aristocrat as the weighted average $(1/5)U(r) + (4/5)U(r')$ of the separate utilities of 30 quarters of corn, no iron, and of 40 tons of iron, no corn. The "mixture" is preferable, or at least no worse, than the two extremes, in this precise sense. (The effect of this restriction is that the solution of the marginal utility condition turns out to be unique.)

The relationship between net products and gross products is (15.3). We use the matrix W, inverse to V, to express gross products in terms of net products:

$$y_j = \sum_{i=1}^{n} r_i W_{ij} \qquad (15.15)$$

If the economy is productive, theorem 3.10 asserts that the coefficients W_{ij} are nonnegative. Hence, if all the net products are nonnegative, so are all the gross products. The limitation imposed by the finite amount of available land L then becomes, combining (15.4) and (15.15):

$$\sum_{i=1}^{n} r_i \lambda_i = L \quad \text{where} \quad \lambda_i = \sum_{j=1}^{n} W_{ij} b_j \qquad (15.16)$$

The coefficients λ_i are the marginal amounts of land; we see this by differentiating the first equation (15.16):

$$\partial L / \partial r_i = \lambda_i \qquad (15.17)$$

Our maximization problem is then: Maximize the function $U = U(r_1, r_2, \ldots, r_n)$ subject to condition (15.16). This is solved in a standard way by introducing a Lagrange multiplier t to take care of the side condition. The result is:

$$\partial U / \partial r_i = t \lambda_i \qquad (i = 1, 2, \ldots, n) \qquad (15.18)$$

which is the desired marginal utility theorem, relating marginal utility to marginal quantities of land.

In the *absence* of commodity taxation, the matrices W in (15.16) and W' in (15.12) are simply equal to each other; then direct comparison yields the relationship $\lambda_i = p_i/R$ and hence:

$$\partial U / \partial r_i = (t/R) p_i = s p_i \qquad (i = 1, 2, \ldots, n) \qquad (15.19)$$

This is the relationship between marginal utility and prices which are undistorted by commodity taxation. We call attention to the discussion in section E which contains objections to this interpretation of (15.19).

Next, let us say a few words about "cardinal utility" and "ordinal utility." A utility *function* $U = U(r_1, r_2, \ldots, r_n)$ assigns a numerical value of utility to every bundle of consumption goods; in particular, the consumer is supposed to be able to assert that a certain bundle is, say, three times as "utile" to him as some other bundle. This rather implausible concept is called "cardinal utility." On the other hand, suppose the consumer, faced with two bundles of goods, r and r', can decide only between three alternatives: (i) r is less "utile" than r', (ii) r and r' are equally "utile," (iii) r is more "utile" than r'. This concept is called "ordinal utility" since it enables us to establish a rank ordering for all bundles of consumption goods, but not a numerical utility.

Mathematically, the matter is quite trivial. Let $F(U)$ be an arbitrary monotonically increasing function of U. Given any utility

function $U(r)$, we can define a new, rescaled utility function U^*, say, by:

$$U^*(\mathbf{r}) = F\left\{U(r)\right\} \tag{15.20}$$

The theory based upon cardinal utility is *equivalent* to the theory based on ordinal utility if and only if every significant conclusion derived from the utility function U can also be derived equally well from the utility function U^*.

We now show that this is actually the case for the conclusions of interest to us. Our essential conclusion was equation (15.18). Had we started from U^*, we should have obtained, instead:

$$\partial U^*/\partial r_i = t^*\lambda_i \qquad (i = 1, 2, \ldots, n) \tag{15.21}$$

where t^* is a new Lagrange multiplier. We now use (15.21) to *derive* (15.18), thereby proving the equivalence. Apply the chain rule of differentiation to (15.20):

$$\partial U^*/\partial r_i = (dF/dU)(\partial U/\partial r_i)$$

and substitute this into (15.21). Since F is a monotonic function, dF/dU is positive and hence we can divide by it. This yields, from (15.21)

$$\partial U/\partial r_i = t^*(dF/dU)^{-1}\lambda_i = t\lambda_i \quad \text{where} \quad t = t^*/(dF/dU) \tag{15.22}$$

Comparison of (15.22) with (15.18) establishes the theorem. As can be seen, we feel that Professor Hicks has made rather heavy weather of a simple thing in his *Value and Capital* (Hicks 1939). However, we are highly sympathetic to the assertion that consumers should not be expected to decide on cardinal utility, and thus conclusions which depend strictly on cardinal utility [and are therefore *not* invariant under the transformation (15.20)] should be avoided.

The quicksand foundations
of econometrics

A. Introduction

Chapter 11 made use of results from econometric models, and there we gave a very brief account of such models (section 11B). That account was descriptive, not critical. The purpose of the present chapter is to take a critical look at the *econometric theory* on which the analysis of such models is conducted.

Since our conclusions will be largely negative, it is important to state, right at the outset, some things which we do *not* claim, or believe.

1. We have nothing against the construction and testing of economic models. On the contrary, we believe this to be a highly worthwhile activity in applied economics.

2. We have no quarrel with mathematical statistics where this mathematical theory is applicable. The issue here is whether it is applicable to economic models, or more precisely, to what extent it is applicable.

3. We are aware that many econometricians consider that their theory needs to be improved, and they use, in practical work, methods and concepts which are either outside their formal theoretical framework, or even contrary to that framework. We applaud this tendency; but in this chapter, we are concerned with econometric theory as such, not with practical work by econometricians.

4. We are also aware that many econometric theorists would not touch most published econometric studies with a ten-foot pole. However, we would argue that this sharp cleavage between theory and practical application is itself an indication that something is fundamentally wrong with the theory; and we propose to show

what it is. Econometric theorists tend to believe that practical econometric studies are faulty because they fail to apply econometric theory properly. We assert that the opposite is true: The theory is faulty and therefore is not applied "properly" in practice; nor should it be.

Econometric theory has achieved a dominant position in the construction and evaluation of economic models. This theory makes heavy use of both the techniques and the language of mathematical statistics. With a literature of such mathematical sophistication, it is not surprising that laymen, including nonmathematical economists, accept without question the contention that econometric theory is the best, indeed the only proper, theory available. Econometricians are happy to agree.

However, this glib conclusion is by no means obvious. Mathematics, including mathematical statistics, is after all a strictly logical structure. Equation 1 is used to deduce equation 2; equation 2 is used to deduce equation 3; and so on, and on, and on. *But what if equation 1 is wrong in fact, i.e., is in disagreement with the actual situation in the world in which we live?*

In that case, we have an enormous, elaborate, logical structure built on a foundation of quicksand. In our view, and this is what we propose to argue in this chapter, this is true of econometric *theory*, though not necessarily of practical econometric methods. Far from blaming economic model builders for not using their econometric theory properly, we should argue that these model builders are doing exactly the right thing by largely ignoring econometric theory in much of their practical work of model specification and evaluation, only paying lip service to this theory now and then. We blame them only for paying lip service.

The crucial initial assumption of econometric theory, the "equation 1" of this elaborate mathematical structure, is the assumption that the "disturbance terms" in structural equations are random variables suitable for classical mathematical statistics to be applied. (A subsidiary assumption, of less concern to us here, is the assumption that these random variables follow some very simple distribution law, for example, Gaussian multivariate normal distribution.)

If one accepts this basic assumption, then the rest is clear sailing in principle, even though the mathematics may get quite complex for nonmathematicians. Standard statistical theory is then available to decide what is meant by a "good fit," parameters of the model can be "estimated" by standard statistical methods, the range of permissible values of these parameters can also be estimated, and so on.

By this stage, we have reached chapter 2 of books on econometric methods. We are not concerned with this mathematical development; rather, we wish to return to chapter 1, to the supposed justification for the basic assumption, for equation 1. We ask the following questions:

1. Is the basic assumption concerning the disturbance terms likely to be satisfied in practice, in the context of actual econometric models?

2. Is there any evidence that the basic assumption is in fact satisfied?

3. If not, should one use the theory of mathematical statistics for such models?

B. A textbook example

Johnston (1972) is a very widely used text on econometrics. Very early on, on page 17, Johnston presents a table of figures on road casualties and numbers of licensed motor vehicles. These figures are intended to illustrate a simple linear regression, and they are analyzed in that fashion. The parameters of the straight line fit to the data are determined by minimizing a sum of squares of the deviations ("residuals") of the data from the straight line. After this, the properties of the estimators are elucidated. These statistical estimators are shown to be "best linear unbiased." The t-distribution and the F-distribution of mathematical statistics make their appearance. We even get a lemma and its proof. By now, the student is suitably impressed with the rigor and mathematical standard of this whole approach.

Such a student is unlikely to ask searching questions about the very basis for the analysis. Yet, what is not said in all this, but what most certainly should have been said, is that *the figures are clearly inconsistent with the analysis!*

In Table 16.1, we reproduce the original figures and, along with them, the residuals from the "best fit." These residuals are then plotted against the independent variable X (the number of registered motor vehicles) in Figure 16.1.

It is apparent from Table 16.1 that the negative residuals of any size are concentrated at the two ends of the range (X below 430 and X above 650), whereas positive residuals are concentrated in the middle of the range (X between 430 and 650). This is clear evidence that the underlying relationship has an inherent curvature, and should not be approximated by a straight line.

The same appears, much more clearly, from inspection of Figure 16.1. The curved line drawn on that figure is obtained from fitting

Table 16.1

A Textbook Example of an Econometric Fit

X	Y	Best fit[a]	Residual
352	166	165.7	0.3
373	153	172.2	−19.2
411	177	184.1	−7.1
441	201	193.4	7.6
462	216	200.0	16.0
490	208	208.7	−0.7
529	227	220.9	6.1
577	238	235.9	2.1
641	268	255.8	12.2
692	268	271.7	−3.7
743	274	287.6	−13.6

[a] The "best fit" is $Y^* = 55.85 + 0.312X$; the "residual" is $Y - Y^*$.

a quadratic formula $Y = a + bX + cX^2$ to the original points and subtracting from this the straight line fit of Johnston (1972). The difference represents the part of the residuals which can be accounted for on nonrandom grounds. It is apparent that the points are, on the average, much closer to the curve than to the X-axis. This can also be confirmed by working out the sum of the squares of the residuals from the straight line fit (1123) and from the quadratic fit (634). The step from a straight line to a quadratic fit has just about halved the sum of squares, a very significant improvement.

It follows that the "model" used for the straight line fitting (i.e., the assumed relationship $Y = A + BX$) contains serious "specification errors." The residuals from the mis-specified relationship are *not* due entirely, or even largely, to purely random influences. On the contrary, these residuals contain a highly significant systematic, nonrandom component. Any analysis which starts from the assumption that no such nonrandom component exists is an invalid analysis. Conclusions drawn from such an analysis are without logical foundation. Equation 1 is wrong.

One reply is to say that, though it may be unfortunate that such an error has crept into a widely used text, this whole thing is making a mountain out of a molehill. Johnston could have, and should have, picked a better example for his chapter, one where linear regression is not so obviously invalid. This, the argument runs, is hardly a case against econometric theory as such.

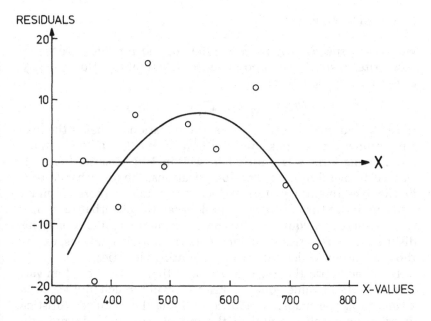

Figure 16.1

Residuals from Table 16.1 are plotted against the independent variable X. There is an evident curvature. The plotted curve represents the *predicted* residuals, from a *quadratic* fit to the same points.

Taken by itself, this rejoinder may appear to have some force. But there are two important points on the other side of that argument:

1. This disregard of the most elementary principles of applied data analysis, the failure to list or plot the residuals, or even to look at them, is unfortunately only too typical of what happens all too often in actual econometric work. Students should be warned against this sort of thing, in the strongest possible terms. It is *not* a light matter, of no importance, that the leading textbook in the field, far from warning students against this error, is actually itself guilty of the same error, in the very first example taken from "real life" data.

2. While it is entirely possible to find a better illustrative example for linear regression, it does *not* follow that all specification errors in practical econometric model building can be eliminated by respecification of the model. On the contrary, we intend to show that, in all actual models, specification errors are the price one *must* pay for having any sort of workable model at all. To this argument, we now turn.

C. Specification errors

We need a specific equation to refer to, and for this purpose we now write down a typical econometric structural equation, namely, a consumption equation:

$$C(t) = C_0 + m Y(t-1) + u(t)$$

Here C_0 and m are parameters of the equation, m being the marginal propensity to consume. The final term $u(t)$ is a "disturbance term." This term was omitted in section 10B because, there, we wanted to avoid unnecessary complications; the disturbance term in the investment equation (which *was* retained there) is much more important for the Frisch model than the disturbance term in the consumption equation. But an econometric model usually has disturbance terms specified for *all* its structural equations, except those equations which represent accounting identities.

In econometric theory, it is *assumed* that $u(t)$ is a random variable with mean value equal to zero. (Usually, much more specific assumptions are made, in addition, about the detailed statistical distribution of all the $u(t)$ in the model; but these do not concern us here.) We wish to discuss this basic assumption, that $u(t)$ is a random variable.

First of all, the quantity $u(t)$ is by no means confined to econometrics. It has an ancient and honorable history in the engineering profession. If we think of the quantity $C_0 + m Y(t-1)$ as the "result computed from the formula" and of $C(t)$ as the true result, then $u(t)$ is simply the difference between them. This is well known in engineering as the *finagle factor*, which is the quantity which must be added to the result obtained by the engineer from his formula, in order to get the right answer. Generations of engineers are prepared to swear to the importance, indeed to the essential necessity, of this factor. But mighty few of them, if any, think of it as a *random* factor.

In our opinion, the words used most commonly in econometrics to denote $u(t)$ carry unwanted connotations: "Disturbance term" or "shock term" suggests that any departure from the formula is an unwelcome disturbing influence, or even a nasty shock, to our perfect equations; and "noise term" implies, outright, that $u(t)$ has its origin in a random noise effect; i.e., it (implicitly) assumes what needs to be proved. We shall use "discrepancy term" for $u(t)$. This is a neutral word; a "discrepancy" may be due to random noise, or to some other source, or to a combination of the two.

It would be idle to deny, and we do not deny, that random noise

effects do exist in consumption and do contribute to the discrepancy term. Consumer behavior is hard to predict, and not merely in the area of fashion. No simple equation and, probably, not even a complicated equation, is likely to fit actual data precisely. (It would be a brave man indeed who tried to fit, *in detail*, the points of Figure 16.1 for motor accidents; there is clearly some pretty wild "jumping about" of these points.)

But, and this is the main point, is this random noise component the *only* contribution to $u(t)$, or even the contribution of biggest size and most importance? To see that this hypothesis cannot be expected to hold, let us now list several separate *nonrandom* sources of discrepancies, each of them likely to be of very considerable practical importance.

1. *Truncation error*: Even if consumption depends only on income, why should it be a *linear* function of income? There is no more reason to believe this for consumption than for motor accidents. To allow for this, we should replace the linear form $C_0 + mY$ by some curved relationship; for example:

$$C_0 + m_1 Y + m_2 Y^2 + m_3 Y^3 + \ldots + m_N Y^N$$

We can certainly get better fits this way; indeed, for any finite number of data points, we can obtain a perfect fit, zero residuals, merely by choosing a large enough value of N. But such a procedure is senseless: any *new* data point is likely to fall far away from that sort of prediction. The data do not warrant high values of N. We are thus *forced* to use some simple relationship (for example, a low value of N), containing but a few parameters. But while our assumed relationship is simple, and must be simple, the real world is not simple. There is therefore bound to be *nonrandom* discrepancy between our equation and the real world result.

2. *Lag structure error*: Our consumption equation makes $C(t)$ depend on income in the preceding period, $Y(t-1)$, only. Consumers, however, do not have such very short memories of past income levels. We should therefore include terms involving $Y(t-2)$, $Y(t-3)$, etc., probably to quite some depth (particularly for a quarterly model). Yet, the data do not warrant this. By introducing such a complex lag structure, we necessarily introduce many more parameters than the data warrant. Conversely, when we retain a very simple lag structure, we must anticipate another *nonrandom* discrepancy between our equation and the truth.

3. *Aggregation error*: The national income Y and national consumption C are highly aggregated quantities. Consumption of, say, motor cars might well show a strong functional relationship with

the income of those consumer groups that are in the habit of buy-
ing motor cars. But it does not follow automatically that a true
functional relationship exists between the aggregates Y and C. In-
come distribution, different propensities to consume of different
income groups, etc., all need to be allowed for. If we want precise,
accurate relationships, we must be prepared to disaggregate our
model heroically. Yet, this process of disaggregation produces
models which are enormous, unwieldy, and so complicated that no
one except the model builder himself knows what is inside the
monster—and probably he does not know either, because he has
forgotten half the equations and three quarters of the reasoning
that went into them. Any practically useful model *must* be strongly
aggregated, giving rise to a third source of *nonrandom* discrepancy.

4. *Omitted variable error*: The propensity to save is commonly
believed to be influenced by the interest rate $r(t)$ on money invest-
ments. Thus $r(t)$ should appear in our consumption equation. Since
it doesn't, it is an "omitted variable." Again, if consumers are con-
cerned about losing their jobs, they may save more in anticipation
of a rainy day. Thus, the current rate of unemployment, and trends
in that rate, are strong candidates for inclusion in a consumption
equation. Some economists would like to include the current rate
of money inflation, and trends in *that* rate. For each structural
equation of a model, it is only too easy to give excellent economic
reasons for including scores of additional explanatory variables.
But it is impossible to let everything depend on everything else by
direct causal links; otherwise we again have entirely too many pa-
rameters for our limited and inaccurate data to support.

5. *Unknown variable error*: Consumption expenditure contains
an element of anticipation of the future, of confidence (or lack of
confidence) in continuance of the consumer's income, his job, his
location, etc. A man expecting to be forced to move to a differ-
ent city will spend less on his house and garden than one who
thinks he will be able to stay. But expectations, anticipations, and
confidence are awkward material with which to construct an econ-
ometric model. Econometricians have an almost religious horror of
including variables for which firm data are missing, no matter how
much economists might insist that just these variables are of major
importance. This trouble is by no means confined to variables
which are hard to measure in principle. There are other variables,
for example, the pay-back time in the theory of investment evalu-
ation, chapter 13, which are measurable by standard survey meth-
ods, but for which neither current data nor past data have in fact
been obtained. By omitting such variables, the econometricians are

bound to introduce severe *nonrandom* errors into their structural equations.[1]

These five types of nonrandom errors are not the only ones, but they suffice for our purpose: *We have excellent reason to expect nonrandom sources of discrepancies, i.e., specification errors, of significant size, in all practical econometric models; obvious data limitations make it impossible to eliminate these errors.*

In principle, econometric theorists recognize the possibility of specification errors. But the amount of attention devoted to such errors is completely out of proportion to their true importance. In Johnston (1972) the index entry "specification error" directs us to a discussion of less than two pages, in a book of four hundred (!) pages. The *only* specification error discussed there is our type four, the omitted variable error. This distribution of emphasis between random noise errors and nonrandom specification errors is wildly misleading. Unfortunately, it is also entirely typical.

One might hope to find a more adequate treatment of specification errors in the periodical literature of econometrics. Hope one might, but largely in vain. The distribution of emphasis is, if anything, even more lopsided than in the textbooks. Until fairly recently, there was just one major econometric paper on specification errors, by Ramsey (1969).[2] This paper presents four tests designed to detect the presence of certain types of specification errors. This is certainly a step in the right direction. Ramsey's paper also shows that the Durbin-Watson (Durbin 1950, 1970) test, the one used most widely in practice, is insensitive to important types of specification errors. Still, 1969 is thirty years (!) after Keynes' (1939) devastating critique of the foundations of econometrics;[3] worse yet, the Ramsey tests were ignored altogether for a number of years and have been employed very sparingly indeed more recently (Harper 1977, Loeb 1976, Harvey 1977); when they were used, the tests showed that *all* models under consideration failed one or more tests. The gravity of the situation has been empha-

[1] Formally, errors of types 4 and 5 are the same, i.e., omission of some variables. But a type 4 error can be corrected by inclusion of known data, whereas one requires new data gathering in order to correct a type 5 error. In our view, type 5 errors are probably the ones of most importance in practice. For example, no investment equation which ignores pay-back time is at all realistic or likely to provide an adequate (to say nothing of a good) fit.

[2] Mathematical statisticians produced such papers much earlier, e.g., Cox (1961). The early econometric papers were devoted mainly to the omitted variable error (Cragg 1968, Praetz 1977); subsequently, interest has widened, e.g., Breusch (1980), Hendry (1978, 1979), Leamer (1978), Mizon (1977), Ramsey (1972), Sims (1977), White (1980).

[3] For a complete historical account with full references, see Patinkin (1976).

sized by Granger (1974), and even more acidly by Leontief (1970): "In no other field of empirical enquiry has so massive and sophisticated a statistical machinery been used with such indifferent results."

It is sad that econometric theory places so little emphasis on specification errors. Sad, yes; but surprising, no. For econometric *theory*, the consequences of admitting that specification errors are present, of *necessity*, in all practical models are too awful to bear thinking about. The entire theory is founded on the assumption that the model is either free of specification errors altogether, or else that these errors combine with each other and cancel each other in just such a way that the overall net discrepancy terms $u(t)$ can be represented, to an entirely adequate approximation, by a purely random variable with some simple (usually normal) distribution. *The entire technical mathematical apparatus of econometrics is predicated on this basic assumption and loses its rationale if this assumption is not valid.*

At this point, let us quote Bertrand Russell (1936):

> I wish to propose for the reader's favourable consideration a doctrine which may, I fear, appear wildly paradoxical and subversive. The doctrine in question is this: that it is undesirable to believe a proposition when there are no grounds whatever for supposing it true.

The essay from which this quotation is taken is concerned with religious, not econometric, dogma. But the doctrine espoused applies to both. Nothing short of a miracle could make all the types of specification errors cancel each other in precisely that way needed to give a net result equivalent to a normally distributed random variable. The miracle required is of the same order as the most spectacular religious miracles. Yet, we have much less incentive to accept the econometric miracles: Unlike the bishops, the econometricians do not even *promise* us sure entry to paradise as the reward for believing in *their* miracles.

D. Discussion

We have now demonstrated that it is *inevitable* that the discrepancy terms contain significant nonrandom contributions; and there is no reason to suppose that these discrepancy terms can be represented correctly by Gaussian random variables. What follows from this?

First, and most important, *standard statistical methods of analysis are out of place in this area of research*. The statistical methods are "unbiased," "efficient," etc., *if* the underlying statistical

assumption is valid, i.e., *if* the discrepancy terms are correctly represented by random variables with the postulated distributions. Since this is false, *there is no secure logical basis for the application of mathematical statistical theory.* On the contrary, the technical statistical apparatus of econometric theory is a misapplication of mathematical statistics.

There is clearly no warrant for *insisting* on statistical methods in the area of economic model building. One cannot and should not insist on the use of an apparatus when the logical foundations for its use are absent. Some people may feel, though, that this statistical apparatus exists, at least, and, in the absence of anything better, one might as well use it even if the logical foundations are rather shaky. What harm can it do?

The answer is: Plenty of harm!

First, the statistical apparatus is hard to apply unless the model equations are kept very simple, either completely linear or nearly so. For example, equations might be linear in logarithms of variables rather than in the variables themselves; or there might be ratios of current values to price indices, which is of course a nonlinear type of term. But such nonlinearities are "mild" compared to the sort of thing that economic theory might suggest, such as "floors" or "ceilings," or both, to all sorts of quantitative relationships. The Phillips curve must become *highly* nonlinear in the close neighborhood of full employment. An accelerator equation for investment must be subject to a floor (hence highly nonlinear) arising from the limited, and slow, rate of physical depreciation of existing capital stock. Such examples can be multiplied ad infinitum.[4]

But, whenever such things are suggested to econometric model builders, their reply is only too predictable: "Sure, we know about such effects. But we cannot incorporate them into our model, because then we could no longer apply standard econometric theory. Therefore, our only choice is to approximate these effects very crudely, or omit them altogether."

This is the first, extremely severe, harm done by the insistence on formal statistical theory in this area: Practical models[5] are mutilated to fit into a narrow theoretical statistical mold, at the expense of economic realism. Yet there exists no valid logical reason for insisting on this mold.

A second, very bad, effect is the substitution of an inapplicable

[4] Econometric techniques for handling such things are now being developed (e.g., Berndt 1974, Richard 1980) but are terribly complex, to the point of being impractical.

[5] See, e.g., Challen (1979).

formal statistical theory for common sense in data analysis. How often, in the literature of econometric models, have you seen actual plots of residuals? Or even a discussion of what the residuals look like? Much more rarely, we should say, than is obviously desirable. Formal statistical criteria such as DW and R^2 are calculated and quoted, but the residuals are ignored. Statistical theory induces an entirely unwarranted sense of complacency. Our textbook example of section B is, unfortunately, only too relevant to common practice. For this example, the Durbin-Watson coefficient DW turns out to be in the "twilight region," where the property tested for (auto-correlation of the residuals) is neither confirmed nor denied. Nor is auto-correlation the real fault!

One particularly bad area of complacency is in error estimates for parameter values and for predictions of the future. A theory based on the assumption that the discrepancy terms are purely random variables is bound to lead to the conclusion that these discrepancy terms, in the same structural equation at different time periods and/or in different structural equations, have a strong tendency to cancel each other in their ultimate effects. The "law of large numbers" is expected to hold. But this law does *not* hold when the errors have strong nonrandom components. Such components have no tendency to cancel, but rather tend to reinforce each other. For this reason, *the standard "confidence intervals" of econometric theory are highly likely to be underestimates, often very bad underestimates, of the true errors.*

It is therefore *not* an accident, or simple bad luck, that econometric models have such a very indifferent track record in forecasting. The forecast errors are estimated from statistical theory and are *therefore* highly likely to be strongly underestimated. Far from helping, this misapplication of statistical theory has brought the whole field of model building into quite unnecessary bad repute. Without this statistical theory, model builders would not be misled into making exaggerated claims of precision for their forecasts, or for their parameter values.

Still another problem arises in models specified in continuous time, i.e., where t is taken to be a real variable, not jumping by finite jumps. In this case, the structural equations become differential equations, rather than the more familiar difference equations of "period models"; see, for example, sections 10B and 10C. Numerical analysts have developed extremely efficient methods for solving coupled systems of ordinary differential equations, notably the fourth-order Runge-Kutta method (see Conte 1965, p. 220). Yet, this method is *not* used in the standard work on models specified in continuous time (Bergstrom 1976; Wagner

1978). Rather, they use a second-order technique of very much poorer accuracy. The reason is that the second-order technique (but not the fourth-order technique) allows one to employ standard statistical methods of estimation.

But the statistical estimation procedure in question is predicated upon the assumption that the discrepancy terms are not only random variables, but even random variables of the special kind called "white noise."[6] There does not seem to be a single argument in favor of (or, for that matter, against) this white noise assumption in the literature. This most fundamental matter of all is simply taken for granted, as if it were a self-evident truth!

Yet, as soon as we start to think seriously about this assumption, it looks peculiar indeed. Consider a structural equation for the rate of change dI/dt of net investment. Suppose the discrepancy term $u(t)$ happens to be positive at some time t. This indicates that, at this time, investment outlays are rising faster than expected from the formula. Given the crude nature of most investment equations, such a discrepancy is hardly surprising. However, it would be not only surprising, but positively astounding, should there be a sudden reversal of the *sign* of $u(t)$ the week after. Investment confidence is known to be volatile, but it is hardly likely to veer about suddenly every single week. Yet the white noise assumption implies that there is no correlation whatever between $u(t)$ and $u(t')$ at two different times $t \neq t'$, no matter how close together these two times are. The sudden reversal of sign of $u(t)$, which is so unlikely on commonsense economic grounds, should have a 50-50 chance of happening on the white noise assumption!

Thus, one need merely state the *meaning* of the white noise assumption to conclude that this assumption is highly unreasonable in the context of an economic model. (In its proper sphere, communications engineering, the white noise assumption is perfectly sensible.) Nonetheless, just for the sake of a spurious statistical orthodoxy on the basis of *that* assumption, clearly superior methods of numerical analysis are discarded in favor of vastly inferior techniques.

But, some may object, if we are not to use standard statistical methods in economic model building and analysis, what are we to use? What other methods are there?

If by a "method" one means a cut-and-dried prescription which

[6] Crudely speaking, "white noise" means a disturbance which is entirely uncorrelated in time; i.e., the noise term $u(t)$ at time t has no statistical relationship at all to the noise term $u(t')$ at some other time t', no matter how close these two times are to each other. A full mathematical definition of white noise would carry us too far, particularly since we strongly disapprove of using the white noise assumption in an economic context.

can be taught to any fool, or even a computer, then indeed one is in trouble. But model building is not, and never has been, a task for fools or computers. It is one of the most difficult, challenging, and intricate fields of applied economic research. Fools should stay out of it.

Specification errors, *not* purely random errors, are the main enemy of the economic model builder. His first and overriding concern must be with lessening (*not* eliminating——that is impossible) specification errors. *The elaborate statistical methodology which is designed to decrease the effects of purely random errors is largely irrelevant to the real problem faced by the model builder, and, being irrelevant, tends to be misleading.* The model builder needs more robust, commonsense methods of data analysis.

Equations should be tested one at a time, *not* by "full information" techniques which try to look at the whole set of equations at once. The effect of the latter is to modify parameters in one equation, so as to lessen the results of the error introduced by another equation. In consequence, it is impossible to tell which equation (or equations) is mainly responsible for the errors. By contrast, testing one equation at a time has a good chance of showing up the particularly faulty equations in the model. For each equation, the residuals should be evaluated and listed and plotted. It is not at all sufficient to correlate the residuals with each other, to test for auto-correlations. Rather, the residuals should be plotted, in turn, against each of the explanatory variables of the model, as well as against some of the omitted variables. Any strong apparent dependence in such a plot is grounds for suspicion. It is important to *plot* residuals, graphically, not merely list them numerically. The human eye, inspecting a graph, is much better at pattern detection than any mechanical rule. The computer can calculate the residuals and prepare the graph, but the computer is no substitute for human intelligence in actually looking at the graph.

After each equation of the proposed model has been tested individually and the most glaring specification errors have been improved, only then should one start to look at the model as a whole. For this purpose, an obvious device is *simulation*, preferably for a number of time periods ahead, not just for one period. We may start from a time such as three years ago and run the model forward to the latest time for which we have data, e.g., a year ago. This provides a sensitive test of the specification of the model as a whole. The simulation should be deterministic, *not* stochastic. The underlying assumption for stochastic simulation is just the one we have argued against throughout this chapter, namely, the

assumption that the discrepancy terms are purely random variables. There is no basis in logic for this assumption and, hence, also not for stochastic simulation. (This is one more point where econometric theory is misleading; it asserts that stochastic simulation is inherently superior; it is not.) If the simulation shows that one particular endogenous variable is out by a mile, then the structural equation for that variable, and for variables closely related to it, should be looked at again.

What about error estimates? What are the likely errors in our estimates of the parameters of the model and in our predictions of the future behavior of the economy? The statistical method used in econometric theory has the virtue that it provides clear and definite answers to such questions. Unfortunately, these answers are clearly and definitely wrong. The true errors are underestimated, often disastrously so.

From one point of view, providing no answers at all is still better than providing answers which are badly wrong. If one does not know, it is safer as well as more honest to admit so, openly.

However, there is no need to be so completely ignorant of likely errors. There is of course no cut-and-dried prescription for estimating errors when the most important source of error is mis-specification. But several things can be done:

1. The model builder may start from a point in the past and let the model simulate forward in time to a point in the more recent past. He can then compare his "pseudoforecast" with the (already known) true outcome.

2. An extremely valuable procedure is to build a "trivial model," for example, one which says that the future can be predicted by simple mechanical extrapolation of past trends. The trivial model can then be used for a similar "pseudoforecast." If the trivial model predicts as well as, or better than, the econometric model (this is by no means an uncommon occurrence), then one's confidence in the econometric model is decreased substantially (Smyth 1975, Blatt 1979a).

These suggestions are by no means original or novel. They are just common sense and are in fact used quite frequently by practical model builders. Such men are much more sensible than the statistical theory on which, ostensibly though not in reality, they base their work. We have no wish to attack practical model builders. On the contrary, we wish to free them from needing to pretend to adhere to econometric theory. Far from being any help in modeling or understanding the economy, this theory is an outright hindrance to progress.

We close this chapter with a quote from an extensive discussion on a survey paper by Zellner (1979). The quote is from Rothenberg (1979): "Indeed, one is sometimes led in despair to give up all hope of using formal statistical methods to describe our data-mining practices."

And high time, too!

Bibliography

ADELMAN, Irma and Frank.
1959 "The Dynamic Properties of the Klein-Goldberger Model." *Econometrica*, 1959, *27*(4), 596-625. 11B, E.

ALLAIS, M.
1953 "L'Extension des Théories de l'Equilibre Economique Général et du Rendement Social au Cas du Risque." *Econometrica*, 1953, *21*, 269-290. 12C.

1979 and O. Hagen (eds.). *Expected Utility Hypotheses and the Allais Paradox: Contemporary Discussions of Decisions under Uncertainty with Allais' Rejoinder*. Dordrecht, Holland: Reidel, 1979. 12C.

AMANO, A.
1964 "Neoclassical Biased Technical Progress and a Neoclassical Theory of Economic Growth." *Quarterly Journal of Economics*, 1964, *78*, 129-138. 7D.

ARA, Kenjiro.
1959 "The Aggregation Problem in Input-Output Analysis." *Econometrica*, 1959, *27*, 257-262. 5D.

ARDITTI, Fred D.
1977 and Haim Levy. "The Weighted Average Cost of Capital as a Cut-Off Rate." *Financial Management*, 1977, *6*, 24-34. 13A, C.

ARROW, Kenneth J.
1951 "Alternative Approaches to the Theory of Choice in Risk-Taking Situations." *Econometrica*, 1951, *19*, 404-437. 12F.

1954 and Gerhard Debreu. "Existence of an Equilibrium for a Competitive Economy." *Econometrica*, 1954, *22*(3), 265-290. 7D.

1959 "Toward a Theory of Price Adjustment." In *The Allocation of Economic Resources*, ed. by M. Abramovitz et al. Stanford: Stanford University Press, 1959, 41—51. 7D.

1960 S. Karlin, and P. Suppes (eds.). *Mathematical Methods in the Social Sciences*. Stanford: Stanford University Press, 1960. 7D, 10C.

1961 H. B. Chenery, B. S. Minhas, and R. M. Solow, "Capital-Labour Substitution and Economic Efficiency." *Review of Economics and Statistics*, 1961, *43*, 225-250. 7C.

1965 *Aspects of the Theory of Risk-Bearing*. Helsinki: Yrjö Jahnsson
 Säätio, 1965. 12B. 13A.

1968 "Applications of Control Theory to Economic Growth." In *Lectures
 in Applied Mathematics*, Vol. 12. Providence, Rhode Island: 1968.
 11A.

1970 and M. Kurz. *Public Investment, the Rate of Return, and Optimal
 Fiscal Policy*. Baltimore: Johns Hopkins Press, 1970. 11A.

1971 and Frank H. Hahn. *General Competitive Analysis*. Edinburgh:
 Oliver and Boyd, 1971. 3C, 7D.

1973 and David A. Starrett. "Cost- and Demand-Theoretical Approaches
 to the Theory of Price Determination." In *Carl Menger and the
 Austrian School of Economics*, ed. by J. R. Hicks and W. Weber.
 Oxford: Oxford University Press, 1973, pp. 129-148. 7D.

ARTIS, M. J.
1977 and A. R. Nobay (eds.). *Studies in Modern Economic Analysis*.
 Oxford: Basil Blackwell, 1977. 16C.

ASH, J. C. K.
1975 SEE D. J. Smyth.

ATKINSON, Margaret.
1978 and Jacques Mairesse. "Length of Life of Equipment in French
 Manufacturing Industries." *Seventh Conference of Economists*.
 Sydney: Macquarie University, August 1978. 5D.

BAGEHOT, Walter.
1873 *Lombard Street*. London: Kegan Paul, 1873. (Page quotations from
 1906 edition.) 7D, 14B, D.

BANZ, Rolf W.
1978 and Merton H. Miller. "Prices for State-Contingent Claims: Some
 Estimates and Applications." *Journal of Business*, 1978, *51*(4),
 653-672. 13A.

BARLOW, R.
1965 and F. Proschan. *Mathematical Theory of Reliability*. New York:
 Wiley, 1965. 13C.

BARRO, Robert J.
1976 and Hershel I. Grossman. *Money, Employment, and Inflation*.
 London: Cambridge University Press, 1976, 1C.

BATTEN, David F.
1979 "The Estimation of Capital Coefficients in Dynamic Input-Output
 Models." *Eighth Conference of Economists*. Melbourne: La Trobe
 University, August 1979. 5D.

BECKER, S.
1964 and F. Brownson. "What Price Ambiguity? Or the Role of Ambi-
 guity in Decision-Making." *Journal of Political Economy*, 1964, *72*,
 63-73. 12F.

BENASSY, Jean-Pascal.
1973 *Disequilibrium Theory*. Ph.D. thesis, University of California, 1973.
 1C.

BEN-HORIM, Moshe.
1979 "Comment on 'The Weighted Average Cost of Capital as a Cutoff
 Rate.'" *Financial Management*, 1979, *8*, 18-21. 13A, C.

BERGSTROM, A. R.
1976 (ed.). *Statistical Inference in Continuous-Time Econometric Models.* Amsterdam: North Holland, 1976. 16D.

BERNDT, E. K.
1974 with B. H. Hall, R. E. Hall, and J. A. Hausman. "Estimation and Inference in Nonlinear Structural Models." *Annals of Economic and Social Measurement,* 1974, *3/4,* 653-665. 16D.

BERNOULLI, Daniel.
1738 *Specimen Theoriae Novae de Mensura Sortis.* St. Petersburg, 1738. English translation in *Econometrica,* 1954, *22,* 23-36. 12B.

BERNSTEIN, Richard H.
1981 "Avoiding Irrationality in the Use of Two-Parameter Risk-Benefit Models for Investment under Uncertainty." *Financial Management,* 1981, *10*(1), 77-81. 12 E.

BLACK, F.
1973 and M. J. Scholes. "The Pricing of Options and Corporate Liabilities." *Journal of Political Economy,* 1973, *81,* 637-654. 13A.

1976 "The Pricing of Commodity Contracts." *Journal of Financial Economics,* 1976, *3,* 167-179. 13A.

BLAIR, John M.
1974 "Market Power and Inflation: A Short-Run Target Return Model." *Journal of Economic Issues,* 1974, *8,* 453-478. 1C.

BLAKLEY, G. R.
1967 and W. F. Gossling. "The Existence, Uniqueness and Stability of the Standard System." *Review of Economic Studies,* 1967, *34,* 427-431. 1C.

BLATT, John M.
1978 "On the Econometric Approach to Business-Cycle Analysis." *Oxford Economic Papers,* 1978, *30,* 292-300. 11C.

1979 "Investment Evaluation Under Uncertainty." *Financial Management,* 1979, *8,* 66-81. 13A.

1979a "Investment: Fact and Neo-Classical Fancy." *Eighth Conference of Economists.* Melbourne: La Trobe University, August 1979. 13A, D.

1980 "On the Frisch Model of Business Cycles." *Oxford Economic Papers,* 1980, *32*(3), 467-479. 11D, E.

BLAUG, Mark.
1968 *Economic Theory in Retrospect.* 2nd edition. London: Heinemann, 1968. 1A.

1975 *The Cambridge Revolution: Success or Failure.* London: Institute for Economic Affairs, 1975. 1C.

BLISS, C.
1975 *Capital Theory and Distribution.* Amsterdam: North-Holland, 1975. 1C.

BODKIN, Ronald G.
1969 "Real Wages and Cyclical Variations in Employment: A Re-examination of the Evidence." *Canadian Journal of Economics,* 1969, *2,* 353-374. 10C.

BORCH, Karl Henrik.
1968 *The Economics of Uncertainty.* Princeton: Princeton University Press, 1968. 12B, C, 13A.

1968a and J. Mossin (eds.). *Risk and Uncertainty.* New York: St. Martin's Press, 1968. 12F.

BOSCHAN, Charlotte.
1971 SEE G. Bry.

BOUDREAUX, Kenneth J.
1977 and Hugh W. Long. *The Basic Theory of Corporate Finance.* Englewood Cliffs, NJ: Prentice-Hall, 1977. 13A, C.

1979 and Hugh W. Long. "The Weighted Average Cost of Capital as a Cut-Off Rate: A Further Analysis." *Financial Management,* 1979, *8,* 7-14. 13A, 13C.

BOWDEN, R. J.
1972 "More Stochastic Properties of the Klein-Goldberger Model." *Econometrica,* 1972, *40,* 87-98. 11B.

BOWER, Richard S.
1973 and Donald R. Lessard. "An Operational Approach to Risk Screening." *Journal of Finance,* 1973, *28*(2), 321-338. 13A.

1975 and Jeffrey M. Jenks. "Divisional Screening Rates." *Financial Management,* 1975, 42-49. 13A.

BRAY, Jeremy.
1978 "Cracking Open the Secrets of the Treasury's Black Box." *New Statesman,* 14 July 1978, 42-45. 11D.

1979 "New Models of the Future." *New Statesman,* May 1979, 710-714. 11D.

BRECHLING, Frank P. R.
1965 SEE F. H. Hahn.

1975 *Investment and Employment Decisions.* Manchester: Manchester University Press, 1975. 13A.

BREMS, H.
1977 "Reality and Neo-Classical Theory." *Journal of Economic Literature.* 1977, *15*(1), 72-83. 8C.

BRENNAN, M. J.
1978 and E. S. Schwartz. "Corporate Income Taxes, Valuation, and the Problem of Optimal Capital Structure." *Journal of Business,* 1978, *51,* 103-114. 13A.

BREUSCH, T. S.
1980 and A. R. Pagan. "The Lagrange Multiplier Test and Its Applications to Model Specification in Econometrics." *Review of Economic Studies,* 1980, *47*(1), 239-253. 16C.

BRODY, A.
1972 SEE A. P. Carter.

BRONFENBRENNER, M.
1963 and F. D. Holzman. "Survey of Inflation Theory." *American Economic Review,* 1963, *53*(4), 593-661. 1C.

BROWN, M.
1962 "The Constant Elasticity of Substitution Production Function." Report No. 6219. Rotterdam: Econometric Institute, June 1962. 7C.

1963 and J. S. de Cani. "Technological Change and the Distribution of Income." *International Economic Review,* 1963, *4,* 289-309. 7C.

BROWNSON, F.
1964 SEE S. Becker.

BRUNNER, Karl.
1976 and Allan H. Meltzer (eds.). *The Phillips Curve and Labour Markets.* Amsterdam: North-Holland, 1976. 10C.

BRY, Gerhard.
1971 and Charlotte Boschan. "Cyclical Analysis of Time Series: Selected Procedures and Computer Programs." Technical Paper 20. New York: National Bureau of Economic Research, 1971. 11D, E.

BURMEISTER, Edwin.
1968 "On a Theorem of Sraffa." *Economica*, 1968, *35*, 83-87. 1C.

BURNS, Arthur F.
1947 and Wesley C. Mitchell. "Measuring Business Cycles." New York: National Bureau of Economic Research, 1947. 11D, E.

CARLSON, C. Robert.
1975 SEE T. J. Nantell.

CARLSON, John A.
1979 "Expected Inflation and Interest Rates." *Economic Inquiry*, October 1979, *17*, 597-608. 1C.

CARMICHAEL, J.
1975 and P. M. Norman. "The Supply Price of Capital: An Empirical Reformulation and Some Points of Clarification." Research Discussion Paper 1/75. Sydney: Reserve Bank of Australia, February 1975. 13A.

CARTER, A. P.
1972 and A. Brody (eds.). *Contributions to Input-Output Analysis.* Amsterdam: North-Holland, 1972. 5D.

CARTER, C. F.
1971 and B. R. Williams. *Investment in Innovation.* London: The New Manager's Library, MacDonald, 1971. 13D, E.

CASS, D.
1976 and K. Shell (eds.). *The Hamiltonian Approach to Dynamic Economics.* New York: Academic Press, 1976. 7D.

CHALLEN, D. W.
1979 and A. J. Hagger. *Modelling the Australian Economy.* Sydney: Longman-Cheshire, 1979. 16D.

CHAMBERLIN, Edward H.
1933 *The Theory of Monopolistic Competition.* Cambridge, MA: Harvard University Press, 1933. 1C.

CHAMPERNOWNE, D. G.
1945-
46 "A Note on J. von Neumann's Article on 'A Model of Economic Equilibrium.'" *Review of Economic Studies*, 1945-46, *13*, 10-18. 4E.

1958 "Capital Accumulation and the Maintenance of Full Employment." *Economic Journal*, 1958, *68*, 211-244. 7D.

CHENERY, Hollis B.
1949 "Engineering Production Functions," *Quarterly Journal of Economics*, 1949, *63*, 507-531. 7C, D.

1952 "Overcapacity and the Acceleration Principle." *Econometrica*, 1952, *20*(1),1-28. 9A.

1959 and Paul G. Clark. *Interindustry Economics.* New York: Wiley, 1959. 5D.

1961 SEE K. J. Arrow.

CHOW, Gregory C.
1975 *Analysis and Control of Dynamic Economic Systems*. New York: Wiley, 1975. 11A.

CLARK, David L.
1974 "The Origins of Input-Output Analysis: Walras versus Marx." *Fourth Conference of Economists*. Canberra: Australian National University, August 1974. 5D.

1978 "The Cambridge Controversies in Capital Theory: Some Institutionalist Precursors." *Seventh Conference of Economists*. Sydney: Macquarie University, August 1978. 1C.

CLARK, John Maurice.
1917 "Business Acceleration and the Law of Demand: A Technical Factor in Economic Cycles." *Journal of Political Economy*, 1917, *25*, 217-235. 9A.

CLARK, Paul G.
1959 SEE H. B. Chenery.

CLEMENCE, Richard V.
1953 SEE A. H. Hansen.

CLOWER, Robert.
1965 "The Keynesian Counterrrevolution: A Theoretical Appraisal." Chapter 5 in F. H. Hahn, 1965. 1C.

1967 "A Reconsideration of the Micro-foundations of Monetary Theory." *Western Economic Journal*, December 1967, *6*, 1-8. 1C.

COGHLAN, P. L.
1976 SEE C. I. Higgins.

COLLARD, David.
1973 "Leon Walras and the Cambridge Caricature." *The Economic Journal*, 1973, *83*, 465-476. 1C.

COLLIER, P.
1977 SEE A. C. Harvey.

COMRIE, Leslie John.
1949 *Chambers's Six-Figure Mathematical Tables*. Edinburgh: Chambers, 1949. 13F.

CONOVER, William Jay.
1971 *Practical Nonparametric Statistics*. New York: Wiley, 1971. 11E.

CONTE, S. D.
1965 *Elementary Numerical Analysis*. New York: McGraw-Hill, 1965 (see p. 220). 16D.

COX, D. R.
1961 "Design of Experiments: The Control of Error." *Journal of the Royal Statistical Society, Series A*, 1961, *124*, 44-48. 16C.

CRAGG, John G.
1968 "Some Effects of Incorrect Specification on the Small Sample Properties of Several Simultaneous-Equation Estimators." *International Economic Review*, 1968, *9*(1), 63-86. 16C.

DAVIDSON, Paul.
1965 "Keynes's Finance Motive." *Oxford Economic Papers*, 1965, *17*, 47-65. 1C.

DAY, Richard H.
1972 "Recursive Programming Models of Industrial Development and Technological Change." Chapter 5 in A. P. Carter, 1972. 5D.

DEBREU, Gerhard.
1954 SEE K. J. Arrow.

1959 *Theory of Value.* New York: Wiley, 1959. 1C, 3C.

1962 "New Concepts and Techniques for Equilibrium Analysis." *International Economic Review*, 1962, *3*, 257-273. 3C.

de CANI, J. S.
1963 SEE M. Brown.

DERKSEN, J. B. D.
1940 "Long Cycles in Residential Building: An Explanation." *Econometrica*, 1940, *8*, 97-116. 9C.

DOBB, Maurice.
1973 *Theories of Value and Distribution Since Adam Smith.* London: Cambridge University Press, 1973. 1C.

DOMAR, E. D.
1946 "Capital Expansion, Rate of Growth and Employment." *Econometrica*, 1946, *14*, 137-147. 10C.

1947 "Expansion and Employment." *American Economic Review*, 1947, *37*, 34-55. 10C.

1957 *Essays in the Theory of Economic Growth.* New York: Oxford University Press, 1957. 10C.

DORFMAN, Robert.
1958 with Paul A. Samuelson and Robert M. Solow. *Linear Programming and Economic Analysis.* New York: McGraw-Hill, 1958. 4A, 5D, 7D.

DOWNS, Anthony.
1965 SEE R. J. Monsen.

DRANDAKIS, Emanuel M.
1963 "Factor Substitution in the Two-Sector Growth Model." *Review of Economic Studies*, 1963, *30*, 217-228. 7D.

DUESENBERRY, J. S.
1958 *Business Cycles and Economic Growth.* New York: McGraw-Hill, 1958. 10C.

DURBIN, J.
1950 and G. S. Watson. "Testing for Serial Correlation in Least-Squares Regression." *Biometrika*, 1950, *37*, 409-428. 11E.

1951 and G. S. Watson. "Testing for Serial Correlation in Least-Squares Regression." *Biometrika*, 1951, *38*, 159-178. 11E.

1970 "Testing for Serial Correlation in Least-Squares Regression When Some of the Regressors are Lagged Dependent Variables." *Econometrica*, 1970, *38*, 410-421. 11E.

EDWARDS, Ronald S.
1952 "The Pricing of Manufactured Products." *Economica*, 1952, *19*, 298-307. 1C, 2A.

EICHNER, Alfred S.
1969 *The Emergence of Oligopoly: Sugar Refining as a Case Study.* Baltimore: Johns Hopkins Press, 1969. 1A, 13A.

1973 "A Theory of the Determination of the Mark-Up Under Oligopoly."
 Economic Journal, 1973, *83*, 1184-1200. 13A.

1974 "Determination of the Mark-Up Under Oligopoly: A Reply." *Economic Journal*, 1974, *84*, 974-980. 13A.

1975 "A Theory of the Determination of the Mark-Up Under Oligopoly:
 A Further Reply." *Economic Journal*, 1975, *85*, 149-150. 13A.

1975a and J. A. Kregel. "An Essay on Post-Keynesian Theory: A New Paradigm in Economics." *Journal of Economic Literature*, 1975, *13*, 1293-1314. 1C.

1976 *The Megacorp and Oligopoly*. Cambridge: Cambridge University Press, 1976. 1C, 13A.

1980 *Macrodynamics of the American Economy: A Post-Keynesian Text*. White Plains, NY: M. E. Sharpe, Inc., 1980. 3D, 5D, 9A.

EISNER, Robert.
1956 *Determinants of Capital Expenditures (An Interview Study)*, Urbana: University of Illinois Press, 1956. 13A, D.

1960 "A Distributed Lag Investment Function." *Econometrica*, 1960, *28*, 1-29. 13A.

1963 and Robert Strotz. "Determinants of Business Investment." Research Study Two in *Impacts of Monetary Policy*. Englewood Cliffs, NJ: Prentice-Hall, 1963. 13A.

1974 "Econometric Studies of Investment Behaviour: A Comment." *Economic Inquiry*, 1974, *12*, 91-104. 13A.

ELLSBERG, Daniel.
1954 "Classic and Current Notions of 'Measurable Utility.'" *Economic Journal*, 1954, *64*, 528-556. 12B.

1961 "Risk, Ambiguity and the Savage Axioms." *Quarterly Journal of Economics*, 1961, *75*, 643-669. 12F.

EZZELL, John R.
1979 and R. Burr Porter. "Correct Specification of the Cost of Capital and Net Present Value." *Financial Management*, 1979, *8*, 15-17. 13A, 13C.

FELLNER, William.
1980 "The Valid Core of Rationality Hypothesis in the Theory of Expectations." *Journal of Money, Credit and Banking*, 1980, *12*(4), 763-787. 12F.

FISHER, I.
1930 *The Theory of Interest*. New York: MacMillan, 1930. 1C, 13A.

FLAMANT, Maurice
1968 and Jeanne Singer-Kérel. *Modern Economic Crises*. Presses Universitaires de France, 1968. English translation Barrie and Jenkins Ltd., 1970. 8C.

FOLEY, Duncan K.
1975 "On Two Specifications of Asset Equilibrium in Macroeconomic Models." *Journal of Political Economy*, 1975, *83*(2), 303-324. 9B.

FORD, G. W.
1974 "Computers and the Quality of Working Life." *Search*, 1974, *5*, 369-374. 3D.

FRIEDMAN, M.
1948 and L. J. Savage. "The Utility Analysis of Choices Involving Risk." *Journal of Political Economy*, 1948, *56*, 279-304. 12B.

1956 *Studies in the Quantity Theory of Money* (ed.). Chicago: University of Chicago Press, 1956. 1C.

1963 and A. J. Schwartz. *A Monetary History of the United States 1867-1960.* Princeton: Princeton University Press, 1963. 1C.

1968 "The Role of Monetary Policy." *American Economic Review*, 1968, *63*, 1-17. 1C.

1970 "A Theoretical Framework for Monetary Analysis." *Journal of Political Economy*, 1970, *78*, 193-238. 1C.

1976 *Price Theory: A Provisional Text.* Chicago: University of Chicago Press, 1976. 12F.

FRISCH, Ragnar.
1933 "Propagation Problems and Impulse Problems in Dynamic Economics." In *Essays in Honour of Gustav Cassel.* London: Allen and Unwin, 1933. 1A, 10B, C, 11B, D, 12A.

FURUJA, H.
1962 and K. I. Inada. "Balanced Growth and Intertemporal Efficiency in Capital Accumulation." *International Economic Review*, 1962, *3*, 94-107. 7D.

GALAI, Dan.
1976 and Ronald W. Masulis. "The Option Pricing Model and the Risk Factor of Stock." *Journal of Financial Economics*, 1976, *3*, 53-81. 13A.

GALBRAITH, John Kenneth.
1955 *The Great Crash 1929.* London: Hamish-Hamilton, 1955. Reprinted: Penguin Books, 1961, 1963, 1966, 1968, 1969, 1971, 1975, 1977. 14D.

1958 *The Affluent Society.* London: Hamish-Hamilton, 1958. 2nd. edition: Hamish-Hamilton, 1969. 2nd. edition: Pelican Books, 1970. 1C.

1971 *The New Industrial State* (2nd edition). Boston: Houghton-Mifflin, 1971. 1C.

1973 "Power and the Useful Economist." *American Economic Review*, 1973, *63*, 1-11. 1C.

1973a *Economics and the Public Purpose.* New York: Signet Book, New American Library, 1973. 1C.

1975 *Money: Whence it Came, Where it Went.* London: Andre Deutsch, 1975. 1C, 8C, 10B.

GALE, David.
1956 "The Closed Linear Model of Production." Chapter 18 in *Linear Inequalities and Related Systems*, ed. by H. W. Kuhn and A. W. Tucker. Princeton: Princeton University Press, 1956. 4A, C, F.

1967 "On Optimal Development in a Multi-Sector Economy." *Review of Economic Studies*, 1967, *34*, 1-18. 7D.

1973 "Pure Exchange Equilibrium of Dynamic Economic Models." *Journal of Economic Theory*, 1973, *6*, 12-36. 7D.

1975 and Richard Rockwell. "On the Interest Rate Theorems of Malinvaud and Starrett." *Econometrica*, 1975, *43*(2), 347-359. 7D.

GARBADE, Kenneth D.
1974 "Optimal Policies for Structural Models." Research Memorandum No. 170. Princeton, NJ: Princeton University, October 1974. 11A.

GELBER, Frank H.
1977 "Dual Instability?" Research Memorandum. Sydney: University of Sydney, May 1977. 7D.

GIGANTES, T.
1972 "The Representation of Technology in Input-Output Systems." Chapter 14 in A. P. Carter, 1972. 5D.

GILBERT, R.
1972 SEE J. B. Ramsey.

GOLDBERGER, A.
1959 *Impact Multipliers and Dynamic Properties of the Klein-Goldberger Model.* Amsterdam: North-Holland, 1959. 11B.

GOLE, V. L.
1968 *Fundamentals of Financial Management in Australia.* Sydney: Butterworth, 1968. 13D.

GOODWIN, R. M.
1955 "A Model of Cyclical Growth." In *The Business Cycle in the Post War World*, ed. by E. Lundberg. 1955, pp. 203-221. 1B, 10C.

1967 "A Growth Cycle." in *Capitalism and Economic Growth*, ed. by C. H. Feinstein. Cambridge: Cambridge University Press, 1967, pp. 54-58. 1B, 8D, 10C.

1972 "A Growth Cycle." In *A Critique of Economic Theory*, ed. by E. K. Hunt and Jesse G. Schwartz. New York: Penguin Books, 1972, pp. 442-449. 1B, 8D, 10C.

GOSSLING, W. F.
1967 SEE G. R. Blakley.

GOULD, J.
1968 "Adjustment Costs in the Theory of Investment of the Firm." *Review of Economic Studies*, 1968, *34*, 47-56. 13A.

GRAM, Harvey.
1980 SEE V. Walsh.

GRAMM, Warren S.
1973 "Natural Selection in Economic Thought: Ideology, Power, and the Keynesian Counterrevolution." *Journal of Economic Issues*, 1973, *7*, 1-27. 1C.

GRANGER, C. W. J.
1974 and P. Newbold. "Spurious Regressions in Econometrics." *Journal of Econometrics*, 1974, *2*, 111-120. 16C.

GROSSMAN, Herschel I.
1972 "Was Keynes a 'Keynesian'? A Review Article." *Journal of Economic Literature*, 1972, *10*, 26-30. 1C.

1976 SEE R. J. Barro.

HADLEY, G.
1971 and M. C. Kemp. *Variational Methods in Economics.* Amsterdam: North-Holland, 1971. 11A.

HAGEN, O.
1979 SEE M. Allais.

HAGGER, A. J.
1979 SEE D. W. Challen.

HAGUE, D. C.
1961 SEE F. A. Lutz.

HAHN, F. H.
1964 and R. C. O. Matthews. "The Theory of Economic Growth: A Survey." *Economic Journal*, December 1964, *74*, 779-902. 7D.

1965 and F. Brechling (eds.). *The Theory of Interest Rates*. London: Macmillan, 1965. 1C.

1970 "Some Adjustment Problems." *Econometrica*, 1970, *38*, 1-17. 7A, D.

1971 *Readings in the Theory of Growth*. London: Macmillan, 1971. 7D.

1971a SEE K. J. Arrow.

1973 "On Some Equilibrium Paths." Pages 193-206 in Mirrlees 1973. 7D.

1976 "Keynesian Economics and General Equilibrium Theory: Reflections on Some Current Debates." Technical Report No. 219. Stanford: Institute for Mathematical Studies in the Social Sciences, Stanford University, September 1976. 1C.

HALL, B. H.
1974 SEE E. K. Berndt.

HALL, R. E.
1974 SEE E. K. Berndt.

HAMBERG, Daniel.
1971 *Models of Economic Growth*. New York: Harper and Row, 1971. 7D.

HANSEN, Alvin H.
1953 and Richard V. Clemence. *Readings in Business Cycles and National Income*. London: Allen and Unwin, 1953. 7D, 8C.

HANSEN, Bent.
1951 *A Study in the Theory of Inflation*. London: Allen and Unwin, 1951. 1C.

HARCOURT, G. C.
1968 "Investment-Decision Criteria, Investment Incentives, and the Choice of Technique." *Economic Journal*, 1968, *78*, 77-95. 13D.

1971 and N. F. Laing (eds.). *Capital and Growth*. London: Penguin Books, 1971. 1C.

1972 *Some Cambridge Controversies in the Theory of Capital*. Cambridge: Cambridge University Press, 1972. 1C, 5A, 7C, D, 8A, 10C, 13D.

1973 "The Rate of Profits in Equilibrium Growth Models: A Review Article." *Journal of Political Economy*, 1973, *81*, 1261-1277. 1C.

1976 and Peter Kenyon. "Pricing and the Investment Decision." *Kyklos*, 1976, *29*, 449-477. 13A, D.

1976a "The Cambridge Controversies: Old Ways and New Horizons—or Dead End?" *Oxford Economic Papers*, 1976, *28*, 25-65. 1C.

HARPER, Charles P.
1977 "Testing for the Existence of a Lagged Relationship within Almon's Method." *Review of Economics and Statistics*, 1977, *59*, 204-210. 16C.

HARRIS, D. L.
1973 "Capital Distribution and the Aggregate Production Function." *American Economic Review*, 1973, *63*(1), 100-113. 1C.

HARRIS, Donald J.
 1978 *Capital Accumulation and Income Distribution.* London: Routledge and Kegan Paul, 1978. 1C, 8E.

HARROD, Sir Roy F.
 1939 "An Essay in Dynamic Theory." *Economic Journal*, March 1939, *49*, 14-33. Reprinted in Hansen, 1953. 7D, 10C.

 1948 *Towards a Dynamic Economics.* London: MacMillan, 1948. 7D, 10C.

 1970 "Reassessment of Keynes's Views on Money." *Journal of Political Economy*, 1970, 78, 617-625. 1C.

 1973 *Economic Dynamics.* London: MacMillan, 1973. 7D, 10C.

HART, A. G.
 1942 "Risk, Uncertainty, and the Unprofitability of Compounding Probabilities." In *Studies in Mathematical Economics and Econometrics*, ed. by O. Lange, I. McIntyre, and T. O. Yntema. Chicago: University of Chicago Press, 1942. 12F.

HARVEY, A. C.
 1977 and P. Collier. "Testing for Functional Misspecification in Regression Analysis." *Journal of Econometrics*, 1977, *6*, 103-119. 16C.

HAUSMAN, J. A.
 1974 SEE E. K. Berndt.

HAWTREY, Ralph G.
 1926 "The Trade Cycle." Original (Dutch) in *De Economist*, 1926. Reprinted in *Trade and Credit*. London: Longmans, Green, 1928. Reprinted in *Readings in Business Cycle Theory*. USA: Blakiston Co., 1944. Page references are to the 1944 reprint. 1C, 7A, 7D, 14D.

 1928 *Trade and Credit.* London: Longmans, Green, 1928. 7A, D, 14D.

HEILBRONER, Robert L.
 1972 *The Worldly Philosophers.* 4th edition. New York: Simon and Schuster, 1972. 2D, 14C.

HELLIWELL, J. F.
 1976 (ed.). *Aggregate Investment.* London: Penguin, 1976. 13A.

HELLMAN, R. H. G.
 1980 "Non-Linear Dynamics" (ed.). *Annals of the New York Academy of Sciences*, Vol. 357, Dec. 26, 1980. 8B.

HENDRY, David F.
 1978 and Grayham E. Mizon. "Serial Correlation as a Convenient Simplification, Not a Nuisance: A Comment on a Study of the Demand for Money by the Bank of England." *Economic Journal*, 1978, *88*, 549-563. 16C.

 1979 "Econometrics—Alchemy or Science?" An Inaugural Lecture, London School of Economics, November 1979. 16C.

HICKMAN, B. G.
 1972 (ed.). *Econometric Models of Cyclical Behavior.* 2 vols. New York: N.B.E.R. Columbia University Press, 1972. 11B.

HICKS, Sir John R.
 1939 *Value and Capital.* Oxford: Oxford University Press, 1939. Page quotations are to the second edition, 1948. 12B, 15F.

 1950 *A Contribution to the Theory of the Trade Cycle.* Oxford: Oxford University Press, 1950. 8D, 10A, C, 14D.

1965 *Capital and Growth.* Oxford: Oxford University Press, 1965. 4E, 7D.

1980 *Causality in Economics.* Canberra: Australian National University Press, 1980. 12F.

HIGGINS, C. I.
1976 with H. N. Johnston and P. L. Coghlan. "Business Investment: The Recent Experience." *Conference in Applied Economic Research, Papers and Proceedings.* Sydney: Reserve Bank of Australia, 1976, pp. 11-48. 13A.

HIRSCHLEIFER, J.
1970 *Investment, Interest and Capital.* Englewood Cliffs, NJ: Prentice Hall, 1970. 12B, 13A.

HOLMES, Philip J.
1979 *New Approaches to Nonlinear Problems in Dynamics: Proceedings of a Conference* (ed.), December 9-14, 1979. 8B.

HOLZMAN, F. D.
1963 SEE M. Bronfenbrenner.

HOTSON, J. H.
1967 "Neo-Orthodox Keynesianism and the $45°$ Heresy." *Nebraska Journal of Economics and Business*, 1967, *6*, 34-49. 1C.

HOWREY, E. P.
1971 "Stochastic Properties of the Klein-Goldberger Model." *Econometrica*, 1971, *39*(1), 73-87. 11B.

1972 and Lawrence R. Klein. "Dynamic Properties of Nonlinear Econometric Models." *International Economic Review*, 1972, *13*(3), 599-618. 11B.

HUNT, E. K.
1972 and Jesse G. Schwartz (eds.). *A Critique of Economic Theory.* New York: Penguin Books, 1972. 1C, 8E.

INADA, K.
1962 SEE H. Furuja.

1963 "On a Two-Sector Model of Economic Growth: Comments and a Generalization." *Review of Economic Studies*, 1963, *30*, 119-127. 7C, D.

ISARD, Walter.
1942 "Transport Development and Building Cycles." *Quarterly Journal of Economics*, 1942, *57*, 90-112. 9C.

JAKSCH, Hans Jürgen.
1977 "A Necessary and Sufficient Condition for the Equality of the Expansion Rates in the von Neumann Growth Model." *Journal of Economic Theory*, 1977, *15*, 228-234. 4F.

JENKS, Jeffrey M.
1975 SEE R. S. Bower.

JEVONS, W. Stanley.
1884 "The Periodicity of Commercial Crises and its Physical Explanation." In *Investigations in Currency and Finance*, London: Macmillan, 1884, Chapter 7, pp. 206-220. Reprinted in A. H. Hansen, 1953, pp. 83-95. 11D.

JOHANSEN, Leif.
1959 "Substitution versus Fixed Production Coefficients in the Theory of Economic Growth: A Synthesis." *Econometrica*, 1959, *27*, 157-176. 7C.

JOHNSON, Harry G.
1971 *The Two-Sector Model of General Equilibrium.* London: Allen and Unwin, 1971. 7D.

JOHNSTON, H. N.
1976 SEE C. I. Higgins.

JOHNSTON, J.
1960 *Statistical Cost Analysis.* New York: McGraw-Hill, 1960. 3A.

1972 *Econometric Methods.* 2 edition. New York: McGraw-Hill, 1972, 11C, 16B, C.

JORGENSON, Dale W.
1960 "A Dual Stability Theorem." *Econometrica*, 1960, *28*(4), 892-899. 7D.

1961 "Stability of a Dynamic Input-Output System." *Review of Economic Studies*, 1961, *28*, 105-116. 7D.

1963 "Stability of a Dynamic Input-Output System: A Reply." *Review of Economic Studies*, 1963, *30*, 148-149. 7D.

1963a "Capital Theory and Investment Behavior." *American Economic Review*, 1963, *53*, 247-259. 13A.

1967 and J. Stephenson. "The Time Structure of Investment Behavior in United States Manufacturing, 1947-1960." *Review of Economics and Statistics*, 1967, *49*, 16-27. 13A.

1967a and J. Stephenson. "Investment Behavior in U.S. Manufacturing, 1947-1960." *Econometrica*, 1967, *35*, 169-220. 13A.

1968 and C. Siebert. "A Comparison of Alternative Theories of Corporate Investment Behavior." *American Economic Review*, 1968, *58*, 681-712. 13A.

1968a and C. Siebert, "Optimal Capital Accumulation and Corporate Investment Behavior." *Journal of Political Economy*, 1968, *76*, 1123-1151. 13A.

1969 and J. Stephenson. "Anticipations and Investment Behavior in U.S. Manufacturing, 1947-1960." *Journal of the American Statistical Association*, 1969, *64*, 67-89. 13A.

JUNANKAR, P.
1972 *Investment: Theories and Evidence.* London: Macmillan, 1972. 13A.

KAHN, Richard Ferdinand.
1931 "The Relation of Home Investment to Unemployment." *Economic Journal*, 1931, *41*, 173-198. 9B.

1959 "Exercises in the Analysis of Growth." *Oxford Economic Papers*, 1959, *11*, 143-156. 7D.

KALDOR, Nicholas.
1940 "A Model of the Trade Cycle." *Economic Journal*, 1940, *50*, 78-92. 10C.

1954 "The Relation of Economic Growth and Cyclical Fluctuations." *Economic Journal*, 1954, *64*, 53-71. 10C.

1957 "A Model of Economic Growth." *Economic Journal*, 1957, *67*, 591-624. 10C.

1960 *Economic Stability and Growth.* London: Duckworth, 1960. 10C.

1961 "Capital Accumulation and Economic Growth." In F. A. Lutz, 1961, pp. 177-222. 10C.

1962 and J. A. Mirrlees, "A New Model of Economic Growth." *Review of Economic Studies*, 1962, *29*, 174-192. 10C, 13D.

1972 "The Irrelevance of Equilibrium Economics." *Economic Journal*, 1972, *82*, 1237-1255. 1C.

KALECKI, M.
1937 "A Theory of the Business Cycle." *Review of Economic Studies*, 1937, *4*, 77-97, 10C.

1943 "Political Aspects of Full Employment." *Political Quarterly*, 1943, *14*, 322-331. 10C.

1954 *Theory of Economic Dynamics*. London: Allen and Unwin, 1954. 10C.

KARLIN, S.
1959 *Mathematical Methods and Theory in Games, Programming, and Economics*. Reading, MA: Addison-Wesley, 1959. 3E, 4A, C.

1960 SEE K. J. Arrow.

KEMENY, J. G.
1956 with O. Morgenstern and G. L. Thompson. "A Generalization of the von Neumann Model of an Expanding Economy." *Econometrica*, 1956, *24*, 115-135. 4A, C, D, 6B, C.

KEMP, Murray C.
1971 SEE G. Hadley.

1976 "How to Eat a Cake of Unknown Size." In *Three Topics in the Theory of International Trade*. Amsterdam: North-Holland, 1976. 13A.

1978 and Y. Kimura. *Introduction to Mathematical Economics*. New York: Springer-Verlag, 1978. 3E.

KENNEDY, C.
1972 and A. P. Thirwell. "Technical Progress: A Survey." *Economic Journal*, 1972, *82*, 11-72. 10C.

KENYON, Peter.
1976 SEE G. C. Harcourt.

KEYNES, J. Maynard.
1921 *Treatise on Probability*. London: Macmillan, 1921. Reprinted in *Collected Writings*. Vol. 8. London: Macmillan. 1971-. 12A.

1930 *Treatise on Money*. London: Harcourt Brace, 1930. 1C.

1936 *The General Theory of Employment, Interest, and Money*. London: Macmillan, 1936. Reprinted: London: Macmillan for the Royal Economic Society, 1973. 9A, B, 12A, 13A, E, 14D.

1937 "The General Theory of Employment." *Quarterly Journal of Economics*, 1937, *51*, 209-223. 12F, 13E.

1939 "Professor Tinbergen's Method." *Economic Journal*, 1939, *49*, 558-570. 16C.

KIM, M.
1974 SEE C. Linke.

KIMURA, Y.
1978 SEE M. C. Kemp.

KING, Mervyn.
1974 "Dividend Behaviour and the Theory of the Firm." *Economica*, 1974, *41*, 25-34. 1C.

KLEIN, Lawrence R.
1972 SEE E. P. Howrey.

KNAPP, John.
1973 "Economics or Political Economy?" *Lloyds Bank Review*, 1973, *107*, 19-43. 1C.

KNIGHT, Frank H.
1921 *Risk, Uncertainty and Profit*. Hart, Schaffner and Marx, 1921. Reprinted New York: Harper and Row, 1957. 1B, 12A, 13B, E.

KNOX, A. D.
1952 "The Acceleration Principle and the Theory of Investment: A Survey." *Economica*, 1952, *19*, 269-297. 9A.

KOHLI, Ulrich R.
1979 "Nonjointness and Factor Intensity in U.S. Production." Working Paper, Department of Economics, Sydney University, December 1979. 7D.

KONDRATIEV, N. D.
1922 *The World Economy and its Condition During and After the War*. Russian text. *Vologda*, 1922, p. 242. 9C.

KOOPMANS, Tjalling C.
1964 "Economic Growth at a Maximal Rate." *Quarterly Journal of Economics*, 1964, *78*, 355-394. 4A.

KORNAI, János.
1971 *Anti-Equilibrium: On Economic Systems Theory and the Task of Research*. Amsterdam: North-Holland, 1971. 1C.

KREGEL, J.
1972 *The Theory of Economic Growth*. London: Macmillan, 1972. 1C.

1973 *The Reconstruction of Political Economy: An Introduction to Post-Keynesian Economics*. London: Macmillan, 1973. 1C.

1975 SEE A. S. Eichner, 1975a.

KUCZYNSKI, Marguerite.
1972 and Ronald L. Meek, *Quesnay's Tableau Economique*. London: Macmillan, 1972. 7D, 15A.

KUH, E.
1959 SEE J. Meyer.

KURZ, M.
1968 "The General Instability of a Class of Competitive Growth Processes." *Review of Economic Studies*, 1968, *35*, 155-174. 7D.

1970 SEE K. J. Arrow.

LAIDLER, David E. W.
1977 "Expectations and the Behaviour of Prices and Output Under Flexible Exchange Rates." *Economica*, 1977, *44*, 327-336. 1C.

1977a *The Demand for Money*. 2nd edition. New York: Dun-Donnelley, 1977. 1C.

LAING, N. F.
1971 SEE G. C. Harcourt.

1978 *Technological Uncertainty and the Pure Theory of Allocation*. Adelaide: Flinders University of South Australia, 1978. 12F.

1978a "A Note on the Theory of the Trade Cycle." *Seventh Conference of Economists.* Sydney: Macquarie University, August 1978. 10C.

1980 "A Theory of Business Fluctuations When Investment is Determined by Expectations of 'Foreseeable' New Investment Opportunities." *Australian Economic Papers*, June 1980, *19*(34), 91-111. 10C.

LALL, Kishore.
1974 SEE Gerald A. Pogue.

LARNER, Robert J.
1966 "Ownership and Control in the 200 Largest Nonfinancial Corporations, 1929 and 1963." *American Economic Review*, 1966, *56*(4), 777-787. 1C.

LARSSON, S.
1977 SEE K. R. MacCrimmon.

LAVINGTON, F.
1922 *The Trade Cycle: An Account of the Causes Producing Rhythmical Changes in the Activity of Business.* Westminster: King, 1922. 14D.

LEAMER, Edward E.
1978 *Specification Searches: Ad Hoc Inference with Nonexperimental Data.* New York: Wiley, 1978. 16C.

LEIJONHUFVUD, Alex.
1968 *Keynesian Economics and the Economics of Keynes.* London: Oxford University Press, 1968. 1C.

LEIPNIK, Roy.
1981 and T. Newton. "Irrational Conflict with Intervention." *Third International Conference on Mathematical Modelling*, July 1981. 8B.

LEONTIEF, Wassily W.
1951 *The Structure of the American Economy, 1919-1939.* 2nd edition. Oxford: Oxford University Press, 1951. 3A, 5D.

1953 and others. *Studies in the Structure of the American Economy.* Oxford: Oxford University Press, 1953. 3A, 5D.

1961 "Lags and the Stability of Dynamic Systems." *Econometrica*, 1961, *29*(4), 659-669. 7D.

1970 "Theoretical Assumptions and Non-Observed Facts." *American Economic Review*, 1971, *61*, 1-7. 16C.

LESSARD, Donald R.
1973 SEE R. S. Bower.

LEVHARI, D.
1968 and D. Patinkin. "The Role of Money in a Simple Growth Model." *American Economic Review*, 1968, *58*, 713-753. 7D.

LEVY, Haim.
1977 SEE Fred D. Arditti.

LINKE, C.
1974 and M. Kim. "More on the Weighted Average Cost of Capital: Comment and Analysis." *Journal of Financial and Quantitative Analysis*, 1974, *9*, 1069-1080. 13A, C.

LOEB, Peter D.
1976 "Specification Error Tests and Investment Functions." *Econometrica*, 1976, *44*, 185-194. 16C.

LONG, H. W.
 1977 SEE K. J. Boudreaux.

 1979 SEE K. J. Boudreaux.

LONG, N. V.
 1975 "Resource Extraction Under the Uncertainty About Possible Nationalization." *Journal of Economic Theory*, 1975, *10*, 42-53. 13A.

LORENZ, E. N.
 1963 "Deterministic Nonperiodic Flow." *Journal of Atmospheric Science*, 1963, *20*, 130-141. 8B.

LOŚ, Jerzy.
 1976 "Extended von Neumann Models and Game Theory." In J. and M. Loś, 1976a, pp. 141-157. 4F, 6B, E, 7D.

 1976a and Maria W. Loś (eds.). *Computing Equilibria: How and Why*. Amsterdam: North-Holland, 1976. 7D.

LOVELL, M. C.
 1961 "Manufacturers' Inventories, Sales Expectations, and the Acceleration Principle." *Econometrica*, 1961, *29*, 293-314. 9A.

LUCAS, Robert E., Jr.
 1975 "An Equilibrium Model of the Business Cycle." *Journal of Political Economy*, 1975, *83*, 1113-1144. 10C.

 1980 "Methods and Problems in Business Cycle Theory." *Journal of Money, Credit and Banking*, 1980, *12*(4), 696-715. 12F.

 1981 and T. J. Sargent, *Rational Expectations and Econometric Practices*. Minneapolis: University of Minnesota Press, 1981. 12F.

LUTZ, F. A.
 1961 and D. C. Hague (eds.). *The Theory of Capital*. London: Macmillan, 1961. 10C.

MacCRIMMON, K. R.
 1968 "Descriptive and Normative Implications of the Decision Theory Postulates." In K. H. Borch, 1968a, pp. 3-32. 12F.

 1977 and S. Larsson. "Utility Theory: Axioms vs. Paradoxes." *Conference on Experimental Economics*. Tucson, Arizona: Department of Economics, University of Arizona, March 1977. 12F.

MADDEN, Paul.
 1977 "On Keynesian Economic Theory." *Sixth Conference of Economists*. Hobart: University of Tasmania, May 1977. 1C.

MAGDOFF, Harry.
 1970 "Militarism and Imperialism." *American Economic Review*. 1970, *60*(2), 237-242. 1C.

MAIRESSE, Jacques.
 1978 SEE M. Atkinson.

MALINVAUD, Edmond.
 1953 "Capital Accumulation and Efficient Allocation of Resources." *Econometrica*, 1953, *21*, 233-268. 7D.

MARRIS, Robin.
 1963 "A Model of the 'Managerial' Enterprise." *Quarterly Journal of Economics*, 1963, *77*(2), 185-209. 1C.

 1964 *The Economic Theory of Managerial Capitalism*. London: Macmillan, 1964. 1C.

1968 "Galbraith, Solow, and the Truth About Corporations." *The Public Interest*, Spring 1968, *11*, 37-46. 1C.

1971 and A. J. B. Wood (eds.). *The Corporate Economy*. London: Macmillan, 1971. 1C.

MARSCHAK, J.
1950 "Rational Behavior, Uncertain Prospects, and Measurable Utility." *Econometrica*, 1950, *18*, 111-141. 12B.

MARSHALL, Alfred.
1890 *Principles of Economics*. 1st edition. London: Macmillan, 1890. 9th (variorum) edition. London: Macmillan, 1961. 1A, 2C, 3C.

MARX, Karl.
1867 *Das Capital*. Vol. 1. Original German edition, 1867. English translation, Moscow: Progress Publishers, 1954. 5A, 8E, 10C.

1894 *Capital*. Vol. 3. Published in German by F. Engels, 1894. English translation, Moscow: Progress Publishers, 1959. 3C.

MASON, Edward S.
1959 *The Corporation in Modern Society*. Cambridge, MA: Harvard University Press, 1959. 1C.

MASULIS, Ronald W.
1976 SEE Dan Galai.

MATTHEWS, R. C. O.
1959 *The Trade Cycle*. Cambridge: Cambridge University Press, 1959. 8A, C, 9C, 14C.

1964 SEE F. H. Hahn.

McCALLUM, Bennett T.
1980 "Rational Expectations and Macroeconomic Stabilization Policy: An Overview." *Journal of Money, Credit and Banking*, 1980, *12*(4), 716-746. 12F.

McKENZIE, Lionel W.
1960 "Stability of Equilibrium and the Value of Positive Excess Demand." *Econometrica*, 1960, *28*, 606-617. 7D.

McLAREN, Keith R.
1977 "On the Derivation of Determinate Investment Equations." *Sixth Conference of Economists*. Hobart: University of Tasmania, May 1977. 13A.

McMANUS, Maurice.
1963 "Notes on Jorgenson's Model." *Review of Economic Studies*, 1963, *30*, 141-147. 7D.

MEADE, J. E.
1961 *A Neoclassical Theory of Economic Growth*. London: Allen and Unwin, 1961. 7D.

MEANS, Gardiner.
1935 "Industrial Prices and Their Relative Inflexibility." U.S. Senate Document Q13, 74th Congress, 1st Session, 1935. 1C.

1962 *The Corporate Revolution in America*. Cromwell-Collier, 1962. 1C.

1974 "Cost Inflation and The State of Economic Theory—Comment and Correction," *Economic Journal*, 1974, *84*, 375-376. 1C.

MEDIO, Alfredo.
1975 *Nonlinear Models of Economic Fluctuations*. Thesis, Cambridge University, 1975. 10C.

MEEK, Ronald L.
 1963 *The Economics of Physiocracy, Essays and Translations.* Cambridge, MA: Harvard University Press, 1963. 7D, 15A, E.

 1972 SEE M. Kuczynski.

MEHTA, Ghanshyam.
 1978 "The Keynesian Revolution." *Seventh Conference of Economists.* Sydney: Macquarie University, August 1978. 1C.

MELMAN, Seymour.
 1972 "The Peaceful World of Economics I." *Journal of Economic Issues,* 1972, *6*(1), 35-41. 1C.

MELTZER, Allan H.
 1976 SEE K. Brunner.

MERTON, Robert C.
 1973 "The Theory of Rational Option Pricing." *Bell Journal of Economics and Management Science,* 1973, *4*, 141-183. 13A.

 1974 "On the Pricing of Corporate Debt: The Risk Structure of Interest Rates." *Journal of Finance,* 1974, *29*, 449-470. 13A.

 1976 "Option Pricing When Underlying Stock Returns are Discontinuous." *Journal of Financial Economics,* 1976, *3*, 125-144. 13A.

METZLER, Lloyd A.
 1941 "The Nature and Stability of Inventory Cycles." *Review of Economics and Statistics,* 1941, *23*, 113-129. 9C.

 1946 "Business Cycles and the Modern Theory of Employment." *American Economic Review,* 1946, *36*, 278-291. 9C.

 1947 "Factors Governing the Length of Inventory Cycles." *Review of Economics and Statistics,* 1947, *29*, 1-15. 9C, D.

 1948 "Three Lags in The Circular Flow of Income," 1948. In *Income, Employment, and Public Policy: Essays in Honour of Alvin Hansen,* by L. A. Metzler and others. New York: Norton, 1964, pp. 11-32. 9B, C.

MEYER, J.
 1959 and E. Kuh. *The Investment Decision.* Boston: Harvard University Press, 1959. 13A.

MILLER, M. H.
 1958 SEE F. Modigliani.

 1961 SEE F. Modigliani.

 1963 SEE F. Modigliani.

 1978 SEE R. W. Banz.

MINHAS, B. S.
 1961 SEE K. J. Arrow.

MINSKY, H. P.
 1977 "The Financial Instability Hypothesis: An Interpretation of Keynes and an Alternative to 'Standard' Theory." *Nebraska Journal of Economics and Business,* 1977, *16*, (1), 5-16. 8D, 14D.

MIRRLEES, J. A.
 1962 SEE N. Kaldor.

 1967 "Optimum Growth When Technology is Changing." *Review of Economic Studies,* 1967, *34*, 95-124. 7D.

1973 and N. H. Stern (eds.). *Models of Economic Growth.* London: Macmillan, 1973. 7D.

MITCHELL, Wesley C.
1913 *Business Cycles.* Berkeley, CA: N.B.E.R., 1913. 14D.

1947 SEE A. F. Burns.

MIZON, Grayham E.
1977 "Model Selection Procedures." In M. J. Artis, 1977, pp. 97-120. 16C.

1978 SEE D. F. Hendry.

MODIGLIANI, F.
1958 and M. H. Miller. "The Cost of Capital, Corporation Finance, and the Theory of Investment." *American Economic Review.* 1958, *48*, 261-297. 13A.

1961 and M. H. Miller. "Dividend Policy, Growth, and the Valuation of Shares." *Journal of Business,* 1961, *34*, 411-432. 13A.

1963 and M. H. Miller. "Taxes and the Cost of Capital: A Correction." *American Economic Review,* 1963, *53*, 433-443. 13A.

MOESEKE, Paul van.
SEE van Moeseke.

MONSEN, R. Joseph.
1965 and Anthony Downs. "A Theory of Large Managerial Firms." *Journal of Political Economy,* 1965, *73* (3), 221-236. 1C.

MONTGOMERY, William David.
1971 "An Interpretation of Walras' Theory of Capital as a Model of Economic Growth." *History of Political Economy,* 1971, *3*, 278-297. 3B.

MOOSA, Suleman A.
1977 "Dynamic Portfolio-Balance Behavior of Time Deposits and 'Money.'" *Journal of Finance,* 1977, *32*, 709-717. 1C.

MORGENSTERN, O.
1944 SEE John von Neumann.

1947 SEE John von Neumann.

1956 SEE J. G. Kemeny.

1976 and G. L. Thompson. *Mathematical Theory of Expanding and Contracting Economies.* Lexington, MA: Lexington Books, 1976. 4A, 6C.

1977 "My Collaboration with John von Neumann on the Theory of Games." *Economic Impact,* 1977, *3*, 35-41. Reprinted from *Journal of Economic Literature,* 1976. 4A.

MORISHIMA, Michio.
1958 "Prices, Interest, and Profits in a Dynamic Leontief System." *Econometrica,* 1958, *26*, 358-380. 5D, 7D.

1959 "Some Properties of a Dynamic Leontief System with a Spectrum of Techniques." *Econometrica,* 1959, *27*, 626-637. 5D, 7D.

1964 *Equilibrium, Stability and Growth: A Multisectoral Analysis.* Oxford: Clarendon Press, 1964. 5A, 5C, 5D, 6A, 6D, 7D.

1969 *Theory of Economic Growth.* Oxford: Clarendon Press, 1969, 5A, C, D, 6A, D, 7D.

1973 *Marx's Economics; A Dual Theory of Value and Growth.* Cambridge: Cambridge University Press, 1973. 1C.

MOSSIN, J.
 1968 SEE K. Borch, 1968a.

MUELLER, Willard F.
 1971 Testimony, Hearing Before the Select Committee on Small Business,
 U.S. Senate, 92nd Congress, 1st Session, Nov. 12, 1971 (page 1097).
 1C.

MURAKAMI, Y.
 1979 SEE J. Tsukui.

MUTH, John F.
 1960 "Optimal Properties of Exponentially Weighted Forecasts." *Journal
 of the American Statistical Association*, 1960, *55*, 299-306. 12F.

 1961 "Rational Expectations and the Theory of Price Movements." *Econ-
 ometrica*, 1961, *29*, 315-335. 12F.

MYERS, S. C.
 1965 SEE A. A. Robichek.

NADIRI, M.
 1973 and S. Rosen. "A Disequilibrium Model of Demand for Factors of
 Production." New York: N.B.E.R., 1973. 13A.

NANTELL, Timothy J.
 1975 and C. Robert Carlson. "The Cost of Capital as a Weighted Average."
 Journal of Finance, 1975, *30*, 1343-1355. 13A, C.

NEGISHI, Takashi.
 1962 "The Stability of a Competitive Economy: A Survey Article."
 Econometrica, 1962, *30*, 635-669. 7D.

NERLOVE, M.
 1972 "Lags in Economic Behavior." *Econometrica*, 1972, *40*, 221-251.
 13A.

NEUMANN, John von
 SEE von Neumann.

NEWBOLD, P.
 1974 SEE C. W. J. Granger.

NICKELL, S. J.
 1977 "The Influence of Uncertainty on Investment." *Economic Journal*,
 1977, *87*, 47-70. 13A.

NOBAY, A. R.
 1977 SEE M. J. Artis.

NORMAN, P. M.
 1975 SEE J. Carmichael.

NOUSSAIR, Ezzat.
 1979 Private Communication. 7E.

NOVE, A.
 1974 "Cost Inflation and the State of Economic Theory—A Comment."
 Economic Journal, 1974, *84*, 376-379. 1C.

ORDER, Robert van.
 SEE van Order.

PAGAN, A. R.
 1980 SEE T. S. Breusch.

PASINETTI, Luigi L.
 1974 *Growth and Income Distribution*. Cambridge: Cambridge University
 Press, 1974. 10C.

1977 *Lectures on the Theory of Production*. London: Macmillan, 1977.
1C, 8E.

PATINKIN, D.
1965 *Money, Interest and Prices*. 2nd edition. New York: Harper and
Row, 1965. 1C.

1968 SEE D. Levhari.

1976 "Keynes and Econometrics: On the Interaction Between the Macro-
economic Revolutions of the Interwar Period." *Econometrica*,
1976, *44*, 1091-1123. 16C.

PERRY, G. L.
1964 "The Determinants of Wage Rate Changes and the Inflation-Unem-
ployment Trade-Off for the United States." *Review of Economic
Studies*, 1964, *31*, 287-303. 10C.

PHELPS BROWN, E. H.
1972 "The Underdevelopment of Economics." *Economic Journal*, 1972,
82, 1-10. 1C.

PHILLIPS, A. W.
1958 "The Relation Between Unemployment and the Rate of Change of
Money Wage Rates in the United Kingdom, 1861-1957." *Economica*,
1958, *25*, 283-299. 10C.

PIERSON, Gail.
1968 "The Effect of Union Strength on the U.S. 'Phillips Curve.'"
American Economic Review, 1968, *58* (3), 456-467. 10C.

PIRENNE, Henry.
1925 *Medieval Cities: Their Origins and the Revival of Trade*. Translated
by Frank D. Halsey, 1925. Reprint: Princeton University Press,
1969. 2D.

PITCHFORD, John D.
1977 and Stephen J. Turnovsky (eds.). *Applications of Control Theory to
Economic Analysis*. Amsterdam: North Holland, 1977. 11A.

POGUE, Gerald A.
1974 and Kishore Lall. "Corporate Finance: An Overview." *Sloan Manage-
ment Review*. 1974, *15* (3), 19-38. 13A.

POLANYI, Karl.
1957 *The Great Transformation*. Boston: Beacon Press, 1957. 2D.

POPE, Robin.
1978 "Public Sponsorship and Risk Reduction." *Seventh Conference of
Economists*. Sydney: Macquarie University, August 1978. 13A.

PORTER, R. Burr.
1979 SEE John R. Ezzell.

PRAETZ, Peter D.
1977 "The Detection of Mis-Specification in Multiple Regression Models."
Working Paper No. 12, Dept. of Econometrics and Operations Re-
search, Monash University, Melbourne, 1977. 16C.

PROSCHAN, F.
1965 SEE R. Barlow.

QUESNAY, Françis.
1760 *Oevres economiques et philosophiques de François Quesnay*. New
York: Burt Franklin, 1888, 1969. 1B, 7D, 8D, 15A.

1972 SEE M. Kuczynski.

RAMSEY, J. B.
1969 "Tests for Specification Errors in Classical Linear Least-Squares Regression Analysis." *Journal of the Royal Statistical Society (Series B)*, 1969, *31*, 350-371. 16C.

1972 and R. Gilbert. "A Monte Carlo Study of Some Small Sample Properties of Tests for Specification Error." *Journal of the American Statistical Association*, 1972, *67*, 180-186. 16C.

RAU, Nicholas.
1974 *Trade Cycles: Theory and Evidence*. London: Macmillan, 1974. 9A, B, 10A, B.

RAZIN, Assaf.
1972 "Optimum Investment in Human Capital." *Review of Economic Studies*, 1972, *39*, 455-460. 7D.

RICARDO, David.
1821 *The Principles of Political Economy and Taxation*. 3rd edition, 1821. Reprinted in Everyman's Library. London: Dent, 1911. 2B, 3A, C, 5B, 8E, 14B.

RICHARD, J.-F.
1980 "Models with Several Regimes and Changes in Exogeneity." *Review of Economic Studies*, 1980, *47* (1), 1-20. 16D.

ROBBINS, Lionel.
1935 *An Essay on the Nature and Significance of Economic Science*. London: Macmillan, 1935. 1C.

ROBICHEK, A. A.
1965 and S. C. Myers. *Optimal Financing Decisions*. Englewood Cliffs, NJ: Prentice-Hall, 1965 (see pages 79-83). 13A.

ROBINSON, E. A. G.
1954 "The Changing Structure of the British Economy." *Economic Journal*, 1954, *64*, 443-461. 14A, B.

ROBINSON, Joan
1933 *The Economics of Imperfect Competition*. London: Macmillan, 1933. 1C.

1938 Review of "The Economy of Inflation" by C. Bresciani-Turroni, *Economic Journal*, 1938, *48*, 507-513. 1C.

1954 "The Production Function and the Theory of Capital." *Review of Economic Studies*, 1954, *21*, 81-106. Reprinted in *Collected Economic Papers*. Vol. 2. Oxford: Blackwell, 1960. 1C, 5A, 7D, 9A, 10C.

1956 *The Accumulation of Capital*. London: Macmillan, 1956 (see p. 8). 12E, 13A, 14C.

1970 "Capital Theory Up to Date." *Canadian Journal of Economics*, 1970, *3*, 309-317. 1C.

1974 "History Versus Equilibrium." Thames Papers in Political Economy. London: Thames Polytechnic, Autumn 1974. 1A.

ROCKWELL, Richard.
1975 SEE D. Gale.

RONCAGLIA, Alessandro.
1978 *Sraffa and the Theory of Prices*. London: Wiley, 1978. 2C.

ROSEN, S.
1973 SEE M. Nadiri.

ROSTOW, W. W.
 1948 *British Economy of the Nineteenth Century*. Oxford: Oxford University Press, 1948. 8C.

ROTHENBERG, Thomas J.
 1979 "Comment." *Journal of the American Statistical Association*, 1979, *74*, 648-649. 16D.

ROWLEY, J. C. R.
 1970 "Investment Functions: Which Production Function?" *American Economic Review*, 1970, *60*, 1008-1012. 13A.

 1972 "Investment and Neoclassical Production Functions." *Canadian Journal of Economics*, 1972, *5* (3), 430-435. 13A.

ROY, A. D.
 1952 "Safety First and the Holding of Assets." *Econometrica*, 1952, *20*, 431-449. 12F, 13A, 13C.

RUSSELL, Bertrand.
 1936 *On the Value of Scepticism*. London: Macmillan, 1936 (p. 1). 16C.

SALMON, Mark.
 1977 and Peter Young. "Control Methods and Quantitative Economic Policy." CRES Working Paper R/WP15. Canberra: Australian National University, 1977. 11A.

SAMUELSON, Paul A.
 1939 "Interactions of the Multiplier Analysis and the Principle of Acceleration." *Review of Economics and Statistics*, 1939, *21*, 75-78. 9B.

 1939a "A Synthesis of the Principle of Acceleration and the Multiplier." *Journal of Political Economy*, 1939, *47* (6), 786-797. 1B, 8B, 10A.

 1947 *Foundations of Economic Analysis*. Cambridge, MA: Harvard University Press, 1947. 1B.

 1952 "Probability, Utility and the Independence Axiom." *Econometrica*, 1952, *20*, 670-678. 12F.

 1958 SEE R. Dorfman.

 1973 "Optimality of Profit-Including Prices under Ideal Planning." *Proceedings of the National Academy of Science U.S.A.*, 1973, *70* (7), 2109-2111. 8E.

SARGAN, J.D.
 1958 "The Instability of the Leontief Dynamic Model." *Econometrica*, 1958, *26*, 381-392. 7D.

 1961 "Lags and the Stability of Dynamic Systems: A Reply." *Econometrica*, 1961, *29* (4), 670-673. 7D.

SAUL, S. B.
 1970 (ed.) *Technological Change: The United States and Britain in the Nineteenth Century*. London: Methuen, 1970. 3D.

SAVAGE, Leonard J.
 1948 SEE M. Friedman.

 1954 *The Foundations of Statistics*. New York: Wiley, 1954. 2nd edition. New York: Wiley, 1972. 12F.

SCHOLES, M. J.
 1973 SEE F. Black.

SCHRAMM, R.
 1970 "The Influence of Relative Prices, Production Conditions and Adjust-
 ment Costs in Investment Behaviour." *Review of Economic Studies*,
 1970, *37*, 361-376. 13A.

SCHUMPETER, Joseph A.
 1935 "The Analysis of Economic Change." *Review of Economic Statistics*,
 1935, *17*, 2-10. Reprinted in: *Readings in Business Cycle Theory*.
 ed. by American Economic Association. USA:Blakiston, 1944,
 pp. 1-19. 14D.

 1939 *Business Cycles: A Theoretical, Historical and Statistical Analysis of
 the Capitalist Process*, New York: McGraw-Hill, 1939. 14D.

SCHWARTZ, A. J.
 1963 SEE M. Friedman.

SCHWARTZ, E. S.
 1978 SEE M. J. Brennan.

SCHWARTZ, Jacob T.
 1961 *Lectures on the Mathematical Method in Analytical Economics*. New
 York: Gordon and Breach, 1961. 1B, 10C.

 1965 *Theory of Money*. New York: Gordon and Breach, 1965. 1B.

SCHWARTZ, Jesse G.
 1972 SEE E. K. Hunt.

SHACKLE, G. L. S.
 1940 "The Nature of the Inducement to Invest." *Review of Economic
 Studies*, 1940, *8*, 44-48. 12F.

 1949 *Expectation in Economics*, Cambridge: Cambridge University Press,
 1949. 13A.

 1967 *The Years of High Theory*. Cambridge: Cambridge University Press,
 1967. 12A, F.

 1974 *Keynesian Kaleidics*. Edinburgh: Edinburgh University Press, 1974.
 12A, F.

SHAPIRO, Alan C.
 1979 "In Defense of the Traditional Weighted Average Cost of Capital as
 a Cutoff Rate." *Financial Management*. 1979, *8*, 22-23. 13A, C.

SHELL, Karl.
 1967 (ed.) *Essays on the Theory of Economic Growth*. Cambridge, MA:
 M.I.T. Press 1967. 7D.

 1976 SEE D. Cass.

SHUBIK, Martin.
 1970 "A Curmudgeon's Guide to Microeconomics." *Journal of Eco-
 nomic Literature*, 1970, *8* (2), 405-425. 1C.

SIEBERT, C.
 1968 SEE D. Jorgenson.

 1968a SEE D. Jorgenson.

SIMS, Christopher A.
 1977 *New Methods in Business Cycle Research: Proceedings from a Con-
 ference* (ed.). Federal Reserve Bank of Minneapolis, Minneapolis,
 1977. 11B, 16C.

SINGER-KÉREL, Jeanne.
 1968 SEE M. Flamant.

SMALE, Stephen.
1976 "Dynamics in General Equilibrium Theory." *Proceedings of the American Economic Association*, 1976, *66* (2), 288-294. 7D.

SMITH, Adam.
1776 *An Inquiry into the Nature and Causes of the Wealth of Nations.* 1776. Reprinted in The Modern Library. London: Dent, 1937. 3C, 5B, 6D, 8E.

SMITH, Clifford N., Jr.
1976 "Option Pricing; A Review." *Journal of Financial Economics.* 1976, *3*, 3-51. 13A.

SMYTH, D. J.
1975 and J. C. K. Ash, "Forecasting Gross National Product, the Rate of Inflation and the Balance of Trade: The O.E.C.D. Performance." *Economic Journal*, 1975, *85*, 361-364. 12F, 16D.

SOLOW, ROBERT M.
1956 "A Contribution to the Theory of Economic Growth." *Quarterly Journal of Economics*, 1956, *70*, 65-94. 7D.

1958 SEE Robert Dorfman.

1959 "Competitive Valuation in a Dynamic Input-Output System," *Econometrica*, 1959, *27*, 30-53. 7D.

1960 "Investment and Technical Progress." In *Arrow*, 1960, pp. 89-104. 7D.

1961 SEE K. J. Arrow.

1963 *Capital Theory and the Rate of Return.* Amsterdam: North Holland, 1963. 13A.

1966 with J. Tobin, C. C. von Weizsäcker, and M. Yaari. "Neoclassical Growth with Fixed Factor Proportions." *Review of Economic Studies*, 1966, *38*, 79-115. 7D.

1968 and Joseph E. Stiglitz. "Output, Employment and Wages in the Short Run." *Quarterly Journal of Economics*, November 1968, *82*, 537-560. 10C.

1968a "The Truth Further Refined: A Comment on Marris." *The Public Interest*, Spring 1968 (11), 47-52. 1C.

SRAFFA, P.
1960 *Production of Commodities by Means of Commodities; Prelude to a Critique of Economic Theory.* Cambridge: Cambridge University Press, 1960. 1A, B, C, 2A, B, C, 3C, 4A, 5B, C, D, 7D.

STARRETT, David A.
1973 SEE K. J. Arrow.

STEIN, J. L.
1966 "Money and Capacity Growth," *Journal of Political Economy*, 1966, *74*, 451-465. 7D.

STEPHENSON, J.
1967 SEE D. Jorgenson.

1967a SEE D. Jorgenson.

1969 SEE D. Jorgenson.

STERN, N. H.
1973 SEE J. A. Mirrlees.

STIGLITZ, Joseph E.
1968 SEE R. M. Solow.

1972 "Some Aspects of the Pure Theory of Corporate Finance: Bank-ruptcies and Take-Overs." *Bell Journal of Economics*, 1972, *3* (2), 458-482. 13A.

STONE, Brice M.
1979 "The Hart Definition of Knightian Uncertainty." Unpublished pre-print. 12F.

STROTZ, Robert.
1963 SEE Robert Eisner.

SUPPES, P.
1960 SEE K. J. Arrow.

SWAN, T. W.
1956 "Economic Growth and Capital Accumulation." *Economic Record*, 1956, *32*, 334-361. 7D.

TAUBER, Edward M.
1970 "The Oligopolistic 'Lock-In.'" *Applied Economics*, 1970, *2* (3), 225-229. 1C.

TERBORGH, G.
1949 *Dynamic Equipment Policy*. New York: McGraw-Hill, 1949. 13E.

THIRWELL, A. P.
1972 SEE C. Kennedy.

THOMPSON, G. L.
1956 SEE J. G. Kemeny.

1976 SEE O. Morgenstern.

THUROW, Lester C.
1969 "A Disequilibrium Neoclassical Investment Function." *Review of Economics and Statistics*, 1969, *51*, 431-435. 13A.

TOBIN, J.
1955 "A Dynamic Aggregative Model." *Journal of Political Economy*, 1955, *63*, 103-115. 7D.

1965 "Money and Economic Growth." *Econometrica*, 1965, *33*, 671-684. 7D.

1966 SEE R. M. Solow.

TOOKE, Thomas
1838 *A History of Prices and of the State of the Circulation*. Reprinted London: P. S. King and Son, 1928. 1A.

TORRE, V.
1977 "Existence of Limit Cycles and Control in Complete Keynesian Sys-tem by Theory of Bifurcations." *Econometrica*, 1977, *45*(6), 1457-1466. 1B.

TOWNSEND, Robert.
1970 *Up the Organization*. New York: Alfred S. Knopf, 1970. 1C.

TREADWAY, A.
1969 "Rational Entrepreneurial Behaviour and the Demand for Invest-ment." *Review of Economic Studies*, 1969, *36*, 227-239. 13A.

1970 "Adjustment Costs and Capital Inputs." *Journal of Economic Theory*, 1970, *2*, 329-347. 13A.

1971 "The Rational Multivariate Flexible Accelerator." *Econometrica*, 1971, *39*, 845-855. 13A.

TSUKUI, Jinkichi.
1968 "Application of a Turnpike Theorem to Planning for Efficient Accumulation: An Example for Japan." *Econometrica*, 1968, *36* (1), 172-186. 7D.

1979 and Yasusuke Murakami. *Turnpike Optimality in Input-Output Systems*. Amsterdam: North Holland, 1979. 7D.

TURNOVSKY, S. J.
1977 *Macroeconomic Analysis and Stabilization Policies*. London: Cambridge University Press, 1977. 11A.

1977 SEE J. D. Pitchford.

UZAWA, H.
1961 "On a Two-Sector Model of Economic Growth." *Review of Economic Studies*, 1961, *29*, 40-47. 7D.

1963 "On a Two-Sector Model of Economic Growth II." *Review of Economic Studies*, 1963, *30*, 105-118. 7D.

VAN MOESEKE, Paul.
1980 "The General von Neumann Program." *International Economic Review* (to be published). 4F.

VAN ORDER, Robert.
1976 "Excess Demand and Market Adjustment." *Economic Inquiry*, 1976, *14*, 587-603. 10C.

VEBLEN, Thorstein.
1934 *The Theory of the Leisure Class*. New York: The Modern Library, 1934. Reprinted Boston: Houghton-Mifflin, 1973. 1C.

VOLTERRA, V.
1931 *Théorie Mathématique de la Lutte Pour la Vie*. Paris: Gauthier-Villars, 1931. 10D.

VON NEUMANN, John.
1937 "A Model of General Economic Equilibrium and a Generalization of Brouwer's Fixed Point Theorem." *Ergebnisse Eines Mathematischen Kolloquiums*, ed. by Karl Menger. Vienna, 1937, pp. 873-83. 4A.

1944 and Oskar Morgenstern. *The Theory of Games and Economic Behavior*. 1st edition. Princeton: Princeton University Press, 1944. 12B.

1945 "A Model of General Economic Equilibrium." *Review of Economic Studies*, 13, 1-9. (English translation of von Neumann 1937.) 4A, C.

1947 and Oskar Morgenstern. *Theory of Games and Economic Behavior*. 2nd edition. Princeton: Princeton University Press, 1947. 12B.

VON WEIZSÄCKER, C. C.
1966 SEE R. M. Solow.

1973 "Morishima on Marx." *Economic Journal*, 1973, *83*, 1245-1254. 1C.

WALRAS, Leon.
1874, *Eléments d'économie politique pure*. Lausanne: L. Corbaz, 1874,
1877 1877. English translation by William Jaffé. *Elements of Pure Economics*. London: Allen and Unwin, 1954. 2C, 3C, 7D.

WALSH, Vivian.
 1980 and Harvey Gram, *Classical and Neoclassical Theories of General Equilibrium. Historical Origins and Mathematical Structure.* New York: Oxford University Press, 1980. 1C, 8E.

WAN, Henry Y., Jr.
 1971 *Economic Growth.* New York: Harcourt, Brace, Jovanovich Inc., 1971. 5A, 7D.

WARD-PERKINS, Charles Neville.
 1950 "The Commercial Crisis of 1847." *Oxford Economic Papers,* January 1950, *2,* 75-94. Reprinted in A. H. Hansen, 1953. 8C.

WATSON, G. S.
 1950 SEE J. Durbin.

 1951 SEE J. Durbin.

WEINTRAUB, Sidney.
 1971 "Keynes and the Monetarists." *Canadian Journal of Economics,* 1971, *4* (1), 37-49. 1C.

 1973 *Keynes and the Monetarists.* New Brunswick, NJ: Rutgers University Press, 1973. 1C.

 1974 "Cost Inflation and the State of Economic Theory—A Comment." *Economic Journal,* 1974, *84,* 379-382. 1C.

WEIZSÄCKER, C. C. von.
 SEE von Weizsäcker.

WELLS, Graeme.
 1977 "Approximately Optimal Macroeconomic Stabilization Policy: An Application." *Sixth Conference of Economists.* Hobart: University of Tasmania, May 1977. 11A.

WESTON, J. Fred.
 1973 "Investment Decisions Using the Capital Asset Pricing Model." *Financial Management,* Spring 1973, *2* (1), 25-33. 13A.

WHITE, Halbert.
 1980 "Using Least Squares to Approximate Unknown Regression Functions." *International Economic Review,* 1980, *21,* 149-170. 16C.

WILES, Peter.
 1973 "Cost Inflation and the State of Economic Theory." *Economic Journal,* 1973, *83,* 377-398. 1C.

 SEE also:

 1974 "A Reply to the Above Comments." *Economic Journal,* 1974, *84,* 383-386. 1C.

WILLIAMS, B. R.
 1971 SEE C. F. Carter.

WONG, R.
 1975 "Profit Maximization and Alternative Theories: A Dynamic Reconciliation." *American Economic Review,* 1975, *65,* 689-694. 13A.

WOOD, A. J. B.
 1971 SEE R. L. Marris.

WORSWICK, G. D. N.
 1972 "Is Progress in Economic Science Possible?" *Economic Journal,* 1972, *82,* 73-86. 1C, 13A.

WURTELE, Zivia S.
1959 "A Note on Some Stability Properties of Leontief's Dynamic Models." *Econometrica*, 1959, *27* (4), 672-675. 7D.

WYMER, Clifford R.
1978 "Continuous Models in Macro-Economics: Specification and Estimation." *Seventh Conference of Economists*. Sydney: Macquarie University, August 1978. 16D.

YAARI, M.
1966 SEE R. M. Solow.

YOUNG, Peter.
1974 "Recursive Approaches to Time Series Analysis." *Bulletin of the Institute of Mathematics and its Applications* (IMA), 1974, *10* (5/6), 209-224. 11A.

1976 "Some Observations on Instrumental Variable Methods of Time-Series Analysis." *International Journal of Control*, 1976, *23* (5), 593-612. 11A.

1977 SEE M. Salmon.

ZELLNER, Arnold.
1979 "Statistical Analysis of Econometric Models." *Journal of the American Statistical Association*, 1979, *74*, 628-643, 650-651. 16D.

Index

About the Author

John M. Blatt has been professor of applied mathematics at the University of New South Wales in Australia since 1959. He previously held research and teaching positions in physics at the Massachusetts Institute of Technology (1946-1949), the University of Illinois (1950-1953), and Sydney University (1954-1958). He is the author of five books and many scholarly papers; his first book, *Theoretical Nuclear Physics*, was written with Viktor Weisskopf.

Professor Blatt is a fellow of the Australian Computer Society and a member of the Australian Mathematical Society and the Economic Society of Australia and New Zealand.

Printed in the United States
by Baker & Taylor Publisher Services